VISUAL CULTURE IN CONTEMPO

C000060847

Exploring a wealth of images ranging from woodblock prints to oil paintings, this beautifully illustrated full-color study takes up key elements of the visual culture produced in the People's Republic of China from its founding in 1949 to the present day. In a challenge to prevailing perceptions, Xiaobing Tang argues that contemporary Chinese visual culture is too complex to be understood in terms of a simple binary of government propaganda and dissident art, and that new ways must be sought to explain as well as appreciate its multiple sources and enduring visions. Drawing on rich artistic, literary, and sociopolitical backgrounds, Tang presents a series of insightful readings of paradigmatic works in contemporary Chinese visual arts and cinema. Lucidly written and organized to address provocative questions, this compelling study underscores the global and historical context of Chinese visual culture and offers a timely new perspective on our understanding of China today.

XIAOBING TANG is Helmut F. Stern Professor of Modern Chinese Studies and Professor of Comparative Literature at the University of Michigan, and author of *Origins of the Chinese Avant-Garde.*

VISUAL CULTURE IN CONTEMPORARY CHINA

Paradigms and Shifts

XIAOBING TANG

CAMBRIDGE
UNIVERSITY PRESS

CAMBRIDGE
UNIVERSITY PRESS

University Printing House, Cambridge CB2 8BS, United Kingdom

Cambridge University Press is part of the University of Cambridge.

It furthers the University's mission by disseminating knowledge in the pursuit of education, learning and research at the highest international levels of excellence.

www.cambridge.org
Information on this title: www.cambridge.org/9781107446373

First published 2015

Printed in Spain by Grafos SA, Arte sobre papel

A catalogue record for this publication is available from the British Library

Library of Congress Cataloging-in-Publication Data
Tang, Xiaobing, 1964–
Visual culture in contemporary China : paradigms and shifts / Xiaobing Tang.
pages cm
Includes bibliographical references and index.
ISBN 978-1-107-08439-1 (Hardback) – ISBN 978-1-107-44637-3 (Paperback)
1. Art and society–China–History–20th century. 2. Art and society–China–History–21st century. 3. Art, Chinese–20th century. 4. Art, Chinese–21st century.
5. China–Civilization. I. Title.
N72.S6T36 2015
709.51′09045–dc23 2014021599

ISBN 978-1-107-08439-1 Hardback
ISBN 978-1-107-44637-3 Paperback

Contents

v

Acknowledgments

The initial impetus for this book may be traced back to the introductory courses on modern Chinese literature and culture that I taught when I was first an assistant professor at the University of Colorado, Boulder, in the early 1990s. I remember having slides made from the recently published *China's New Art, Post-1989* and trying to make sense of artwork from that volume to my students – and myself – by showing posters from an earlier era. Over the past twenty-some years, I have offered related courses at several universities, but the range of visual images I have presented has kept expanding. I want to take this opportunity to thank the many students who have shared my interest, made insightful comments, and stimulated my thinking. If by any chance some of you come across this book and flip through it, I hope you will be able to relate to what you find here.

This volume results from research and teaching over many years, during which time we have all witnessed the dramatic changes that have reshaped China and brought forth new issues and experiences. The writing of this book therefore reflects shifts in my own perspectives too, and it records my efforts to understand the complex meaning of a fast-changing China on the one hand, and to convey that understanding to my students and the general public on the other. I am fully aware that my efforts have received support from many individuals and various institutions. Without such support, this book project would not have gone very far.

In 2007, with funding from the American Council of Learned Societies, I organized an international conference on "Scenes and Visions: Approaches to Modern Chinese Visual Culture" at the University of Southern California. This was when the idea for this book first took root in my mind. Then, in October 2013, I organized another international and similarly multidisciplinary conference at the University of Michigan to reconsider socialist culture in twentieth-century China. This second conference received generous financial and staff support from the Center for Chinese Studies on campus. On both occasions, I gave presentations that eventually grew into chapters in the current volume, but it was the work of participating scholars and our shared research interests that I found most inspiring.

I drafted most of the chapters for the book in the 2011–12 academic year, when I was a fellow at the University of Michigan Institute for the Humanities. It was a productive year, and I enjoyed conversations with Daniel Herwitz, Artemis Leontis, David Porter, Matthew Lassiter, Joan Kee, Daniel Hack, and other colleagues at the institute. I owe a debt of gratitude to Donald Lopez and Yopie Prins who, as department chairs, endorsed my application for the fellowship to begin with.

Over the years, I have presented different stages of my research on contemporary Chinese visual culture at a number of institutions. One of the earliest occasions was a public lecture that I gave at the Fort Wayne Museum of Art in Indiana in 1996, when the touring exhibition of *China's New Art, Post-1989* opened there. Between 2007 and 2013, I had the pleasure of visiting and speaking at Stanford University, the University of Minnesota, Harvard University, Emory University, the National Museum of Korea, the University of California in Berkeley, Indiana University, the University of York in the UK, the Shenzhen Museum of Art, and Peking University in China. Presentations during these visits allowed me to interact with different audiences and clarify my ideas. I thank all the colleagues and institutions that invited me and offered me these opportunities.

More specifically, I express my thankfulness to the following individuals for their support, engagement with my work, and various other forms of assistance: Ban Wang and Jean Ma at Stanford; Li Yang, Yao Daimei, Wang Huangsheng, Yin Shuangxi, Wang Guangyi, Chen Qi, and Wang Mingxian in Beijing; Johnson Tsong-Zung Chang in Hong Kong; Liu Qingyuan, Cai Tao, and Li Gongming in Guangzhou; Gao Shiming, Fang Limin, Lü Peng, and Zhang Yuanfan in Hangzhou; He Kun and Li Chuankang in Yunnan; Jie Li at Harvard; Wang Zheng, Philip Hallman, Alan Young, Robert Demilner, Liangyu Fu, Katie Dimmery, and Angie Baecker at the University of Michigan; Stanley Rosen at the University of Southern California; Hannah Kendal and He Weimin at Oxford University; and Marien van der Heijden in Amsterdam.

I am both honored and delighted that Cambridge University Press is the publisher. I am most grateful to Lucy Rhymer for her enthusiasm from the very beginning. As commissioning editor, she recognized the relevance of my work and oversaw the project with a clear vision and professional rigor. The four readers for Cambridge University Press offered insightful comments and helped me make the manuscript much stronger. I appreciate their ringing endorsements, and I hope they will find the published version meets their expectations. I alone, however, remain responsible for my arguments as well as all possible errors in the following pages.

Working with the editorial staff at Cambridge University Press was a pleasant as well as a reassuring experience. I thank Amanda George and Beáta Makó in particular for guiding me through the production of the book.

The arduous process of seeking permission to reproduce images as illustrations was greatly facilitated by the Contemporary Art and Social Thought Research Institute at the China Academy of Art in Hangzhou, the Hunan Fine Arts Press, and the Central Academy of Fine Arts Museum of Art. I thank Liu Xiao in Hangzhou, Luo Biao in Changsha, and Liu Xiyan and Yang Linyu in Beijing for their dedicated assistance. I also thank all the artists who readily gave me permission to use their work for free in this publication.

I gratefully acknowledge a publication subvention provided by the Office of Research Funds for Research and Scholarship as well as the Center for Chinese Studies at the University of Michigan.

Chapter 3 is based on my essay "Rural Women and New China Cinema: From *Li Shuangshuang* to *Ermo*," first published by Duke University Press in *positions: east asia cultures critique* (vol. 11, no. 3: 647–74) in 2003 and included here with permission from Duke University Press. I have updated and revised the essay for its appearance in the present study.

A small portion of Chapter 5 appeared in a less-developed form as "Why Should 2009 Make a Difference? Reflections on a Chinese Blockbuster" in late 2009 in *Modern Chinese Literature and Culture*, an online resource center edited by Kirk Denton and based at the Ohio State University. Jason McGrath offered helpful comments on that earlier iteration. I thank both of them for their input.

My sister Xiaoyan in China is always ready to help when I need to find sources or get in touch with people there. I simply cannot thank her enough for all she has done for me.

In 2007, I dedicated my book on the modern woodcut movement to Katia and Kolia, my two little fellow travelers. In a few short years, Katia will be going to college. I hope both Katia and Kolia will have the option of taking a course on modern or contemporary Chinese visual culture in college. It should be an eye-opening experience.

Finally, like my other endeavors, this book would not have been possible without Liza's love and support.

A brief timeline of relevant events

1911 The Wuchang Uprising in central China in October leads to the fall of the Qing dynasty (1644–1912) and the establishment of the Republic of China (ROC) in 1912.

1919 The May 4 student protest movement, first in Beijing and then in other cities, provides momentum to the nascent New Culture Movement.

1927 The political alliance between the Nationalists (KMT) and the Communists (CCP) breaks down as their joint military campaign reaches the Yangtze Delta after defeating regional warlords.

 The Nationalist government of the ROC establishes itself in Nanjing, and the center of the nation's cultural and economic life shifts toward the Shanghai–Nanjing corridor.

1929 The First National Fine Arts Exhibition, organized by the Ministry of Education of the ROC, takes place in Shanghai.

1937 Japan begins its comprehensive invasion of China, an event arguably marking the beginning of World War II. With the fall of Nanjing in December, the Nationalist "Nanjing Decade" comes to an end.

1942 In rural northwest China, where the Communists have established their military and political bases, Mao Zedong delivers a series of talks at the Yan'an forum on literature and art, laying out the guidelines for developing a new culture for the nation.

1945 In Chongqing, the wartime capital of China, the Nationalist government accepts Japan's surrender in September. Soon afterwards, military clashes between the Communists and the Nationalists escalate into a full-blown civil war.

1949 Following decisive victories over Chiang Kai-shek's Nationalist army and with the ROC government withdrawn to Taiwan, Mao Zedong declares the founding of the People's Republic of China (PRC) on October 1.

 In July, an All-China Congress of Literary and Art Workers convenes in Beijing. An art exhibition is held during the congress

and will be retroactively named the First Fine Arts Exhibition of the PRC.

1950 The New Marriage Law, the first legal document of the PRC, is promulgated in April.

The Land Reform Law is promulgated in June and systematic land reform begins in the country.

The Korean War breaks out and China dispatches a Volunteer Army in support of North Korea in October.

1953 The first Five-Year Plan for industrialization and economic development is set in motion.

An international armistice brings the Korean War to an end in July.

The second All-China Congress of Literary and Art Workers takes place in September.

1958 The ambitious Great Leap Forward movement, for the stated purpose of achieving industrialization and increasing agricultural production through collectivization, begins and ends two years later with disastrous consequences.

Construction of the "Ten Great Buildings" begins in Beijing. Most of these monumental public buildings, best known of them being the Great Hall of the People, are completed by October 1, 1959, in order to commemorate the tenth anniversary of the PRC.

1960 The growing ideological divergence between the Communist Parties of the Soviet Union and China is publicized, culminating in military confrontations between the two countries in 1969.

1962 Mao Zedong calls for systematic socialist education in the country and emphasizes the continuation of class struggle under socialism.

Li Shuangshuang is released and by popular vote wins the 1963 Hundred Flowers Award for Best Feature Film.

1966 The Great Proletarian Cultural Revolution is launched.

From August to November, Mao Zedong greets and reviews over 13 million Red Guards traveling to Beijing from across the country.

1968 In Paris, student protests on university campuses and massive general strikes, in part inspired by the Chinese Cultural Revolution, take place in May.

Many countries around the world, from Canada to Japan, witness radical student activism in pursuit of different causes.

In China, with the education system practically shut down, a national campaign to send millions of high-school students from the city to the countryside for further education gets under way.

1971 As the Cultural Revolution enters its less turbulent phase, the
 PRC is admitted to the United Nations, replacing the ROC as the
 government representing China. In the following year, Japan and
 many Western countries, such as Great Britain, West Germany,
 Canada, and Australia, formally recognize the PRC.

1974 An exhibition of Huxian peasant painting begins a tour of several
 European countries.
 In October, a national fine arts exhibition opens in Beijing in
 celebration of the twenty-fifth anniversary of the PRC.

1976 Mao Zedong dies in September. Within a month, his wife Jiang
 Qing and a group of Cultural Revolution radicals are arrested.
 A year later, the CCP announces the conclusion of the Cultural
 Revolution at its eleventh national congress.

1979 The United States establishes diplomatic relationship with the
 PRC on January 1. A few weeks later, Vice Premier Deng
 Xiaoping becomes the first leader of the PRC to visit the United
 States.
 The era of reforms and opening-up begins.
 China Central Television (CCTV) starts broadcasting an
 entertainment program on the eve of the lunar New Year (Spring
 Festival).

1985 A modernist New Wave, embraced by young students of art,
 sweeps across many art academies and universities.
 The year before, *Yellow Earth*, directed by Chen Kaige,
 announced the arrival of the Fifth Generation of filmmakers.
 A group of writers belonging to the generation that was sent
 out to the countryside during the Cultural Revolution calls for a
 "seeking of cultural roots" through literature.

1989 A student-led protest movement in Tiananmen Square draws
 popular support and global media attention. The government
 declares martial law in Beijing in May, and brings in the military
 to clear demonstrators from the square on June 4.
 The Soviet bloc begins to unravel, first in Poland and then
 across Eastern Europe.
 In February, *China/Avant-Garde*, also known as the *China
 Modern Art Exhibition*, opens at the China Art Gallery in Beijing.
 In July, the Seventh National Fine Arts Exhibition takes place as
 scheduled.

1992 In the wake of the collapse of the Soviet Union and the end of the
 Cold War, Deng Xiaoping, in his late eighties, visits the southern
 city of Shenzhen and calls for more comprehensive economic
 reforms and development.

1993 The exhibition *China's New Art, Post-1989* opens in Hong Kong.
 Over the next five years, portions of the exhibition travel to many
 cities in Australia, Canada, and the US, introducing to Western
 viewers new categories of contemporary Chinese art, such as
 Political Pop and Cynical Realism.

2001 On September 11, terrorist attacks take place in New York City
 and Washington, DC.
 In December, China officially joins the World Trade
 Organization, sixteen years after the country first expressed
 interest in becoming a member.

2008 Beijing hosts the Summer Olympics.

2009 Celebrations of the sixtieth anniversary of the PRC include the
 film *The Founding of a Republic*, a major box office hit.

2010 China becomes the second-largest economy in the world, after
 becoming the world's largest automobile market the year before.
 For the first time China's urban population outnumbers its
 rural population. According to a UN agency, China's urban
 population increased from 64 million in 1950 to 636 million.
 The number of Chinese internet users reaches 420 million.

2012 The European Fine Art Foundation reports that in the previous
 year China overtook the US as the world's largest market for art
 and antiques.
 Over 450 new art museums open this year, pushing the total
 number of museums in the country to 3,866, compared to 25
 in 1949.

2013 China adds 5,077 cinema screens in 903 new cineplexes, bringing
 the total number of screens to 18,195. According to the online
 magazine *Variety*, industry experts suggest that China will be
 adequately screened when it has 35,000 to 40,000 cinema screens.
 The total number of cellphone users in China surpasses 1
 billion.
 China experiences the worst air pollution in history. The State
 Council issues a comprehensive plan of action in September,
 vowing to improve air quality measurably by 2017.

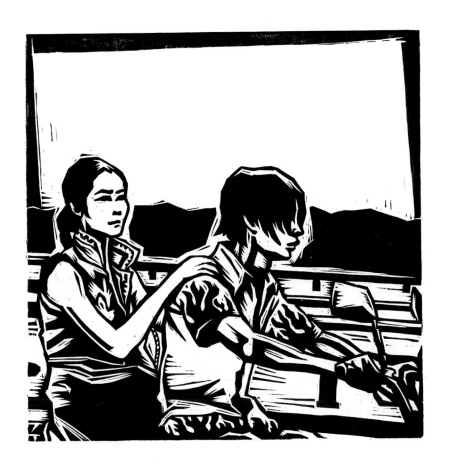

INTRODUCTION

Toward a short history of visual culture
in contemporary China

In this interdisciplinary study, I present and discuss artistic expressions and experiments that are pivotal to our understanding of the logic and complexity of contemporary Chinese visual culture. The six chapters take us from the mid-twentieth century to the present, covering the entire history of the People's Republic. An array of artwork in various media and genres is examined in detail, and more is referred to. Most of these visual objects may be, and some have been, studied in academic disciplines such as art history and film studies, but I believe the notion of visual culture allows us to appreciate their significance in more interactive and more explanatory contexts. More than embodying a specific artistic imagination or conceptual innovation, these works of art take up different positions – from high to low, academic to popular, public to personal – in an evolving structure of visibility, and they contribute instrumentally, as I seek to demonstrate, to the production of a complex visual order and experience that is recognizably Chinese and contemporary. They illustrate a succession of changing practices and paradigms. What this study reveals, I hope, is the deep resonance of continuing efforts to create a distinct Chinese culture and identity in the modern era.

My assertion that these artistic works form part of an ambitious creative project does not mean that contemporary Chinese culture is a monolithic edifice or concept. On the contrary, as the potent visual images and articulations investigated here will show, contemporary Chinese culture is a dynamic as well as a diverse field, driven by a readiness to experiment on many different levels, but also shaped by many forces and constituents. Once we enter this fast-changing field and explore its many trajectories and turning points, we will begin to see that cultural developments in contemporary China are far too complicated, and their respective histories far too intricate, for them to be reduced to a single label or narrative.

A facile dismissal of contemporary Chinese culture as an ominous monolith, therefore, would betray either a distant and uninformed view or a case of willful myopia. My plea for greater historical sympathy and understanding applies to the very notion of visual culture as well. It is problematic, because ultimately ahistorical, to valorize the primacy of visuality in post-industrial consumer societies as a universal postmodern condition. To limit the territory of visual culture to "the transcultural experience of the visual in everyday life" is myopic as it poses little challenge to the existing and unequal global system of image production and distribution.[1] Contemporary Chinese visual culture, I argue, consists of many layers and movements and can hardly be reduced to a mirror image of American or some abstract transnational visual experience.

It is helpful, for comparative purposes, to consider the implications of a recent study of American visual culture. Ever since the early 1990s, we have witnessed in the American academy a steady growth of research interests in

visual culture (or visual studies), a new discipline that has generated a good number of articles, monographs, concepts, debates, and course offerings. A "visual turn" (or what W. J. T. Mitchell prefers to call a "pictorial turn") in the humanities, believed by some to be comparable to and succeeding the momentous "linguistic turn" ushered in earlier by semiotics-based structuralist and post-structuralist theories, seemed to be timely and inevitable. Its proponents often point to the saturation of our contemporary world by images and visuality, finding support in provocative notions such as "the scopic regime" or the "society of the spectacle."

From its beginning, visual culture as an emerging research agenda has maintained a delicate relationship with the established field of art history, although it is an art-historical study of painting and daily experiences in fifteenth-century Italy, published by Michael Baxandall in 1972, that is widely credited for having illustrated the importance of understanding visual culture, or more specifically, for making us appreciate "the period eye" of a given moment.[2] Even more telling, as a chronicler of the rise of visual culture studies finds out, the term "visual culture" first appeared in the title of a 1969 American publication on television and education.[3] In retrospect, this coincidence foretold a productive alliance between film studies and the new interdisciplinary study. By 1995, in his well-noted reflection on visual culture and its intellectual potential, Mitchell was able to refer to it as a "new hybrid interdiscipline that links art history with literature, philosophy, studies in film and mass culture, sociology, and anthropology." It was a new interdiscipline, in Mitchell's view, that ought to distinguish itself from the critical, "iconoclastic" cultural studies with a keen ontological interest in vision and aesthetics. Studies of visual culture "tend to be grounded in a fascination with visual images, and thus to be patient with and attentive to the full range of visual experience from humble vernacular images, to everyday visual practices, to objects of both aesthetic delight and horror."[4]

This description by Mitchell had considerable prescriptive power over the self-positioning of visual culture studies. In its continuing negotiations with art history, visual culture studies seems ever more committed to elevating the popular and the everyday, to acknowledging a wide range of practices of looking while seeking to level hierarchical distinctions between them. There is certainly an appreciable democratizing impulse in this commitment, but lost in the fascination with "everyday visual practices" is often a perception of or insistence on cultural difference and transformation, especially when this everyday life is largely based on experiences in post-industrial, late-capitalist societies, if not more narrowly on an urban setting in such societies. As one commentator observes, overshadowed or downplayed in the elevation of visual culture is "the particular role of the arts to transform the culture of which they are

a part."[5] More recently, Janet Wolff has expressed worries that interests in exploring "the power of images" and "the lure of immediacy" have resulted in the evaporation of the social in theories of visual culture.[6]

The volume *American Visual Cultures*, published in 2005, is interesting to consider because, for one thing, it contains a useful critique of visual culture studies. A collection of essays by multiple authors (many of them based in the United Kingdom), the book engages a series of "visual cultures" in American history from the Civil War of the mid-nineteenth century to the War on Terror at the beginning of the twenty-first. Visual materials analyzed in some thirty short but informative chapters include film, television, photography, painting, illustrations, advertising, and news media. And the topics range from the visualization of Manifest Destiny, images of women in the Civil War, racial gazes, public artwork during the New Deal, Hollywood's Cold War, and Abstract Expressionism, to "queer" photography and post-feminism in TV comedy drama.

In their general introduction to the project, editors Holloway and Beck propose a "social theory of American visual cultures" that will address "the social realm of late American capitalist-democracy," which it is necessary to examine because "we are all conditioned by our structural position within the US-led global market." The social realm in contemporary America, they argue, is "stratified and contested, but it is not intrinsically atomized, any more than it could be described as a seamless historical unity." Moreover, "an essential part of the architecture of the American capitalist-democratic polis" has been the continuing proliferation of visual cultural forms, ever since "the early implementation of sophisticated visual codes in republican portrait painting and in landscape art and photography." Proliferating and innovative visual cultural forms not only saturate American everyday life and continually erode systems of high culture and taste distinctions, but are also an integral productive part of the dynamism and legitimation of the capitalist-democratic order.

With this understanding, the study of visual culture as a constitutive dimension of the American social realm, for Holloway and Beck, ought to be part of the examination that confronts "the role of culture in general in the reproduction of the world, and in the histories that have provided the condition for the emergence of the contemporary over time." Implied in this formulation is a dialectical understanding of the contemporary as both process and result, both historical emergence and systematic reproduction. It is an understanding that enables the two editors to arrive at a critical assessment of visual culture studies that, in their view, first asserted itself as an academic discipline by drawing heavily on "poststructural and postmodern methodologies within cultural studies and social theory."[7]

One indicator of interdisciplinary visual culture studies as "a more or less full-formed 'postmodern' discourse," according to Holloway and Beck, is "its inversion of the old binary that privileged the interrogation of the text's

production over the circumstances in which it is received." There is a determined shift of emphasis in the new interdisciplinary field away from the production of visual culture to consumption of images, away from complex processes of image-making to presumably universally accessible and equal practices of looking. As a result, the editors charge, there is a sense that "visual culture studies has privileged a methodology that is less interested in historicizing culture than in what we might call the culturalizing (or better, the acculturation) of history." There is also a privileging of an abstract, disembodied notion of a global everyday life, happily modeled after the ideal type of urban experience in a post-industrial and consumerist society (if not simply the Fifth Avenue in New York), over the uneven and unequal lived experiences across separate societies and locations.

On this point, I find the observations by Holloway and Beck both timely and provocative:

While it is one thing to suggest that history is made up of everyday experience as it is actually lived and understood by human beings, it is another thing entirely to imply, as visual cultural studies has sometimes done, that it is only everyday experience that constructs history, or that our everyday experience of the world around us is identical with the way that history works.[8]

Their example of a US energy company's logo displayed on a billboard in Kabul or Baghdad is a poignant one. As a visual statement, the logo may be looked at or consumed in a number of ways, and different meanings may be construed around it, but none of the practices of looking "would necessarily trouble or dislodge the historical meaning of that image as an emblem of US corporate power" backed by corporate capital and military might.

Here Holloway and Beck make their most trenchant intervention:

That visual culture studies has tended to conceive the viewing subject as a "consumer" of images (rather than as a "citizen", say, who is a "participant observer") suggests that the dominant critical paradigm of the field accepts the logic of the late capitalist market-place as a historical given, rather than as something that has been contested, or that can be contested, and whose development over time has taken place at the exclusion of other possible modes of securing our material life.[9]

This critique is particularly relevant to our present project because it cautions us against glossing over historical processes, and it underscores the importance of historicizing visual culture against its grain. It also helps us appreciate the fact that, for contemporary Chinese visual culture, the late-capitalist marketplace logic is far from a given in its formation over time, but was fiercely contested and even resisted in recent history. And that history of contestation and resistance is still visible as a meaningful remainder, even, or especially, when a market economy seems to have prevailed and penetrated the fabric of social life in contemporary China.

As we look into the rich visual forms and expressions generated with and for a social vision not centered on the marketplace, we will see ever more clearly that the intended viewing subject was indeed seldom imagined to be a consumer, and that producers of such visual culture assumed a very different position as well. The critical relevance of contemporary Chinese visual culture, as I explain in this study, consists in the *denaturalization of the marketplace logic* that an investigation into the historical formation of the current visual system will lead to, and in the other historical visions and processes that such an investigation will also make visible. To fully engage this visual culture and its historical specificity, we realize that we will need to address a new set of issues and devise corresponding concepts and analytical approaches. We must ask intelligent questions in order to reveal and acknowledge, instead of obscuring, the underlying logic of a diversity of creative efforts, of different paradigms for artistic imagination.

At an early point in their introduction to *American Visual Cultures*, Holloway and Beck state that their project is motivated by a deep concern with "what we, along with many others around the world, consider to be a renewed historical transparency in the operating of American power-elites on the global stage." They refer to the development of a "transnational American studies" in Europe in the 1990s and see their work as continuing that of dismantling the ideological myth of "American exceptionalism," arguing that the contemporary systems of power-relations are as global as they are American.[10] (Mark Rawlinson, another British scholar, published in 2009 a single-authored volume on *American Visual Culture* and framed his enterprise along similar lines.[11]) To study American visual culture in this context is tantamount to unmasking the universalist claims of American exceptionalism and examining their global ramifications. It implies not only a firm grasp of the historicity of various visual practices and pleasures, but also a clear sense of our own embeddedness in the contemporary world.

Whether or not this group of concerned British scholars succeeds in unmasking or halting the "historical transparency" (or rather unprecedented blatancy) of American global power through examining its capacity for visual production may remain an open question, but their reflection on methodology, in particular their self-positioning with regard to the object of their inquiry, offers us a valuable lesson. Visual culture studies is intrinsically interdisciplinary, argue Holloway and Beck, because it not only recognizes the overlapping plurality of its object of study, but also considers the totality of contexts in which we undertake our study. It is a relational totality that is also provisional, "in the sense that it expands or contracts, becoming plastic or porous, according to the diversity of social and historical experience in which the interests of students, teachers and critics are formed."[12]

For the same reason, how we approach contemporary Chinese visual culture hinges upon as much as exposes our own viewing position, or, put differently, our understanding of contemporary China and its relevance. Our respective viewing positions may be informed by many sources and interests, and as a result they allow us to assemble different, even conflicting, scenarios and narratives. The narratives with the most explanatory power, however, are those that also seek to spell out and explain the motivations for telling the story in the first place.

The brief history of visual culture in contemporary China that I attempt here will challenge two narratives prevalent in Western mainstream perceptions of China that find their variations in many related discourses and assumptions, including academic studies. One such narrative describes China today as held together forcibly by a bankrupt authoritarianism, with economic development as the last and dubious resort of legitimation for the existing order. This narrative, with its conceptual origins traceable to European Enlightenment *philosophes'* denunciation of Oriental despotism, underwrites the most virulent form of contemporary "China Threat" hysteria because, by denying legitimacy to the Chinese political system and reality, it not only identifies an ideological enemy to the liberal-democratic West, but also precludes any patient or meaningful engagement with the many dimensions, such as culture, of a living society.

One logical extension of this (lack of) legitimacy narrative, as I discuss further in Chapter 5, is the dissidence hypothesis, which presupposes any expression of criticism voiced in China to be an act of political dissidence against a repressive regime and therefore worthy of sympathy and outside support. The irony is that such a politically dominated and reductive presupposition closely duplicates the reasoning underlying the idealist fervor of "putting politics in command" during the Cultural Revolution era in China itself. It is also a view that readily falls back and draws on the demonization, with its unmistakable racial undertones, of a menacing "Red China" during the Cold War. Here may be one explanation as to why we do not see much of a difference between the left and the right, or the liberal and the conservative, in the political spectrum of the West when it comes to voicing outrage against contemporary China as an authoritarian other. This is why a presidential hopeful in the 2011–12 election season in America would have no qualms about announcing that his realpolitik agenda was to "take China down" by inciting the internet generation in that country so that America would remain on top and win back its economic muscles.[13]

Another popular and equally reductive narrative portrays China as having in recent decades opened up and moved steadily, in large part pushed by the enabling hand of the market and global capital, from

political fanaticism and economic egalitarianism to an embrace of entre-
preneurialism, greater individual freedom and increasing access to Western
products and values. This is a more complex narrative and its basic plot
appears compatible with narrations of the development of contemporary
China that we also find in mainstream media and historiography in China.
To the extent that it acknowledges contemporary Chinese society as
becoming ever more diverse, energetic, and integrated into the global
economy, this narrative of a historic opening-up certainly is persuasive
and offers a good starting point.

Yet as it is told in Western mainstream media, this story often turns into
an exercise in short-term historical memory, through which the long
revolutionary history in modern China is reduced to little more than what
ought to be negated and forgotten. Missing from this near-sighted view of
contemporary China are any efforts at appreciating the historic necessity as
well as significance of the revolution that in the mid-twentieth century
profoundly transformed the Chinese nation. The revolution was fostered,
as the renowned historian Joseph Levenson saw it, by the cosmopolitan
spirit of several generations of Chinese and "may be interpreted, in cultural
terms, as a long striving to make their museums themselves."[14]

On the grand stage of the modern world, Levenson observed sympa-
thetically, the Chinese "had to escape being exhibits themselves, antiques
preserved for foreign delectation." Ever since the earliest days of the
twentieth century, the desire to create a new culture that is both modern
and Chinese, that will allow the Chinese to represent themselves on the
world stage – "against the world to join the world" – has been a driving
force behind many revolutionary and reformist programs. This enduring
cosmopolitan aspiration was emphatically reaffirmed when the Commun-
ist victory and the establishment of the People's Republic in 1949 asserted
the subjecthood of the Chinese people in a world-historical sense and
embraced the vision of a New China, most famously laid out by Liang
Qichao in his unfinished political fiction from 1902, as a sovereign and
strong modern nation-state among the family of nations. Of foremost
priority on the massive reconstruction agenda of New China was the
creation of a new socialist culture that, by synthesizing the native and
the foreign, the traditional and the modern, the virtuous and the revolu-
tionary, would make a distinct contribution to an emergent world culture.

Yet less than two decades into the history of the young People's
Republic, the danger of war "in an embattled age of possible destruction,"
commented Levenson, derailed the cosmopolitan project and "gave
the Cultural Revolution its dual targets, the two cultures, western and
traditional."[15] Levenson was writing in the spring of 1969, when the
Cultural Revolution was still raging across China and access to information
was severely limited. Nonetheless he showed extraordinary insight into
the Chinese revolutionary psyche and, from his commanding view of the

dialectical movement of modern Chinese history, he understood the devastations unleashed by the mass political campaign as ultimately a defensive response to the destabilizing geopolitical threats from outside. As a result, he had the confidence to predict (between 1968 and 1969!) that "one way or another (the choice of ways is fearful), China will join the world again on the cosmopolitan tide."[16] And history has proven his perspicacity. In the last quarter of the twentieth century, China did repudiate the radical "cultural provincialism" of the Cultural Revolution and resumed the cosmopolitan orientation in rejoining a changed world. As a state-sponsored project, this return or opening-up relied for its legitimation and success on the many legacies – from political symbolism to institutional infrastructure to mobilizational mechanisms – of the Chinese revolution, even though it also entailed drastic changes in many practices and conceptions, including the purposes and functions of the government. Not surprisingly, the reform era also prompted extensive debates and reflections on the revolutionary heritage.

Without understanding the logic of revolutionary cosmopolitanism ("let foreigners not be cosmopolitans *at Chinese expense*," as is spelled out by Levenson) or the Chinese revolution as an inevitable and necessary foundation, we would not be able to make sense of much of Chinese society or culture today. Indeed, we would find ourselves acting like many media commentators in the West, who seem simply unable to reconcile what they regard as stunning outbursts of Chinese national pride and patriotic fervor with Chinese consumers' astonishing appetite for Western brand names, or to comprehend why, as I explore in Chapter 5, Chinese viewers should find *The Founding of a Republic* an engaging as well as an entertaining film. We would, again like many an ill-informed outside observer, hold onto the events in 1989 as the defining moment of contemporary China and equate the Cultural Revolution to the history of the Chinese revolution, if not to modern Chinese history altogether.[17]

Against a broad backdrop of historical change and continuity I view and study contemporary Chinese visual culture. "Contemporary" is understandably an elastic notion, but in this study I intend it to refer to the period from the founding of the PRC in 1949 to the present, drawing on an established periodizing category in literary studies in China. (For this highly evolved academic tradition, "modern literature" is a specific concept and conventionally covers literary developments from around 1915 to 1949.) The advantage as well as challenge of utilizing this designation of the "contemporary" comes from the fact that it compels us to narrate and think through the successive stages that form the complex contours and layers of contemporary culture, or, as Holloway and Beck put it, "the histories that have provided the condition for the emergence of the contemporary over time." This does not mean the history of New China since 1949 is the outer limit to the sources or manifestations of

contemporary culture. For instance, the conception of a painting such as *The Bloodstained Shirt*, as I discuss in Chapter 2, draws on images and texts from a long pre-PRC revolutionary history. Another example may be the robust revival today of traditional or pre-revolutionary beliefs, rituals, customs, ceremonies, and even superstitions, most of which were once strenuously denounced and suppressed during the nation's drive for a cosmopolitan modernity. A study of contemporary culture may not include a full account of the originations of such cultural traditions, but it should nonetheless explain the contemporary significance of their revival, and the process of explaining is where we try to restore historical depths to the notion of the contemporary and approach it as a historically determined emergence.

Here I should reiterate the claim of limited scope that we find in many a volume on visual culture. The objective of organizing a volume on *American Visual Cultures*, as its editors make clear, is not "to present an exhaustive account of modern American history." "Nor would we claim to have assembled a comprehensive taxonomy of American visual cultures, or of the possible approaches to visual culture criticism."[18] All of these disclaimers are applicable to the present volume, and, given the fact that my study here has a modest episodic structure similar to Mark Rawlinson's volume on American visual culture, I share his hope that the book will serve to generate more interest in issues raised either directly or indirectly here. This is indeed "a suggestive rather than exhaustive survey" of possible topics in a study of paradigms and shifts in contemporary Chinese visual culture.[19]

The artistic work and objects that I highlight and analyze in the volume belong to a history of visual culture that contains many shifts and realignments, changing values and expectations. They also reveal a continually vibrant cultural production dedicated to addressing, always in its own terms and contexts, many issues that we recognize as similarly important in other contemporary cultures and societies, such as the tension between high or elite and popular art forms, the evolving positions of the avant-garde, and the complicated relationships between art, politics, and commerce. One central formation that brings these familiar issues together and yet gives them a specific and far-reaching historical turn is that of socialist visual culture, the creation of which, as I discuss in Chapter 1, was a collective and deeply inspiring project in the 1950s, the period of socialist collectivization and construction, or high socialism, in China.

Socialist visual culture is the starting point in the brief conceptual history that I offer here, because this is a moment that expressed a critical awareness of the relationship between the visual and social transformation. It projected a visual order in which the traditional hierarchy between fine art and popular art should be overcome, and a radically new visuality and structure of visibility should be promoted by all available means. (For this

reason, as I will argue, visual culture suggests a more capacious research agenda than conventional art history when it comes to fully understanding artistic production and circulation during the socialist era.) More importantly, the production of such a visual culture was coordinated by the new socialist state and predicated on two imperatives: to create an inspirational visual environment in support of the socialist revolution, on the one hand, and to invent fresh national forms by modernizing indigenous traditions and nativizing modern imports, on the other. These twin imperatives are the key reasons why mainstream visual images and imaginations from this era, whether found on posters or in the cinema, were so persistently positive and didactical, and why, in terms of formal innovations, a campaign to update the folk art of New Year prints would soon be followed by calls to make oil painting more Chinese.

The visual experience during high socialism was intense for several reasons. It was part of an unprecedented program to construct a unified and progressive national culture, but more directly it was expected to help legitimate the newly formed and reconfigured nation-state. The condition of production for this visual culture was in fact never far removed from the constant threat of war, both real and potential. The Korean War, we may recall, broke out on China's doorstep hardly a year after the founding of the PRC at the end of a massive civil war, and threw the country back into mobilizational gear for the following three years, while the shadow of a military showdown with the US-backed Nationalist forces, now stationed in Taiwan, would loom on the horizon for a much longer period. A full history of socialist visual culture in China must take into account the geopolitical pressures and consequences of the Cold War as well as its flash points.

Socialist visual culture is also an important concept with which to approach the aggressive visual language and practices of the Cultural Revolution (1966–76). The bombastic posters and graphics accentuating waves of mass mobilization signaled a further intensification of the revolutionary imperative of socialist visuality. Driven by war fantasies, modern-day hero worship, and impatience with post-revolutionary everyday life, the explosive Cultural Revolution visual ephemera broadcast a violent grassroots rebellion that was clearly anti-institutional, anti-establishment, and yet endorsed by Mao Zedong, the supreme leader of the PRC and a visionary revolutionist. While on one level the youthful cultural revolutionaries may betray a "cultural provincialism," as Levenson reasoned, in their rejection of both Western and traditional cultural heritages, on another we sense an unexpected but deep affinity between the Red Guard art movements in 1967 and the Situationist International, their European contemporaries who were calling for a permanent revolution of everyday life and argued for the need for a cultural revolution in the developed capitalist world – the society of survival and the spectacle.[20] This was a

global connection, as I suggest in Chapter 4 and elsewhere, that ought to complicate our appreciation of the meaning of the avant-garde.[21]

In the early 1970s, as the Cultural Revolution entered its second phase, efforts to restore the order and discipline of the earlier stage of socialist construction were continually made and then frustrated, while principles for producing a revolutionary visual culture were codified and systematically implemented, as Paul Clark observed recently in his history of the cultural production of this turbulent period.[22] (Clark also noted that "throughout the Cultural Revolution perhaps the most artistically satisfying art available in China came in book illustrations and comic-book retellings of fiction and films."[23])

The ending of the Cultural Revolution in 1976 began a long process of healing, reflection, and reorientation for a nation exhausted by repeated urgings to engage in continuous revolution. The "intellectual emancipation" in the late 1970s set in motion a gradual debunking of many theories and practices drilled in during the Cultural Revolution, helping in the process to build up a societal consensus on the urgency of reform. "Voices of Spring," a short story published by Wang Meng in 1980, both expressed and legitimated the widespread desire to return to a normal life as well as to embark on a new journey. Aboard a sealed boxcar packed with travel-weary passengers, an engineering physicist, who has recently returned from a study trip to Frankfurt, Germany, is going to his remote hometown in the northwest to visit his aging father for the first time in over twenty years. "Everyone is going home for the lunar New Year, the Spring Festival, the favorite old Chinese festival of us all. Thank heavens the whole country can now have a happy New Year. No one can destroy the Spring Festival anymore in the name of 'revolutionizing' it."[24] When the pensive physicist gets off the train at the end of the story, he notices "the rusty, shabby exterior of the boxcar" but is heartened by the handsome locomotive at the head of the train, "with a brand-new, immaculately clean, light-weight diesel engine."[25] This battered but reenergized train, clearly intended as a metaphor for China in the wake of the Cultural Revolution, is eager to move into the future and will, as we now know from historical hindsight, be continually upgraded and accelerate headlong through ever extending horizons in the decades to come. All the passengers, too, will find themselves profoundly changed and repositioned in the course of the journey.

By the mid 1980s, a post-Cultural Revolution visual culture had become palpable. The search for fresh and expressly cosmopolitan visual languages drove recent graduates from art academies to restage one modernist art movement after another, from Expressionism to Dada, culminating in an eye-opening New Wave in 1985. A concurrent new wave in cinema was just as electrifying and brought forth what was to be known as the Fifth Generation with its impassioned revisions of history and cultural memory. In the meantime, television was quickly entering Chinese households,

along with calendars and other mass-produced images that were appreciated more for their pleasing, even entertaining, attributes than strident political significance. The Spring Festival Evening Gala, a show first introduced on China Central Television on the eve of the lunar New Year in 1979 and broadcast live on the same occasion since 1983, signaled the dawning of a televisual culture that was to reshape first urban and then rural everyday life as no other visual medium had before. (The television set as an object of desire is pointedly commented on in the 1994 film *Ermo*, as we shall see in Chapter 3.)

Underlying the emerging paradigms of visual expressions and activities was a shared desire to break free of the ideological straitjackets imposed during the Cultural Revolution, which the governing Communist Party publicly disavowed and denounced in 1981 as a grave error committed by Mao with catastrophic consequences. The shared desire was often eloquently voiced through appeals for greater creative freedom and aesthetic autonomy. The new domains of visual practices, some of them in fact motivated to revive discredited traditions, therefore constituted a centrifugal movement away from a singular mode of visual production. The same decentralizing force was even more noticeable on the economic front, as the government, set on the course of reform and opening-up, methodically dismantled structures inherited from high socialism and began experimenting with responsibility systems, market mechanisms, and special economic zones. China in the reform era, as David Harvey narrates in his 2005 *A Brief History of Neoliberalism*, became an integral part of the neoliberal embrace of market ideology and has since contributed significantly to a new wave of globalization.[26]

The spirited exploration of new terrains in the post-Cultural Revolution visual field would be at once broadened and regulated in the 1990s by various forces, with the marketplace playing an increasingly prominent role. From a burgeoning image-conscious consumer culture that overtook public billboards and television screens, to a rebellious experimental art that catered to international art collectors and interest groups, new agencies and systems in the production of visual excitement proliferated and constantly clashed with existing institutions and viewing habits. They also brought forth formats, tastes, discourses, and standards that are globally current and often derived from Western experience and precedence.

As market-generated diversity became a structural feature of contemporary Chinese visual culture, and as the embrace of globalization implied comprehensive questioning of not only Cultural Revolution extremism, but also the post-Cultural Revolution consensus and much more, a different anxiety arose. The arrival of the 1990s, observed literary critic and historian Chen Sihe, witnessed the transition of Chinese society from an age with "a shared name" to an "unnamable age," in which commercialism and the restratification of society made what once functioned as

mainstream values and norms lose their pertinence.[27] This anxiety over the disappearance of a unifying as well as an uplifting narrative about Chinese culture and sense of order was widely echoed, as many scholars and observers began describing the contemporary situation as "postmodern," "post-socialist," or "post-revolutionary," all of the terms suggesting skepticism toward a once positive term or prospect, all of them no doubt capturing an aspect of a complex transformation as well. Yet this prevalent "post-ness" also demanded a narration of *the present as an emergence rather than as a given*. This is when a comparative viewing of genre variations over time becomes particularly revealing. The fading of positive visions of fulfillment into a void of meaning and flat surface, as we will see in Chapter 3, underlies the epochal narrative spun by a series of cinematic representations of rural women from the early 1960s to the mid 1990s.

The impossibility of giving the present a definitive name serves as a reminder of the challenge in comprehending the enormity of the changes that have transformed life in contemporary China in every aspect. It also mirrors the peculiar and unorthodox position that China occupies in the world today. While the government has made every effort to join in and abide by the existing world order laid out since World War II, overseeing an arduous process of compliance finally to secure accession to the World Trade Organization in 2001, China remains the largest Communist-led country, refusing to collapse, as did the entire former Soviet bloc, at the end of the Cold War, and insisting on describing itself as a socialist state with Chinese characteristics. Contemporary China, as a result, presents a vast land of competing, if indeed conflicting, signs and languages, of unexpected combinations, ingenious compromises, and maddening contradictions, a land upon which the most spectacular instance of *bricolage* is staged and extended in the spirit of pragmatic experimentalism. The difficulty of summarizing contemporary China in a neat description, I believe, should be appreciated as a productive situation rather than a source of concern or anxiety. It underscores the fact that social and economic developments there have not followed any existing or preconceived paths. We cannot afford to reduce contemporary Chinese visual culture to one single image or dimension, any more than we can affix a simple and familiar label to that country and believe we have thereby "got" it.

Contemporary China as a gigantic, multilayered case of *bricolage* makes it hard to sort out its visual culture, or to give it a categorical label. (A 2006 exhibition in the Netherlands, *China Contemporary*, attests *both* to the explosive proliferation of contemporary visual culture *and* to the challenge of grasping its multiple dimensions.[28]) It is also hard to resist the temptation of making sense through synecdoche, whereby we convince ourselves that we have seen the whole picture by focusing on one partial aspect or fragment. A case in point may be the keen interest shown by some American academics and cultural elites in Chinese underground filmmaking

or independent documentary. Its critical thrust notwithstanding, such attention is often maintained at the expense of mainstream Chinese cinema or television, or a sense of relationality between the mainstream and the underground. Far more challenging, I would argue, is the task of trying to make sense of mainstream Chinese culture, because its essential components pose thorny questions not only to its own signifying processes, but also to any facile dismissal or outrage directed against it.

The same multiple signifying contexts in China also turn socialist visual culture into a meaningful legacy, as we witness in the conceptual evolution undergone in the work of contemporary artist Wang Guangyi. The revolutionary past remains relevant less as a political mandate or paradigm, as I discuss in Chapter 4, than as a source of collective memory and cultural identity, adding to the repertoire with which contemporary Chinese may express themselves. Socialist visual culture gains new relevance in the age of transnational flow of capital as well as images because it was, after all, centrally coordinated to visualize and represent the Chinese nation as a revolutionary subject in charge of its own destiny. Its nature as a fundamentally public *and* political visual culture is thrown into sharp relief against a powerful global institution called contemporary art. The promotion of "Chinese contemporary art" since the 1990s by the international art establishment and its subsequent institutionalization in China, I argue in Chapter 6, has resulted in a skewed understanding of the richness of contemporary Chinese art on the one hand, and in an increasingly elitist insulation of art institutions from public life on the other.

As topics explored in the second half of the present volume suggest, the production of visual culture in contemporary China, much like the Chinese economy, interacts with overlapping global contexts to an extent hardly ever seen before. We should not be surprised to see Chinese visual products and expressions receive greater global recognition as China continues to assert its presence and seek integration in the world, a cosmopolitan aspiration explicitly voiced in the slogan of the 2008 Beijing Olympic Games: "One World One Dream." We should also be prepared for the changes and differences that China, having arrived as a major player in the US-led world system, is bound to introduce to the world as we know it. Such changes and differences will come about in many areas, including the way we see the world, ourselves, and China itself.

If we truly believe in diversity and a multicultural world, we should feel encouraged by what China and other rising nations such as India, Brazil, and South Africa will bring, given their rich cultural traditions and resources. As the opinion-maker Fareed Zakaria sees it, the world in the twenty-first century is not defined by the decline of America, but rather by "the rise of everyone else."[29] It should not be about taking others down so that we remain unchallenged. It is this historic rise on a global scale that, I believe, ought to form the ultimate horizon and perspective for studies of

contemporary China in general, and of Chinese visual culture in particular. It is my hope that the paradigms and shifts in visual culture that I examine in the following pages will help us understand the aspirations and legacies that will continue to sustain the creation of artistic experiences and expressions in a changing China.

NOTES

1 Nicholas Mirzoeff, "Introduction: What Is Visual Culture?," in Mirzoeff, *An Introduction to Visual Culture* (New York: Routledge, 1999), 26.

2 See Michael Baxandall, *Painting and Experience in Fifteenth Century Italy: A Primer in the Social History of Periodical Style* (Oxford: Clarendon Press, 1972), 29–103.

3 Margaret Dikovitskaya, "The Study of Visual Culture: A Bibliographic Essay," in Dikovitskaya, *The Study of the Visual After the Cultural Turn* (Cambridge, MA: MIT Press, 2006), 6–7.

4 W. J. T. Mitchell, "Interdisciplinarity and Visual Culture," *The Art Bulletin*, vol. 7, no. 4 (1995), 542.

5 Arthur Efland, "Problems Confronting Visual Culture," *Art Education*, vol. 58, no. 6 (2005), 39.

6 Janet Wolff, "After Cultural Theory: The Power of Images, the Lure of Immediacy," *Journal of Visual Culture*, vol. 11, no. 1 (2012), 3–19.

7 David Holloway and John Beck, "General Introduction: Towards a Social Theory of American Visual Cultures," in Holloway and Beck, eds., *American Visual Cultures* (London: Continuum, 2005), 2–4.

8 Holloway and Beck, "General Introduction," 5.

9 Holloway and Beck, "General Introduction," 6.

10 Holloway and Beck, "General Introduction," 2.

11 See Mark Rawlinson, *American Visual Culture* (Oxford: Berg, 2009), 1–6.

12 Holloway and Beck, "General Introduction," 9.

13 Remarks made by Jon Huntsman, former US ambassador to China, at a debate between Republican candidates on foreign policy issues in South Carolina on November 12, 2011.

14 Joseph Levenson, *Revolution and Cosmopolitanism: The Western Stage and the Chinese Stages*, with a foreword by Frederick E. Wakeman, Jr. (Berkeley: University of California Press, 1971), 1.

15 Joseph Levenson, *Revolution and Cosmopolitanism*, 53.

16 Joseph Levenson, *Revolution and Cosmopolitanism*, 55.

17 For a discussion of how "Western minds" made sense of the events of 1989, see Daniel F. Vukovich, *China and Orientalism: Western Knowledge Production and the P.R.C.* (London: Routledge, 2012), 26–9. A patent example of Chinese experience being relentlessly simplified in the disguise of open access is when Google insists that what you may wish to know about Tiananmen Square is and should be all about the Tiananmen tankman.

18 Holloway and Beck, "General Introduction," 9.

19 Mark Rawlinson, *American Visual Culture*, 1.

20 See Timothy Clark *et al.*, *The Revolution of Modern Art and the Art of Modern Revolution*, first composed in 1967 (Norfolk, UK: Chronos Publications, 1994).

21 See my essay, "On the Concept of the Avant-Garde in Chinese Art," *Journal of Korean Modern and Contemporary Art History*, vol. 20 (2010), 202–14.

22 Paul Clark, *The Chinese Cultural Revolution: A History* (Cambridge University Press, 2008), 202. "A careful analysis of the more significant artworks from the period reveals the ways in which these ten years continued the debates and efforts at answers that had obsessed Chinese artists throughout the twentieth century, including after 1949."

23 Clark, *The Chinese Cultural Revolution*, 211.

24 Wang Meng, "Voices of Spring," in *The Butterfly and Other Stories* (Beijing: Panda Books, 1983), 139.

25 Wang Meng, "Voices of Spring," 159.

26 See David Harvey, *A Brief History of Neoliberalism* (Oxford University Press, 2005), 120–4.

27 See Chen Sihe, "Gongming yu wuming" (Shared Naming and Absence of Naming), first published in 1996, in *Chen Sihe zixuan ji* (*Selected Essays of Chen Sihe*) (Nanning: Guangxi sifan daxue, 1997), 139–52.

28 See *China Contemporary: Architecture, Art, Visual Culture*, exhibition catalogue (Rotterdam: NAi Publishers, 2006).

29 See Fareed Zakaria, *The Post-American World*, release 2.0, 2nd edn (New York: Norton, 2011).

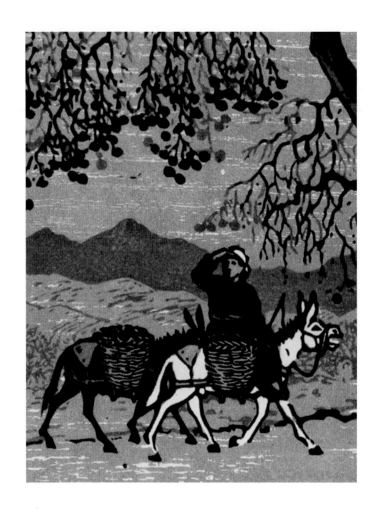

CHAPTER I

How was socialist visual culture created?
Part I: Revelations of an art form

> We are all convinced that our work will go down in the history of mankind, demonstrating that the Chinese people, comprising one quarter of humanity, have now stood up.

> An upsurge in economic construction is bound to be followed by an upsurge of construction in the cultural sphere. The era in which the Chinese people were regarded as uncivilized is now ended. We shall emerge in the world as a nation with an advanced culture.
>
> Mao Zedong, 1949[1]

In retrospect, the creation of a socialist visual culture was a grand, exhilarating project that, in the mid-twentieth century, enthralled generations of Chinese artists and left behind a rich and distinct heritage. As we move farther away from the heady days of the socialist revolution, it becomes increasingly evident that the creative project of the bygone era answered forcefully the imperative of cultural transformation that was at the core of China's search for modernity. It is also clear that the project pointed to a specific vision of becoming modern.[2]

The earliest systematic expression of the transformation imperative was the call for a "New Citizen," passionately voiced in 1902 by Liang Qichao (1873–1929), a leading advocate for reform in the moribund final years of the Qing dynasty. Only by molding the Chinese into a new and self-conscious nation, Liang reasoned, would it be possible for China to rejuvenate and modernize itself. Ever since the late Qing, the idea of "awakening" the nation became a central motif in modern Chinese political culture.[3] The New Culture Movement that unfolded less than two decades later continued embracing Liang's vision of an awakened Young China, but pursued a much more dynamic and more comprehensive agenda of cultural critique and importation. From the late 1910s into the 1920s, diverse intellectual agendas converged with an explosive force in urban centers and sent successive shockwaves far and wide into the rest of the country and collective consciousness. Exuberantly cosmopolitan and anti-conformist, the New Culture Movement affirmed the centrality of new cultural values and practices to achieving modernity in China.

When the People's Republic was founded in 1949, celebrations of the arrival of a New China acknowledged the emotional appeal of a national awakening that Liang Qichao had first envisioned half a century earlier. Widespread jubilation also expressed genuine excitement at the prospect of bringing into existence, under the aegis of a newly established and democratic nation-state, a meaningfully new culture and society, of bidding farewell to a parochial, bankrupt, and humiliated Old China, and of asserting an independent modern China on the world stage. As an elated poet proudly proclaimed at the time, "Time Has Begun!"[4]

Looking back and from a distance, we readily recognize a distinctive style underlying an array of visual materials from the era of socialist construction in New China, which began in earnest a few short transitional

years after the founding of the People's Republic. Such materials include not only paintings, posters, billboards, pictorials, newspapers, illustrations, and photographs, but also cinema, theater, architectural designs, public monuments and squares. Together they formed a visual sphere that contributed to the mainstream culture of the socialist period, which also witnessed corresponding changes in everyday language, address, and attire, in literature, music, and performance, and in various rituals and ceremonies both public and private. This mainstream culture, in particular its visual component, may best be described as "socialist modern" and appears all the more coherent and penetrating when recalled in our purportedly post-socialist contemporary world, either through ambivalent nostalgia or poignant mockery.

WHAT TO LOOK FOR: A QUESTION OF METHOD

To the extent that we cannot possibly overlook the stylistic and conceptual singularity expressing itself in virtually all aspects of socialist culture, we also realize "socialist modern" was a moment of prodigious cultural production and innovation. Two features of the socialist mode of cultural production are most salient: centralized orchestration on the one hand, and high productivity on the other. It is tempting to view such productive capacity as the result of central planning and to regard control or manipulation by the state or, more darkly, by the governing Chinese Communist Party (CCP), as the defining feature of socialist culture. A prevailing approach to cultural expressions of the socialist period is one that hypostasizes coercion or control and focuses on instrumentalism without exploring the meaning of heightened production and innovation.

In his recent study of *Mao's New World*, for instance, Chang-tai Hung proposes studying "how the CCP introduced a new political culture into the young PRC that transformed the nation into a propaganda state with the aim of consolidating the Party's power."[5] The historian seems to oscillate between two analytical approaches: one acknowledges the complex processes and implications of cultural transformation; the other examines political intentions and efficacies of cultural policies. He calls for "a more comprehensive treatment of the Communists' transformation of culture," but ends up documenting "how the Party systematically utilized culture as a propaganda tool" in its campaigns for political legitimacy. In spite of a useful reminder that "To view culture as mere epiphenomena of social and economic policies is to distort the fundamental nature of the Chinese Communist Revolution,"[6] Hung's study nonetheless remains largely predicated on a view of the Communist Party and the socialist state it established as extrinsic or manipulating forces in the course of cultural-political developments in modern China. His main interest is to show how a new political culture, systematically produced and disseminated, served to

legitimate a regime that had no evident or acceptable legitimacy. As a result, in revisiting a series of history paintings commissioned by the state, he focuses on demonstrating their creators' subservience to political authorities and lack of artistic autonomy. In presenting the New Year's prints movement as a concerted effort to reach the rural population, he sympathizes with peasant conservatism, transposing onto their passive resistance the classical Western liberalist value of society defending itself against an intrusive, if not altogether tyrannical, state.[7]

Knowledgeable historian as he is, Chang-tai Hung in his account of socialist visual culture resorts to essentially the same reductionist method that he deplores as a basic operation of the new political culture in the young PRC. While theoreticians and functionaries of the socialist state are shown to be keen on subjugating cultural production to political control for utilitarian purposes, our historian now regards all cultural manifestations from that era as reducible to immediate political calculations and efficacies. Even expressions of apparently apolitical sentiments, such as peasant preferences for traditional New Year decorations, are read as a political statement. The irony here lies in the fact that mainstream opinion in the 1950s would react to those apolitical sentiments in a comparable way, the difference being that, instead of touting them as grassroots resistance, as our contemporary historian is quick to do given his agenda, opinion-makers back then would identify such mentality as premodern backwardness to be overcome.

It is indeed difficult not to see political contestation everywhere, if one regards the legitimacy of the new social order as forced and merely political, or, worse, when one is reluctant to allow for or accept its legitimacy at all. Yet viewing socialist New China solely in terms of political legitimacy or lack thereof not only collapses the new regime's multiple overlapping historical contexts and meanings, but also blocks us from recognizing what is being articulated in and through political discourse and mobilization. In other words, with regard to the political culture of socialist China, it should be more revealing to see politics as a forceful response to cultural issues, than to see culture as being exploited for political purposes. In his study Chang-tai Hung does not spell out what may have been "the fundamental nature of the Chinese Communist Revolution," and I would suggest that the revolution radically and systematically extended the striving for a profound cultural transformation.

Seeing socialist New China as a continuation of the project to achieve cultural modernity offers us a vantage point on several levels. First of all, it allows us better to recognize deep-seated origins and aspirations of the Communist-led revolution; it should also help us better grasp questions the socialist era sought to answer and the theoretical as well as the practical difficulties it ran into. In short, such a historicizing overview makes the revolution narratable and therefore pertinent, not only to its participants

but also to the post-socialist present that we inhabit. This in turn makes us better positioned to see why it is unproductive, and ultimately reductive and biased, to characterize the revolution as misguided or, worse, a case of senseless violence. Even the most radical and traumatic decade of the Cultural Revolution (1966–76), as Paul Clark has shown recently with ample documentation, should not be dismissed as "an aberration," but bore witness to a range of experimentation that "continued, deepened, or distorted the modern inheritance of cultural responses to China's changing global condition."[8]

On another level, with the understanding that cultural transformation was a driving force of the socialist era, we will be better positioned to appreciate socialist culture for its productive power as well as for its innovations. In addition to new forms of representation or expression, socialist culture also and often more urgently needed to create new modes and relationships of cultural production. An artist's relationship to his work and to his audience, for instance, was reformulated so as to turn the artist into an active producer in the new society. Art itself, both as aesthetic experience and as a cultural institution, was also redefined through a historicist discourse that relegated artistic autonomy or aesthetic disinterestedness to outdated, pre-socialist systems and limitations. As a result, the socialist mode of cultural production was profoundly experimental because it was unprecedented and purposely antithetical to established practices. A critical component of the concerted experiment was to promote public culture and to encourage participation by ordinary citizens. "In the sphere of cultural production," observes Paul Clark while commenting on practices fully carried out during the Cultural Revolution, "the amateur challenged the entrenched elitism of the professional."[9]

Collective and coordinated efforts were a hallmark of the socialist mode of cultural production, paralleling the socialist vision of industrialization and collectivization in agriculture. The high degree of uniformity in cultural products from this era thus bespeaks large-scale experiments to produce and shape a new sensibility and structure of feeling that was emphatically modern. Going far beyond formal innovations in artistic creation, experimentation was indeed driven by bold and imaginative anticipation of the practice as well as the institution of cultural production in a self-consciously new society. A seemingly paradoxical but logical consequence of experimentation on this level, as I will explain below, was that more familiar and conventional forms would be adopted because they were charged with conveying truly revolutionary messages.

As we look closely at the socialist era and contemplate its visions, we realize that socialist visual culture was of paradigmatic significance because it was centered on producing a new way of seeing. In this new visual order and practice, it was important not only to see with a socialist eye, but also to recognize and affirm socialism in everyday life. At issue were both *how*

and *what* to see, which made the creation of a socialist visual culture a dynamic and continually interactive as well as reflective process.

In a recent, semiotics-informed study of cultural production in the Soviet Union, Evgeny Dobrenko asserts that socialist realism was itself a political economy, "a sum of reality-transforming discursive practices whose product is 'real socialism.'" "It was precisely in the arts, through Socialist Realism, that Soviet reality was translated and transformed into socialism ... Therefore, Socialist Realism should be regarded as the production of not only particular symbols but also visual and verbal substitutes for reality."[10] Dobrenko's insightful observations remind us of the transnational connections that underlay the socialist movement in mid-twentieth-century China. For the Soviet influence on Chinese literary and visual arts in the early 1950s was systematic and far-reaching. His study also throws into relief some key issues that we must consider while reexamining socialist visual culture, even though in the end we may find it a far more complex story than socialism being the main product of socialist realism, or socialism being hardly more than a semiotic simulation. Dobrenko's assertion fails to address, at least in the Chinese context, the pivotal and inspiring project of an artist's self-transformation.

Before we look further into a specific art form and the concrete processes of creating socialist visual culture during the decade following the founding of the People's Republic, we may venture some general observations about the conditions and features of this distinct visual culture.

Promoted and coordinated by the new socialist state, instead of being determined by the market, socialist visual culture was an *emergent as well as a dominant* mainstream artistic production; it was a critical component of the new mass culture that the socialist state found it urgent to develop, for political legitimation as much as for cultural transformation. At once emergent and dominant, the process of creating a socialist visual culture was a dynamic and experimental one, punctuated by continual theoretical debates and reflections. It was a process in which committed artists played a leading role, often with the conviction that they were the vanguard of a far-reaching cultural revolution. (This in part explains why "visual culture" points to a far more capacious field of study than does fine arts or art history.) A key concept in the process was that of "social life" or simply "life," which served as both concept and reality, both cause and effect, of the production process. "Social life" was as much the object of knowledge and representation as it was the object of transformation and creation.

Faithful to the basic tenets of a socialist new culture, visual images and expressions produced during this period were resolutely public-oriented and socially engaged, responding agilely to state policies and calls for action. The prototype of socialist visual culture is the public poster, which is the *structural equivalent*, as I have suggested elsewhere, of the commercial advertisement in a capitalist visual environment.[11] Poster-style visual works

project a positive outlook and communal values; they also valorize ready accessibility and intelligibility over solipsistic depths or diffusive abstractions. Familiar or even conservative forms are therefore activated and resorted to, because the ideas or messages they help package and deliver are often radically unconventional and indeed revolutionary. A related element was the search for "national forms" that entailed modernizing traditional aesthetic habits and sensibilities as well as adapting them to contemporary life. Experimentation in socialist visual culture, however, was most significant in forming new production modes and relationships: for instance, in redefining the status of an artist, in the promotion of amateur artists, and in programmatic efforts to bring art closer to life.

All of the observations above are pertinent to the development of printmaking, arguably the most socialist art form, in the 1950s. What this development reveals is far more than the art of printmaking or a specific art history; it tells us a great deal about how the field of art was transformed in an effort to produce a socialist visual culture.

FOR A NEW VISUAL EXPERIENCE

The Chinese expression, "all neglected enterprises await revival," often used to describe the aftermath of a regime change, captures the sense of anticipation and excitement that the founding of the People's Republic generated across the land in the mid-twentieth century. The exalting vision of a new beginning galvanized numerous artists and writers, who embraced the new social order being introduced by the Communist Party as an epochal turning point, a moment of unprecedented liberation that ushered in a national rebirth of epic scale.

Three months before the grand ceremony in Tiananmen Square proclaiming the birth of the PRC on October 1, 1949, an All-China Congress of Literary and Art Workers had already been convened in Beijing, bringing together over 800 delegates that represented various regions, traditions, and affiliations, with the largest contingent coming from zones controlled by the Communists in the preceding civil war years. The Congress established a national organization of cultural workers and called for the creation of "people's literature and art in New China." It also formed two national associations, for writers and visual artists respectively. In conjunction with the two-week-long convention, the Congress organized an art exhibition, later retroactively named the First National Fine Arts Exhibition in the history of New China, which featured many works created by artists from "liberated areas," as Communist-controlled regions were familiarly known then.[12] Among the some 550 works of art, woodcuts from liberated areas, in particular Yan'an, had a prominent position and, along with popular folk-style New Year's prints and picture stories, showcased the latest achievements in "people's arts."

During the Congress, Jiang Feng (1910–82), a woodcut artist and leader of the art field within the Communist establishment, gave a detailed report on the development of visual arts in the liberated areas. He attributed the proliferation of popular and folk forms and their broad impact in Communist-controlled regions to Mao Zedong's 1942 "Talks at the Yan'an Forum on Literature and Art." The central idea of Mao's historic "Talks" was summarized as "literature and art serving workers, peasants, and soldiers," and Jiang Feng lauded many aspects and successes of artwork produced under this basic guideline, including, for instance, creations by factory workers and soldiers as amateur artists.

In discussing new challenges ahead, Jiang Feng observed that as the revolution had moved from the country to cities, future artwork should serve urban residents and industrial workers while continuing to meet the demands of the vast rural population. To accomplish this colossal task, he laid out two steps. One was to train, as expeditiously as possible, a large number of art cadres as well as methodically to transform artisans and traditional ink-and-brush painters so that their art could be useful in factories, villages, and military barracks; the other was to produce large quantities of artwork by means of modern printing technology so as to claim a predominant share of the cultural market, currently filled with conventional New Year's prints and commercial calendar posters.[13]

The first step proposed by Jiang Feng reflects a key element of Communist policy toward art and literature. The idea that an artist's own transformation or "*gaizao*" was prerequisite to the creation of meaningful new art had long been a central belief propelling successive left-wing literary and art movements ever since the 1920s.[14] During the 1940s, when the Communist movement consolidated itself in Yan'an and turned its attention to organizing an effective cultural front, the CCP further theorized the importance of fashioning writers and artists gathered there into a new kind of cultural producer. Mao Zedong's series of "Talks at the Yan'an Forum on Literature and Art," delivered in May 1942, contains the most systematic exposition on the need for self-transformation on the part of writers and artists. To create a work of art accessible to the vast majority of the Chinese people, Mao stated, "our writers and artists should fuse their thoughts and feelings with those of workers, peasants, and soldiers." Such a fusion could be "a long and even painful process of tempering oneself," but Mao promised its reward would be artistic creations understood and appreciated by the national public.[15] A truly revolutionary writer or artist would therefore strive to acquire a new subjectivity through realigning himself and identifying with those whose cause he sought to support. Furthermore, Mao urged writers and artists to learn from the language of the populace and to draw inspiration from the life of the people – "the broadest and richest source" – in their efforts to create revolutionary works of art.

For the young men and women drawn or committed to the Communist movement, the project of creating a revolutionary literature and art that Mao outlined in his "Yan'an Talks" was as deeply compelling as it was empowering. It entailed not only a radical inversion of the established cultural hierarchy and aesthetic order, but also a determined shift from a Western-oriented outlook and city-centered modern imagination, which had been the hallmark of May Fourth anti-traditionalism. The new program was one of rediscovery and affirmation of native resources attributed to the Chinese people, itself now proclaimed and called upon as the historic subject and mainstay of a national liberation. Moreover, the program turned the artist's self-transformation into an integral part of the creative process, with a meaningful synthesis of art and life, self and nation, posited as its dialectical and fulfilling outcome. Many writers and artists took Mao's call to heart in the 1940s and enthusiastically contributed to what was soon recognized as "Yan'an literature and art," or "Yan'an artistic culture," a distinctive body of innovative works that Jiang Feng, in July 1949, would celebrate as historic achievements inspired by Mao's "Yan'an Talks."

In the tortuous course of modern Chinese intellectual and cultural developments, as Li Jiefei and Yang Jie point out in a recent study, the Yan'an era marked a "cultural reorientation" in China's search for modernity.[16] This reorientation initiated an effort to adapt and reactivate familiar signs and forms that constituted the non-elite and folkloric tradition of native culture. Valorized in this new mode of cultural production was not artistic originality or individual talent, but rather ingenious adaptations and recodings that would bring together existing cultural forms and radically new concepts and visions. Adaptations (*gaibian*), according to Li Jiefei and Yang Jie, subsequently became a key operation in the socialist cultural production, because the objective of Yan'an literature and art was ultimately not about satisfying individual expressive desires or privileging aesthetic connoisseurship; it was instead about accomplishing a systematic and grand project of popularizing a new and revolutionary national culture.[17] Therefore, adaptations were processes of negotiation in which revolutionary ideas encountered enduring indigenous practices and habits, and familiar cultural forms were modified to accommodate new and challenging content. Like similar practices in other cultural contexts, such as many Hollywood films or TV serializations of masterpieces, adaptations became ingenious translations in the production of a changing mass culture.

The second step that Jiang Feng regarded as instrumental – namely, the mass-production of art objects for the rural as well as the urban population – underscored a situation that art workers of the Yan'an tradition had yet to learn how to cope with. Severely limited access to modern printing technology during the war period had shaped the methods of cultural

production in the liberated areas. Now that modern means of printing had become available and a national audience was to be addressed, it became clear that the Communist system of making art had to be extended as well as updated so that it could effectively contribute to the making of a new national culture. Mass-produced visual art for a national audience became a significant challenge because both art and the nation had to be reimagined. The pressing question was what artistic forms and visual expressions would befit the idea of a yet-to-be-created New China.

It therefore makes good historical sense that a national campaign to produce new-style New Year's prints (*nianhua*) would become the first art movement in the young PRC. In November 1949, a few months after the All-China Congress of Literary and Art Workers, the Ministry of Culture of the recently formed central government issued a directive through *The People's Daily*, calling on cultural and educational organizations around the nation to coordinate the making of new *nianhua* in welcoming the first Spring Festival, or lunar New Year, in the history of the PRC. Putting up colorful images of various deities and auspicious emblems around the household for good luck and prosperity in the coming year was a widespread tradition in town and countryside alike, and it was this tradition that the new *nianhua* campaign aimed to update. For the new-style prints to go up in early 1950, the Ministry of Culture directive listed several important themes to promote, such as the founding of the PRC and the recovery and development in industrial and agricultural production. It also gave specific instructions on appropriate visual styles, printing options, pricing strategies, and distribution channels. "The new *nianhua* should put emphasis on representing the happy and uplifting new life of the working people as well as their brave and wholesome visages."[18] By April 1950, *The People's Daily* reported that over 200 artists from twenty-six localities had developed over 412 new print designs during the campaign, with over seven million copies sold (Figure 1.1).[19]

Cultural and art historians are quick to see a continuity between the new *nianhua* campaign and the practices of the Yan'an era. The national campaign had the intensity of a military operation that had often propelled cultural productions in Yan'an in the early 1940s, a period, after all, defined by demanding wartime conditions. Keenly aware of it being a project in time of peace, however, organizers of the new *nianhua* campaign in 1950 initiated and refined many mechanisms, such as workshops and conferences, open competitions and awards. The results were designs and paintings that bore little resemblance to the traditional or commercialized *nianhua*, even though their intended usage remained the same. The look and concept of *nianhua* was radically altered; indeed the *new nianhua* was born as a hybrid visual object.

There is no question that the campaign was orchestrated to help the new government gain further legitimacy. Yet it was far more than a matter of

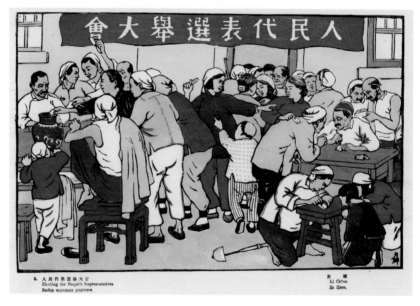

1.1 Li Qun, *Electing the People's Representatives*, 1950, New Year print. Produced by
the New Rongbao Studio in Beijing, this image was based on a multiblock
woodcut print that the artist made in 1948.

imposing political authority or normalcy. By advertising the new govern-
ment's positive visions through images and artifacts that were explicitly
associated with deep-rooted folk wishes for a good life and happiness, the
new *nianhua* campaign also sought to introduce a new visual environment
and cultural values (Figure 1.2). Instead of merely epitomizing "the com-
plete but uneasy merger of art and politics in the new regime,"[20] the
campaign illustrated the enormous productive power unleashed by the
new mode of state-coordinated cultural production. For this new mode,
art and politics were not antithetical or incompatible spheres; rather they
formed an effective alliance, or powerful technology, in creating and
promoting a new visual culture that was at once national and modern
(Figure 1.3).[21]

 Hand in hand with the new *nianhua* campaign, not surprisingly, was a
renewed effort to update the elite, connoisseur-centered ink-and-brush
painting. In early 1950, the inaugural issue of *People's Arts*, the organ of
the national Art Workers Association (AWA), published an essay by the
accomplished painter Li Keran (1907–89) on this topic. Refuting a pessim-
istic view on the fate of Chinese painting in the People's Republic, Li
Keran believed the radically new era had brought closure to a lifeless
formulaic tradition. For it to be relevant in the new society, traditional
painting had to respond to the demands of the people and open itself to
new methods as well as new realities.

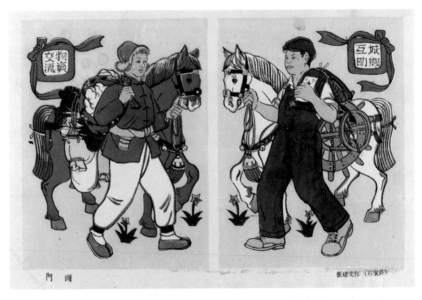

1.2 Zhang Jianwen, *Door Prints*, 1950, New Year print. Modeled after traditional prints of protective and auspicious deities, this pair of new-style prints promotes mutual aid and exchange of goods between town and country.

If the source of inspiration for Chinese painting, owing to the influence of an indigenous Daoist cosmology, had been "Nature" until this art form went into decline and ossified into a rigid formalism from the Yuan dynasty of the thirteenth and fourteenth centuries onward, Li Keran argued, the first step toward its contemporary reform was to rediscover this sustaining source, which, he further pointed out, ought to be not just "Nature," but rather "Life." Evoking Mao Zedong's postulation of the "broadest and richest source" for artistic creations in the life of the people, the artist called for a "deep immersion in life." Only then could one hope to bring forth fresh content as well as innovative form to a time-honored and entrenched art, and allow it to address the needs of one's own time. For Li Keran, the current age was a time of profound historic change of global proportions, in which the people of New China had not only liberated themselves, but would also help oppressed peoples around the world achieve their own emancipation. "Such an unprecedented full life is bound to enrich the content of Chinese painting as never seen before."[22]

The urgent task of modernizing Chinese painting that Li Keran outlined in his essay involves technical innovations, and he embraced the task with a commanding historical vision, which in turn demanded an active reconceptualization of the role of the artist. The essay reiterated a concern that had vexed several generations of artists and critics ever since the beginning of the twentieth century.[23] One major difference this

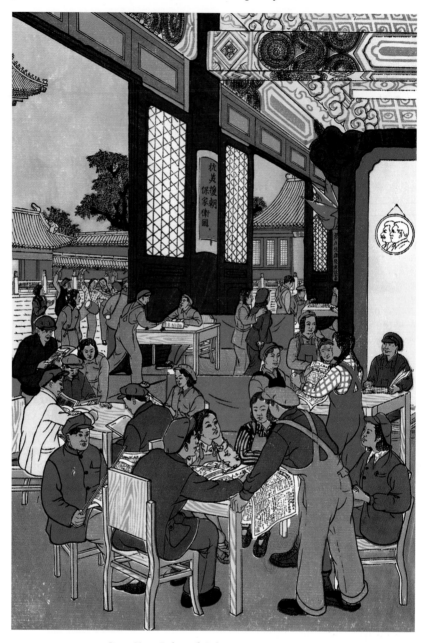

1.3　Jiang Yan, *Palace of Culture*, 1951, New Year print.

time around was the shift of focus to the painter and to changing his way of seeing.

In a companion piece on the same topic, the prominent woodcut artist Li Hua (1907–95) further emphasized the importance of a

conceptual reorientation. He regarded the core issue in reforming Chinese painting as transforming the artist's mindset, and as radically rejecting the premise of a "literati painting" that catered to the elite and the privileged. Only with "a new world view, a new conception of art, a new aesthetics and class position," wrote Li Hua, would it be possible for an artist to produce "a new Chinese painting with a new form and content." In this new era of the people, he believed, "art should have as its starting point the majority's interests, and the value of art should be assessed from the viewpoint of the masses."[24] Li Hua's statements reflect his position as a printmaker long devoted to the modern woodcut as a populist and politically committed artistic medium that, since the early 1930s, had defined itself in opposition to both literati ink-and-brush painting and oil painting as a Western import.[25] As we will see shortly, however, the woodcut itself would face new challenges in the era of the people.

The political as well as cultural imperatives that motivated first the new *nianhua* campaign and then calls for a reformed Chinese painting were best articulated in the editorial that appeared as a mission statement in the same inaugural issue of *People's Arts*. Under the title "Endeavor to Represent New China," the editorial celebrated a historical turning point and enumerated challenges facing Chinese artists in the new era. The operative verb in the editorial title, which also works as an exhortation, is *biaoxian*, which literally means "to bring to the surface or visibility," and which since the late 1920s has often meant, in writings and theorizations of the artistic and literary avant-garde of various persuasions, both "to represent" and "to express." As I have observed, this potent verb in modern Chinese art discourses frequently governs two separate objects – social life and genuine emotion – and it underscores "the necessity of unifying subjective understanding and objective truth, which in turn translated into a determination to render reality through a revelatory artistic vision."[26] For the editors of *People's Arts* in February 1950, the fundamental task was indeed to make visible a New China by establishing a new way of seeing as well as a new conception of art. It was a magnificent undertaking because the subject matter of artistic representations was defined as no less than the creation of a new national life and identity that had not been conceivable until now.

The historical moment identified by the editorial was a monumental beginning. The creation of the People's Republic had ushered in the grand enterprise of "building a new country that is independent, strong, peaceful, democratic, and free." A main task for art workers at this juncture was to publicize the Common Program, or the de facto Constitution of the young PRC, adopted by the People's Political Consultative Conference in September 1949.[27] To carry out this task effectively, "artists should themselves become citizens of the new epoch," actively participating in

the construction of New China. Only through such participatory experiences and with right self-positioning would an artist be able to achieve "correct and perceptive" depictions of reality, while avoiding "superficial, even distorting" representations. The emphasis was firmly placed on the artist embracing the dynamic process of nation-building and regarding art as part of the collective cause.

This new identity of the artist would determine not only how an emerging reality and new society ought to be seen and recognized, but what means of artistic expression would be effective. Any innovative form of visual arts that met the aesthetic demands of the vast majority of the people, asserted the editorial, would be welcome, and the long list of possibilities that followed indicates what constituted "people's arts" at the time: painting, printmaking, sculpture, architecture design, *nianhua* prints, comic strips, lantern slides, paper cutouts, pictorials, posters, illustrations, and decorative arts.[28]

To the emerging mode of producing a public visual culture, the cultural hierarchy distancing a refined and rarefied ink-and-brush painting from an often coarse and ephemeral *nianhua* print was no longer pertinent. (The second issue of *People's Arts* in 1950 was devoted to the new *nianhua* campaign.) Nor was aesthetic autonomy or artistic freedom of the individual a sacred value. The art market was to be curtailed and eventually rendered irrelevant as well. (One of the fears that Li Keran tried to allay in his essay was the disappearance of a market for Chinese painting when the People's Liberation Army entered Beijing in 1949.)

For practitioners and visionaries engaged in the exciting project of ushering in a new cultural production, the main issues were how to make art a public experience, how to modernize traditional forms and practices, and, most critically, how to strive for self-transformation as an artist so as to see the changed world as it ought to be seen. Their task, in short, was to develop a socialist eye or vision. They carried on the spirit of the avant-garde as they sought not only to introduce formal innovations but also to implement cultural transformations and to redefine art in the process. This awareness of a pioneering position was clearly voiced in the *People's Arts* editorial when art workers were urged to collaborate with "folk artisans and craftsmen," helping them reach higher standards in the common cause of creating a people's art.

For the purpose of creating a new art and visual culture, a programmatic restructuring of the art world was to unfold on many levels, often with the Soviet precedence as a model. The initial stage of swift and systematic restructuring took place from 1949 to 1952 and, as Julia Andrews observes, was "dominated by the revolutionary ideals and aesthetics of Communist artists such as Jiang Feng."[29] Artist associations were formed at the provincial level and in major municipalities across the nation; art journals were created and publications issued; national exhibitions were planned and

organized; existing art academies were reorganized, renamed, and put under the leadership of Communist cadres; students were enrolled and most artists became salaried government employees. A new art system was put in place, with many projects to undertake and many experiments to conduct in expressive representations of New China.

THE CRISIS OF REVOLUTIONARY ART AFTER LIBERATION

The sixth and final issue of the bimonthly *People's Arts* in 1950 published an essay by the veteran printmaker Li Qun (1912–2012) on a series of crises facing the art of printmaking, or specifically the black-and-white woodcut. It was first of all a crisis of stagnation, Li Qun warned, because the woodcut movement, which had in the 1930s and 40s served as the primary form of revolutionary art, had witnessed a decline in both productivity and quality since 1949. He suggested a host of possible causes for such a situation. Many experienced woodcut artists, for instance, had gone on to do administrative work, whereas young printmakers were not yet quite ready. Improved material support and printing technologies had made other visual arts, such as the new *nianhua*, posters, and oil painting, much more popular. Unlike the new *nianhua* broadly welcomed by the populace, the woodcut had failed, lamented Li Qun, to adapt itself to the new era, and as a result had lost its appeal to viewers of the new society.

According to Li Qun, the crisis of stagnation revealed at least two main problems with the woodcut. One had to do with its formal properties. As the first generation of modern woodcut artists, to which Li Qun belonged, turned mostly to European masters for examples and inspiration, it seldom looked back at the native tradition. The woodcuts it created, therefore, "lack a Chinese character, as well as the simple, clear, direct, and earthy look that is associated with Chinese folk art." This explained why the woodcut had little attraction for the general public, and "it is a hard lesson for us all to keep in mind." Li Qun did acknowledge that, during the Yan'an period and thereafter, many woodcut artists began to incorporate native forms and indigenous styles, but their efforts did not have a national impact, which led to the current state of affairs: "Many of our works have no definite subject matter; many are naturalistic; many lack a sense of reality; many fail to represent effectively the working people; many have duplicated Western forms wholesale." [30] In this context, Li Qun regretted his own obsession with the formal features of a black-and-white woodcut and offered self-criticism.

Li Qun did not go so far as to imply that the stark art form was no longer appropriate in the new society. Instead he urged serious soul-searching on the part of woodcut artists. The current age being completely different from previous times, it demanded that fundamental changes be made in artistic practices. Here a second and more serious problem arose:

Gone are a more familiar life of old and its subject matter, but we are not yet entirely knowledgeable of the new life and the new subject matter. As a result, as is shown in some works, we may find it hard to avoid singing praise of the new life in an old tune, or conveying a new content through an old form.

More specifically, he commented that woodcut artists were more successful in depicting peasant life, but had a poor record of representing industrial workers and soldiers. The few attempts at portraying workers were often no more than a distant factory scene dominated by machinery. From these woodcuts it was impossible to gain a clear view of the factory workers of the new era, or to obtain a sense of contemporaneity. In order to create works with greater intellectual content and educational value, Li Qun recommended that woodcut artists further their study of Marxist theory and current policies, go deeper into the new life of the working people, continue changing their own attitude and worldview, and learn from Chinese fine arts as well as folk art. The objective was to bring about a radical change not only "in the outlook of woodcut artists as well as in our works," but also "in the relationship between all the woodcut works and the broad spectrum of working people."[31] Only then would the art of the woodcut better serve the people.

When read carefully, with its dated nomenclature unpacked rather than ridiculed, Li Qun's essay contains a perceptive analysis of a difficult transition. It remains the most comprehensive reflection on the self-reinvention that an art form, once firmly associated with a revolutionary movement, will need to undergo when the revolution has succeeded and introduced a new order. The essay may be read as a commentary on the larger question of how to create a new order in the wake of a revolution. The crisis of the woodcut is the crisis of a revolutionary art finding itself thrust into a post-revolutionary condition, in which it has to transition from an anti-establishment, often denunciatory critical art to a positive and educational art so as to remain relevant and purposeful with regard to the revolution it has passionately endorsed.

The series of insufficiencies that Li Qun identified in the woodcut in 1950 were fundamentally on the conceptual level. Anxiety over these insufficiencies was translated into the need for self-transformation on the part of the artists, and their artwork would subsequently serve as an expression or evidence of their own transformation, of being in step with changed times. As Wang Qi (1918–), another noted printmaker and theorist, would phrase it a decade later in 1959, the majority of woodcut artists in the 1930s and 1940s, with the exception of those active in the liberated areas, expressed "a strong spirit of critical realism" in their works, which became insufficient in the stage of socialist construction.[32]

A key factor in this difficult transition is that socialist construction was largely conceived of as another revolution. As such it presented a challenging situation to artists. They were expected to continue to play a

mobilizational role, but they were also expected to contribute to the new project of construction; their art should educate the people, but they were required to reform themselves so as to understand and learn from the people. In short, the woodcut movement had to express its avant-garde aspirations under new circumstances.

The problems that Li Qun observed were not isolated or specific to the woodcut. They reflected larger structural tensions underlying the new mode of cultural production. These tensions would be addressed at the second All-China Congress of Literary and Art Workers, which took place in September 1953. Over the four years since the first Congress, the new PRC had consolidated itself politically and economically. It had carried out a massive land reform program in the countryside, turning hundreds of millions of peasants into landowners. The government had also conducted a series of reform movements in social life, the economy, and among intellectuals. In the meantime, from 1950 to 1953, the Chinese military had fought in the Korean War and the nation was further energized by patriotic passions. While the Korean War was going on, the central government set in motion, following the Soviet model, the first Five-Year Plan for economic development and restructuring, the main objectives being socialist industrialization and reorganization in agriculture and commerce. Such a rapid pace of change excited delegates to the second Congress as they believed they were witnessing history unfolding and surging forward before their very eyes. Yet they also had a collective sense of anxiety. Their consensus, as Guo Moruo (1892–1978), president of the organization, stated in his opening speech, was that "the glorious vision of a socialist society" had presented itself concretely, but the field of literature and art was failing to meet the demands of the times and of the nation. "Our literary and artistic work, frankly put, has fallen behind reality."[33]

This frustrating sense of their work failing to keep up with rapid changes in other aspects of social life was addressed in a lengthy report that Zhou Yang (1908–89), then deputy Minister of Culture and a leading literary theorist of the CCP, delivered at the Congress. As was the convention with such official statements, Zhou Yang opened his speech with an encouraging review, asserting that "our literary and artistic activities have moved along with the progress of our nation's collective enterprise." Of the many positive results, he appreciated the flourishing of the new *nianhua* and picture books, which offered a successful example of new content finding expression in existing popular folk art. Yet new creative works were few and far between, and the images they presented often appeared pale and ineffective in light of the new reality, which Zhou Yang described as a national life "so rich and varied, filled with so many dynamic changes." He analyzed an array of causes, from conceptual to methodological to administrative, that had contributed to the unsatisfactory situation, singling out rigid conceptual abstractions and formulism as two common symptoms

that exposed a debilitating lack in both an artist's grasp of reality and his artistic methods and skills. (Zhou Yang's stern criticism of the National Federation of Literary and Art Workers as an insular, "lifeless" institution underscored the growing tension between bureaucratization and the demand for innovative transformation.)

For writers and artists to fully engage in the new historic era of socialist construction, which was marked by the dominant role of a nationalized economy and the increasing prominence of "socialist elements in people's life," Zhou Yang proposed socialist realism as a timely and enabling method and the highest standard for creative works and criticism in literature and art. There was nothing unfathomable or mysterious about socialist realism, he remarked, as long as writers and artists were willing to learn and participate. Pointing out that the Soviet experience had provided an excellent precedent, he urged creative study on the part of Chinese artists and writers.

The primary imperative of socialist realism, according to Zhou Yang, is that writers and artists familiarize themselves with the new life, represent new role models, and express new ideas and emotions among the people. The goal is to advocate new moral values and virtues and inspire social progress. He quoted Mao Zedong's criticism of many writers who, failing to understand history as continual progress, try desperately to keep old things from dying or being replaced. The socialist realist imperative derives from the belief that culture is an active force in social development. Culture is not revered as a static codification of established values and practices, or even allowed to be a defensive buffer against the impact of change and upheaval. It would not be tolerated, above all, as a veiled attack against the new social order. Cultural construction in the socialist realist mode parallels and supports socialist developments in industry, agriculture, and human relations, all of which are believed to constitute a magnificent and unprecedented collective enterprise.

For an effective production of new cultural values and forms, centralized planning and coordination in the mode of modern industry and military operations provide a model for mobilizing and empowering writers and artists. In order for their work to be meaningful, writers and artists must engage in socialist construction and gain insight from it, instead of being outsiders or passive observers. Furthermore, they must study native cultural forms so as to reach the largest audience. In short, "we demand that in terms of content, literary and art works represent characters and ideas of the new age, and in terms of form, they express our national style and spirit."[34] These guidelines Zhou Yang laid out in his report would explain two salient features of literary and artistic works from the 1950s: a determined positivity in emotion and conceptualization, and a growing interest in incorporating popular indigenous forms.

Also during the Congress, Jiang Feng, as head of the AWA, reported on the organization's work since 1949. After enumerating specific achievements in the new people's arts, he devoted much space to addressing various problems. The number of new works may have appeared impressive, but their quality was compromised due to stunted artistic skills and lack of intellectual depth. Jiang Feng attributed this compromise in part to a trend to put speed above quality, as artists were often pressured into doing a rushed job, with no time for the necessary refinement. He also echoed Zhou Yang in his criticism of rigid formulism and conceptual abstractions as detrimental tendencies that easily led to imposing shallow political concepts on superficial observations of life. He specifically analyzed two negative consequences in visual arts. One was an overemphasis on comprehensive coverage that resulted in a disregard for the possibilities of visual arts. Some artists would even turn to words or symbols, instead of images, to convey ideas, paying no attention to compositional unity or formal harmony. Another phenomenon was the indiscriminate depiction of masses of people, without close attention to individual characters or emotion. Overall, creativity was lacking and a general conservatism meant old methods and subject matter persisted.[35]

Like Li Qun before him, Jiang Feng was also keenly aware of problems facing the art of woodcut. In January 1954, he shared his thoughts through *Fine Arts*, a new incarnation of *People's Arts*. He began his article by lamenting that the once influential and highly regarded art had declined precipitously in recent years, becoming almost the most neglected form in graphic arts. Among the previously active woodcut artists, few continued to make prints. The reasons for this situation were multiple and Jiang Feng largely reiterated Li Qun's earlier analysis. To revive this art form, which could not simply be replaced by painting, just as painting itself could not be replaced by photography, it would be important to improve the quality of woodblock prints. Unlike Li Qun, who put much emphasis on the artists' own repositioning, Jiang Feng focused on formal aspects and encouraged the exploration of different styles without compromising the fundamental features of a woodcut. He expressed reservations about the use of multiple color blocks to duplicate the effects of an oil painting, and cautioned against woodcut artists choosing to depict complex scenes that would be best left to other media. He also deplored the fact that many woodcut artists would choose grand themes and scenes over inspiring scenes from everyday life, landscapes, still lives, and portraits.[36]

Critical observations made first by Li Qun and then Jiang Feng on the development, or lack thereof, in the art of woodcut in the first years of the 1950s corroborated a shared sense that literary and artistic production had indeed fallen behind. A concerted effort to address this situation was made at the second Congress in 1953. For one thing, institutional changes were

introduced to better coordinate production. The AWA was to be renamed the Chinese Artists Association (CAA) and would play a leadership role as an organization of dedicated artists. A commission on creative art was to be established within the new CAA, with separate sections on painting in general, Chinese painting, printmaking, and other visual arts. One of the first tasks of the printmaking section was to revitalize this once vibrant art form and organize a national exhibition. It was not accidental, as Wang Qi would remark in his review of the 1950s, that printmaking should have acquired a new momentum after 1953.

CLARIFYING A SOCIALIST VISION

In September 1954, hardly a year after the reorganization that brought forth the CAA, a national print exhibition opened in Beijing, presenting almost 200 works by eighty-five printmakers. The speed at which organizers put the exhibition together was hardly extraordinary in a society increasingly animated by the prospect of accelerated modernization through collectivization. The exhibition was an uplifting event, especially to an involved printmaker such as Li Qun, who promptly published an essay in *Fine Arts* to cheer "the new harvest" in the field of printmaking.

It was an exhibition that, in Li Qun's view, differed on several accounts from all previous art shows featuring printmaking. Its most prominent distinction was that prints no longer depicted the hardship suffered by the Chinese in the old society, but for the first time were entirely about people's happy life in New China. "Because new realities in China after the revolution have presented new subject matter to artists, the art of printmaking has as a result created completely new images." Another difference was the broad range of topics as well as stylistic diversity it presented (Figure 1.4). The third feature of note was that nearly half the works on display were multiblock color prints, a development that Li Qun viewed as an attempt on the part of printmakers to satisfy popular demand, since readers and editors were thought to prefer color prints to monochromatic woodcuts (Figure 1.5).

Li Qun then went on to recommend several works by young printmakers and offered detailed technical analysis. Works he appreciated generally fall into two categories. The first are prints depicting common people working in various locations and professions, such as *Floral Tapestry* by Li Huanmin (1930–), a recent trainee at the very young Central Academy of Fine Arts (Figure 1.6). The second and larger group is of landscapes. One of the prints attracting much attention and admiration at the exhibition was Liang Yongtai's *Where No One Has Been Before*, which Li Qun also liked and found evocative of traditional Chinese landscape painting. He felt "its sentiment is radically new, presenting a

1.4 Lin Yangzheng, *Daddy Is Working*, 1954, woodcut print.

1.5 Zhang Jianwen, *My Native Land*, 1953, multiblock woodcut print.

1.6 Li Huanmin, *Floral Tapestry*, 1954, woodcut print.

view that is sublime and profound, profuse and yet refreshing."[37] Li Qun noted in conclusion that a number of works still seemed crude and superficial, and he encouraged printmakers to keep up with the times and put out better works.

Jiang Feng also wrote to commend printmakers across the country for their hard work and to congratulate them for an impressive achievement. Like Li Qun, he noticed that many works in the exhibition were of landscapes, even when the idea was to represent construction projects or peaceful everyday life. He described the appeal of these works as that of expressive poetry and recognized their historical significance: "In the history of modern woodcuts, this is the first time for woodcut artists to develop such a deep interest in natural scenery and to turn to the genre of landscape painting in depicting current life." For an art form not known for its depictions of nature in the modern era, Jiang Feng believed the new development would help enrich a tradition and ought to be encouraged. He cautioned against narrow-mindedly regarding artists' interest in landscapes as a distraction or an escape. "Even pure landscapes, so long as they are excellently executed, can equally inspire people to work and strive against adversity."[38]

Jiang Feng's position on the issue of landscape painting referred back to the crises of the woodcut that Li Qun had discussed previously. It also agreed with Zhou Yang's policy statement, made in his report to the second Congress, that "we need paintings about human subjects as much as landscape paintings; we need militant marches as much as lyrical songs; we need advanced and complex artistic forms as much as mass-produced, easily accessible forms."[39] Indeed, Zhou Yang had argued that the new age and society needed more and better landscape art. Yet, to some print-makers, a turn to landscape would amount to a betrayal of the combative tradition of the medium. This concern reflected a deeper anxiety over cultural orientations. The rapid transition from revolution to post-revolution, from wartime mobilization to peacetime construction, had thrown into painfully sharp relief the symbolic investment of an artistic medium. For a revolutionary artistic discourse that had largely rejected landscape painting as frivolous or, worse, as emblematic of elite taste and privilege, what constituted a new socialist landscape became a very sensitive issue.

Soon enough, critical responses to Li Qun's and Jiang Feng's views on landscape prints rose from different quarters. First it was a young art student, who disagreed with Li Qun's praise of a color print depicting a scene from the Sino-Soviet shipyard in the port city of Lüshun. Based on the opinions of workers, who complained that the printmaker had focused on the most dilapidated and disorderly corner of their shipyard, the art student wondered why the printmaker had turned a blind eye to an awe-inspiring modern factory that stood for the thriving shipbuilding industry of the nation. Li Qun had suggested that *A Scene from the Shipyard* was a competent and pleasing landscape print, but the young challenger regarded it as a complete failure, for "even a landscape painting should also possess certain intellectual substance." He also attributed its

failure to the printmaker's lack of meaningful life experiences.[40] Published in *Fine Arts*, the critical letter from the art student carried the additional weight of representing responses from ordinary working people.[41]

Within days, a group of artists based in Guangzhou voiced its support of the criticism and directed much more serious charges against Li Qun and Jiang Feng. Sensing a deliberate promotion of landscape painting among authoritative figures in Beijing, the Guangzhou group in the south expressed dissent and warned against a trend toward abandoning political engagement. "We are not opposed to landscape painting, but we wish to raise a question: Isn't it true that artwork should reflect real struggles in the present even more?" Recent articles and art reproductions published in Beijing, charged the Guangzhou group, revealed a bourgeois interest in techniques, even a capitulation to the cultivation of taste practiced by the literati of feudal times. For a socialist artist, the more compelling and exciting realities were the numerous heroes and their heroic action that had emerged in the great era of socialist transformation and construction. "If we artists cannot see it, it means a loss of political sensitivity." With this understanding, the artists in Guangzhou argued that human subjects were far more important to study and represent in visual arts than landscapes or scenery. They regarded the recent national print exhibition as misguided in pushing landscapes while including few careful studies of contemporary heroes. Furthermore, they found historically inaccurate Jiang Feng's claim that the exhibition represented the first time that woodcut artists had turned to landscapes as an engagement with reality.[42]

The criticisms made by the Guangzhou collective were published in *Fine Arts*, but did not draw an open or hostile rebuttal. Its extensive fault-finding against the art establishment in Beijing seemed to belie a deep unhappiness with central authority, while its vigilant questioning of interest in landscapes expressed a fundamentalist commitment to the revolutionary tradition, for which art was for political mobilization and agitation rather than aesthetic cultivation or appreciation. Such determined resistance to landscape painting was not unanticipated by Jiang Feng, who pointedly advised against a narrow-minded dismissal of the new genre.

We may describe the tension between the Guangzhou artists on the one side and the Beijing critics and editors on the other as that between a radical group and moderates, between revolutionary fundamentalists and revolutionary establishmentarians. These were not entrenched positions, as the two groups would frequently realign themselves over different issues or against common challenges. Nor were they opposed to each other in terms of their ultimate objective of creating a new society. Their difference in the present context had to do with divergent views on the function and meaning of art: while one group upheld art as an imperative for continuous movement, the other recognized it as an institution contributing to social progress and cultural cohesion. On the genre of landscape painting,

debates between fundamentalists and establishmentarians would help clarify what might constitute a socialist landscape.

A good case in point is the controversy over the woodblock print *Where No One Has Been Before*, which Li Qun applauded in his review of the national print exhibition. This exquisite print was created by Liang Yongtai (1921–56), a mature and energetic woodcut artist known for his fascination with life on the railroad. At the 1954 national print exhibition, the print was well received by viewers and critics alike and was subsequently widely publicized. After coming across the image, an engineer in Shanghai wrote to *Fine Arts* and questioned whether the bridge highlighted in the print was not modeled on a famous K-shaped bridge that the French colonialists had built in the early twentieth century on the Kunming–Haiphong railway in Yunnan, southwest China. This inquiry into troublesome colonial associations of a key element in a work that was meant to celebrate the achievements of New China touched off an extensive debate that lasted almost a year, pitting several prominent artists and critics against one another. At issue were not so much direct confrontations over what was expected of a work of art in socialist society, as over how a socialist work of art was to be created (Figure 1.7).

The first and most serious charges were made in early 1955 by Li Hua, now head of the recently created Prints Group within the Creative Art Commission of the CAA. Finding the artist's explanation of how he had come up with the design of the bridge unsatisfactory, Li Hua criticized Liang Yongtai for having failed to follow the socialist realist principle and for creating a hodgepodge based on abstract concepts rather than on meaningful engagement with contemporary reality. It was a failure in methodology because the artist did not bring himself to see any actual railroad constructions around the country, but was happy to stay in his studio and resort to daydreaming.[43]

Li Hua's stern reprimand elicited a lengthy response from a renowned film critic, who defended Liang Yongtai's work on the ground that it had been broadly appreciated, which meant that, as a work of art, it was effective as well as truthful. The critic also questioned Li Hua's mechanical understanding of socialist realism and pleaded for greater care and support of imaginative artists.[44] His response, in turn, was taken up by another printmaker and theorist in an even longer rebuttal. Wang Qi, who had expressed appreciation of Liang Yongtai's fine print in an earlier article, now sided with Li Hua and regarded the artist as misguided and irresponsible in his approach. The visual pleasure and formal unity of the print, Wang Qi argued, was unmistakable, but it served to divert the viewer's attention away from the critical question of whether it was a truthful representation of life. He also revealed that even before the K-shaped bridge became an issue, some printmakers had expressed concern that the style in this work was too similar to that of an ornate British wood engraving.[45]

1.7 Liang Yongtai, *Where No One Has Been Before*, 1954, woodcut print.

Besides published articles, conflicting viewpoints on *Where No One Has Been Before* were also expressed at several meetings, and the dispute largely revolved around what should be the correct relationship between a socialist realist artist and life experiences. Yet there were other dimensions to the raging controversy. For instance, several artists from Guangzhou,

where Liang Yongtai was based and respected, defended the artist and took pains to explain his creative process, whereas prominent printmakers in Beijing appeared much more uncompromising.[46] On this point, the tension was probably less one of principle than of regional or personal relationship.

In May 1955, the editors of *Fine Arts* reported that since Li Hua's intervention, many readers had responded as well. What had unfolded, according to the editors, was a timely discussion with regard to "important issues, such as the ideas, methods, and attitudes, in artistic creation."[47] In the subsequent issue of the journal, excerpts from submissions by some fifteen readers were published. Most of the letter-writers liked Liang Yongtai's work and did not find Li Hua's criticism convincing. Some even detected a "bourgeois naturalistic view" in Li Hua's insistence that art should depict actual events.[48] In November 1955, *Fine Arts* published a critical response to Wang Qi, in which an oil painter reiterated the distinction between artistic truthfulness and facts, and rejected naturalistic faithfulness as incompatible with socialist realism. By then, the exchanges had little to do with the specific artwork and had turned into elaborate discussions of the creative process.

It was extraordinary that no one involved in the debate bothered to introduce, at least in public, more information on or simply a reference to the K-shaped bridge under discussion. Also known as the Faux Namti Bridge, the steel structure, completed by the French Batignolles Construction Company in 1908, was celebrated at the time as an engineering feat and still spans a gorge today. A widely circulated photograph of the bridge in situ, appearing in a 1911 volume published in London and called *The Railway Conquest of the World*, bears an undeniable resemblance in composition to Liang Yongtai's print from 1954 (Figure 1.8).[49] There is also no doubt that the printmaker was aiming at a reliable diagram of the actual bridge. What is evidently different between the historic photograph and the print is of course the artist's loving rendition of lush vegetation, wild life, and a peaceful and inviting deep valley in spite of a train roaring by overhead. Nonetheless, either by accident or out of innocence, Liang evoked a historical moment in his exquisite print and it was a moment that Li Hua would find deeply incompatible with, indeed antithetic to, the ethos of socialist New China, a central tenet of which would be decolonization of the national imagination.

Read today, articles and statements in the debate may strike us as hopelessly dated and contrived as well as pointless. Yet controversies were an important aspect of the emerging and yet dominant mode of cultural production. The extended debate about Liang Yongtai's work initiated a general discussion of the relationship between art and life in the socialist era, and it had the effect of confirming the centrality of this relationship in public discourse on art. The debate effectively circulated and helped

1.8 The Faux Namti Bridge, photograph published in 1911.

popularize concepts and values essential to socialist realism, as evidenced in the facility with which readers from different backgrounds entered the controversy employing the same theoretical vocabulary. Through this debate, as an art critic observed more recently, artists as well as the public

came to see "political correctness and unambiguity" as principal values in the construction of socialist public art.[50] The debate drove home the idea that socialist artwork belongs to the public domain and is therefore subject to public scrutiny. It also clarified the expectation that socialist realist art be informed with a deep historical consciousness, and that national identity and collective aspiration be pivotal to a socialist landscape.[51] (The artist was never compelled to acknowledge the connection between his work and the Faux Namti Bridge, but as the controversy broke out, Liang was already making an effort to go beyond his studio and take sketching tours of construction sites and fishing villages. It was during one such tour of a remote island that he died an untimely death in 1956.)

While the debate about *Where No One Has Been Before* was still going on, Li Hua had a good opportunity to address other issues in contemporary printmaking and to outline future directions. In March 1955, the Second National Art Exhibition, organized by the CAA, opened in Beijing and presented close to 1,000 works, among them 124 prints. Li Hua was pleased with the wide range of subject matter in the print section. He also found the increased diversity in styles encouraging. Yet broadened scope aside, Li Hua saw few works with a penetrating vision or critical relevance to contemporary life, which made him concerned that printmaking might turn into a decorative and frivolous art. To "meet the ever higher expectations from the people," printmakers must take up serious subject matter, Li Hua exhorted. They should better hone their skills of depicting human subjects and creating memorable characters. They also needed to focus on the unique expressiveness of their medium, instead of trying to duplicate the effects of an oil, watercolor, or ink-and-brush painting. Here Li Hua specifically recommended that the traditional method of water printing, or what he described as "multiblock watercolor printing," be studied and revived.[52]

Compared to Li Qun's survey of a crisis-ridden field less than five years before, Li Hua's assessment of contemporary printmaking was more reassuring, and his suggestions for future efforts more specific. The basic theoretical framework remained the same, as both emphasized the need for artists to experience and participate in contemporary life, to continue studying and improving their skills, and to incorporate native forms. But there was also a significant difference. Whereas in 1950 Li Qun concluded his essay by urging a radical change, as we have seen, "in the outlook of woodcut artists as well as in our works," in 1955 Li Hua believed this need for self-transformation should be coordinated with developments on the institutional, or what he called the "objective," level. This new objective dimension was the considerable institutional and organizational build-up in the field of art since 1950. It was part of a rapidly developing socialist mode of cultural production. This was why, for Li Hua, the exciting challenge now was to "bring printmaking in step with the grand socialist construction in our country."

ACCELERATING TO A CULTURAL REVOLUTION

The National Print Exhibition of 1954 was retroactively named the first exhibition on this scale when the Second National Print Exhibition opened two years later, in October 1956. The exhibition in 1954 had been a truly groundbreaking event, as it introduced several issues that would dominate the field of printmaking over the following years. Besides the question of landscape prints and the legacy of public participation, the first national exhibition drew attention to the growing prominence of color prints as well as the need to incorporate and update native forms. Most importantly, it provided an opportunity for concerned artists to reflect on the status and function of printmaking in the socialist era.

The Second National Print Exhibition opened amid a call from the government for greater creativity and openness in intellectual life. The policy of "Let a hundred flowers blossom and a hundred schools of thought contend" had been recently advanced as the basic principle in promoting cultural creativity and scientific research in the period of socialist construction. With 327 works by over 150 printmakers, the exhibition registered a robust growth in the field of printmaking since its predecessor, which in turn reflected the success of the Prints Group in its concerted effort to revitalize this art form. (In the same month as the exhibition opened, the Prints Group launched a bimonthly journal dedicated to printmaking.) There was due celebration of the achievements, but attention continued to rest on some of the same issues as in the earlier exhibition, such as the predominance of landscape prints, often in the form of multiblock color prints. The reason for printmakers to prefer color prints to a more elemental and striking black-and-white woodcut, according to the reviewer Xinchao, was that the editors of many journals and pictorials were much happier to use the former as illustrations and pictorial inserts. Printmakers therefore saw little choice but to cater to this popular demand.[53]

In response to the proliferation of color prints, Li Qun, one of the executive editors of the new journal *Prints*, published an essay in December 1956 to discuss the features and challenges of this form. His essay set off an extended exchange that continued over the next few years. Most of the discussion was conducted in technical terms, but there was an aesthetic as well as a cultural dimension. On the technical level, the concern was that by trying to approximate the effects of an oil or watercolor painting, a print would lose its own visual appeal and distinction. On the cultural and aesthetic level, a black-and-white woodcut constitutes a much more direct and aggressive visual statement than a color print, which is often more pleasing and conveys an appreciative but a more diffused view. The anxiety underlying the tension therefore was centered on how to maintain the critical position of a revolutionary art form in the post-liberation era.

It was the same tension between a fundamentalist commitment and an establishmentarian effort that we discussed above. That a pastoral image such as Li Qun's *Dawn* and a vociferous print in support of Arab peoples' struggle should have appeared around the same time is not surprising. These two prints of comparable size have hardly anything in common, but they ought to be viewed together, as they each express artistic commitments and visions central to the socialist moment (Figures 1.9 and 1.10).

In June 1958, the journal *Prints* published a range of opinions in a special forum on the issue of color prints. By then the Third National Print Exhibition had already taken place, and the intellectual as well as political life in New China had weathered the turbulent storm of an "Anti-Rightist Campaign," during which many artists, writers, editors, and professors were singled out and silenced for speaking their mind about current policies. Jiang Feng, for instance, was denounced as a rightist and stripped of his leadership roles in the art world. In the aftermath of the campaign, urban intellectuals were dispatched to the countryside to work toward better integration with the common working people.[54] Many artists, such as Gu Yuan (1919–96), found themselves in the countryside being reeducated about rural life.[55] Hardly had the turmoil of the Anti-Rightist Campaign died down than a national movement to engineer a Great Leap Forward in every aspect of socialist construction was underway at the beginning of 1958 (Figure 1.11).

Against such rapidly shifting currents in social and political life, the Third National Print Exhibition, which opened in February 1958, prompted many printmakers to reassess the role of printmaking. Some saw an opportunity to reclaim the woodcut as a vital art form in the present upsurge of political mobilization and revolutionary enthusiasm. On March 5, the Prints Group convened thirty printmakers in Beijing to discuss how to push for a corresponding great leap forward in art and culture. Vowing to amplify the revolutionary tradition and strive for even greater achievements, printmakers at the meeting issued a general challenge to artists across the nation. They committed themselves to continuing their intellectual transformation and to practicing socialist realism in their work; they would each produce ten or more works for submission to the upcoming national art exhibition, and as a group they would create 2,112 works by the year's end. Moreover, at least 60 percent of this body of work would be about various aspects of socialist construction. Half would be black-and-white woodcuts, and the traditional method of water printing would be employed as much as possible in making color prints. The printmakers also promised to hold a printmaking workshop at the Beijing People's Art House, where they would serve as volunteer instructors.[56]

The emphasis of this challenge to fellow artists was on boosting artistic productivity, proudly in sync with the ethos of the age of the Great Leap

1.9 Li Qun, *Dawn*, 1957, multiblock woodcut print.

Forward. While the Beijing-based group of printmakers wanted to see their art play a leading role in the new socialist culture, their sense of a heightened revolutionary development in social life also enabled a radical critique of contemporary printmaking, often by means of questioning its growing technical sophistication and institutional entrenchment.

1.10 Mao Huaisu, *They Are Fighting for Justice*, 1958, multiblock woodcut print.

There was a general consensus that the Third National Print Exhibition, which presented works by 201 printmakers, demonstrated a level of technical competence and creativity unmatched in the previous two events. Multiblock color prints, for instance, were more sophisticated, and the traditional method of water printing was successfully used by many printmakers (Figure 1.12).[57] But technical gains, in the view of printmaker Ma Ke, were not sufficient to counterbalance a widespread sense that contemporary prints had lost much of the revolutionary tradition of this art form. (During the previous national exhibition, Xinchao had also observed that post-liberation works seldom possessed the same emotional power or captivating vision as before.)

Ma Ke pointed to two institutional causes for this deplorable loss. One was that most printmakers had moved to the city after 1949 and lost contact with the working people; the other was that their works, especially their original prints, seldom reached the public. Most often a woodblock print was reproduced in journals and newspapers, but high-quality reproductions were limited and expensive, and original prints were altogether beyond the reach of ordinary people. Ma Ke urged greater accessibility to what ought to be a public art. He also expressed confidence that in the current campaign to go to the countryside, printmakers would overcome their insulation and interject refreshing vitality into their art.[58]

This anxiety over the loss of a revolutionary tradition, as we have seen, was already voiced in Li Qun's survey of printmaking in 1950, although at the time his main concern was how to adapt to a new environment. By 1958,

1.11 Xu Lin, *Bustling Suburb of Beijing*, 1958, multiblock woodcut print.

1.12 Chen Tianran, *Winter Seeding in the Mountains*, 1958, multiblock
woodcut print.

Li Qun, recently appointed co-deputy director of the Prints Group, saw the overcoming of such an anxiety in a new direction. "In today's dynamic movements toward cultural revolution and technological revolution, tens of thousands of working people have turned from viewers of art to makers of art," he observed. An unprecedented situation therefore presented itself in this socialist new age, when workers, peasants, and soldiers not only appreciated prints, but also aspired to become makers of prints. Li Qun celebrated this development as a momentous turning point.

For many years, it has long been the highest ideal of our printmaking movement to help the vast number of working people to master the art of printmaking, and to make it a means of their self-expression. Now this ideal is beginning to become reality. We are absolutely elated and every printmaker should be a facilitator of this process. In the near future, the field of printmaking in China will have a new look, and Chinese printmaking will enter a brand new stage.[59]

To be an effective facilitator of this new stage, professional printmakers should help amateur printmakers develop their interest and acquire techniques for creative use, rather than as academic credentials. In art as much as in science, Li Qun wrote, it was critically important to be adventurous and free from blind faith in authority or convention.

In reminding his fellow printmakers of the populist roots and social commitment of their art, Li Qun underscored the idea of waging a *movement* to energize contemporary printmaking. As a movement, the collective enterprise of printmakers was to go beyond existing institutions as well as conventions in seeking new possibilities. For Li Qun, the printmaking movement, in trying to bring about an art of the people and by the people, was in perfect alignment with the socialist movements in revolutionizing culture and technology. A fundamental goal of the socialist revolution, to Li Qun and his generation of artists, was to enable the common people to become makers of art and culture. It was a deeply inspiring, because profoundly ethical and humane, vision of overcoming the entrenched separation of art from life, and of undoing hierarchies in culture as well as in social life.

By recalling at this juncture the original mission of printmaking as an art movement, rather than as an institution or establishment, Li Qun also laid bare a defining feature of socialism in New China. It was becoming ever more evident that the socialist revolution would not be successful or complete without a corresponding cultural revolution. This explains why cultural activities, from artistic creation to public participation, were always at the center of the socialist experience. On a more local level, we see it was no coincidence that in late 1958 a major art critic and theorist would write to expound on the historic value of "fine arts by workers, peasants, and soldiers."[60] We can also understand why there seems to be such a strong stylistic and conceptual continuity between Li Qun's 1958 essay and the

policies and documents that both preceded and proliferated during the Great Proletarian Cultural Revolution, formally launched in 1966.

The ardent desire to take a great leap forward in the art of printmaking soon led to the Fourth National Print Exhibition, opened simultaneously in Beijing and Chongqing in October 1959. From over 1,200 submissions, close to 300 works were selected, and many of the 200 artists represented in the show were young and came from all walks of life as well as different ethnic minorities. After making selections for the exhibition, Li Hua was overjoyed at the tremendous growth of the field and anticipated the formation of an "army of artists coming from the people."[61] His own print from 1959, *Taming the Yellow River*, also showed a remarkable departure from an image that the veteran printmaker had created two years earlier of agricultural work in the mountains. The newer work projects not only a much keener sense of time and a modernizing project, but also a less ambiguous, indeed clearer, image of collective work as a core socialist value. In other words, *Taming the Yellow River* clarifies the themes of an ideal public poster in the new visual culture (Figures 1.13 and 1.14).

It being the tenth anniversary of the founding of the PRC, Li Hua and Li Qun also selected 160 prints from the past decade and published a commemorative volume. The artwork collected there illustrates most vividly the emergence and clarification of a socialist way of seeing. (Both *Agricultural Work in the Mountains* and *Taming the Yellow River* are included.) Looking back at the historical document, we cannot but notice

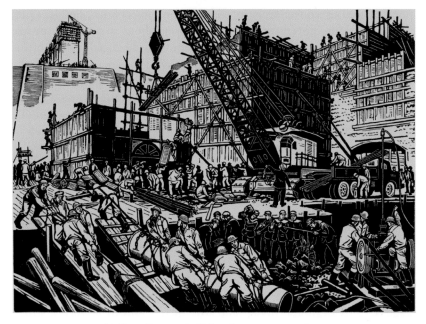

1.13 Li Hua, *Taming the Yellow River*, 1959, woodcut print.

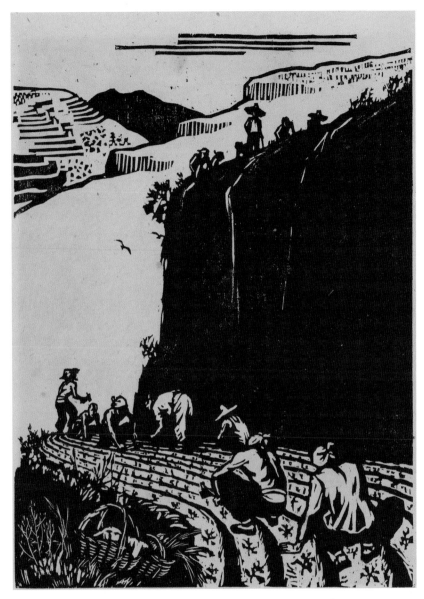

1.14 Li Hua, *Agricultural Work in the Mountains*, 1957, woodcut print.

how singularly consonant and distinctive the visual images seem to be. It is unlikely that we would mistake them for works from another era or location. Their uniqueness bespeaks the striving for a socialist modernity, a collective enterprise that galvanized several generations of printmakers in defining a socialist vision and producing a new visual order and experience. What these artists also produced self-consciously in the process were new

1.15 Xu Kuang, *Waiting for the Ferry*, 1959, multiblock woodcut print.

subject positions and relations that informed their artwork and would contribute, in their hopeful view, to the creation of a socialist culture and society. They gave compelling expression to a youthful optimism, as well as an ardent belief that the present is but a transition to a bright future (Figure 1.15).

We may revert to socialist realism as an unthinking term in describing, or decrying, the style of these images, their intended effect or function, but for their creators, socialist art was a transformative process that would not come about without an artist endeavoring to acquire a new vision. We can hardly grasp the rich legacy of socialist visual culture if we fail to see the

many layers, debates, deliberations, and aspirations underlying its production. More directly, our own historical imagination will be impoverished if we do not recognize these visual images and documents as resulting from an unprecedented experimental mode of cultural production, central to which was the greatly challenging project of creating a public art as well as making a socialist artist.

NOTES

1 Mao Tse-tung, "The Chinese People Have Stood Up!" in *Selected Works of Mao Tse-tung* (Peking: Foreign Languages Press, 1977), vol. v, 15–18.
2 According to Lin Chun in an insightful study, socialist modernization in twentieth-century China had three equally compelling commitments or pursuits: national unity and sovereignty, social equality and justice, industrialization and economic development. "Together, national pride, socialist ambition, and economic drive underlay the Chinese desire for distinction and international recognition." See Lin Chun, *The Transformation of Chinese Socialism* (Durham, NC: Duke University Press, 2005), 60.
3 On this enduring motif, see John Fitzgerald's important study, *Awakening China: Politics, Culture, and Class in the Nationalist Revolution* (Stanford University Press, 1996). For a study of Liang Qichao's notion of the "new citizen," see Xiaobing Tang, *Global Space and the Nationalist Discourse of Modernity: The Historical Thinking of Liang Qichao* (Stanford University Press, 1996).
4 Hu Feng, *Shijian kaishi la* (Time Has Begun), in *Hu Feng quanji* (*Complete Works of Hu Feng*) (Wuhan: Hubei renmin, 1999), vol. 1, 101–281. The first movement, as the poet calls it, is an "Ode to Joy," composed in November 1949.
5 Chang-tai Hung, *Mao's New World: Political Culture in the Early People's Republic* (New York: Cornell University Press, 2011), 5.
6 Hung, *Mao's New World*, 21.
7 Hung, *Mao's New World*, 208.
8 Clark, *The Chinese Cultural Revolution*, 5–7.
9 Clark, *The Chinese Cultural Revolution*, 255.
10 Evgeny Dobrenko, *Political Economy of Socialist Realism*, trans. Jesse M. Savage (New Haven, CT: Yale University Press, 2007), 6–7.
11 See Chapter 9, "New Urban Culture and the Anxiety of Everyday Life in Late Twentieth-Century China," in Xiaobing Tang, *Chinese Modern: The Heroic and the Quotidian* (Durham, NC: Duke University Press, 2000), 273–94.
12 For an account of the July 1949 All-China Congress of Literary and Art Workers in English, see Julia F. Andrews, *Painters and Politics in the People's Republic of China, 1949–1979* (Berkeley: University of California Press, 1994), 34–8.
13 Jiang Feng, "Jiefangqu de meishu gongzuo" (Work in Fine Arts in the Liberated Areas), collected in *Jiang Feng meishu lun ji* (*Collected Essays on Fine Arts by Jiang Feng*) (Beijing: Renmin meishu, 1983), vol. 1, 16–22.
14 See Xiaobing Tang, *Origins of the Chinese Avant-Garde: The Modern Woodcut Movement* (Berkeley: University of California Press, 2008), esp. Chapter 2, "Art Theory as Passionate Discourse on Subjectivity," 43–74.

15 See Mao Tse-tung, "Talks at the Yan'an Forum on Literature and Art," in *Selected Works of Mao Tse-tung* (Peking: Foreign Languages Press, 1975), vol. III, 82. Translation slightly modified.

16 Li Jiefei and Yang Jie, *Jiedu Yan'an: wenxue, zhishifenzi he wenhua* (*Reading Yan'an: Literature, Intellectuals, and Culture*) (Beijing: Dangdai Zhongguo, 2010).

17 See Li Jiefei and Yang Jie, *Reading Yan'an*, 211.

18 "Guanyu kaizhan xin nianhua gongzuo de zhishi" (Directives on Starting the Work on New Year's Prints), *Remin ribao* (*People's Daily*), November 26, 1949.

19 See Lü Peng, *A History of Art in Twentieth-Century China*, trans. Bruce Gordon Doar (Milan: Charta, 2010), 455.

20 Hung, *Mao's New World*, 185.

21 For an insightful recent study of the new *nianhua* movement, see Yang Dong, "Minzu wenhua chongjian shiye xia de xin nianhua yu xin nianhua yundong" (The New *Nianhua* and New *Nianhua* Movement from the Perspective of the Reconstruction of a National Culture), in Chen Xiangbo and Xu Ping, eds., *Ershi shiji Zhongguo pingmian sheji wenxian ji* (*Documents on Twentieth-Century Chinese Graphic Designs*) (Nanning: Guangxi meishu, 2012), 231–45.

22 Li Keran, "Lun Zhongguo hua de gaizao" (On Reforming Chinese Painting), *Renmin meishu* (*People's Arts*), no. 1 (February 1950), 35–8.

23 For two related studies, see Ralph Croizier, *Art and Revolution in Modern China: The Lingnan (Cantonese) School of Painting, 1906–1951* (Berkeley: University of California Press, 1988), and Christina Chu, "The Lingnan School and its Followers: Radical Innovation in Southern China," in Julia F. Andrews and Kuiyi Shen, eds., *A Century in Crisis: Modernity and Tradition in the Art of Twentieth-Century China* (New York: Guggenheim Museum, 1998), 64–79.

24 Li Hua, "Gaizao Zhongguo hua de jiben wenti" (The Basic Issues in Reforming Chinese Painting), *Renmin meishu*, no. 1 (February 1950), 39–41.

25 For a discussion of the historical development of the modern woodcut, see my study, Tang, *Origins of the Chinese Avant-Garde*, esp. Chapter 5, 165–210.

26 Tang, *Origins of the Chinese Avant-Garde*, 217.

27 This historical event is the main story told in *The Founding of a Republic*, a 2009 film that I will examine closely in Chapter 5.

28 See "Wei biaoxian xin Zhongguo er nuli: dai fakan ci" (Endeavor to Represent New China: In Place of a Mission Statement), *Renmin meishu*, no. 1 (1950), 15.

29 Andrews, *Painters and Politics in the People's Republic of China*, 41.

30 Li Qun, "Lun dangqian muke chuangzuo zhu wenti" (On Issues in the Making of Woodcuts Today), originally published in *Renmin meishu*, no. 6 (1950), collected in Qi Fengge, ed., *Ershi shiji Zhongguo banhua wenxian* (*Documents on Twentieth-Century Chinese Printmaking*) (Beijing: Renmin meishu, 2002), 68.

31 Li Qun, "On Issues in the Making of Woodcuts Today," 69–70.

32 Wang Qi, "Shinian lai de banhua yishu" (The Art of Printmaking over the Last Ten Years), *Meishu yanjiu* (*Studies in Fine Arts*), no. 1 (1959), 7–14.

33 Guo Moruo, "Tuanjie yixin, chuangzuo jingsai" (Let Us Come Together and Begin a Competition in Creativity), collected in *Moruo wenji* (*Collected Writings of Guo Moruo*) (Beijing: Renmin wenxue, 1963), vol. XVII, 249–52.

34 Zhou Yang, "Wei chuangzao gengduo de youxiu de wenxue yishu zuopin er fendou" (Endeavor to Create More and Better Literary and Artistic Works),

collected in *Zhou Yang wenji* (*Collected Writings of Zhou Yang*) (Beijing: Renmin wenxue, 1985), vol. 11, 254.

35 Jiang Feng, "Sinian lai meishu gongzuo de zhuangkuang he quanguo meixie jinhou de renwu" (The Work in Arts over the Past Four Years and the Future Tasks of the AWA), *Meishu (Fine Arts)*, no. 1 (1954), 5–8.

36 Jiang Feng, "Duiyu fazhan he tigao muke chuangzuo de yijian" (Suggestions on Developing and Enhancing the Making of Woodcuts), *Wenyi bao (Literary and Art Gazette)*, no. 1 (1954), 35–6.

37 Li Qun, "Banhua yishu de xin shouhuo" (New Harvest in the Art of Printmaking), *Meishu*, no. 9 (1954), 37–8.

38 Jiang Feng, "Muke yishu de xin chengjiu" (The New Achievements in the Art of Woodcut), *Wenyi bao*, no. 18 (1954), 39.

39 Zhou Yang, "Endeavor to Create More and Better Literary and Artistic Works," 249.

40 Sui Jun, "Dui taose muke *Zaochuanchang yi jiao* de yijian" (My Criticism of the Multiblock Color Print *A Scene from the Shipyard*), *Meishu*, no. 11 (1954), 52.

41 For a related analysis, see Li Zhaoxia, "Duzhe yu meishu piping huayu de jiangou" (The Reader and the Construction of Art Criticism as a Discourse), *Meishu guancha (Fine Arts Observations)*, no. 12 (2011), 111. According to Li Zhaoxia, even though the editorial board determined which readers' correspondence was selected for publication, public readers and their reactions to the journal were an integral and indispensable part in the construction of art discourse in New China.

42 "Guangzhou meishujie dui meixie lingdao he *Meishu* yuekan de yijian" (Criticisms of the AWA Leadership and the *Fine Arts* Monthly from the Art Circles in Guangzhou"), *Meishu*, no. 1 (1955), 8–10.

43 See Li Hua, "Muke *Congqian meiyou ren daoguo de difang* de wenti" (Problems with the Woodcut *Where No One Has Been Before*), *Meishu*, no. 2 (1955), 43–4. Liang Yongtai's letter to the journal *Fine Arts* follows Li Hua's article and appears on p. 45 of the same issue.

44 See Zhong Dianfei, "Bixu jiayi xiaoxin de baohu chuangzuo" (We Must Take Care to Protect Creative Work), *Meishu*, no. 3 (1955), 9–12.

45 See Wang Qi, "Huajia yinggai zhongshi shenghuo shijian" (Artists Should Pay Attention to Praxis of Life), *Meishu*, no. 4 (1955), 37–41.

46 In March 1955, the Prints Group of the Creative Art Commission of the CAA called a second meeting in response to different assessments of Liang Yongtai's work. Then, at the beginning of May 1955, a more heated discussion took place at the second plenary meeting of the executive board of the CAA. For a summary of the May 1955 discussion, see Shui Zhongtian, "Nandao shenghuo shi zheyang de ma? wushi niandai youguan banhua chuangzuo de yichang taolun" (Is Life Really Like This? A Discussion of the Making of Prints in the 1950s), collected in Shui Zhongtian, *Lishi, yishu yu ren (History, Art, and Human Beings)* (Nanning: Guangxi meishu, 2001), 391–399.

47 See *Meishu*, no. 4 (1955), 37.

48 See "Guanyu muke *Congqian meiyou ren daoguo de difang* de taolun" (Discussions of the Woodcut *Where No One Has Been Before*), *Meishu*, no. 5 (1955), 45–8.

49 F. A. Talbot gives a detailed description of the construction of the bridge and its technical features in *The Railway Conquest of the World* (London: William

Heinemann, 1911), 302–4. Two photographs preceding p. 285 in the volume show the bascules being lowered from the two sides of the gorge during construction. Now referred to as the Wujiazhai Railway Bridge, the structure still functions and is on the national registry of historic sites designated for preservation.

50 See Peng Jie, "Congqian youren zouguo de lu: zhuiji Liang Yongtai xiansheng de yishu rensheng" (Where Someone Has Walked Before: A Review of Liang Yongtai's Artistic Life), in *Liang Yongtai: chungui er huashi* (*Liang Yongtai: Achievements in Youth*) (Hong Kong: Gongyuan chuban, 2007), 3–13, esp. 10–12.

51 Liang Yongtai's print, despite the controversy, was anthologized in *Shinian lai banhua xuanji* (*Selected Prints from the Past Decade*) (Shanghai renmin meishu, 1959). This volume, edited by Li Hua and Li Qun, was intended to present the best work on the tenth anniversary of the founding of the PRC.

52 Li Hua, "Wei tigao banhua chuangzuo de zhiliang er nuli" (Let Us Strive To Enhance the Quality of Printmaking), *Meishu*, no. 5 (1955), 6–8.

53 Xinchao, "Banhua chuangzuo de yixie wenti" (Some Issues in Printmaking), *Meishu*, no. 10 (1956), 34–5.

54 "The inevitable path for all revolutionary artists," stated an editorial in *Fine Arts* in January 1958, was "integration with workers and peasants." See *Meishu*, no. 1 (1958), 3–5.

55 In January 1958, Gu Yuan announced his decision to go back to the country-side to temper himself and to "strike my artistic roots deep into the earth of the life of the working people." See his "Huidao nongcun qu" (Return to the Countryside), *Meishu*, no. 1 (1958), 6. In December of the same year, *Fine Arts* published a lengthy report by Gu Yuan on his experience of living and working among the peasants in a county in Hebei province. See "Nongcun shi zhishi haiyang, shi hongzhuan xuexiao" (The Countryside is an Ocean of Know-ledge, a School for Training Red Experts), *Meishu*, no. 12 (1958), 18–20.

56 See "Beijing tongxun zhiyi" (News from Beijing no. 1), *Banhua* (*Prints*), no. 10 (1958), 4.

57 See Li Pingfan, "Zhengqu gengda de fengshou" (Work for an Even Greater Harvest), *Meishu*, no. 5 (1958), 32–3.

58 Ma Ke, "Zai qianjin de daolu shang" (On the Way Forward), *Banhua*, no. 10 (1958), 3–4.

59 Li Qun, "Cujin banhua yishu de da puji da fanrong" (Accelerate the Great Popularization and Development of the Art of Printmaking), *Banhua*, no. 13 (1958), 4.

60 See Wang Chaowen, "Gong nong bing meishu, hao!" (Fine Arts by Workers, Peasants, and Soldiers Are Good!), *Meishu*, no. 12 (1958), 11–17.

61 See Li Hua, "Da yuejin, da fengshou" (Great Leap Forward, Great Harvest), *Banhua*, no. 19 (1959), 34.

CHAPTER 2

How was socialist visual culture created?
Part II: Revelations of a history painting

Upon entering the National Museum of China (NMC), a colossal architectural complex on the east side of Tiananmen Square in the heart of Beijing, we may easily find ourselves dwarfed and disoriented by the vast vaulting space and soaring escalators. On any given day, the reportedly largest museum space in the world may support a busy overlapping schedule of exhibitions, lectures, screenings, and performances with its forty-eight galleries and other state-of-the-art facilities. Formed in 2003 from a merger of two modern institutions – the Museum of Chinese History and the Museum of the Chinese Revolution – the NMC commands tremendous resources and takes as one of its mandates to integrate presentations of the revolutionary twentieth century with those of the much longer history of Chinese civilization. The desire for a coherent grand narrative is best reflected in two permanent exhibitions, *Ancient China* and *The Road to Rejuvenation*, which the prestigious institution introduced in early 2011, when it reopened after undergoing renovations that lasted three years.

In June 2011, in celebration of the ninetieth anniversary of the Chinese Communist Party, the NMC drew from its rich collections and installed in the most prominent Central Hall another regular exhibition, *Masterpieces of Modern Chinese Art*. All but one work, created by prominent artists between 1951 and 1972 and mostly under the auspices of the former Museum of the Chinese Revolution, deal with pivotal episodes or figures in the revolutionary twentieth century. (The sole exception is Xu Beihong's [1895–1953] majestic ink-and-brush painting *The Old Man Removes the Mountain*, which the artist finished in 1940 under the duress of the Japanese invasion.) These masterpieces constitute a specific "modern art" not only because their subject matter is emphatically modern Chinese history, but also because they all share – indeed they contributed to – a distinct visual style that was dominant in the mid-twentieth century, a style promoted at the time as an innovative synthesis of revolutionary realism and revolutionary romanticism. Modern in form as well as content, these works of art may best be described as exemplifying a "socialist modern." Most of the seventy-four works in the exhibition are oil paintings, including such iconic images as *The Founding of the People's Republic* (1953) by Dong Xiwen (1914–73) and *The Tunnel War* (1951) by Luo Gongliu (1916–2004), but there are also nine ink-and-brush paintings, fourteen sculptures, and one drawing in pencil.

The pencil drawing stands out in this celebrated collection not merely because it is one of a kind. In vivid detail and a rich monochrome evocative of a black-and-white photographic image, it depicts a large number of almost life-size characters on a sizable canvas intended for oil painting. The title of the work is *The Bloodstained Shirt*, finished in 1959 by Wang Shikuo (1911–73) (Figure 2.1). From an initial viewing, we see a group of Chinese villagers engaged in a public meeting in what appears to be a courtyard, with a woman close to the center holding up the eponymous bloodstained

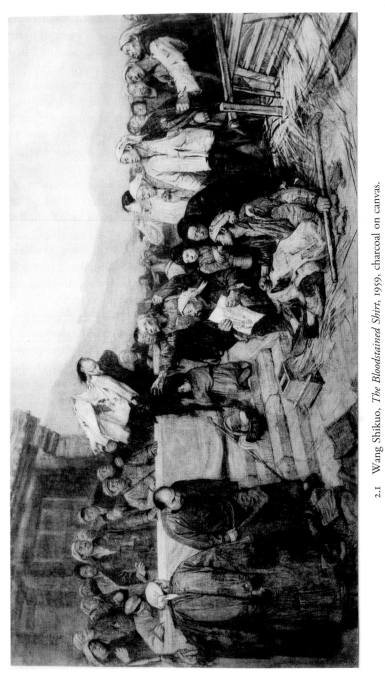

2.1 Wang Shikuo, *The Bloodstained Shirt*, 1959, charcoal on canvas.

shirt, her head turned back in speechless anguish. While almost everyone to her right looks intently at the woman and the unfurled shirt, most of the men and women to her left, including a child clinging to her legs, focus their attention on the bald-headed man standing at the bottom of a terrace to the left of the canvas. With his head bowed, the man clutches his long dark gown and seems to be stealing a glance at the crowd facing him, a hard glint clearly visible in his upturned eyes. Immediately next to him and to the far left of the frame looms a young man holding a spear, whose patched overcoat is weighty and emphasizes his monumental presence. Then we realize that across the canvas, on the far right, there is a grave older man holding a rifle. Together they constitute a solemn militant presence framing the entire scene.

As we look more closely, we notice that every figure depicted reacts to the scene differently and in character. The central characters, from the reclining man in need of a crutch in the foreground to the woman holding the shirt and standing tall on the raised terrace, form a rising column of humanity, seemingly pulsating with a dynamic rhythm as it leans forward precipitously. We sense the scene is caught in a moment of stunned and suspenseful silence. This charged pause seems to be part of a dramatic unfolding, and a climactic denouement is yet to come. In the next instant, the blind old woman at the center, who reaches out her trembling hand as if trying to grab the bald-headed man, will start speaking, and everyone in the scene will voice their reaction to the sight of the bloodied shirt. A furious and terrifying outburst of emotion, of communal outrage, is about to shake us even more. Action is going to sweep over them, and the current composition as well as the momentary balance between all the characters, even their relation to each other, will be altered radically and irrevocably. There is a great sense of drama, and the scene is charged with theatrical potency.

The Bloodstained Shirt is an epic depiction of the historic land reform that forever transformed the tradition-bound Chinese countryside and society in the mid-twentieth century. It remains the most comprehensive, therefore the most paradigmatic, visual representation of the sweeping and unprecedented land redistribution program undertaken by the Communist Party. Not surprisingly, it is the only artwork on this topic we will come across in the *Masterpieces of Modern Chinese Art* exhibition at the NMC. It is also the artist Wang Shikuo's most important work, a towering achievement that took years and numerous revisions to emerge. In the end it remains an unfinished work, because the artist's ultimate goal was to render it in oil and create a grand historical vista in rich color and texture. In 1973, about fifteen years after finishing the large-scale pencil drawing, Wang went to a village in Henan Province to do further studies for the final version in oil. There, while sketching a portrait of two villagers, he collapsed in front of his easel. He died of a stroke the next day at sixty-two years of age.

On the hundredth anniversary of the artist's birth, a Wang Shikuo retrospective took place in May 2011 at the art museum of the Central Academy of Fine Arts in Beijing (CAFA), where he was for over twenty years a faculty member and an administrator. In the accompanying volume and exhibition catalogue, Pan Gongkai, president of the CAFA and a renowned artist himself, salutes Wang Shikuo as a great realist with a humanist commitment and refers to *The Bloodstained Shirt* as "a successful example of the revolutionary realist art of New China." The creative process that the artist consciously explored and theorized, Pan observes, exerted a lasting influence on art education as well as artistic practices in the PRC. "No student studying the history of Chinese art in the twentieth century," he writes, "can afford to neglect Wang Shikuo's achievements and his impact on fine arts education." He further suggests that studying the history of modern Chinese art is inseparable from a study of the turbulent history of revolution in modern China.[1]

Indeed, a complex work such as *The Bloodstained Shirt* demands that we view it in close relation to the Chinese revolution, specifically the impassioned land reform movement and its earth-shaking reverberations. It is bound to be a reflective viewing experience as our own relationship to the depicted scene and its characters inevitably becomes part of our inquiry and understanding. For the necessarily violent process of systematically expropriating landowners makes it impossible for us, as for the artist, to remain disinterested observers. How to visually present and narrate the revolutionary project of redistributing land among the landless majority was an artistic as well as a conceptual challenge to the artist. Similarly, for contemporary viewers like ourselves, looking at the image across a historical distance, the challenge is to appreciate the work as belonging to an emergent way of seeing and representational order that was at once revolutionary and systematic, with implications at once political and artistic. Pivotal to this new representational order were Chinese peasants, occupying the center stage of history in a collective heroic role as they had never done before and would hardly ever do again.

THE SCENE OF THE REVOLUTION

In reflecting on the process of creating *The Bloodstained Shirt*, Wang Shikuo traced its impetus to his direct participation in the land reform movement. Even though he had grown up in the countryside, he wrote, it was his experience in the movement that helped him further understand rural life and appreciate Chinese peasants from a political perspective.[2] Wang had joined a government task force that was dispatched, upon the promulgation of the Land Reform Law in June 1950 by the newly founded People's Republic, to a village outside Beijing to oversee the implementation of the law. The main agenda of land reform, according to the law, was

to abolish the exploitative system privileging the landlord class and to institute peasant ownership, with the goal of enhancing agricultural productivity in preparation for the industrialization of the nation. The idea of equalizing land ownership was at the origin of the Republican revolution advocated by Dr. Sun Yat-sen in the early twentieth century, but it was the Communist government that finally had the political will and power to put it into practice nationwide. In ending the traditional system of land ownership, in the course of over two years the reform would affect the lives of over 300 million Chinese peasants and radically change the political, social, economic, and cultural landscape of the country.

Yet the systematic land reform that began in 1950 was not the first time that Wang Shikuo had come into direct contact with or portrayed peasant life in his art. As a respected artist active in Yan'an, the Communist base area in rural Shaanxi during the 1940s, he had on many occasions interacted with local villagers and recorded his observations in a large number of sketches, often on very crude homemade paper. A severe shortage of basic supplies, caused by the ongoing Japanese invasion as well as continual blockades imposed by the Nationalist forces against Yan'an, also meant the artist had little chance of painting in oil, which was his true passion. Wang's most celebrated work from the Yan'an era was a woodblock print depicting a communal effort to compel a village wastrel to turn over a new leaf.

A result of his involvement in a campaign organized by the Communists in rural communities to promote new mores and social cohesion, *Reforming a Village Bum* (1943), measuring about 6.5 inches × 10.25 inches, shows the artist's extraordinary talent in depicting peasant life and telling a complex human story. From the grave and fatherly village elder to a hot-tempered activist at the center of the scene, from the despairing wife with her back turned to us to disappointed neighbors, everyone acts in his or her character and together they stage a theatrical confrontation that suggests many narrative possibilities. Crucial details, such as the village bum's tattered clothing and the setting of an open courtyard, are coordinated to dramatize the social as well as the moral poignancy of the moment. It is a work in which Wang Shikuo relied on descriptive lines in relief printing, rather than shadows and tonal masses, to appeal to a native visual sensibility, a deliberate stylistic choice made by many woodcut artists based in Yan'an. It is also a work for which the artist did numerous character studies and experimented with different compositions (Figure 2.2).[3] When Xu Beihong saw the colored print in 1949 during what was to become the First National Fine Arts Exhibition, the French-trained great master was completely won over and marveled at its sophistication in every aspect (Figure 2.3).

Similarly, the national land reform in 1950–3 was not the first time that the Communists organized the redistribution of land in the Chinese

2.2 Wang Shikuo, study for *Reforming a Village Bum*, 1942, charcoal on paper.

2.3 Wang Shikuo, *Reforming a Village Bum*, 1947, multiblock woodcut print.

countryside. Ever since the 1920s, the Communist revolution, in seeking to secure an alliance with the impoverished peasants who constituted the great majority of the country's population, had recognized the vital importance of the land question. From his field study in Hunan in 1927,

Mao Zedong the rising leader within the still young CCP became deeply convinced of the force of a peasantry mobilized through systematic land redistribution. In the famed report on his investigation, he spoke enthusiastically of the historic potential of a revolution from the bottom up:

> In a very short time, in China's central, southern and northern provinces, several hundred million peasants will rise like a mighty storm, like a hurricane, a force so swift and violent that no power, however great, will be able to hold it back. They will smash all the trammels that bind them and rush forward along the road to liberation. They will sweep all the imperialists, warlords, corrupt officials, local tyrants and evil gentry into their graves.[4]

The pounding hurricane that Mao expected to sweep across the country did not materialize right away, but his detailed analysis, as well as his passionate endorsement, of the peasant movement struck the keynote of the oncoming Chinese revolution.

From the 1930s onward, mobilization of the rural poor steadily grew into a fundamental operation for the Communist Party, and a set of techniques and policies was gradually perfected in the process.[5] As Peter Townsend, an Englishman who witnessed firsthand the land reform in the 1950s, observed at the time,

> "Land to the Tiller" is not a new slogan. Land reform itself is not an innovation. For nearly two decades the Chinese have practised it, experimented with it, and modified it in the Chinese Soviets and Liberated Areas. By 1949, land reform had brought land to 120 million peasants; and its techniques, raised almost to a science by constant practice, made land reform a steady, unhurried progress in the wake of civil war.[6]

Historians may divide the process of land reform in the 1950s into different stages and they have different assessments of its consequences, but there is a general consensus that the methods employed by the Communists were increasingly effective.[7] In his report, Townsend noted two important elements of the process: work teams sent by the government to supervise land reform, and the communal "speaking bitterness meetings" that mobilize the peasants. "Impetus came from outside the village, from teams of government workers; from active peasants from other areas; from students and teachers who had taken courses on land reform." When a work team arrived, its members would live in peasant households, work in the field, and seek out potential activists, often from among the poorest in the village. The work team was itself a novel experience for an ordinary peasant, as he "had never before encountered people connected with government on this intimate level," remarked Townsend. "And he responded, slowly learning to open his mouth, overcoming his fear of landlords often armed and always dominant, moving towards the passionate, communal 'speak bitterness meeting' when all the villagers would stand up and tell of their sufferings."[8]

Passionate public venting of grievances against the landlord was a pivotal event, with all the symbolic functions of a theatricalized communal ritual, in the land reform movement. "The importance of this preparatory stage lay not so much in the punishment of malefactors as in the consequent release of the peasant from fear," Townsend continued in his report. "No longer was he isolated and bound by a silence imposed by terror. He had become one of many breaking those bonds; and from then onwards the course of land reform lay increasingly with the peasants, its application becoming a matter for Peasants Associations." The public act of "speaking bitterness" therefore constituted a highly symbolic moment of defying the old order in the community and of identifying the source of suffering in an evil and inhumane class enemy. To arrive at this moment, villagers had to be encouraged to sever traditional social bonds, such as clan, familial, and neighborly relations, and to regard their hitherto *naturalized world* in terms of class relations and political struggle. In slowly learning to open their mouth, as Townsend described it, villagers had to acquire a new vocabulary, speak a new language, claim a public role, and in effect assume a new subject position. They must stage a revolution against the symbolic order that was their old world. Violent and destructive as it was, the process empowered the hitherto powerless and produced new subjects and experiences.

The goal of land reform, as a recent study of CCP policies, reports, and directives related to the historic movement confirms, was much more than simply to redistribute the land or establish a new ownership system. "Far more important was to transform the social structure and political relations in the rural village, to shape the political identity of the peasantry, and to consolidate the governing position of the Chinese Communist Party."[9] *Fanshen*, as William Hinton explained in his classical account of revolution in a Chinese village, was a most important word in a whole new vocabulary that the Chinese revolution had created. "Literally, it means 'to turn the body,' or 'to turn over.' To China's hundreds of millions of landless and land-poor peasants it meant to stand up, to throw off the landlord yoke, to gain land, stock, implements, and houses."[10] Yet for the Communist work teams overseeing land reform, it was even more critical for the peasants to achieve *fanxin*: to turn their heart over, to have a new mindset, to become a revolutionary subject. Without a genuine *fanxin*, a radical change of one's worldview, *fanshen* alone was not sufficient or sustainable.[11]

In his monumental work, *Fanshen*, Hinton reconstructed for us a memorable moment in the revolutionary history of the village of Long Bow in southern Shanxi, a land-locked province in central China. The incident took place in 1945, not yet in the course of land reform, but rather as part of a campaign to punish local collaborators after the Japanese surrender at the end of the eight-year War of Resistance. It was a public

meeting that failed to achieve its purpose, and, in Hinton's novelistic narration, the event made it abundantly clear why the practice of "speaking bitterness" would matter so much.

One afternoon, "several hundred stolid peasants" were gathered in the village square to find the former pro-Japanese village head standing in front of them, "his face ashen, his tunic shabby and soiled." Then the new village chairman took the stage and urged his curious audience to "speak out the bitter memories of the past." "He spoke plainly. His language and his accent were well understood by the people among whom he had been raised, but no one moved and no one spoke." Finding the situation intolerable, the new vice-chairman of the village jumped up and struck the accused on the jaw. "The blow jarred the ragged crowd. It was as if an electric spark had tensed every muscle. Not in living memory had any peasant ever struck an official. A gasp, involuntary and barely audible, came from the people and above it a clear sharp 'Ah' from an old man's throat." The former village head was terrified, the new vice-chairman continued to bark his demands, and the crowd looked on. "The people in the square waited fascinated, as if watching a play. They did not realize that in order for the plot to unfold they themselves had to mount the stage and speak out what was on their mind. No one moved to carry forward what Kuei-ts'ai had begun."[12]

Public trial as theater, or the importance of theatricality in political empowerment, would be intuitively grasped by organizers of land reform, to whom bringing forth passionate and steadfast speakers and rabble-rousers was crucial to the success of the revolutionary project. It was imperative that the peasants participate in the publicly staged political theater, to step into a new role of themselves as themselves, and in the process to find a new voice and articulate a new agency. Only then, with their participation as actors rather than as spectators, would there be a revolutionary event to unfold and continue. Only then would it become possible for land reform to avoid succumbing to the conventional script of a mob robbing the rich.

In practice, the imperative to perform revolutionary subjecthood in order to carry out land reform had at least two salient implications for a "speaking bitterness" (*suku*) meeting. One was that for the political theater to be effective, it must be a carefully orchestrated production.[13] Every detail, from the pacing of the event to its setting, from seating arrangements to the order in which speakers took their turns, needed careful consideration and planning. Advance coaching might be necessary too, to ensure the main speaker or "host of bitterness" (*kuzhu*) set the right tone for the following acts. The other major implication was that, since political agency was constituted in performance and through theatricality, its upkeep or management required periodic repetition, even intensification, of the performative act and the theatrical production itself.[14]

The open theater of "speaking bitterness" therefore at once set forth plot requirements and allowed for improvisations. While the specific content of their bitterness (*parole*) could vary from one speaking subject to another, the governing form or structure (*langue*) had to remain stable for the drama to come to its desired culminating scene. It was this theater as political technique, as Townsend put it in 1953, that was "raised almost to a science by constant practice" and ensured the steady progress of land reform. The logic as well as effect of this political theater was what Wang Shikuo sought to explain and illustrate in *The Bloodstained Shirt*.

REVOLUTION AS COMEDY

The most detailed description of such a theatricalized political happening, of its cast, rehearsal, and production, and finally of its consequences, may be found in two full-length novels about land reform, both published in 1948. More than any reports or documentaries of actual proceedings in a given locale, *The Sun Shines over the Sanggan River* by Ding Ling (1904–86) and *The Hurricane* by Zhou Libo (1908–79) offer a panoramic view as well as frame-by-frame analysis. And since both authors were veteran Communists and they wrote to celebrate land reform, the remarkable similarity in terms of plot development and character typology between these two texts is hardly surprising. (As a result, upon their publication, these two novels were recommended as guidebooks and instructional manuals to many work teams sent to various parts of the country.)

It makes good sense, for instance, for the narrator in Ding Ling's novel to refer to the public trial as the "decisive battle" and build it up as the triumphant climax toward the end of the narrative. The trial, fittingly enough, takes place on the village stage, where the evil landlord is forced to kneel, humiliated, and beaten up. As the agitated villagers unleash their newly aroused anger and hatred, the description of the badly battered landlord suggests the witnessing of an almost comic transformation of an unsympathetic character through make-up. It is a partisan narrative voice reminiscent of and consistent with the tone that Mao Zedong adopted in his 1927 report on the peasant movement in Hunan.[15] "Qian Wengui crawled to his feet again and kneeled to kowtow to everyone. His right eye was swollen from beating so that it looked even smaller. His lip was split and mud was mixed with blood. His bedraggled moustaches drooped limply: altogether a ridiculous sight."[16] Eventually he is led away, and villagers proceed to form a land assessment committee, electing as its members the most outspoken accusers at the trial. "As the meeting broke up they shouted for joy, a roar like thunder going up into the air. This was an end, it was also a beginning."[17]

The trial scene in *The Hurricane* by Zhou Libo follows the same emotional pattern and sequence of action, except that it is more intense, and the result more radical. It reads even more like a dramatization of what Wang Shikuo was to visualize in *The Bloodstained Shirt* a decade later. All the characters that we find in Wang's drawing make their literary appearance here: children, village men and women, work team members, activist peasant leaders, young militiamen armed with spears and rifles, even an old woman who loses her eyesight from mourning her husband's death at the hands of the condemned landlord. The location for the public trial in the novel is the courtyard inside the landlord's fortified mansion, and a table removed from his study is set up as the provisional tribunal.

As soon as the peasant leader announces the opening of the trial and invites those present to come forward to "speak up and settle scores," a young man takes the lead, accuses the landlord of murdering his mother, and asks for permission to strike him. "From all sides, a loud roar came over like spring thunder. Everyone raised their stick or spear, and the crowd surged forward like a flood wave." Amidst the surging crowd, a middle-aged woman walks up to Han, raises her stick, and cries "You . . . you killed my son." "Her elm stick fell on Han's shoulder, but when she wanted to continue, she had no strength left. She dropped the stick, threw herself upon him and bit his shoulder and arm, not knowing how to vent her hate." Widow Zhang's action and despairing plea for the return of her son further incenses the crowd. As men and women tearfully demand the return of their loved ones, a young member of the work team begins to weep, and the team leader orders another to take notes in his stead. In the end Han the landlord is found liable for the death of scores of villagers. After the team leader telephones the county government and receives instructions, Han is taken outside the East Gate of the village and executed. Over a thousand villagers celebrate in a procession, "shouting slogans, singing songs, blowing trumpets, beating gongs and drums."[18] It is as much a scene of communal exorcism as it is a demonstration of the emancipatory impact of *fanshen*.

The presence of a grief-stricken widow in the rousing scene acknowledges the fact that at many speaking bitterness meetings women played a critical role of catalysis. They were often the most effective speakers because, as organizers of land reform in Hebei realized, they had the power to move the audience to tears with their vivid and emotional testimonials.[19] From her survey of the tradition of "emotion work" in the Chinese revolution, Elizabeth Perry concurs that "once cadre activists had opened the door to emotional contestation, village women were often the first to enter the fray. Their gender having accustomed them to an expressive mode of communication, women inveighed against past injustices with particular fervor."[20] Fervor and emotional appeal aside, what rural women

gained through the theater of "speaking bitterness" was an unprecedented opportunity to speak in public and claim a political role.

The status of women in rural communities would change even more significantly when land reform was accomplished, because women would receive the same amount of land as their menfolk. "More striking still," noted Townsend in 1953, was the effect of land reform on the hitherto propertyless women. "It was the first taste of freedom, releasing them for work in huge areas where tradition had tied them to housework." When they stood up and vented their grievances during land reform, rural Chinese women truly began the long process of breaking free of traditional bonds, of moving toward an equal political and economic footing with men. They were the forerunner of a character such as Li Shuangshuang, who, as we will see in the next chapter, asserts herself as the outspoken, public-minded new woman in the subsequent era of people's communes.

While the bestirring trial scene in *The Hurricane* adds much depth to our viewing of *The Bloodstained Shirt*, there is a rich tradition of visual images that Wang Shikuo's work directly engages as well. The most prominent art form in visual representations of land reform was, from the early 1940s to the early 1950s, the black-and-white woodcut. One main reason for this situation was that many woodcut artists actively participated in the Communist revolution; another was the fact that neither oil nor ink-and-brush painters had developed the visual idiom, or skill, necessary for coping with the subject matter in a timely fashion. Woodcut artists, however, had already begun depicting the "reduction of rent and interest rate" campaign in the early 1940s, when the Communist government initiated the reform in areas under its control in order to mobilize the rural population in the war of resistance against Japan.

The classical image from this period is the 1943 woodcut *Rent Reduction Meeting* by the prodigiously talented printmaker Gu Yuan (Figure 2.4). The argument between the landlord and villagers presented here concerns rent rates rather than land ownership or grievous injustices. There is no work team overseeing the process, nor the threat of force, as the villagers are armed with no more than an abacus and a ledger. Yet the artist shows a keen eye for theatricality and captures a moment full of dramatic under-pinnings. The well-robed landlord points his finger to heaven to plead his case, while the villagers, as will become a defining feature of this genre of images depicting dramatic confrontation, represent a range of different ages and temperaments. There is a woman with her child in the scene, but at this point they are not yet at the forefront of the action. (The instrument for measuring grain in the foreground will reappear in *The Bloodstained Shirt*.) That the heated discussion takes place inside the landlord's house suggests the conflict is still containable, even though there is a clear defiance in finger-pointing and in the peasant resting his foot on a bench.

2.4 Gu Yuan, *Rent Reduction Meeting*, 1943, woodcut print.

Similar to Wang Shikuo's print *Reforming a Village Bum* from the same year, Gu Yuan also primarily used plain descriptive lines to render the characters, and the scene is presented as if capturing a theatrical production.

The Rent Reduction Meeting is a significant work because it initiated a series of woodblock prints depicting the confrontation between a lone landlord and a surrounding group of peasants. It established a paradigm for visually representing and narrating such a historic event. Jiang Feng's 1944 woodblock print *Settling Accounts*, for instance, is an elaboration on Gu Yuan's work, with many of its details retained, but the conflict, now under the guidance of a work team, is moved outside the house and heats up considerably (Figure 2.5).[21] The number of villagers depicted is much greater, and the setting, in which natural scenery is pitted against a manmade structure, will be repeated in several more works to come, including Wang Shikuo's much later and larger canvas.

A woodcut by Zhang Huaijiang (1922–89) in 1950 brings us ever closer to *The Bloodstained Shirt*. By then, land reform in liberated areas, about which Ding Ling and Zhou Libo had written the two canonical novels, had come to an end, and with the promulgation of the Land Reform Law, the movement was to reach the rest of the country. In terms of emotion and the implied narrative, *Struggle against the Village Bully* reflects the much more militant "speaking bitterness" meetings in the liberated areas (Figure 2.6). There are armed militiamen, and the accused landlord no

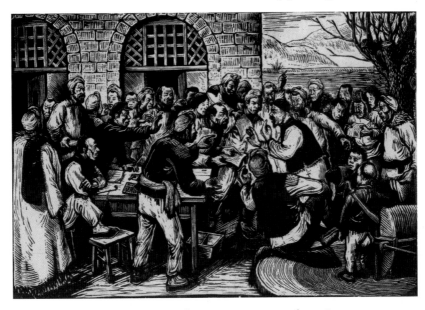

2.5 Jiang Feng, *Settling Accounts*, 1944, woodcut print.

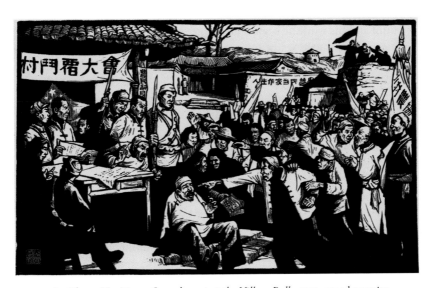

2.6 Zhang Huaijiang, *Struggle against the Village Bully*, 1950, woodcut print.

longer stands up. The action still takes place in a courtyard, with a
makeshift tribunal set up to the left on a raised terrace, from where the
work team exercises supervision and control. Above all, village women,
although not yet at the forefront, now claim a more prominent role than
in either Gu Yuan or Jiang Feng. Both conceptually and in terms of

composition, this work directly prepared the comprehensive scene that Wang Shikuo would undertake to construct a few years later.

A TOTALITY OF RELATIONS EXHIBITED

In conceiving of his own take on representing the land reform movement, Wang Shikuo may or may not have seen Zhang Huaijiang's 1950 print, but he would have been aware of the earlier images by Gu Yuan, Jiang Feng, and several other important printmakers. Wang, Gu Yuan and Jiang Feng were colleagues in Yan'an and Jiang served as one of his two referees when Wang joined the CCP in 1942. Wang may or may not have read either of the two canonical novels about land reform, but he researched in related records and drew on his own experience as a work team member. The key visual motif that set in motion his creative process, for instance, he came across in a pictorial narrative about land reform.[22]

There is no question that *The Bloodstained Shirt* self-consciously belongs to the tradition of visually narrating the process of redistributing land among Chinese peasants as a justified and radical revolution. Yet Wang Shikuo's image also records a significant development; its differences from previous woodblock prints, including the one by Zhang Huaijiang that it resembles closely, are notable on many levels. His use of a different medium and his working on a much larger canvas were both consequential decisions. His theoretically informed reflections on the creative process and intended effect, as we will see, were extensive and articulate. The relationship between his project and existing depictions of the land reform movement, whether visual or literary, is one of adaptation, through which the artist sought to refine and clarify an existing paradigm, bring it closer to current expectations, and endow it with farther-reaching historical resonances.

Adaptations, as we mentioned in the previous chapter, allow for negotiations between fresh content and inherited form, between specific contexts and general principles. In addition they open up a space for experimentation where the foreign and the native, the modern and the traditional may be synthesized or cross-pollinated. Many cultural products in the era of high socialism resulted from adaptations across media and genres because the approach best supported the idea of building a socialist culture that was at once new and familiar, national and cosmopolitan. As Wang Shikuo began working on *The Bloodstained Shirt*, for instance, Zhou Libo's 1948 novel *The Hurricane* had been adapted into a pictorial narrative for young and even illiterate readers (1954), translated into English with illustrations by Gu Yuan (1955), produced in the theater with the advice of a Soviet expert (1956), and republished with much more elaborate illustrations by another woodcut artist (1959). Moreover, a major cinematic adaptation was on its way (1961, dir. Xie Tieli).[23] In due course, *The Bloodstained Shirt* itself would be adapted in other media and used as a

model. Along with many other related materials, it provided a motivating template for conducting public meetings, in particular those "struggle sessions" against denounced officials or authority figures, during the Cultural Revolution. As I will suggest in Chapter 4, much of the youthful violence in the early phase of the Cultural Revolution drew its justification as well as its model from the revolutionary history of the CCP.

From Wang's deliberations on how to represent visually a revolutionary situation, we gain a better understanding of the complex issues involved, both in the depicted scene and in its political and ethical implications. They show that what the artist engaged in is a profoundly conceptual form of art. The different drafts that Wang Shikuo went through before arriving at the final version therefore constitute a rich study of the visual logic and representational strategies that underlay this subgenre of images about land reform. Most important, however, is the fact that Wang Shikuo conceived of and developed *The Bloodstained Shirt* after land reform had been completed in all regions of the country (with the exception of Tibet) and the era of socialist construction had begun. The artist's task was therefore to create a comprehensive history painting rather than to render a documentary sketch. In revisiting a crucial scene from land reform, he would have to establish a more encompassing narrative and search for a more systematic, more monumental visual form and language for it.

A preliminary sketch that Wang Shikuo did in 1954 began a five-year-long process of developing *The Bloodstained Shirt*, through a dozen drafts and scores of character studies, into the paradigmatic work that it would become (Figure 2.7). It was a prolonged process because, in trying to represent land reform after the fact and on an epic scale, the artist needed to address several related issues, all of which had an implication for his decisions on matters of form. A defining feature of visual arts, as Wang Shikuo was keenly aware, is that "abstract ideas must be expressed through concrete visual images."[24] Indeed, working on his masterpiece was for Wang a continual process of elaborating his conceptual framework while seeking to express it in the most effective visual form. From this constant movement between concept and image, there emerged a history painting fraught with rich symbolism and layers of temporality, but with its narrative possibilities clearly delineated to ensure an unambiguous reading. Moreover, the process led the artist to produce a series of portraitures that provides us with an extensive iconography of Chinese peasants as never seen before. It is a process that extended the vocabulary of socialist visual culture while foregrounding its grammatical structure.

In Wang Shikuo's own analytical account, a conceptual question lay at the outset of his creative process. How was he, as a visual artist, to represent a complex historical event such as land reform? It was a conceptual question because, he realized, a visual representation would necessarily be a form of abstraction as well as generalization. The term he used to describe this

2.7 Wang Shikuo, draft composition for *The Bloodstained Shirt*, undated, charcoal on paper.

intellectual operation is "*gaikuo*," meaning to induce and summarize general characteristics from particular phenomena or experiences. As he began considering various possibilities, the artist "felt the challenge of summarizing, through one visual image, such a complicated massive revolutionary movement that had a tremendous historical impact."[25] The process of "*gaikuo*" entailed sorting through the many dimensions of the movement and grasping its most significant aspect or import. It also meant that the artist had to clarify his own position with regard to what he was considering and what was to be shown and depicted. With his support of the land reform program and his sympathy for the peasants, Wang Shikuo was not exactly hampered by emotional ambivalence, moral ambiguity, or skepticism over revolutionary violence. Rather, his initial anxiety was over how to represent such a large-scale social revolution in its totality – totality in terms not only of all the participants involved, but also of the revolution as a radical and unprecedented transformative process. It was an anxiety over how to view the event from a comprehensive and historical, instead of a personal and partial, perspective.

The imperative for an artist to see the whole picture in order to make a meaningful intervention in social life was central to the realist discourse that undergirded the project of socialist literature and art during this period. Only through such a commanding view, which allows the artist to recognize and sort out different dimensions of reality as constitutive of an interconnected and interactive whole, would he be able to grasp its deeper meaning and appreciate its historical relevance. Only then, as Wang

Shikuo put it while commenting on works by young artists, would an artist be confident and clear-sighted enough to know what to depict, which details to focus on, and how to make decisions about composition.[26] Realism in this understanding described an epistemological project more than an aesthetic style or visual technique, although its advocates would often embrace representational art, believing that it at once facilitates the cognitive process and enables the artist to present his insight in accessible and public-oriented terms. One direct source of this realist discourse was the theory of socialist realism, which in the mid 1950s was embraced as the guiding principle of cultural production in socialist New China. Formulated in the Soviet Union in the 1930s, socialist realism demanded from an artist first of all "a historically concrete presentation of reality in its revolutionary development."[27]

A related and more elaborate theoretical source that influenced Wang Shikuo and his contemporaries was Georg Lukács's theory of realism, especially what the Hungarian Marxist literary critic formulated in his influential 1938 essay "Realism in the Balance." The task of a realist writer or artist, asserts Lukács, is to "depict the vital, but not immediately obvious forces at work in objective reality," which involves piercing the surface of partial, subjective experiences and uncovering "a totality of social rela-tions." A successful realist writer or artist discovers such a totality through abstraction (which would be what Wang Shikuo called "*gaikuo*"), but then presents his discovery artistically, as a mediated immediacy, rather than abstractly. This dialectical process therefore contains, as Lukács puts it, both an intellectual and an artistic dimension and is not possible without arduous and creative work. Because of its penetrating vision, a great realist work does more than mirror reality like an indexical photograph; it "captures tendencies of development that only exist incipiently and so have not yet had the opportunity to unfold their entire human and social potential."[28] For this reason, Lukács regards realist writers committed to discerning and giving shape to future tendencies as forming a genuine avant-garde on the cultural front.

Evidently, Wang Shikuo took to heart the realist method that was forcefully laid out by Lukács and subsequently advanced in mainstream discourse on literature and art in socialist China during the 1950s. The creative process that he described with regard to *The Bloodstained Shirt* reflects his conscientious effort to put into practice this method, and he made it clear that the process consists of conceptual as well as artistic development. His initial anxiety stemmed from a desire to grasp a complex totality realistically, but this anxiety of scale was assuaged by a conceptual abstraction, or a summary "*gaikuo*," of what land reform was all about. The subject of what he was to represent, Wang reasoned, should be the direction of historical movement when Chinese peasants, under the leadership of the CCP, came to express themselves during land reform and

confronted the landlord class as the cause of their suffering and poverty. This thesis statement identified the main parties in the revolutionary situation and their relationship to each other. It also reiterated the artist's belief in land reform as a historical necessity.

If realism is dependent, as Fredric Jameson concludes in presenting Lukács's theorizations, on "the possibility of access to the forces of change in a given moment of history,"[29] its appeal to any participant in drastic and systematic social transformation, by the same token, resides in "the totality of social relations" that a realist work of art strives to map and reveal. Yet the Lukácsian conception of totality, Jameson also reminds us, must be read "not as some positive vision of the end of history . . . but as something quite different, namely a methodological standard."[30] Indeed, for Wang Shikuo, realism was not merely a way of seeing the world, but also a way of making his art relevant to the world. It was a teachable method for creating meaningful artwork.

The most germane moment through which to dramatize his central thesis, Wang Shikuo realized, would be the public "speaking bitterness" meeting, where peasants acquire a voice while publicly denouncing a landlord (Figure 2.8). It is a moment that would "better present a comprehensive view of the movement, and demonstrate the legitimacy as well as necessity of the struggle."[31] It is, in other words, a moment with great narrative possibilities, perfect for a history painting that seeks to explain a process *in medias res*. Yet conceptual clarity did not translate automatically into a coherent or competent visual presentation. The artist could visualize some individual characters and details, but several drafts ended in failure because, as he put it in hindsight, he had not yet found "the key that could

2.8 Wang Shikuo, draft composition for *The Bloodstained Shirt*, 1954,
charcoal on paper.

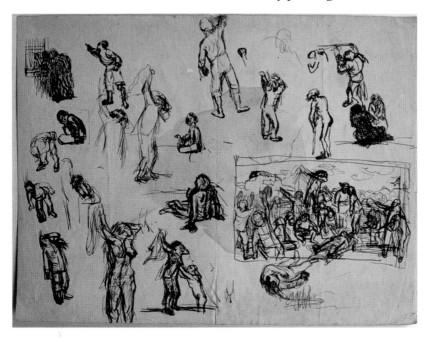

2.9 Wang Shikuo, draft composition for *The Bloodstained Shirt, ca.* 1954, pen on paper.

unlock, for the sake of a visual image, the door to the central theme." That key would come to him by accident. In a story about a bloodstained shirt that he read in a picture book on land reform, he instantly recognized a felicitous visual device that would make the entire picture cohere. And he realized he was looking at the title for his still-to-be-created masterpiece as well (Figure 2.9).

The image of the bloodstained shirt had the power to activate the artist's imagination because it exemplified the artistically achieved "new immediacy" that Lukács viewed as indispensable in the creation of great realist art. It is a tangible conceptual object, an abstraction in sensory form (Figure 2.10). Its introduction into the work in progress had consequences on several levels. First of all, it brought forth a subtle shift in the by now familiar pattern in visualizations of the confrontation between peasants and their landlords. There was still to be passion and agitation in the new work, but the bloodied shirt would serve as direct forensic evidence of the landlord's ruthlessness and provide an emotional as well as a moral justification for the public demand for redress. As a mnemonic object, therefore, the bloodstained shirt would prompt narration and help sustain the public theater of "speaking bitterness" with a dramatic plot and temporality. It would function as a key that opens the door to a visual narrative, or, as Wang Shikuo described it, to "a dramatic plot suitable for visual presentation."[32] The shirt would serve as the necessary motif that

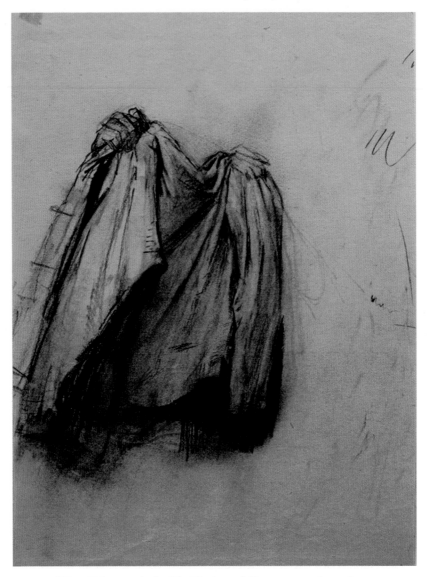

2.10 Wang Shikuo, study for *The Bloodstained Shirt*, *ca.* 1954, charcoal on paper.

motivated and organized the narrative of history painting. As a result, from the artist's earlier, much more expressive preparatory drawings and sketches, a new and dramatic compositional outline emerged (Figure 2.11).

The stylistic shift at this point is striking and instructive to explore. Although Wang Shikuo was always known for his superior drawing skills, the preliminary sketches he did while searching for a visual narrative are clearly suggestive of an Expressionist idiom and sensibility. Some of the

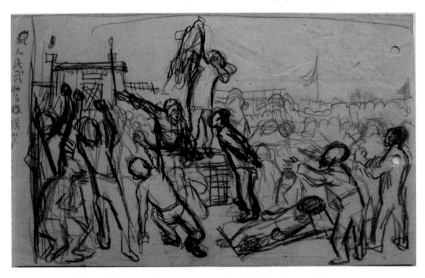

2.11 Wang Shikuo, draft composition for *The Bloodstained Shirt, ca.* 1954, charcoal on paper.

figures are reminiscent, with their raw and tumultuous passion, of the rushing rebellious German peasants that Käthe Kollwitz immortalized in her prints, which, when introduced in the 1930s, had inspired a powerful vision among young Chinese woodcut artists. It is also interesting to note, in this context, that Lukács's essay "Realism in the Balance" was written primarily as a rebuttal of Ernst Bloch's defense of Expressionism. Lukács's charge was that modern literary schools, Expressionism included, "all develop their own artistic style – more or less consciously – as a spontaneous expression of their immediate experience."[33] Whereas Bloch believed the Expressionist movement was more fruitful in visual arts than in literature and that some Expressionist images possess "a lasting importance and greatness,"[34] Lukács regarded the novel as the most powerful art form for a realistic representation of the totality of social relations. We will not be able to do justice to their spirited debate here. Suffice it to observe that for Wang Shikuo, the initial search was for a dramatic plot that would give his depiction of land reform the structure and comprehensiveness of a novelistic narration. Not surprisingly, one of the earliest reviewers of *The Bloodstained Shirt* would describe it as "narrative painting."[35] An accomplished oil painter and Wang's contemporary observed in 1962 that Wang Shikuo's style is closer to drama than to opera, more realist than romantic.[36] Some twenty years later, another critic would compare Wang Shikuo with Kollwitz and express preference for the latter's powerful and mysterious romanticism over the former's rational and closely orchestrated realism.[37]

FOR AN ICONOGRAPHY OF HEROIC PEASANTS

The new composition, centered on a peasant woman holding the blood-stained shirt, allowed Wang Shikuo to see the surrounding characters in the scene as forming an emerging political community shaped by the unfolding event that they witness and participate in. He quickly established four groups of characters that he needed to create in relation to the woman at the center. These four groups represent the different roles that are necessary to make the situation into a complex and fulfilling drama; they also contain positions that both anticipate and orient viewers' responses, emotional as well as intellectual.

As the artist worked through different drafts, the narrative acquired more detail, and his composition more precision. At the center of the scene is the group that awaits its turn to speak and give its testimonials at the public tribunal. The group includes the old blind woman, the old man holding an evidently exploitative lease agreement, and the crippled young man held up by his aging mother. They are the central characters in this unfolding drama and each one has a story to tell of their victimhood. At one point Wang thought of lining up more victims with physical injuries, but then decided that they should not take up too much room and turn the scene into a morbid ogling session for the viewer.[38]

This decision entailed far more than aesthetic considerations. It registered recognition of peasants as emerging speaking subjects and political agents, rather than as passive objects of observation or sympathy. Realism as Wang Shikuo understood it was not to be contented with naturalistic depiction or even humanistic compassion. As Marston Anderson pointed out in an insightful study, a persistent question for avowed practitioners of realist fiction at the formative stage of modern Chinese literature was one with grave moral and social implications: "was their real reason for writing about others a desire to help them or to distance themselves by labeling and defining them?"[39] Such a question, according to Anderson, exposed the limits of realist literature that privileged mimetic verisimilitude in the 1920s and 1930s, and in turn propelled Chinese writers to experiment "tirelessly in an effort to mediate the conflicting demands of realism and political praxis."[40] By the time Wang Shikuo began his depictions of the peasants, realism and political praxis were not regarded as being contradictory. On the contrary, they were embraced as the necessary commitments of great art. Aligning himself with the peasants and adopting their view, the artist saw them as heroes and historical subjects defined in terms of their opposition to the landlord class.

As a result, directly opposite the first group of motivated speakers is the lone landlord. From his own experience, Wang Shikuo knew that in the later stage of land reform, landlords usually would not appear in front of the villagers but be tried *in absentia*. If he were to be faithful to this historical

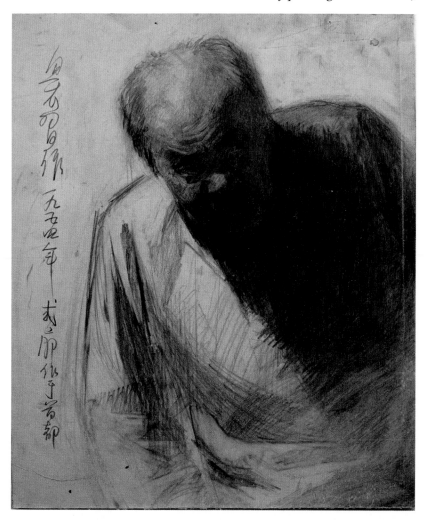

2.12 Wang Shikuo, study for *The BloodStained Shirt*, 1954, charcoal on paper.

fact, Wang felt that his composition would lose a focal point and the villagers' outrage would lack a visible target. It would also result in a less than convincing visual representation of class as a relational concept. He therefore evoked poetic license in placing the landlord in the picture, believing that the detail would not distort the fundamental truth of, or CCP policies about, land reform. He also wanted it to be evident from the landlord's eyes and tightly held fist that the erstwhile powerful may be subdued at the present moment, but is far from accepting defeat (Figure 2.12).[41]

The next structurally indispensable group is the team of leaders. They are not at the center of the painting or even in sharp focus, but they

oversee the course of action from the raised terrace. A white cloth hanging over the makeshift tribunal highlights, both visually and functionally, their authoritative presence, even though they are located toward the background, and the young man busily taking notes accords the proceedings further judicial solemnity. The uniformed man sitting to the left of the note-taker is apparently the head of the Communist work team, whereas the peasant standing in the middle is the local leader, probably the chair of the recently formed Peasant Association. As the balanced center of political power at the scene, they complement each other through their posture and appearance, which in turn tell of their different backgrounds and experiences. The work team leader and the peasant chairman are readily recognizable because they are, as we will discuss shortly, composed as typical characters. They each embody the most representative features that the artist observed of their respective roles and identities, and as successful composites, they would gain currency in the system of signs and images that socialist New China constructed in its various cultural products. They were visual prototypes, in other words, to be adapted in many other settings and renditions.

Standing behind the political leaders are villagers gathered to witness the proceedings. This particular assembly on the far left, rendered less distinct because of the increasing distance, serves at least two functions. First, its presence signifies popular backing for the new political power; second, its varied reaction to the scene unfolding in the foreground corresponds to that of the villagers on the other side of the canvas. Common villagers as eyewitnesses and moral judges thus constitute the fourth and largest group in the picture. It is a diverse group with many individual and yet typical characters as its members, whose relationship to the story of the unfurled shirt is the closest to our own (i.e. the presumed viewers') relationship to it. That this group is spread out and forms an encircling wall of rapt observers suggests that viewers in front of the picture are structurally included as part of its extension. As stand-ins for potential viewers, the villagers mirror what our reaction to the scene may or should be.

As the fourth group in effect illustrates the concept of the people, its members must represent all possible differences in age, gender, and attitude. (There is even a baby held by its mother.) The most prominent trio of this group, as a visual counterpart to the leaders to the left, is placed to the right and behind the mother who bends over to support her son, and whose black jacket emphasizes the three characters in sharp profile. The young woman is shocked by what she just heard and cannot take her eyes off the shirt, whereas the two men turn to look at the landlord, their different ages and temperaments in sharp contrast. The younger man is one of the key characters that Wang Shikuo spent much time working on. Through him the artist wanted to project "the image of an activist who is intelligent and motivated, and who shows steadfast courage and confidence

in struggles with the enemy."[42] To convey the young activist's moral rectitude and dignity, the artist experimented with different postures and decided to accent the character's muscular physique and strength as an outward expression of his inner fortitude.

Indeed, each character in the picture, regardless of their role or placement, is a careful study. Once the new composition took shape, it became clear to Wang Shikuo that this "totality of social relations" was still largely an abstraction. To make it more concrete and visually accessible, he needed to consider whom to include, what each character is like, and how they relate to each other. He was aware that characters in a painting cannot speak or act, like those in a drama or a novel. They are shown in a static moment instead. "Yet in our art we need to make the viewer, from seeing the visual rendition of each and every character in the picture and the relationship among them, feel that everything is in motion. From a static image, the viewer should be able to understand the causal relations of events."[43] In other words, Wang Shikuo regarded the key to successful history painting as placing credible, highly representative characters in a dramatic situation, in which their past is revealed and their future becomes imaginable or even ineluctable.

Without referring to or rehearsing Lessing's influential formulation of the fundamental differences between painting and poetry as those between spatial and temporal or visual and narrative arts, Wang elegantly stated the more dialectical understanding that the eighteenth-century German philosopher and art critic presented after laying out those facile distinctions as first principles. "All bodies," including objects with visible properties, observed Lessing in his famous essay on the Greek sculpture *Laocoön*, "exist not only in space, but also in time." "Painting, in its coexistent composition, can use but a single moment of an action, and must therefore choose the most pregnant one, the one most suggestive of what has gone before and what is to follow." By contrast, "poetry, in its progressive imitations, can use but a single attribute of bodies, and must choose that one which gives the most vivid picture of the body as exercised in this particular action."[44] The history painting that Wang Shikuo aimed to achieve is nothing less than a synthesis of these two requirements derived from classical art. The most pregnant moment of action must be highlighted by "a single descriptive epithet" that gives the most vivid picture of the body, in the sense that each body or object is represented by means of a defining and typical feature.[45]

A great deal of creative energy was therefore focused on developing individual characters, especially those playing a significant role. This was the stage where, directly reminiscent of the process of creating his 1943 print *Reforming a Village Bum*, Wang Shikuo would construct a life story for each character and work toward a visual image that best translates that story. It was still a process of first deriving a conceptual abstraction or

"*gaikuo*" from life experiences and observations, but Wang put even greater emphasis on the importance of identifying with the peasant characters and of assuming their viewpoint and subject position. The imperative to see through the eyes of those the artist identified with and wished to represent was justified in contemporary theoretical parlance as the critical need for cultural workers to understand reality and "go deep into life." It was predicated on the belief that revolutionary art and literature would be possible only when the artist underwent a self-transformation and fused his feelings with the public that he desired to address. The directive "go deep into life" therefore entailed a conceptual decentering of the artist as an inexplicable individual genius; it also bespoke a commitment to extending the new socialist representational order to include the hitherto marginalized or disenfranchised. For Wang Shikuo, to observe and participate in life ultimately meant to study and understand human subjects, to go beyond various stereotypes and preconceptions. It was an "indispensable labor in the creative process" that would, as he saw it, "enrich our emotions" and enable us "to find the newest and aesthetically most satisfying form of expression."[46]

As an "ideal character" needed for the composition became identifiable, he remarked, it would already be a mixture of concept and emotion, and the next step, which was to achieve a visual rendition of a still largely conceptual image, would rely on many sources, searches, combinations, and revisions. This was also where Wang Shikuo found the notion of a typical character enabling rather than restricting. For Wang, a typical character should be the opposite of a flat, abstract, and lifeless stereotype. "If a painting contains a good idea and plot, but lacks typical characters created for it," he remarked, "it is bound to end in rigid formulism and conceptualism. Such a work will fail to leave a deep impression on the viewer."[47] A typical character should be a memorable composite because it is at once recognizable and unique, and because it will contribute to the developing dramatic conflict in a logical and yet unforeseen manner.[48] The old blind woman, for instance, was based on many peasant women that the artist had met and observed during land reform and on other occasions (Figure 2.13). Her role in the story is representative of that of a rural woman who, having endured pain and hardship in the past, now stands up courageously to seek revenge against her class enemy. By depicting her appearance, expression, and gesture, the artist wished to "reveal the inner world of such a mother, portray her past, and explain her changes in the present and her ideals."[49] She is not merely a visual spectacle but also a full-fledged character with an individuality defined by her life experience.

Wang Shikuo's tremendous effort to populate a large canvas with credible and yet typical characters produced, beyond what appears in the published work, an extraordinary collection of close studies of villagers, most of them in the form of pencil or charcoal drawings, some as sketches

2.13 Wang Shikuo, study for *The Bloodstained Shirt*, 1955, charcoal on paper.

in oil or even as ink-and-brush paintings. His goal of ultimately creating an oversize oil painting meant most of the studies were done in considerable detail. Supported by his conceptual framework and artistic pursuit, these studies form a gallery of heroic portraits of contemporary peasants, giving them a sympathetic visual representation on a scale rarely seen before. Adopting the viewpoint of the mobilized peasants, the artist sought to show them as human subjects who, in articulating a new political identity, become expressive, dignified, and distinct individuals. He effectively refined, from his numerous studies, a visual idiom and style for representing Chinese peasants as new social and political agents. As a result, he

has been described as a "peasant painter" and is often compared to Jean-François Millet, both of whom, in the words of contemporary oil painter Zhu Naizheng (1935–2013), are great artists who expressed a profound compassion in their work and devoted their art to the common people in the most sincere way possible.[50]

In early 1957, even before it was finished, Wang's character studies for the yet-to-be-completed oil painting were publicized in the prestigious *Fine Arts* magazine, along with an essay celebrating the coming forth of "a magnificent monumental work that encapsulates life in an epoch."[51] That Wang Shikuo was making a unique contribution to the development of a new iconography of Chinese peasants was readily recognized and endorsed by reviewers. After *The Bloodstained Shirt* was finished as a drawing and published widely in 1959 to commemorate the tenth anniversary of the People's Republic, a commentator hailed it as an unprecedented achievement in revolutionary history painting. "In the new artwork of our nation, this is the first time that so many impressive and moving images of awakened peasants were created. These are typical peasants in the triumphant stage of the new democratic revolution. These are typical peasants because they are real, historically self-conscious, and imbued with the spirit of the Chinese nation."[52]

The real subject matter of *The Bloodstained Shirt*, indeed, is the acquisition of political subjecthood by Chinese peasants through the historic land reform. It is also about recognizing the rural population as a major social and political force that has arrived and will play a pivotal role in the course of the revolution. This is where Wang Shikuo significantly extended an existing genre on land reform, especially the pictorial convention. Compared to previous visual representations, such as those by Gu Yuan and Zhang Huaijiang, which would function as either advocacy for or documentation of an ongoing movement, *The Bloodstained Shirt* contains a much more complex narrative through which the artist strives to visualize the formation of a new collective identity. About this central theme of his work, Wang Shikuo was very clear. "While working on the peasant images, I did not forget the main characteristics of the working people in China, their diligence, intelligence, courage, and profound honesty."[53] He intended the different peasant characters in his work to display ideas and emotions that would identify them as belonging to a new historical era. This new historical era, then described as "the age of new democratic revolution," was understood as a transitional period leading to socialism. Composed after land reform and during the first Five-Year Plan of socialist construction, *The Bloodstained Shirt* is therefore as much about representing land reform as it is about envisioning Chinese peasants as dedicated and productive socialist subjects.

Upon its completion, Wang Shikuo's large-scale drawing was widely published in journals and newspapers as exemplary work. Circulating as

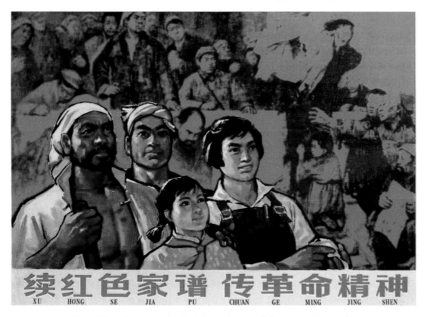

2.14 Feng Zhi, *Continue the Red Genealogy and Carry on the Revolutionary Spirit*, 1963, poster.

a pictorial insert or leaflet, this grand history painting contributed significantly to the new visual grammar and order of representation. By 1963, as Mao's theorization of "class struggle" as a fundamental feature of the socialist cause propelled a massive and militant "socialist education" campaign across the nation, the historical narrative embedded in *The Bloodstained Shirt* gained a new urgency. The carefully constructed scene was readily viewed as a visual schema and illustration of a revolutionary heritage and identity. A mass-produced, stridently red political poster from 1963, for instance, reproduced a large portion of the monochromatic drawing as at once veritable referent, memory, and legacy that defined the present (Figure 2.14).[54] The quoted original signified much more than an imaginative work of art; it stood for how the historical origin of the current moment ought to be recognized and claimed.

In such circumstances, it was extraordinary that a critic should have raised issues on formal grounds, arguing that compositionally Wang Shikuo's work was ineffective because it staged competing shows between key characters, such as the blind woman and the shirt-holder. Too many virtuoso actors on stage, he complained, made it hard for a viewer to concentrate or follow the action.[55] This criticism, published in the journal *Fine Arts* in 1963, was quickly rejected by established critics and ordinary readers alike. Ensuing responses included further appreciation of the artist's achievements and expert discussions of the constraints as well as

potentials of narrative painting. There was also serious questioning of the dissenter's motives and political incorrectness.[56] Even more revealing, from our perspective today, were the many readers' letters that editors of *Fine Arts* made available in the journal's "Public Forum," most of them endorsing Wang Shikuo for his realism and historical insight. Two readers specifically recounted their experience of witnessing villagers identify with characters in *The Bloodstained Shirt* and seeing themselves as part of a historical drama that was now vividly rendered in the drawing.[57] Opinions expressed in those public forums may sound dated now, but the fact that readers from all walks of life were mobilized to defend the merits and relevance of a history painting was testimony to the underpinnings of socialist visual culture.

A CODA ON VISUAL REVISIONS

What Wang Shikuo helped establish and codify through *The Bloodstained Shirt* and its related images, therefore, is a new visual idiom and grammar for representing peasants in socialist New China. We may better appreciate this achievement if we view Wang's masterpiece next to a set of images created by the veteran printmaker Li Hua in the 1940s on the eve of the Communist victory. Titled *Angry Tide*, this series of black-and-white woodcuts shows unmistakable indebtedness to Käthe Kollwitz's impassioned depiction of German peasants in revolt (Figure 2.15). The fantastic

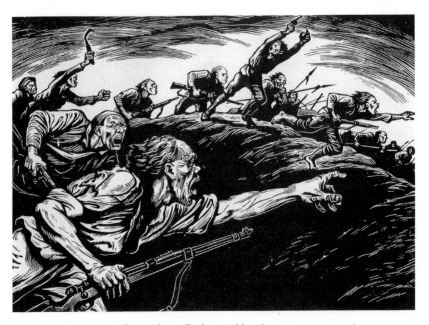

2.15 Li Hua, *Rise, Slaves Who Suffer from Cold and Hunger*, 1947, woodcut print.

scene of armed peasants bellowing and sweeping over a barren hill expresses the artist's ardent desire for and support of a revolutionary uprising against oppression. From medium to composition, every aspect of Li Hua's dynamic woodcut stands in contrast to Wang Shikuo's layered history painting. Yet the most noticeable difference between these two works, in view of our current discussion, is how the peasant subjects are depicted. This difference should also make it clear that it is far more productive to investigate, as we have done so here with regard to *The Bloodstained Shirt*, how the artist saw and what determined his vision, than to try to determine whether he was truthful in representing, for instance, land reform.

Their marked differences aside, we may nonetheless see Wang Shikuo and Li Hua as of the same generation of artists who recognized the fundamental role that Chinese peasants were to play in the revolution, political as well as social. They were both socialist artists in that they devoted their talent to the cause of socialism. That their passion and commitment have lost their appeal in the twenty-first century is well illustrated in a parody such as Cao Yong's 2007 oil painting (Figure 2.16). More than an irreverent retake on a classic, a practice that is widespread in contemporary art and popular culture, Cao Yong's canvas points to the altered status of peasants in Chinese society or social imaginary today. Furthermore, it directs our attention to the changed role and self-positioning of a contemporary artist, who seems to relish the part of a

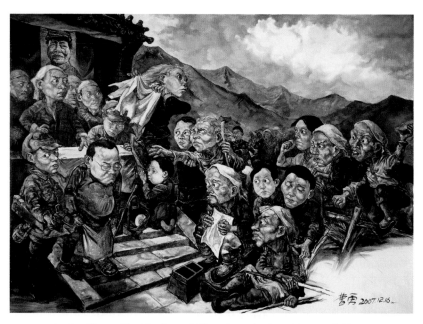

2.16 Cao Yong, *The Bloodstained Shirt, Revised Edition*, 2007, oil on canvas.

disengaged, if also cynical, commentator, bystander, or joker. This contemporary comic revision of *The Bloodstained Shirt* was part of a massive exhibition held in 2010 at several venues, including the National Convention Center by the Olympic Park, in Beijing. Titled *Reshaping History*, the exhibition made it abundantly clear that Chinese contemporary art operates on principles markedly different from those underlying socialist art and visual culture. (Coincidentally, in 2005, an independent documentary consisting of personal accounts by surviving participants was released to relate and expose the cruelty and Machiavellianism of the land reform movement. Its title is *The Hurricane* [dir. Duan Jinchuan and Jiang Yue], in direct reference to and rebuttal of Zhou Libo's 1948 novel as well as the 1961 film based on it.)

An earlier and more meaningful engagement with *The Bloodstained Shirt* as a visual paradigm in fact took place in the late 1970s amid a general discontent with and rejection of the excesses of the Cultural Revolution. As a prominent example of the "Scar Art" that joined a rising cultural movement to expose the pain caused by the "ten-year disorder" and to call for a new departure, *Snow on an Unspecific Day in 1968* (1979) by Cheng Conglin (1954–) depicts the bloody aftermath of an armed conflict between rival Red Guard factions at the height of the Cultural Revolution (Figure 2.17). The trampled snow, as well as the torn and dirtied white shirt of the confused young woman in the center, serves as the visual symbol of innocence lost or abused. It is a history painting executed in the convention of representational realism, and its composition, rhetoric, and theatricality closely echo those in Wang Shikuo, even though the color scheme is now a colder one and the characters appear more numerous and more disorderly. Removed from the 1979 painting is the key element of an evil landlord, whose absence indicates that no clear cause or explanation for the messy situation is available or can be readily externalized. A crucial difference between these two scenes of public venting of bitterness, separated by twenty years of tumultuous history, therefore lies in the lack of emotional directionality in the later version, which in the given context also meant a deep skepticism toward the rationality of human action. Yet the passionate appeal and persuasiveness of *Snow on an Unspecific Day in 1968* in the wake of the Cultural Revolution stemmed in large part from its graphic realism, its dramatization of the truth of a historical experience. Realism was similarly called upon to legitimate a new sense and order of reality.

That no parodies in the vein of Cao Yong's "revised edition" of *The Bloodstained Shirt* have surfaced in contemporary Chinese art to transfigure and poke fun at *Snow on an Unspecific Day in 1968* is no accident or oversight. It is an absence that loudly affirms the historical narrative of the 1979 painting as not having become problematic or disavowed in the same way, at least as far as artistic discourse and production are concerned.

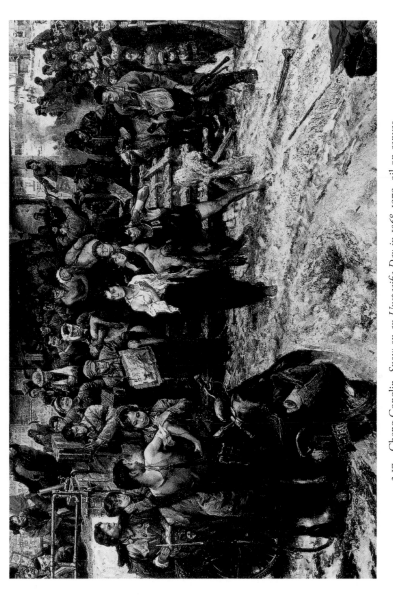

2.17 Cheng Conglin, *Snow on an Unspecific Day in 1968*, 1979, oil on canvas.

Scar Art and its realistic truth claim, in the mainstream account of the history of art in contemporary China, remains a turning point that laid the foundation of subsequent developments. It sent forth, as art historian Lü Peng describes it, "the signal that Chinese art was searching for its own truth after the Cultural Revolution and was breaking free of all dogmas that had been imposed on it."[58] Scar Art, however, was not so much a turning away from realism as a style or strategy as it was a repositioning of the artist in relation to his or her art and to what was represented. The most significant departure of *Snow on an Unspecific Day in 1968* and many other works in Scar Art therefore is their sympathy with the experience of the young artists' own generation or social group. (Cheng Conglin painted his teenage self as an eyewitness on the far right of the canvas.) Whereas Wang Shikuo strove to represent Chinese peasants as scarred but resilient historical agents to identify with, the Scar artists of the late 1970s validated their autobiographies and self-portraits as pathos-filled historical reflection. A personalized approach to history and self-expression has since instituted itself as a central ethos of contemporary art in China. For an artist in the twenty-first century to offer a bemusing retake on *Snow on an Unspecific Day in 1968*, therefore, more than artistic ingenuity is needed. He or she will need to embrace a radically different vision.

As we will see in the following chapters, developments in contemporary art have given rise to a new anxiety over the status of both art and artist, and have necessitated a reconsideration of socialist visual culture, which as a public legacy acquires a critical poignancy in contemporary China. We will have an opportunity to consider why the much-celebrated "Chinese contemporary art" is a loaded term and does not coincide with "contemporary Chinese art," which is a broader and more pertinent concept. Only with the rise of contemporary art, I argue, does it become both possible and necessary for us to grasp the full extent and depth of contemporary Chinese art. A good case in point is that the rich symbolism and resonances of Wang Shikuo's masterpiece are underscored, rather than diminished, in its contemporary parody. We may find Cao Yong's derivative image more entertaining and less strident, but it also serves to make visible a lost or disavowed way of seeing and of making art that was motivated by a desire actively to fuse art and life, self and other.

Finally, the fact that the original *Bloodstained Shirt* is prominently exhibited in the National Museum of China may prompt many reactions in contemporary viewers, from confusion to a sense of irony, even bitterness, since the socialist mode of cultural production, of which the artwork is a good illustration, has been steadily dismantled in contemporary China, and the achievements of land reform have long been reformed and rescinded. Seeing the work on display in the NMC makes us wonder how we may relate it to the post-revolutionary present.[59] This is a question I explore further in the next chapter, in which we will examine a series of

cinematic works and revisions that take us from the early 1960s to the 1990s. We will discuss how to appreciate the persistence and mutations of a paradigm, be it visual or narrative, and how best to make sense of evident shifts and discontinuities.

Our study of *The Bloodstained Shirt* in the present chapter, however, makes clear that the history of a history painting is just as intriguing a subject for investigation. The making of a visual representation of a past event is itself a complex event, informed and determined by many factors, often at a self-conscious removal from those shaping the depicted scene. Our investigation, furthermore, can hardly proceed independently of current perspectives and considerations. Viewed in such overlapping historical contexts, Wang Shikuo's renowned work reveals a systematic logic and practice in the creation of a socialist visual culture. More poignant, in trying to present a commanding view of history as momentous becoming, *The Bloodstained Shirt* registers imaginings of a conceivable future. It is a past future that did not turn into the present that we inhabit, but our present may be impoverished if we refuse to recognize it as part of an unforgettable past.

NOTES

1 Pan Gongkai, "Shidai zhi zi" (Son of the Times), in Xu Bing, Wang Huangsheng, and Yin Shuangxi, eds., *Cong Yan'an dao Beijing: ershi shiji Zhongguo meishu jujiang Wang Shikuo (From Yan'an to Beijing: The Great Artist in Twentieth-Century Chinese Art, Wang Shikuo)* (Beijing: Wenhua yishu, 2011), 11.

2 Wang Shikuo, "*Xueyi* chuangzuo guocheng zhong jiechu dao de jige wenti" (Issues Encountered During the Creation of *The Bloodstained Shirt*), *Meishu yanjiu (Fine Arts Research)*, no. 1 (1960), 8–12.

3 For a discussion of his experience in creating *Reforming a Village Bum*, see Wang Shikuo, "Ticai yu zhuti, shenghuo yu yishu xingxiang" (Subject Matter and Themes, Life and Artistic Images), *Meishu (Fine Arts)*, no. 3 (1959), 4–5. For a recent study of this work and its historical background, see Yin Shuangxi, "Gaizao yu chongsu: Wang Shikuo *Gaizao erliuzi* zai yanjiu" (Transformation and Reformation: Further Study of Wang Shikuo's *Reforming a Village Bum*), *Meishu yanjiu*, no. 4 (2011), 30–2, 41–8.

4 Mao Tse-tung, "Report on an Investigation of the Peasant Movement in Hunan, March 1927," in *Selected Works of Mao Tse-tung* (Peking: Foreign Languages Press, 1964), vol. 1, 23–4.

5 "Perceiving the revolution as one that to a large extent was aimed at solving the land problem," observes Lin Chun, "the communists, long before taking national power, began to destroy the rural infrastructure of the old regime." See Lin Chun, *The Transformation of Chinese Socialism*, 43.

6 Peter Townsend, "The Meaning of Land Reform in China," *Monthly Review: An Independent Socialist Magazine*, vol. 5, no. 3 (1953), 127.

7 For instance, Philip Huang sees three broad patterns displayed in the three stages of the actual process of land reform. See Philip C. C. Huang, "Rural Class Struggle in the Chinese Revolution: Representational and Objective

Realities from the Land Reform to the Cultural Revolution," *Modern China*, vol. 21, no. 1 (1995), 105–43.

8 Peter Townsend, "The Meaning of Land Reform in China," 128.

9 Peng Zhengde, "Tugai zhong de suku: nongmin zhengzhi rentong xingcheng de yizhong xinli jizhi" (Venting Grievances During Land Reform: A Psychological Mechanism in Forming Peasant Political Identity), *Zhonggong dangshi yanjiu* (*Research in the History of the Chinese Communist Party*), no. 9 (2009), 112–20. Quotation from p. 115.

10 William Hinton, *Fanshen: A Documentary of Revolution in a Chinese Village* (Berkeley: University of California Press, 1997, first published 1966), vii.

11 As an internal CCP report on the progress of land reform in Hebei in 1947 concluded, "the more bitter the grievances, the more successful the following struggle, and the more likely for the masses to turn their heart over. Otherwise, even if they turn their body over, their heart may not." See Li Lifeng, "Tugai zhong de suku:Yizhong minzhong dongyuan jishu de weiguan fenxi" (Venting Grievances During Land Reform: A Microanalysis of a Technique for Mass Mobilization), *Nanjing daxue xuebao: zhexue, renwen kexue, shehui kexue* (*Journal of Nanjing University: Philosophy, Humanities and Social Sciences*), no. 5 (2007), 97–109. Quoted source on p. 99, n. 6.

12 Hinton, *Fanshen*, 112–14.

13 Chen Yung-fa offers detailed analyses of the process of land reform as well-orchestrated theatrical performances in *Making Revolution: The Communist Movement in Eastern and Central China, 1937–1945* (Berkeley: University of California Press, 1986).

14 Philip Huang's reading in his essay "Rural Class Struggle in the Chinese Revolution" may be a good example of this.

15 One of the fourteen achievements of the peasant movement in Hunan in 1927, according to Mao Zedong, was to overpower the landlord class politically. A device or technique for achieving this political overthrow was "crowning the landlords and parading them through the villages." "This form of punishment more than any other makes the local tyrants and evil gentry tremble. Anyone who has once been crowned with a tall paper-hat loses face altogether and can never again hold up his head." See Mao Zedong, "Report on an Investigation of the Peasant Movement in Hunan, March 1927," 37.

16 Ding Ling, *The Sun Shines Over the Sanggan River*, trans. Yang Hsien-yi and Gladys Yang (Peking: Foreign Languages Press, 1954), 291. Translation slightly modified.

17 Ding Ling, *The Sun Shines Over the Sanggan River*, 294.

18 Chou Li-po (Zhou Libo), *The Hurricane*, trans. Hsu Meng-hsiung (Peking: Foreign Languages Press, 1955), 145–8. Translation modified. Earlier in the novel, there is a moment similar to what William Hinton describes in *Fanshen*. As Old Tian, an "honest but timid old fellow," starts to recount the cruelty of the landlord Han Laoliu in front of a group of villagers, the crowd is enraged and demands justice. "A man came up and slapped Han across the face. Blood gushed from his nose. 'Good! A good blow! Give him another!' shouted somebody else. However, the sight of blood melted the hearts of many, especially women, and silence fell." See Hinton, *Fanshen*, Chapter XII, 103–6.

19 See Li Lifeng, "Venting Grievances During Land Reform," 104.

20 Elizabeth Perry, "Moving the Masses: Emotion Work in the Chinese Revolution," *Mobilization: An International Journal*, vol. 7, no. 2 (2002), 115.

21 In comparing the difference in composition between Jiang Feng and Wang Shikuo, Li Zhaoxia observes that it is visually more effective, as Wang does, to put the landlord on the left and the peasants to the right. See Li Zhaoxia, "Wang Shikuo yu *Xueyi*" (Wang Shikuo and *The Bloodstained Shirt*), *Wenyi zhengming* (*Literary and Art Debates*), no. 4 (2012), 57–9.

22 See Wang Shikuo, "Subject Matter and Themes, Life and Artistic Images," 5.

23 For a pertinent study of the novel, see my essay "Baoli de bianzhengfa: chongdu *Baofeng zhouyu*" (The Dialectics of Violence: Re-reading *The Hurricane*), first published in 1992, reprinted in Xiaobing Tang, ed., *Zai jiedu: dazhong wenyi yu yishi xingtai* (*Re-reading: Literature and Art for the Masses and Ideology*), expanded edn (Peking University Press, 2007), 111–27.

24 Wang Shikuo, "Issues Encountered During the Creation of *The Bloodstained Shirt*," 11.

25 Wang Shikuo, "Issues Encountered During the Creation of *The Bloodstained Shirt*," 8.

26 See Wang Shikuo, "Subject Matter and Themes, Life and Artistic Images," 3.

27 The classical formulation of socialist realism was developed at the First Soviet Writers' Congress held in 1934. For the full statement adopted by the Soviet Writers' Union, see Regine Robin, *Socialist Realism: An Impossible Aesthetic*, trans. Catherine Porter (Stanford University Press, 1992), 11.

28 Georg Lukács, "Realism in the Balance," in Theodor Adorno *et al.*, *Aesthetics and Politics* (London: Verso, 1980), 47–8.

29 Fredric Jameson, *Marxism and Form: Twentieth-Century Dialectical Theories of Literature* (Princeton University Press, 1971), 204.

30 Fredric Jameson, *The Political Unconscious: Narrative as a Socially Symbolic Art* (New York: Cornell University Press, 1981), 52.

31 Wang Shikuo, "Issues Encountered During the Creation of *The Bloodstained Shirt*," 8.

32 See Gao Yan, "Genggao de juqi shehui zhuyi xianshi zhuyi de qizhi" (Raising the Flag of Socialist Realism even Higher), *Meishu*, no. 2 (1957), 9.

33 Georg Lukács, "Realism in the Balance," 37.

34 Ernst Bloch, "Discussing Expressionism," in Adorno *et al.*, *Aesthetics and Politics*, 18.

35 See Gao Yan, "Raising the Flag of Socialist Realism Even Higher," 7–9.

36 See Ai Zhongxin, "Youhua fengcai lun" (On Different Styles of Oil Painting), originally published in *Meishu*, no. 2 (1962), excerpted and reprinted in *Wang Shikuo yishu yanjiu* (*Studies of Wang Shikuo's Art*) (Beijing: Renmin meishu, 1990), 172–3.

37 Liu Xiaochun, "*Xueyi* yu xingxiang siwei de feiyue" (*The Bloodstained Shirt* and the Leap of Imagination), originally published in 1983, reprinted in *Studies of Wang Shikuo's Art*, 121–31.

38 Wang Shikuo, "Issues Encountered During the Creation of *The Bloodstained Shirt*," 9.

39 Marston Anderson, *The Limits of Realism: Chinese Fiction in the Revolutionary Period* (Berkeley: University of California Press, 1990), 26.

40 Anderson, *The Limits of Realism*, 200.

41 Wang Shikuo, "Issues Encountered During the Creation of *The Bloodstained Shirt*," 9, 11.

42 Wang Shikuo, "Issues Encountered During the Creation of *The Bloodstained Shirt*," 10.

43 Wang Shikuo, "Issues Encountered During the Creation of *The Bloodstained Shirt*," 11.

44 Gotthold Ephraim Lessing, *Laocoön: An Essay upon the Limits of Painting and Poetry*, trans. Ellen Frothingham (New York: Noonday Press, 1957), 91–2.

45 For a critique of Lessing's essay on the limits of painting and poetry, see W. J. T. Mitchell, "The Politics of Genre: Space and Time in Lessing's *Laocoön*," *Representations*, no. 6 (1984), 98–115. Mitchell argues that the spatial–temporal distinction in arts is misleading as a generic differentiation and that Lessing was attempting to reinforce a cultural hierarchy of poetry over painting, categorical boundaries over sensory immediacy. "Lessing rationalizes a fear of imaginary that can be found in every major philosopher" (111).

46 See Wang Shikuo, "Subject Matter and Themes, Life and Artistic Images," 5.

47 Wang Shikuo, "Issues Encountered During the Creation of *The Bloodstained Shirt*," 9.

48 In discussing the concept of a "typical character" in Lukács, Jameson observes that the typical is not a "one-to-one correlation between individual characters" and "fixed, stable components of the external world itself." It is "rather an analogy between the entire plot, as a conflict of forces, and the total moment of history itself considered as process" (*Marxism and Form*, 195).

49 Wang Shikuo, "Issues Encountered During the Creation of *The Bloodstained Shirt*," 9.

50 Zhu Naizheng, "Wancheng ziji lishi shiming de zhencheng yishujia" (A Sincere Artist who Accomplished his Historic Mission), reprinted in *Studies of Wang Shikuo's Art*, 102–17.

51 Gao Yan, "Raising the Flag of Socialist Realism Even Higher," 9.

52 Sun Meilan, "Shiping *Xueyi*" (A Critical Essay on *The Bloodstained Shirt*), *Meishu yanjiu*, no. 1 (1960), 13–15. Quote from p. 15.

53 Wang Shikuo, "Issues Encountered During the Creation of *The Bloodstained Shirt*," 10.

54 In an essay on visual images produced during the Socialist Education campaign of 1963–5, Li Gongming refers to a large reproduction of *The Bloodstained Shirt* as a mural in a traditional residential complex in a small town in Guangdong. Li comments that Wang Shikuo's iconic work was very influential at the time, because it was readily accessible. See Li Gongming, "'Shejiao yundong' tuxiang de chuangzuo yu zuoyong" (The Making and Functions of Images for the "Socialist Education Campaign"), online journal *Dongfang zaobao* (dfdaily.com) (Shanghai), December 12, 2012, www.dfdaily.com/html/8759/2012/12/10/907923.

55 Lin Bingwen, "Ping *Xueyi*" (On *The Bloodstained Shirt*), *Meishu*, no. 5 (1963), 36–8. Lin was a middle-school teacher and his piece was published in the "Public Forum" section of the journal, which was usually devoted to readers' responses and commentaries.

56 See, for instance, Chi Ke, "Dui 'Ping *Xueyi*' de yiyi" (My Disagreement with "On *The Bloodstained Shirt*"), *Meishu*, no. 6 (1963), 36–8; Ding Yongfa, "Fenqi cong nali lai" (Where Does the Disagreement Come From?), *Meishu*, no. 6 (1964), 15–18.

57 See Ma Xiao, "Tingting nongmin dui 'Ping *Xueyi*' de fanying" (Listen to the Peasants' Responses to "On *The Bloodstained Shirt*"), *Meishu*, no. 6 (1963), 38–40; "Yingdang yong jieji guandian lai pingjia *Xueyi*: laigao zhaiyao" (We Should Evaluate *The Bloodstained Shirt* from the Perspective of Class: A Summary of Submissions), *Meishu*, no. 2 (1964), 34–7.

58 Lü Peng, *A History of Art in Twentieth-Century China*, 760. He continues: "Artists basically adopted realist techniques but shied away from the stylization it acquired in the Cultural Revolution, moving instead in the direction of addressing real issues and effecting a fundamental change in stance" (760).

59 In May 2013, when I revisited the NMC, many of the works from the *Masterpieces of Modern Chinese Art* exhibition of 2011 were on display in the Central Hall, including the two versions of Dong Xiwen's *The Founding of the People's Republic*, but *The Bloodstained Shirt* was nowhere to be found.

CHAPTER 3

*What do we see in
New China cinema?*

A direct answer to the question above, when we understand and agree to its specific referent, may simply be this: we see New China. A more elaborate response should follow: We see cinematic expressions and projections of the idea of a New China, an idea that, as is discussed in Chapter 1, gained historic momentum and reality with the founding of the PRC in 1949 and galvanized generations of Chinese in the mid-twentieth century. What we see in the mainstream filmmaking tradition since the late 1940s are often cinematic celebrations of the making of New China – her emergence and significance as well as her promises and potentials. New China cinema, in other words, was an integral part of the project of creating a socialist New China, and it strove to illustrate how this emerging sociopolitical entity ought to be seen and imagined. It generated visions of reality and sought to have an impact on what was to become real life, but such visions should not be equated with reality itself, which we grasp as always standing in tension with its representations, cinematic or otherwise. We therefore can hardly expect to ascertain through this cinema what China was really like in the socialist era, any more than we may count on a latter-day revision or remake to reveal to us its true reality. We may also describe New China cinema in terms of what is absent from it. We do not see, for instance, outright martial arts films, dystopian fantasies, horror or erotic thrillers. Rarely do we find, even by the 1980s, crowd-pleasing slapstick comedies or auteur-centered and audience-specific art films.

However, this does not mean New China cinema did not develop its own genres and conventions. On the contrary, by the early 1960s, many film types were fully recognized, either in terms of subject matter (such as war films, history films, films about ethnic minorities or contemporary life), or some other criteria (such as musical films, opera films, adaptations of modern literary classics).[1] One representative genre that attracted increasing attention during this period was rural films, or films about life in the contemporary countryside. (In the parlance of the Chinese film industry, they are categorized as *nongcun pian*.) The generic identity of a "rural film" is principally determined by its subject matter, but distinct features, even formulaic conventions, in its sound track, visual vocabulary, and plot premises often quickly prepare the audience for a rustic experience. Without exception, a rural film is expected to be narrative cinema, driven by plot and character developments.[2]

In this chapter we will examine the evolution of rural films through a series of four films produced over a thirty-year time span. Our focus will be on the representation of women and social change in these films. To some, this topic may sound banal or anything but refreshing, since it would be extremely hard to find a Chinese film from the late 1940s to the 1990s that does not reflect, represent, advocate, cope with, or directly participate in social change. Indeed, the course and content of New China cinema is unmistakably characterized

by its sometimes exhilarating, sometimes tormented relationship with a tumultuous political history and cultural transformation. This dominant tradition of social engagement dates back to a defining formative stage of Chinese cinema during the 1930s, when the silver screen's mobilizational potential was seized upon as a timely solution for a nation in crisis and its entertainment value was resisted as at best frivolous. New China cinema, as a crucial cultural institution of the new socialist nation-state, amplified such an educational function and, in all sincerity, offered carefully composed imagery to visualize current policies and collective aspirations.

If we wish to extract one defining feature of New China cinema, I would argue, it is precisely this deep-rooted seriousness in its self-conception and presentation. Even in the Fifth Generation's more self-conscious pursuit of a new cinematic language, which for many critics signaled the arrival of an artsy (if belated) New Wave or New Chinese cinema in the mid 1980s, lightheartedness is still assiduously avoided. More often than not, the defamiliarized narratives and extraordinary visual images characteristic of Fifth Generation filmmaking are defiantly displayed against the grave backdrop of historical events and obsessions, readily reinforcing, as I will discuss further in Chapter 5, certain distant and exoticizing perceptions of Chinese society.

Chinese rural films may not attract the most attention in current academic research agendas, but in my view they provide an excellent entry point into contemporary Chinese social history and visual culture. To begin with, the four films that I will discuss here, selected from the high point of the socialist stage in New China cinema to post-Fifth Generation filmmaking, present a good opportunity for us to sort out the generic features or conventions of rural films. At the same time, the cross-references and revisions that we observe in these filmic texts demand a comparative viewing. This will help us appreciate an enduring representational strategy, in modern Chinese literature as well as cinema, of gauging the impact of social change through the focal figure of a rural woman. It will also prompt us to assemble a multilayered historical narrative, through which we may be better able to recognize the symbolic and cultural meanings of generic variations over time. Such a diachronic tracking of variations may begin with but will necessarily go beyond a static or morphological description of generic features. For what we will find, by looking into the evolution of these rural films, are indeed different visions of becoming modern that bestirred a predominantly agrarian nation in the second half of the twentieth century.

Moreover, through this comparative viewing we arrive at an understanding of New China cinema as a historical concept. By the turn of the 1990s, as I explain below, with the film industry systematically reaching out not only to various forms of capital investment and methods of production, but also to different genres, effects, and markets, New China cinema as a

key cultural institution of the socialist state came to an end, and the notion of Chinese cinema, like many other fields of cultural production, such as art and literature, acquired a much more complex identity in its effort to participate as well as compete in a new wave of globalization. Yet this transition does not spell the demise of all that New China cinema envisioned and created. The genre of rural films is a good case in point. Updated and transformed, it persists and remains relevant, because the legacy of New China cinema persists less as a political constraint or imposition than as a long-enduring cultural aspiration and social commitment. Such is the significance of the socialist visual experience in contemporary Chinese art as well, as I seek to show in the next chapter.

RURAL FILMS AND THE QUEST FOR A NATIONAL CINEMA

As early as 1953, at the launch of the first Five-Year Plan of socialist construction, policymakers had already put the production and exhibition of "rural feature films" on the agenda of the newly centralized film industry. The goal was both to engage and to represent the vast peasant population in the nation. The task was quickly grasped as part of a cultural revolution that would further consolidate the political legitimacy of the nascent People's Republic. Largely in response to the collectivization movement in the countryside during the late 1950s, film studios put out an increasing number of films that explicitly addressed the new life of a peasant community, such as a village, a commune, or a production team. While much emphasis was placed on creating lifelike, credible characters through evocations of a local culture, a positive if didactic message would necessarily present itself through a final resolution of dramatic conflicts, which usually meant a happy ending to the satisfaction of the rural audience.

In an ideal-type rural film, the plot development ought to be moderately paced and emotionally unambiguous, and a systematic contrast must be erected to distinguish positive from negative characters. While continuity editing and explanatory narration strive for a fluid reality effect, most frame compositions are stable, dramatically lit, and shot at medium or long range. The desired effect is to facilitate audience access and identification through visual clarity and strong emotional appeal. In addition, the musical component should draw on a local or regional heritage, accented by traditional instrumentation and folksy singing that augment the communal or festival atmosphere at appropriate moments, a feature not dissimilar to that of a "cinema of attractions."

Through its efforts to engage a peasant audience, therefore, the genre of rural films actively incorporates many indigenous aesthetic preferences and forms of entertainment, which could then lead to a departure from the classical Hollywood narrative cinema that had directly shaped Chinese filmmaking until the late 1940s. (A notable film displaying many of the

features summarized here is *Young People in Our Village*, part 1 [dir. Su Li, 1959]). As one film critic put it in 1960, rural films may well indicate the direction of an emerging Chinese national cinema.[3] They certainly helped define and promote a celebratory vision of life in the socialist countryside.

Generic conventions notwithstanding, rural films in the mode of communal comedy only had a brief and interrupted history. Besides, those techniques for projecting a peaceful, idealized image of the contemporary countryside could not really establish the rural films as a distinct genre, because the same cinematic projections were also employed in portraying socialist industrialization and development. If the initial idealization in rural films owed much to the doctrine of socialist realism until the early 1960s, films made about the countryside during the early 1980s, including *Our Leader Niu Baisui* (dir. Zhao Huanzhang, 1983) and *Life* (dir. Wu Tianming, 1984), mark the coming of age of rural films as a separate genre. Especially with *Life*, which incidentally appeared in the same year as the much-celebrated *Yellow Earth* (dir. Chen Kaige) and shared a similar deep-seated emotional ambivalence toward the barren loess of northwest China, the distance between country and city entered rural films as an inescapable pathos. Realism in rural films thereby acquired a radically different valence when life in the countryside was no longer viewed as fulfilling, self-sufficient, or even adequate.

By the early 1990s, when it became apparent to Chinese directors that only films about rural landscape and obscure customs would attract organizers of international film festivals abroad,[4] and when members of the Fifth Generation were suspected of orientalizing a rural China of the past as exotica for a foreign market, the notion of rural films underwent yet another expansion. Life in the countryside would now be subjected to a careful ethnographic study in cinema. The international and domestic success of Zhang Yimou's 1992 film *The Story of Qiu Ju* was a significant turning point, not only because a key Fifth Generation director had made a documentary-style film about the contemporary countryside, but also because it was produced with offshore financing.[5]

The classic, paradigmatic rural film of the idealist phase, by all accounts, is *Li Shuangshuang* (dir. Lu Ren, 1962), a light but edifying comedy about new collective life in a people's commune. Adapted from a 1959 short story by Li Zhun (published in *People's Literature* in 1960), the film was a sensational success and won the second Hundred Flowers Award for best feature film in 1963 by a nationwide audience vote (Figure 3.1). That the original literary text was first written in 1959 is significant because it is a story about exciting changes brought to the countryside during the Great Leap Forward, a massive and ambitious national campaign waged in 1958 to leapfrog the country into advanced stages of modernization, specifically to "catch up with England and surpass America" in industrial output. Yet the sense of urgency and overconfidence begat willful policies

3.1 Cover of *Popular Cinema*, May–June 1963, with Zhang Ruifang (1918–2012), starring as Li Shuangshuang.

that soon led to ruinous results, the most devastating among them being the widespread famine that claimed millions of lives in the countryside and which would haunt Chinese politics and collective memory for generations to come.

The short story "A Brief Biography of Li Shuangshuang," nonetheless, was written to show, as Richard King observes in his study, "the Great Leap Forward as it should have been . . . a time of hope, common purpose, and irrepressible energy that would liberate peasant women from drudgery into active participation in the life of the nation."[6] King also reports that the author Li Zhun believed his story reached some 300 million readers through numerous reprints, in addition to being adapted into pictorial narratives, a film, and various local operas for an even greater impact.[7] There are some subtle but meaningful shifts in focus and detail between the original short story and its filmic adaptation, but there is no doubt that, as King comments, "Li Shuangshuang, and the many works that bear her name, was the cultural success story of the Great Leap."[8]

Soon after the release of *Li Shuangshuang* to an enthusiastic reception, the China Film Press put out a volume on the germination, production, and exhibition of the film as an exemplary process, obviously intending it to be a guide for future developments in New China cinema. In addition to the director's shooting script, some essays in this volume, such as those by the lead actors, the cinematographer, the set designer, and the musical composer, delve into various technical aspects of the filmmaking process.[9] (Incidentally, the film was shot on location in Henan, one of the provinces that suffered the most casualties during the post-Great Leap Forward famine.) While this volume offers a valuable document for a study of the innovations and objectives of New China cinema, the film itself, with the passing of the people's commune and the fading of a socialist vision that was once eagerly and collectively willed to become reality, now appears dated and staged, if not altogether wistful.

Watching the film in our post-socialist contemporary world, just like reading the original short story, therefore requires a due exercise of our historical imagination. We will need to recognize such cultural expressions as once palpable desires and lived experiences; we gain nothing by dismissing them as deliberate deception or organized propaganda, just as attributing the Great Leap Forward to sheer madness or personal folly will only impoverish our understanding of that extraordinary moment of history and its many complex dimensions. With sympathetic viewing, we will see the central issues that the film identifies and tries to address, such as women's social role and agency, the need to reconfigure the time-honored demarcation between feminine domestic space (or *nei*) and masculine public space (or *wai*), and the desire for and pursuit of a better life, still remain and are continually revisited in films from the 1980s and 1990s. Indeed, in hindsight, *Li Shuangshuang* amounts to a determinedly visionary answer to some of the intractable problems encountered by the project of modernizing Chinese tradition and society.

Moreover, from a formal perspective, we can still appreciate the concentrated search for a socialist cinema in the making of *Li Shuangshuang*, and

we ought to analyze and appreciate the film's popular appeal rather than dismiss it as either unabashed or insidious propaganda. As Chris Berry argued through an insightful analysis in the early 1990s, this is a film that overcomes the identificatory cinematic apparatus that dominates Hollywood narrative cinema. In dissociating the subjective camera from any one particular character or viewing position, *Li Shuangshuang* on the cinematic level constructs "a privileged place of perception" for the viewing subject, a third place that, by signaling the presence of an objective, all-encompassing position, escapes the mirroring relationship induced by the camera between the viewer and a given character. Berry calls the construction of this third viewing place a Chinese convention, which "constitutes part of an anti-individualistic aesthetic" and is "contrary to the Western paradigm, and clearly worthy of further investigation."[10]

This privileged place of perception that commands the viewer in *Li Shuangshuang*, which Berry also refers to as an "abstract place of order," seems to continue in a later film, although in a more pronounced and self-conscious manner. What I have in mind is the series of shimmering, depthless images of old village women sunning themselves on a barren hill that is inserted, often unexpectedly, in the narrative of *Ermo* (dir. Zhou Xiaowen, 1994). These exdiegetic shots are often carefully framed so as to suggest a timeless, even spectral, vista that is of a nature drastically different from the flow of alien televisual images that the film *Ermo* also introduces and comments on. Without a single word, not even any discernible facial expression, those old women nonetheless emit a lasting comment on the life and struggle of Ermo, a new peasant woman of the 1990s. This commentary is of a more visual nature and adds much depth to the field of vision that the film presents. By making the viewer aware of a detached, time-honored perspective on the action unfolding on the screen, those seemingly impassive grannies unsettle the viewer's identification with the younger Ermo or any other characters. At the same time, their ethereal presence, conveyed by the use of a zoom lens and a trailing sound track, interjects into the visual field of the film an intersubjective tension and brings to the fore abstract qualities and relations that cannot be reduced to material, quantifiable shape or form. In other words, this strategy of indicating a third place of perception in narrative cinema does not necessarily serve only an active purpose of anti-individualism or the collectivist agenda. It can also amount to a historical lament, an alternative of disengagement, and a withdrawal from the goings-on of a busy contemporary everyday life.

Whereas the commanding camera in *Li Shuangshuang* aspires to a national form as much as to pedagogical efficacy, the fantastic evocation of a historical space in the sobering drama of *Ermo* extends the anthropological gaze that sustains much of the filmmaking by the celebrated Fifth Generation. Separated by over thirty years of profound changes in Chinese

society as well as in the film industry, these two distinct cinematic presentations nonetheless share salient formal features specific to rural films. What I demonstrate in this chapter is why we ought to view these two films together, mediated by two other intervening films, also about rural women: *In the Wild Mountains* (dir. Yan Xueshu, 1985), and *Women from the Lake of Scented Souls* (dir. Xie Fei, 1992).

SOCIAL CHANGE AND A COMIC ROLE REVERSAL

If these brief readings of a privileged point of view in *Li Shuangshuang* and *Ermo* are valid, they will only remind us further how different these two films actually are and how much the social and cultural situations have changed between them. For *Li Shuangshuang*, as Paul Clark classifies it in his description of Chinese film genres from 1956 to 1964, belongs to the "cheerful type" that focuses on contemporary subjects rather than on revolutionary history or ethnic minorities. Cheerful and uplifting, films on the new society were produced "to assist with current political, social, and economic campaigns. For education as much as entertainment, these films presented model characters in model situations."[11]

Li Shuangshuang, the title character, is just such a model heroine whose endearing quality is her cheerful exuberance and enthusiasm for the collective good. She embodies a new rural woman in the socialist era, who is no longer contented with domestic duties and virtues but seeks actively to participate in communal life, assuming a public agency not allowed her until now. Her immediate predecessor, as I suggest in Chapter 2, is the courageous village woman who acquired a public voice in those "speaking bitterness" sessions during land reform. More generally, Shuangshuang, along with many other women characters in fiction or on stage, is portrayed as a spirited beneficiary of and devotee to a far-reaching and programmatic women's liberation movement that was always an instrumental part of the socialist revolution in the mid-twentieth century.[12]

The main conflict and action of the 1962 film, in the convention of a light comedy, unfolds between Shuangshuang and her husband, Xiwang, a vacillating "middle character" whose patriarchal habits, selfishness, conservative attitude, and hesitancy about public responsibility are poked fun at and overcome in due course. While the husband Xiwang embodies traditional mentalities that may undermine the new communal life, the depiction of Shuangshuang as both an affectionate and yet stubborn wife and as a proud, good-natured, and yet principled member of the commune projects an exemplary peasant woman with positive qualities befitting the socialist age.[13] At the final moment of happy reconciliation, therefore, the scenarist and the director of the film arrange for the couple to affirm their mutual love against a background of pastoral peace and contentment. After a long shot of another young couple running off in laughter, the

film cuts back to a medium shot of Xiwang and Shuangshuang, who turn from looking into the distance to regard each other. With a broad smile and some shyness, Xiwang compliments Shuangshuang that she is becoming more and more beautiful, to which she replies, approvingly, "But aren't you also changing?" Upon hearing this, he takes from her hands her tote bag, a loving gesture and a direct echo of the opening scene, where he tosses his shirt for her to wash on their way home from the field. It also constitutes a symbolic comment on the positive influence of Shuangshuang (Figure 3.2), for his transformation owes much to her determination, and he is able to appreciate his wife's beauty only when he identifies with the values she stands for. Yet this acknowledgment of her predominance is subtly balanced out when, in the final frame, Xiwang turns, walks out of the frame, and leaves her no other choice but to follow behind him.

In spite of the reassuring promise of domestic harmony at the end, much of the film's comedy revolves around the personality clash between husband and wife, a domestic conflict that is given social content and relevance. Shuangshuang is an enthusiastic, outspoken activist for the new collective; she has an infectious laugh and is broad-minded. Xiwang, however, while an essentially good person, is often indecisive and much too concerned with other people's opinions to speak his mind. In other words, she is a much stronger character and assumes an active role in

3.2 A happily married couple at the end.

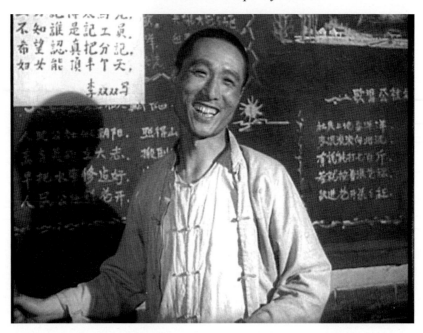

3.3 Xiwang does not know how to react to a public poster his wife Shuangshuang
has put up.

public life, whereas her husband is weak, malleable, and often completely
absent from the scene. The implicit structure of the comedy therefore
relies heavily on a perceived role reversal insofar as it continually reveals the
husband's misrecognition of his wife's public identity. (His outmoded
mindset is poignantly marked, for example, when the village party
secretary criticizes Xiwang for dismissively referring to his wife as "the
cook in my house" and for failing to realize the importance of a hand-
written poster that she has put up at the village center [Figure 3.3].)
Shuangshuang's empowerment, by contrast, is shown to stem from her
going beyond the confines of the domestic household and in her direct
involvement in communal affairs.

This deliberate and revealing trope of role reversal also continues into
Ermo, where the title character as the strong-willed wife of an emasculated
husband has to cope with a radically different reality (Figure 3.4). Instead
of striving for a comic resolution, however, *Ermo* delves deeply into
disillusionment and even despair in the post-socialist age of rising con-
sumerism.[14] Its cinematic style readily recognizable as indebted to some
classic Fifth Generation films, *Ermo* presents a sober study of rural life in
the 1990s and raises questions about the promise of a fulfilling new life. It
also brings critical attention to issues of desire and commodity fetishism.
Before we examine *Ermo* and its message about loss through possession
more closely, it may help to look briefly into two other films that employ

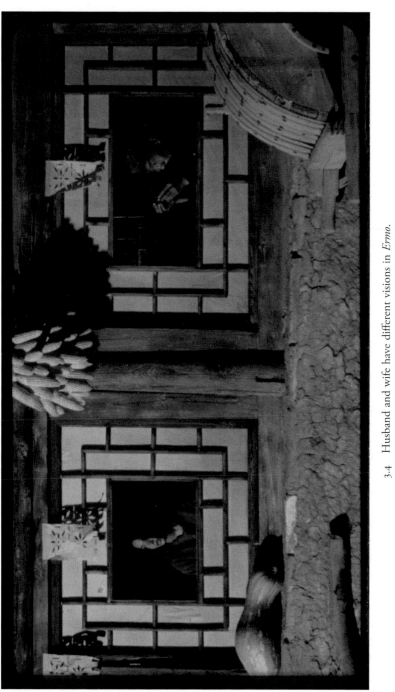

3.4 Husband and wife have different visions in *Ermo*.

the same trope of role reversal. They provide a thematic as well as a cinematic transition, I would argue, between *Li Shuangshuang* and *Ermo*, moving us from comedy to tragedy, from stylized celebration to intense critical introspection.

The first film that we ought to study in this context, and in appreciating the genre of rural films in New China cinema, is *In the Wild Mountains*. Following the intricate story of two peasant couples and their different choices in the age of economic reform, the 1985 film illustrates the liberating impact of the market and urban culture on the mentality of peasants living in remote rural areas.[15] In 1986, it reaped major Golden Rooster Awards for artistic achievement. Even though there was some controversy over its message, reviewers and critics enthusiastically endorsed the film for its stark realism, stylistic coherence, technical breakthroughs, and adroit storytelling.

Central to the plot of *Wild Mountains* is a rather improbable dramatic recombination of two peasant couples, through which the more curious and adventurous Guilan, wife of the overcautious Huihui, divorces her husband and marries his younger brother Hehe, an intrepid entrepreneur who knows only too well the bitter taste of failure. The older brother, in the process, ties the knot with his former sister-in-law, who has separated from her husband because she could no longer put up with his various doomed business ventures. Sharing the same time-honored attachment to the land, Huihui the older brother and his new wife find support in each other, and their wedding is presented in the film as a boisterous communal affair. The other couple in the meantime has to withstand considerable derision in the rural community, and their wedding is never directly shown. However, the happy occasion of their introducing to the village its first electric grain-grinder, which a joyful Guilan promises will benefit everyone, brings the film to its forgiving and uplifting end. Although "wife swapping" seems to be the conventional summary of the plot, one critic pointed out that it would be more accurate to describe it as "husband swapping," since the focus of the film is on women, especially the awakening and self-assertion experienced by Guilan.[16] Interestingly enough, another commentator observed that this vivacious, uninhibited peasant woman directly recalls the spirited character of Shuangshuang from more than twenty years earlier.[17]

Yet on almost every level, including the creation of Guilan as a woman driven by her desire for a more fulfilling life, *Wild Mountains* registers a self-conscious departure from the cinematic tradition represented by *Li Shuangshuang*, even though both films present a happy ending and both creatively support current social and cultural orientations. Unlike the artificially bright lighting, thematized set design, or post-production recording that we find in the earlier black-and-white film, every effort was made (a stationary camera, on-site recording, and set and costume designs) to represent a hard reality in the color picture of 1985. In contrast

3.5 A hard rural life with its simple pleasures.

to the visual and conceptual clarity of *Li Shuangshuang*, in the later film we witness critical attention to a disorderly everyday life and messy emotional entanglements. The general color tone of *Wild Mountains* is a subdued bluish-green, with external musical commentary replaced by natural sound recordings, and many of the interior scenes dimly lit to reflect the hardship and poverty of peasant life in remote mountain regions. The cinematic effect is such that a dormant, poverty-stricken rural landscape offers both the background to and justification for the desire for a better life expressed by the young couple (Figure 3.5).

One striking contrast between *Li Shuangshuang* and *Wild Mountains* concerns the filming of physical labor. If for the socialist new woman and her fellow commune members, agricultural work is a meaningful and enjoyable enterprise, a point driven home in the 1962 film through recurrent images of clean, energetic, and brightly lit faces and bodies (Figures 3.6), for people living in the wild mountains in the 1980s, labor appears all too repetitive and mind-numbing. Instead of collective work in the sunny field, a solitary individual pushing a grindstone in circles now becomes a favorite visual metaphor for the toll exacted by menial labor on the human body and soul. The revolving grindstone also symbolizes an inescapable and yet changeless everyday life and history. In the history of New China cinema, one may argue that demeaning labor emerged as a central theme in the film *Life*, together with which *Wild Mountains* (both from the same Xi'an Film Studio and within one year of each other) established a visual vocabulary of critical realism for the genre of rural films.

3.6 In *Li Shuangshuang*, women work and sing as commune members.

The post-socialist refusal to idealize labor would be given a new twist in *Ermo*, where the transition between plot developments is often close-ups of the heroine kneading dough for noodles with her bare feet. The series of shots of Ermo as almost inorganic body parts serves to comment on her pent-up libidinal energies and to suggest a disjointed life (Figures 3.7).

This stylistic rewriting, or reenvisioning, of the earlier, paradigm-setting *Li Shuangshuang* obviously goes beyond debunking its idealization of rural life and celebration of collective farm work. The reenvisioning also involves a reexamination of the trope of role reversal, and this is where a comparison of *Li Shuangshuang* with *Wild Mountains* becomes even more telling. While in the 1962 film it is the overcautious and malleable husband who is transformed so as to appreciate the beauty of his forthright wife, the drama of husband swapping of the mid 1980s centers on how the guileless wife breaks free from her surroundings and embarks on a more adventurous path. More specifically, the later film is about the awakening of self-consciousness and desire for change in Guilan, whose transformation is aided by her sympathy for the younger brother's restless search for opportunities, her curiosity about the outside world, and their visit to the local town, which illustrates to her the excitement of urban life.

A defining difference between Shuangshuang and Guilan, therefore, is the latter's growing awareness of her own body and of herself as a young woman. (We therefore see, sequentially, Guilan's disappointment when she comes to bed and fails to wake up her snoring husband, her decision to

3.7 Ermo labors alone at night.

3.8 Guilan gets ready to go to a fair in town.

clean her mouth with saltwater, her appreciation of the present of a mirror
from Hehe her brother-in-law, and her talking about being embarrassed in
a public bathhouse, surrounded by naked women [Figure 3.8].) Shuang-
shuang, by contrast, is throughout the film shown to be everything but a
desiring individual self-conscious of her own body as seen by others. She is
a loving wife, a caring mother, and a big sister, as well as a communal
leader; her happiness is always of a public nature, and her dismay is rarely a
solitary experience. Guilan, in satisfying her curiosity about the outside
world, finds herself isolated in the village and is subjected to humiliation as
well as loneliness. Such internal anguish, together with her growing desire
for excitement, leads Guilan to gain a detached, transcending view of her
surroundings. This is emphatically visualized late in the film when Guilan
climbs a hill and finds that someone has harvested her wheat crop for her.
A nearly 360-degree rotation of the camera simulates Guilan's panoramic
survey of the "wild mountains" and articulates a new self-awareness, and
also a liberating self-assertion.

In the well-structured world of Shuangshuang (visually conveyed by
numerous square doors and window frames in the film), however, we
seldom enter her private field of vision, and her frustrations would never
turn her into a pensive individual or keep her from the public view
(Figure 3.9). She is so wholeheartedly committed to the village as a
complete socialist universe that the camera never rises to offer the audience
a bird's-eye view of its boundaries. (In *Ermo*, by contrast, we constantly get
to see the village from midair and take in its sleepiness and limits.)

3.9 Shuangshuang prepares a message to the commune leader.

As two similarly strong-willed women, Shuangshuang and Guilan high-light the logic of two separate social formations: in one case, a politically conscious and empowered woman valiantly combats the forces of old habits and prejudices; in the other, an increasingly self-conscious woman undergoes the pain of learning to desire and in the process becomes an outcast. Always enjoying the backing of the paternal village party secretary and, when necessary, the head of the commune party branch, Shuang-shuang stands for the collective interest of the commune and wins respect from fellow members. Her complaint against her husband, at one point, is that he fails to help her do a better job serving the commune.

Guilan the young rural woman of the 1980s, by contrast, has no such network of support or political authority to turn to. The nurturing extended family of the socialist era turns into a crowd of impassive spectators in the age of economic reform. When she returns home from visiting the local town and decides to steel herself to seek a reconciliation with her husband, Guilan quickly realizes that she is the victim of a vicious rumor and the object of censorious ogling. She loses all hope as she sees in her husband an accomplice of the shamelessly prying crowd. In this crucial scene that leads to their divorce, the camera brings us closer to Guilan than ever before to magnify her loneliness and anguish, with an unusual close-up of her face set against blurred onlookers. The confused husband, by contrast, is mostly kept in the background, deep inside the house and slightly out of focus. His rage against Guilan, after she implores him to

defend her innocence, testifies to his submission to social pressure, spelled out in this sequence by intermittent shots of the peeping villagers, evidently from his perspective. In a structurally similar scene of confrontation from *Li Shuangshuang*, it is the husband who appears humiliated and hurries out, while Shuangshuang, surrounded by several unsympathetic characters (all clad in dark or gray clothes), remains radiantly defiant.[18]

Just as the strengths of the two women derive from separate sources, so the two husbands are challenged for different reasons. As we have seen, Xiwang's misrecognition of his wife's new public identity leads to his being constantly affronted and yet put on the defensive. Huihui, similarly overcautious and mindful of fellow villagers' gossip, however, does not appreciate his wife's gravitation toward a new way of life, which he regards as ultimately threatening to the stability of his universe and his respectability. His overcautiousness, therefore, stems from his resistance to change, and once he senses Guilan's support for his own enterprising brother, he pointedly asserts his control over family affairs, declaring that he, rather than his wife, is the master of the house. As the tension escalates, he violently smashes household objects to vent his anger, thereby metaphorically tearing apart his first marriage. (Xiwang, on the other hand, would never be emboldened to accuse his wife of infidelity or insubordination. His only choice, when hard pressed, is to leave home and avoid being embarrassed by her public role.) Nonetheless, Huihui will have to admit defeat in the end, if only because his adherence to traditional life is shown to be a cause without a future. Toward the end of *Wild Mountains*, he and his new wife are seen watching from a distance as the other new couple celebrates the arrival of the electric grinder. A prolonged take by a steady camera, which shows the forlorn couple slowly pushing the grindstone in the foreground, mirrors the sinking-in of a hard lesson.[19] Obviously agitated by the festivity, the grim-faced husband decides that they have to bite the bullet and pay for a power line to their house, regardless of the cost.

Even though Huihui's change is only hinted at and a little too late to salvage his marriage with Guilan, it is still a positive sign of hope generously offered by the film. The optimistic belief in modernization endorsed by the film determines that Guilan and her new husband be cheered and admired by other villagers as the story draws to an upbeat conclusion. Compared to Xiwang's happy transformation, however, Huihui presents a much more recalcitrant case. Thus we find a strengthened marriage in *Li Shuangshuang*, but divorce and remarriage in its updated version from 1985. Yet if the wavering husband is not amenable to change and the strong-minded wife has her own secrets and lies, a more troublesome situation seems to be inevitable. This scenario is played out in *Ermo* as well as in another film that I will introduce briefly, namely, Xie Fei's internationally acclaimed *Women from the Lake of Scented Souls*.

SELF-TRANSFORMATION AS A SOCIAL PROJECT

A complex and disturbing story told with the intense intellectualism and compassion that characterize Xie Fei's works, *Scented Souls* largely continues the generic tradition of contemporary rural films and yet introduces refreshing variations. The social change that is reflected through the parallel, unhappy fate of two women, Xiang Ersao (or Second Uncle's Wife Fragrance) and her daughter-in-law, registers a much greater historical burden and shows itself to be haunted continually by inertia and repetition. By no means a comedy, the film gradually reveals to us the carefully guarded inner world of Xiang Ersao, who undergoes a painful awakening and a major crisis in the story. Skillful narration and editing aside, the film employs a generally contemplative style, resorting to frequent close-ups and a cinematography with minimum depth to push the search for an answer deep into the central character's psyche.

The opening sequence economically establishes that the central character, Xiang Ersao, is a hard-working, no-nonsense middle-aged woman who appears to be the de facto owner of a thriving family business that produces and sells sesame oil in a rural village (Figure 3.10). Soon we realize that she is also a hardened and calculating matriarch who commands communal respect and has a longtime secret lover, but her epileptic and idiot son makes it all but impossible for her fully to enjoy her accomplishments. Xiang Ersao's biggest success and failure in the course of the film, therefore, is to mastermind a marriage between her son and Huanhuan, a healthy, attractive young girl from a poor family.

3.10 The traditional way of making sesame oil.

Between Xiang Ersao and the upright Shuangshuang or the youthful Guilan, there may be less in common than between the latter two, but they all seem to be the opposite of an obedient or supportive wife. In fact, as one reviewer puts it, Xiang Ersao practically "orders her husband about like a child" and makes all the executive decisions for the family business.[20] Her husband, who is lame and walks with a stick, makes his contribution from behind the store counter during the day but frequents an entertainment boat at night, often staying late to watch pornographic videos smuggled in from Hong Kong. Between husband and wife little emotional exchange takes place except for appearance's sake (such as when a Japanese visitor shows up or during their son's wedding). Occasionally the husband returns home late at night and forces himself on his wife, aroused by either alcohol or explicit videotapes. Removed as he is from the more open realms of home economics and business, the husband resorts to forced sex in the bedroom as a way of asserting his conjugal authority. Once, when Xiang Ersao refuses him after a long day of exhausting work, the husband turns violent, physically abuses her, and justifies it all by reminding her of a wife's duty. On top of that, he makes her avouch, through gritted teeth and facing the camera, that their healthy young daughter is in fact his, although by now the audience is given to understand that the girl is the love child of Xiang Ersao and her secret lover, a truck driver who serves as a link between the village and the city.

This darker side of domestic life exposed in *Scented Souls* therefore brings us to a sphere of hidden agony never really examined in the two previous films that we have looked at, not in the least in *Li Shuangshuang*. It also implies a much grimmer reality than the solutions promised in the other two films: if public life empowers Shuangshuang with a new identity, and if the desire for a more exciting, materially more gratifying life generates a new self-consciousness in Guilan, successes on both accounts do not necessarily ensure or translate into personal happiness for Xiang Ersao. The objectives of social change, in other words, have yet to institute themselves in a private and psychological (even libidinal) domain that is often not synchronic or interchangeable with forms of public identity or social relationships.

At first glance, the awakening that Xiang Ersao experiences seems to be similar to the initiation that befalls Guilan on her visit to the local town. In going to the provincial capital to meet with a potential Japanese investor, Xiang Ersao may seem like yet another rural woman overwhelmed by the urban sound and fury. Yet while the younger woman shows an uninhibited fascination with the town (Guilan runs down the street just to have a better look at a fashionable girl riding a motorcycle), Xiang Ersao appears to be much more self-possessed and purposeful. While the innocent Guilan is attracted to what the city has to offer,

Xiang Ersao is given a chance to see what life in the city may allow, especially in terms of intimate personal lives.

Here we see a series of dissolving images seamlessly take Xiang Ersao deeper and deeper into a muted interior space and an unexpected opportunity for her to reflect on her life. When the Japanese investor Miss Shinyo Sadako invites her to a luxury hotel suite, showers her with gifts, and eventually hurries out for a rendezvous with her boyfriend, Xiang Ersao has much to absorb and figure out. In particular, Miss Shinyo's present of a silk scarf makes her realize that her husband has never bought, or would even care to buy, anything so beautiful for her. Too moved to care about her Japanese hostess's poor command of Chinese, Xiang Ersao recounts her miserable fate of being sold at seven and forced into marriage at thirteen. Soon left alone in the suite, she tries calling her own lover at work and is told that he has gone home for his child's birthday. As this scene of emotional upheaval quietly unfolds, the camera draws ever closer to Xiang Ersao until finally, her pensive face occupying most of the screen, she removes the scarf from around her neck, heaves a barely audible sigh, and stares blankly into nothingness (Figure 3.11).

Compared with the seductively cozy and soft lighting of the orderly hotel interior, the open rural scene that Xiang Ersao returns to in the following sequence appears unruly, piercingly bright, and full of motion and noise. The cue offered by an abrupt cut to the blurred view from a roaring truck is unmistakable: we are back in the real world in which Xiang Ersao will have to function in a different guise and manner. The drama of the rest of the film, therefore, revolves around the tension between her public persona and her emotional life, between her worldly successes and her private agonies. We see how she pulls political strings to force Huan-huan into marrying her epileptic son, thereby directly creating a situation where the younger woman will endure the same unhappiness that afflicts Xiang Ersao herself. As her sesame oil mill becomes mechanized and more productive, we see her psychological balance badly shaken when it dawns on her that she is no more than a mistress or concubine to the truck driver who shows up whenever it is convenient for him. The meticulously maintained contrast (in terms of color scheme and camera positions) between her public image in daylight, including that of her as a stern mother-in-law, and her vulnerabilities as a wife and a mistress at night becomes a systematic commentary on the discontinuities in her life. Such contradictions lead to a bitterly ironic moment when, finally emerging from a sickness caused by the circumstances in which the truck driver breaks up with her, Xiang Ersao, pale and enfeebled, is told by a cheerful village official that her brand of sesame oil has just won a major prize in the provincial competition. Too weak to feign credible joy at the news, Xiang Ersao appears apathetic and makes no comment. The following scene suggests that she manages to escape the cheering crowd and rows a boat

3.11 Presents from Miss Shinyo lead Xiang Ersao to see the emptiness of her life.

to the heart of the lake, where she can openly wail and mourn her loss all by herself (Figure 3.12).

It would be hard to specify what loss Xiang Ersao mourns at this moment, since what has gone awry is more than just her love affair. Against an indistinct grayish background, close-ups of Xiang Ersao's expressionless face emphasize her emotional isolation from her surroundings. Her solitary flight into interiority is further highlighted by crosscutting shots of a

3.12 Xiang Ersao seeks solitude in the lake and bewails her fate.

desolate, reed-lined waterway from her point of view. Such subjective shots are used very sparingly in the film, except where Xiang Ersao is given a chance to observe her daughter-in-law's movements and misery. The narrative implication of those point-of-view shots is that she is bound to recognize her own fate in that of the young woman. This recognition finally arrives when the latest disaster in the marriage she arranges for her son forces Xiang Ersao to face her relationship to herself as well as the external world.

In the wake of her solitary, mournful journey into the heart of the lake, there is a noticeable withdrawal by Xiang Ersao from her familiar public

persona, and the first thing she does to begin dealing with the contradictions in her life is to dissolve Huanhuan's marriage. Significantly, this final scene of resolution takes place by the lakeside and in moonlight, a temporal zone that is associated with Xiang Ersao's troubled private life. In fact, her departure from a deception-filled public life is encapsulated in a previous scene in which a revolving camera is trained on a wistful and pensive Xiang Ersao, who alone faces a rapidly sinking sun, while some faint music of a wedding ceremony drifts in from over the lake. Throughout this crucial scene of emotional and thematic transition, she remains in the same sitting position until darkness settles around her. When she recovers from her reverie, it takes her a second or two to recognize where she is.

The climactic scene by the moonlit lake reminds us how far we are removed from the bustling, emphatically masculine workplace at the beginning of *Scented Souls*. Physically weakened, Xiang Ersao nonetheless has acquired the inner strength to interrupt a vicious cycle or repetition that she herself has taken part in perpetuating. Her decision to free Huanhuan from a wretched marriage therefore promises a profound change in their individual lives as well as in their social relations.

This affirmation of the necessity of change in *Scented Souls* continues the central commitment of both *Li Shuangshuang* and *Wild Mountains*, but it is also increasingly obvious that changes of a different nature are called for in this series of films. The transition from light comedy to sobering drama corresponds to the increasing gravity of the task at hand. This thematic concern with transformation and its implications also offers a fruitful way of viewing *Ermo* from the mid 1990s, in which the possibility of social change gives way to an intractable reality, and any rationalistic optimism about agency and progress appears short-circuited by desire as much as by inertia or ignorance.

DESIRE AND ITS COMMODITY FORM

The central event in *Ermo* reflects a new stage in the development of contemporary Chinese society and, as film critic Dai Jinhua comments, has an allegorical density through which director Zhou Xiaowen, an erratic member of the Fifth Generation, expresses his uncompromising interrogation of modern civilization.[21] The title character, Ermo, lives in a remote rural village but is determined to purchase, at all costs, the largest color television set available so that, for one thing, her son does not have to go over to their next-door neighbor's house to watch television. Obsessed with this goal, the young woman is willing to work in the city and leaves behind her sickly husband and underage son. To make some quick money, she even risks her health by selling large quantities of blood. Along the way, she has an affair with the husband of the neighboring household, which brings Ermo some happy moments but eventually throws her into deep despair when her lover, Blindman, backtracks and demurs about starting a new life with her.

When she finally saves enough money to buy the television set, her health is damaged and her spirit broken. With a vacant look in her eyes, she gets no joy from the gigantic black object that occupies the center of her house and spews alien images. The last scene shows Ermo and her family fast asleep in front of a television set that imperviously broadcasts world weather reports and then nothing but a glaring static.

Made in what has been described as "post-" or "pan-Fifth Generation filmmaking,"[22] *Ermo* certainly remains true to the visual precision, the allegorizing impulse, and an aesthetic of defamiliarization that characterize Fifth Generation works as varied as *King of the Children* (dir. Chen Kaige, 1987), *Ju Dou* (dir. Zhang Yimou, 1990), and *The Story of Qiu Ju*. Yet to fully appreciate the innovations (technical as well as thematic) of *Ermo* within the tradition of New China cinema, we need to view it in the context of the rural films that we have been looking at. No longer directly recognizable as a revision of *Li Shuangshuang*, it nonetheless retains the central trope of designating contradictory approaches to life through husband and wife. Here again we encounter a strong, hard-working, and stubborn wife in Ermo, who single-handedly supports the family, and a grumbling husband who used to be the village head but who is now confined to the house due to back pain. The evolving power balance between a robust Ermo and her emasculated husband mirrors the complex process through which different forms of prestige (e.g., political, economic, moral, and sexual) combat and negotiate with one another in a rural community. Often ignored and humiliated, the watchful husband, still called Chief by fellow villagers, quickly asserts a righteous authority when he intuits an illicit liaison between Ermo and Blindman. While on one occasion he voices systematic objections to Ermo's leaving home to make money, in the end he enjoys the public attention that the oversize television set seems to bring back to him. He evidently craves respect, even though throughout the film he constantly reminds himself as well as others that he is no longer the village chief.

Between *Wild Mountains* and *Ermo* we find much greater structural similarity and helpful comparisons. Instead of a comic and justified husband swapping, the married man who introduces Ermo to new possibilities in the city turns out to be too much of a decent person to transgress social mores. In the end, there is no such happy outcome as people of kindred spirit marrying each other. On the contrary, the subtle shift and realliance between the two couples is the opposite of what happens in *Wild Mountains*. Ermo and Blindman, the two who venture out and contemplate more drastic changes, are thwarted and crestfallen, while their respective spouses – their idle and non-productive counterparts – grow closer to each other and remain a respectable part of communal life.

In terms of style, *Wild Mountains* and *Ermo* share the same pursuit of stark realism, but the later film clearly pays tribute to a by then codified Fifth Generation filmmaking aesthetic. (For instance, technologically

better equipped to achieve better sound effects with on-site stereo recording, *Ermo* augments its naturalistic sound track by featuring a cast that speaks a local dialect. The film was released to the domestic market with subtitles, a significant move first made in *The Story of Qiu Ju*.) The bitter irony of Ermo's success compels the camera to depict her embattled inner world through close-ups as portraiture and to register every new desire and its frustration through comparative repetitions. Overall, *Ermo* is more of a psychological case study of its heroine than *Wild Mountains* is a celebration of the awakening Guilan.

Unlike Xiang Ersao in *Scented Souls*, whose anxiety-ridden private life is gradually revealed to us, Ermo undergoes a devastating disappointment over what she is both able and unable to achieve, rather than through a forced encounter with the dark truth about herself. Compared with the frequent close-ups of an observing or private Xiang Ersao that both project and explore an interior life in turmoil, those of Ermo often record a stubbornness as palpable as her bewilderment. As a small-time vendor of twisted noodles, she has few resources and little communal support, let alone political clout. Nor is she as calculating, as burdened with the painful memory of past scars, or as entrenched in the local power network as the more matronly Xiang Ersao.

Raw, energetic, and determined to reach the concrete goals she sets for herself, Ermo expresses a crude possessive individualism that is entirely absent from Shuangshuang's world, optimistically idealized as a new self-expression for Guilan, but no longer a predominant concern or necessity for Xiang Ersao. We therefore get to see, through a patient long take, Ermo finish drinking, one after another, three impossibly gigantic bowls of saltwater right before she goes to sell blood, having made herself believe that she has ingeniously diluted what will be drawn from her body. At the same time, we realize that her husband's impotence deeply frustrates Ermo and that her affair with Blindman releases libidinal tensions in both parties. She is also the one more emboldened in imagining a new life and in her readiness to brush aside social conventions. When Blindman appears hesitant about her proposal of forming a new family together, Ermo bluntly tells him to go pee like a woman and stops having anything to do with him. Yet her defeat in the end exposes a sad mismatch between her profound longings for a more fulfilling life and the inadequate means and resources she has at her disposal.

The most noticeable difference between Ermo and her various predecessors and sisters may be that the young peasant woman of the 1990s finds herself traveling back and forth between village and town and becoming displaced from both in the process. This displacement, brought about by the dialectic of desire and its postponement, is more of a mental state than a physical condition. Initially not at all interested in selling noodles in the local town, Ermo only gets on Blindman's antiquated truck and rides into

3.13 Ermo and Blindman on their way to town.

town due to a coincidence. The winding dirt road stretching across a barren landscape that the truck has to negotiate indicates the vast distance between the two sites that Ermo is to inhabit (Figure 3.13).

Toward the end of this first trip to town, she wanders into a department store and sees, from behind a mesmerized crowd, a twenty-nine-inch television set broadcasting an erotic scene from some imported soap opera. The colors are so brilliant and the images so vivid that, as Ermo later relates, she can see every blond hair on the foreign couple making love on screen. This may or may not be her first experience with the otherworldliness of televised images and fantasies, but her discovery of and walking toward the bank of television screens in the store is filmed to suggest her being drawn to an unreachable destination or altar. As she reaches the worshiping crowd, the film cuts to the position of the television, and we get to watch frontally, as if from the stable and square vision of a commandeering subject, Ermo's uneasiness with the voyeuristic implication of the situation, her overcoming of inhibitions, and her quick absorption in the programming. A mutual gaze between the enrapt viewer and the television screen is established through a sequence of shots and reverse-shots that resembles an exchange between two subjects (Figures 3.14).

This encounter will repeat itself more than once in the rest of the film and demands to be read as a crucial moment in the formation of Ermo's desire. Even when a power failure suddenly interrupts the televised lovemaking scene, Ermo remains engrossed with the inanimate screen, in all its blankness. The erotic imagery associated with the television set itself as a rarefied object ("This is the only one in the county; not even the county magistrate can afford it," the better-informed Blindman tells Ermo) explains the fetishistic spell that the television will hold over Ermo. She

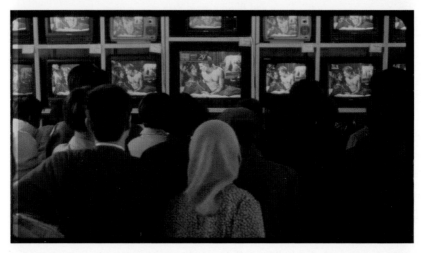

3.14 Ermo encounters television.

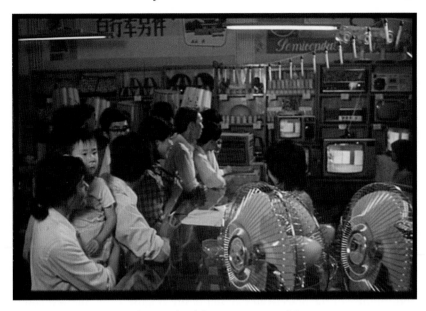

3.15 Guilan in a local department store of the 1980s.

began by wanting to buy a television to pacify her son and to get even with her neighbor, but now her obsession with this particular set points to a libidinal fantasy and investment.[23]

(A similar encounter with television sets as tokens of a tangible modern life also takes place in *Wild Mountains* during Guilan's trip to the local town, but it is filmed differently. We see what Guilan sees in a department store, but the objects of her wonderment do not look back and hold her in a mesmerizing gaze in the same way as in *Ermo*. Instead we observe her from the side, surveying the television sets, with the camera showing the context of Guilan's excitement before zooming in on her as a happily appreciative sightseer [Figure 3.15].)

Yet if the television as *objet petit a* is capable of activating the symbolization process, namely, providing a frame for Ermo's fantasies, it may function as such only as an empty space or void, necessarily unattainable and always metonymic of something else and more. Herein lies the ultimate frustration that is to beset Ermo: although the television set as a commodity may be acquired and delivered, to possess it does not guarantee automatic access to the original moment of pleasurable shock. The television set as a blank screen and the erotic scene as fantasy therefore give rise to two important players in Ermo's world: money and Blindman the truck driver, who is closely associated with money.

The night of her first trip to town, Ermo is shown back at home counting her money for the second time in the film, but the paper money now smells refreshingly different to her and serves as both evidence

3.16 Counting money brings back memory of television.

and promise of the object-cause of her desire (Figure 3.16). She will count
her money several times more in the film, as if to remind herself of the first
encounter. Yet while money as an object and commodity seems to be
tangible and within reach, Blindman presents a bitter disappointment,
ultimately a commonsensical reality that undercuts Ermo's desire for
a new life.

Blindman's participation in Ermo's fantasy begins when his voice
becomes part of the scene where Ermo comes face to face with the
television as the object-cause of her desire. Her wish for a new life with
him, after an amorous night halfway between town and village, expresses
her desire to desire and constitutes an inspired revision of reality. Blind-
man's subsequent qualms about her bold proposal lay bare the inescapable
ordinariness of their lives and insert Ermo back into the inertia of reality.
This setback bluntly deflates the fantasies that support her desire, returns
the main characters' lives to a superficial normalcy and a new balance, and
strips the television of its fetishistic aura. The television set now stops
being metonymic of anything else and turns into a gigantic metaphor for
Ermo's blocked desire. When finally purchased and brought home as an
expensive commodity, it is no more than an awkward, oppressive object
that betrays the disconnection between rural life and televised fantasies.[24]
As if to drive home her injury as a desiring subject, another erotic scene
from the same foreign soap opera that gripped her earlier appears on the
same television set at the end of the film, but this time Ermo and her
family are sound asleep (Figure 3.17).[25]

The jarring, post-programming static on the television that occupies the
entire film screen at the end of *Ermo* invites us to read the film as an
unrelenting scrutiny of the gap between lived experience and projected

3.17 The empty object that Ermo succeeds in acquiring.

images, between peasant life in contemporary China and an impervious global mediascape.[26] The act of exposing the emptiness underneath the flow of televised images can also be viewed as a critique of the general logic of consumer desire and commodity fetishism. Yet Ermo's despair at the end is an utterly debilitating condition precisely because the material change as evidenced by the newly acquired television set now displaces and even mocks her desire for a much more radical transformation. One central question raised by the film is therefore whether consumerism and, by extension, economic development could bring about the kind of change that she, once mobilized as a desiring subject, learns to envision in the process.

With this critique of consumerism, we realize how far removed we are from the world of *Li Shuangshuang*, in which money signifies pernicious temptations and from which commodity exchanges are conspicuously absent. As different as their historical moments may be from each other, however, both Shuangshuang and Ermo pursue an agitating project of becoming modern, the first mandate of which means recognition of women's role and agency beyond the confines of family life. If socialist collectivization inspires Shuangshuang to contribute to her rural community, money and desire combine to mobilize and eventually frustrate Ermo. The multiple roles these two women are called upon to play are strikingly different: whereas Shuangshuang from the socialist age assumes the role of a wife, mother, big sister, proud and productive commune member, women's team leader, and social activist, Ermo in the age of marketization and consumer culture becomes, besides continuing to be a wife and mother, a lover/adulteress, a producer and peddler of homemade goods, a wage earner in town, and a desperate conspicuous consumer. She lives a double and fractured life that would be inconceivable either to the

3.18 Like Guilan and Xiang Ersao before her, Ermo, too, looks into a mirror.

wholesome Shuangshuang or, in fact, to the resilient and optimistic Guilan of *Wild Mountains* (Figure 3.18).

Separated by the momentous passing of socialist collectivism, Shuang-shuang and Ermo may not even recognize each other, but we can hardly see one without also seeing or remembering the other. They are kindred spirits living in profoundly different times. In viewing the four films sequentially and intertextually, we realize that the opposite visions of a new life, as presented in *Li Shuangshuang* and *Ermo*, do not exactly cancel each other out. On the contrary, one often reveals what is incomplete in the other, and therefore they ought ideally to complement each other. For what is sorely lacking in Ermo's life, a development we already notice in Guilan of *Wild Mountains*, is the gratification of communal recognition and an empowering political identity. At the same time, the blissfully open and public life that Shuangshuang so conscientiously leads hardly leaves any space for her as a woman with her own desires and fantasies.

(The era that *Li Shuangshuang* evokes is elegiacally reimagined and powerfully humanized in Zhang Yimou's visionary *The Road Home* [1999], a film about passionate devotion that takes us on a fantastic flight from a drab and disenchanted contemporary world. In the present context, we may view the film as a determined effort to recreate Shuangshuang's world in brilliant color while showing the age of Ermo as devoid of passion and dedication. Another contemporary color film titled *Xilian* [dir. Sun Sha, 1995] tried rolling *Li Shuangshuang* and *Wild Mountains* into one for an upbeat take but resulted in an unsatisfactory story, partly because it failed to recognize the difference between these two previous films.)

Finally, a comparative viewing will also remind us how the genre of rural films has evolved over time. The audience of the depressing drama of *Ermo*

can no longer be imagined to be the same as that of the cheerful comedy of *Li Shuangshuang*, just as the communal festival of viewing a film or enjoying local opera at the socialist village center, as depicted in the 1962 film, has long given way to a dazed consumption of televised images, a terrifying scene that brings *Ermo* to its anticlimactic end.

CODA: CHILDREN AND TRUCK DRIVERS

It should not be surprising that in dramas about husbands and wives there are often children playing supplementary roles, but the involvement of a truck driver in all four films under discussion ought to be an intriguing detail. Indeed, truck drivers in rural films often serve the important structural function of maintaining connection with the city or industry, and of embodying to rural life its mobile and modernized other. That all truck drivers in this series of films should be male cannot but be a culturally and socially overdetermined choice. And that two such drivers (in *Scented Souls* and *Ermo* respectively) are morally weak or questionable characters is not an accident either.

In *Li Shuangshuang* and *Ermo*, the only child of the main couple serves as an indispensable helper in the plot development. In his own aggressive fashion, Ermo's son, Tiger, voices the need for food as well as for a television. He therefore is an agitating agent and remains emotionally indifferent to his parents throughout the film. Shuangshuang's daughter, on the other hand, is a humanizing element that brings her parents together. Her attachment to and dependence on both parents signifies the naturalness of a complete home, and when Xiwang decides to leave home for the second time, he is doubly at fault because he also turns his back on his loving daughter, who earlier has begged him to come home. Thus Xiwang gets even less sympathy from the audience for being an unfeeling father.

In *Wild Mountains*, the problematic relationship between an adventurous young wife and an overcautious husband is already indicated in their not being able to have children. The husband Huihui's love of children, meanwhile, presents an acceptable cause for his eventually marrying his brother's estranged wife, who is burdened with the arduous task of taking care of a son all by herself. (The original literary text on which *Wild Mountains* is based actually makes the symbolic value of fertility much more salient. It tells of Guilan becoming pregnant soon after marrying the now successful entrepreneur, thereby further affirming their happy union as more natural and more fruitful.[27]) More importantly, we as an audience grow ever closer to Guilan when she overcomes her fear of rats and takes loving care of the squirrel farm that Hehe leaves behind.

Xiang Ersao from *Scented Souls*, as we have seen, has a son and a daughter. Her epileptic, half-witted son is obviously the direct result of an unhappy, unacceptable marriage, but he is also an explicit symbol of the

burden and stain of history. The daughter she has with her secret lover seems only to irritate her husband more, because he wants to have another boy, and a healthy one at that. At least according to the logic conveyed in the film, the daughter does not have a real father and will not carry on a doomed family line as does her half-brother.

At the same time, as we move from *Li Shuangshuang* to *Ermo*, an increasingly pivotal role is given to the truck driver. The most important truck driver of the four, who fails to deliver in the end, is of course Blindman in *Ermo*, whose personal failure is made unmistakable in a critical situation when he simply cannot start his outmoded truck to save a life. Throughout the film the truck is an apt symbol of the process in which a modernizing society tries to graft the new onto the old. Similarly, the truck driver in *Scented Souls* cannot deliver in the end either. A city dweller through marriage, he is much too mobile and pleased with himself to face real difficulties or responsibilities. His hurried and undignified departure from a scene of crisis, therefore, is an appropriate exit.

In comparison with these two truck drivers, Hehe in *Wild Mountains* is the image of a purposeful, determined adventurer. Driving a truck is one way of making money, and his hard labor pays off when he comes home on a hand-tractor that is his legitimate property. Hehe's transformation through mechanized mobility is so profound that when he returns triumphantly, even his only "buddy" in the village fails to recognize him at first. If these three truck drivers have an origin in the countryside, they each indicate a different form of uprooting oneself from the rural way of life and its mentality. In contrast to them, the truck driver Xiao Wang, a peripheral character in the comedy of *Li Shuangshuang*, is charged with representing the socialist city and its humble superiority. Thus we see Xiao Wang invited to meet the young woman Guiying by her parents, whose wish is for their daughter to marry a city person. Beseeched by the young woman to intervene, Shuangshuang our heroine intercepts Xiao Wang outside the village, explains Guiying's intention to stay in the countryside, and wins his understanding and support. The truck driver stops on the outskirts of the village, and he walks back to the city full of admiration for people committed to building up a new countryside.

From these characters as well as the dramatic conflict of the four rural films, we assemble a complex and multifaceted narrative about the historic transition from high socialism to post-socialist consumerism, or, in a different register, from New China cinema to the more contemporary and more broadly defined Chinese cinema. Yet it also emerges as a deeply ambivalent narrative because we are compelled to see each of its episodes, or chapters, as a complex present moment, rather than as a passing scene in a story hurtling toward a happy ending. This overarching narrative invites sobering reflection and interrogation because we realize these cinematic works each allow a different entry point, and not all visions or resolutions

contained in them are in alignment. We also become aware that we can hardly appreciate each film, or film as visual expression in general, without endeavoring to assemble a capacious historical narrative at the same time.

We therefore engage ourselves most actively when we view these films sequentially or comparatively, as visual objects whose connections with and revisions of each other we must discover and sort out. It is just as revealing, for instance, to regard *Ermo* as a realistic corrective of *Li Shuangshuang* as it is to view the latter as an imaginative overcoming of the former. Through juxtaposition and recombination, we witness how these past creations acquire a new look and exhibit new meanings. New China cinema, viewed in such light, continues to be relevant insofar as it lets us see where a past vision failed to materialize, and why that vision still lingers and succeeds in interrupting too complacent a view of the present. Our study of contemporary visual culture in China, by extension, becomes meaningful when we recognize rather than dismiss those past visions.

NOTES

1 For a description of film genres developed between 1956 and 1964, see Paul Clark, *Chinese Cinema: Culture and Politics since 1949* (Cambridge University Press, 1987), 94–124.

2 That all four films under discussion are adaptations of previously published literary texts is no coincidence. It suggests that cinematic representations of the countryside are often mediated through a literary narration. Or, put differently, rural life becomes accessible to successful cinematic representation only when it is first rendered into narratives.

3 See Ke Ling, "Shilun nongcun pian: jiantan dianying de minzuhua, qunzhong-hua" (An Essay on Rural Films: Also on Making Cinema a National and Mass-Oriented Form), in his *Dianying wenxue congtan* (*Miscellaneous Essays on Cinematic Literature*) (Beijing: Zhongguo dianying, 1979), 120–39.

4 See Xie Fei's remarks in an interview, "Tiaowang zai jingshen jiayuan de chuangqian" (Looking out the Window of a Spiritual Home), *Dianying yishu* (*Film Art*), no. 3 (1995), 38–46, esp. 42. One of the reasons for Zhou Xiaowen to switch to a rural film such as *Ermo* in the 1990s was also his realization that organizers of foreign film festivals had no interest in Chinese urban films. See Zhou Xiaowen's interview during the shooting of *Ermo* in October 1993, "Zhou Xiaowen, bei dianying kesi de daoyan" (Zhou Xiaowen, a Director Beset by Cinema), *Dianying yishu*, no. 2 (1994), 45–9, esp. 48–9. For an informative overview of this issue, see Yingjin Zhang, "The Rise of Chinese Film Studies in the West," in his *Screening China: Interventions, Cinematic Reconfigurations, and the Transnational Imaginary in Contemporary Chinese Cinema* (Ann Arbor: University of Michigan Press, 2002), 43–113.

5 Foreign investment allowed Zhang Yimou to do the final editing with a 35:1 ratio between film shot and film used, compared with the standard 4:1 ratio in the Chinese film industry at the time. The film won the Golden Rooster Award in 1993 and helped create the category of "joint-production films" for the prestigious award.

6 Richard King, "Introduction," in Richard King, ed., *Heroes of China's Great Leap Forward: Two Stories* (Honolulu: University of Hawaii Press, 2010), 1. "A Brief Biography of Li Shuangshuang," translated by Johanna Hood and Robert Mackie with Richard King, is collected in this volume, 15–62. King's presentation of the Great Leap Forward in the introduction is succinct and informative.

7 For a recent study of the various adaptations of *Li Shuangshuang* and the search for national forms, see Krista Van Fleit Hang, "Creativity and Containment in the Transformations of Li Shuangshuang," in her *Literature the People Love: Reading Chinese Texts from the Early Maoist Period (1949–1966)* (New York: Palgrave Macmillan, 2013), 57–90.

8 King, "Introduction," 8.

9 *Li Shuangshuang, cong xiaoshuo dao dianying* (*Li Shuangshuang, from Short Story to Film*) (Beijing: Zhongguo dianying, 1963).

10 Chris Berry, "Sexual Difference and the Viewing Subject in *Li Shuangshuang* and *The In-Laws*," in Chris Berry, ed., *Perspectives on Chinese Cinema* (London: BFI Publications, 1991), 38.

11 Clark, *Chinese Cinema*, 105.

12 "It was the antipatriarchal Chinese revolution and state feminism that generated an unusually close relationship between feminism and socialism in China," observes Lin Chun in *The Transformation of Chinese Socialism*, 126–7. See her discussion of "egalitarianism's pride and price: gender equality" (113–28) for an analysis of the complex relationship between women's liberation and the socialist revolution.

13 I would contend that Li Shuangshuang is the central positive character rather than another middle character, who, as Paul Clark suggested, is "simply confused and uncertain." See Clark, *Chinese Cinema*, 106. Tony Rayns' elliptical characterization of the film as "a lively satire on the fight for female equality in the rural communes of the early 1960s," to my mind, may be misleading. See Rayns, "The Position of Women in New Chinese Cinema," *East-West Film Journal*, vol. 1, no. 2 (1987), 42.

14 For an informative discussion of the film, see Anne T. Ciecko and Sheldon H. Lu, "*Ermo*: Televisuality, Capital, and the Global Village," *Jump Cut*, no. 42 (1998), 77–83.

15 For a useful introduction to the film's plot and message, see Ma Ning, "Symbolic Representation and Symbolic Violence: Chinese Family Melodrama of the Early 1980s," in Wimal Dissanayake, ed., *Melodrama and Asian Cinema* (Cambridge University Press, 1993), 29–58.

16 See "*Yeshan* tantao lu: 1985 nian gushipian chuangzuo huigu zuotan zhiyi" (Discussions of *In the Wild Mountains*: One of the Round-Table Reviews of Feature Films Made in 1985), *Dianying yishu*, no. 1 (1986), 12.

17 See Ni Zhen, "Cong 'danhua biaoyan' shuoqi" (On "Reducing Performance" and More), *Dazhong dianying* (*Popular Cinema*), no. 5 (1986), 6.

18 This happens when Xiwang, the momentarily repentant husband, returns home from a journey to town, only to find a group of people gathering in the front yard of his home. Following his view, we see his associates, all in dark clothes, standing in front of Shuangshuang, who wears a bright shirt. It quickly becomes clear that she is defending the right of a young woman to choose her own boyfriend in the village. The subsequent shots and camera

movement put the viewer in the position of one of those encircling Shuang-shuang, with well-defined medium shots of the heroine to add force to her rebuttal. When pressured by those present to make a choice between sup-porting his wife or his cohort, Xiwang appears frustrated with Shuang-shuang's meddlesomeness and yet unable to bring himself to chastise her. His extreme displeasure is shown through a close-up, as if seen by Shuang-shuang, and we see him barge out of the front yard, again from the perspec-tive of a bystander.

19 Stationary long takes are very effectively used in *Wild Mountains*. They both reflect the slow pace of rural life and capture the gradation of emotional changes.

20 Jerome Silbergeld, "The Veil of Tradition: Victims, Warriors, and the Female Analogy. *Army Nurse. Woman from the Lake of Scented Souls*," in his *China into Film: Frames of Reference in Contemporary Chinese Cinema* (London: Reaktion Books, 1999), 171.

21 Dai Jinhua, "*Ermo*, xiandai yuyan kongjian" (*Ermo*, the Space for a Modern Allegory), *Dianying yishu*, no. 3 (1994), 43.

22 See Wang Yichuan, "Rushi biaoyan quanli jiaohuan yu chongfu: Zhou Xiaowen zai *Ermo* zhong di huayu lixian" (Realistically Demonstrating the Exchange and Repetition of Power: Zhou Xiaowen's Discursive Adventure in *Ermo*), *Dianying yishu*, no. 3 (1994), 44–7.

23 The television set, in other words, grows into the psychoanalytical *objet petit a* that redefines Ermo's relationship with reality and herself, even after its inanimate quality is exposed by the power failure, for the *objet petit a* is nothing but the object-cause of desire, an empty form filled out by fantasy. As Slavoj Žižek elaborates, the *objet petit a* may be an ordinary, everyday object, but once perceived by a gaze permeated and distorted by desire, it "starts to function as a kind of screen, an empty space on which the subject projects the fantasies that support his desire, a surplus of the real that propels us to narrate again and again our first traumatic encounter with *jouissance*." Slavoj Žižek, *Looking Awry: An Introduction to Jacques Lacan through Popular Culture* (Cambridge, MA: MIT Press, 1991), 133. That the television set serves as a blank screen for staging fantasies is further illustrated in the film when Ermo, upon returning to the department store the next day and finding it closed for inventory taking, peers through the window and looks longingly at the television.

24 For a relevant discussion, see David Morley, "Television: Not So Much a Visual Medium, More a Visible Object," in Chris Jenks, ed., *Visual Culture* (London: Routledge, 1995), 170–89.

25 According to Ciecko and Lu, these scenes are from *Dynasty*; see their essay "*Ermo*," 82–3.

26 For an extended reading that turns the film into an occasion to theorize the relationship between rural China and globalization, see David Leiwei Li, "'What Will Become of Us If We Don't Stop?' Ermo's China and the End of Globalization," *Comparative Literature*, vol. 53, no. 4 (2001), 442–61.

27 See Jia Pingwa, "The People of Chicken's Nest Hollow," trans. Suzanne Convery, in *The Heavenly Hound* (Beijing: Panda Books, 1991), 92–267. (Guilan's character in the novella is named Yanfeng instead.)

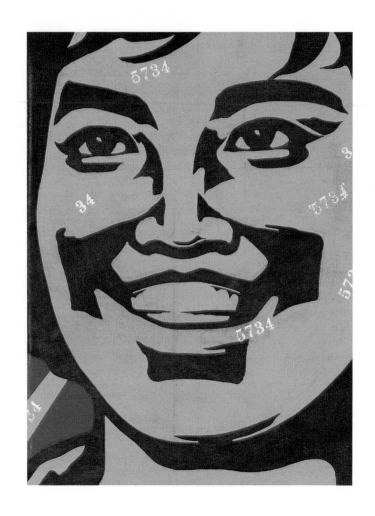

*What does socialist visual experience
mean to contemporary art?*

> An artist may not be able to solve any problems, but it is his basic
> professional duty to raise questions by means of his art and to endow
> his work with signs of intellectual reflection.
>
> Wang Guangyi, 1990[1]

A central figure in the fast-moving and globally connected story of con-
temporary art from China, a story often narrated in close parallel to the
growing prominence of the Chinese economy since the early 1990s, is no
doubt Wang Guangyi (1957–). Best known since the early 1990s for his
Great Criticism series, Wang is described in many surveys and art-historical
accounts as the defining Political Pop artist, a Chinese Andy Warhol with a
poignant political thrust. His bold, poster-like images of Chinese socialist
subjects, be they workers or Red Guards, charging at Western consumer
brand names such as Coca-Cola and Louis Vuitton, splice together dispar-
ate visual icons and logos and often provoke bemused, if also confused,
responses.

International excitement over this refreshing turn in Chinese art was
first registered by *Flash Art: The Leading European Art Magazine*, when it
featured on the cover of its January/February 1992 issue *Great Criticism:
Coca Cola*, the first mature work in what was to become a seemingly
endless series. Almost overnight, Wang Guangyi himself became a hot
brand name and a poster-child for the spectacular success of Chinese
contemporary art. In 2007, Howard Farber, a New York art collector,
who a decade before had paid $25,000 for Wang's *Coca Cola*, raked in
$1.59 million when he sold it at auction in London. Aware that this
particular work had become "the most reproduced image of Chinese
contemporary art," the collector remarked that "every story in any maga-
zine or book about Chinese art would probably use this image."[2] He seems
to have been proved right about Wang's work becoming an icon of
Chinese art, the latest example being the dust cover of *A History of Art
in Twentieth-Century China*, a lavishly illustrated and monumental tome
published by Charta in 2010. The same Howard Farber had also famously
described *Great Criticism: Coca Cola* as "the Mona Lisa of Chinese con-
temporary art" (Figure 4.1).[3]

Indeed, any narrative of the development of Chinese art from the mid
1980s to the twenty-first century would be incomplete without discussing
or reproducing one or more works by Wang Guangyi. Yet the artist
maintains his relevance through far more than a paradigmatic image such
as his *Coca Cola*. By extending his *Great Criticism* series to target a wide
range of objects, from consumer goods to institutions, Wang single-
handedly popularized a playful and fractured way of looking, which allows
a society caught in rapid transformation to see itself with a sense of humor,
estrangement, and maybe unsettled resignation. His work, as art critic Li
Xianting observed early on, has not only influenced many other artists,
but has also spawned a unique Chinese manner of speaking in the

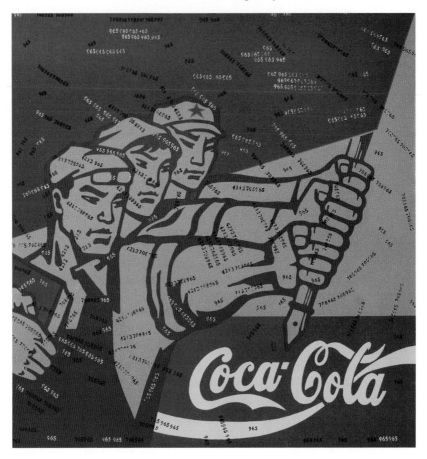

4.1 Wang Guangyi, *Great Criticism: Coca Cola*, 1990–93, oil on canvas.

post-ideological era.[4] In recent years, spinoffs of *Great Criticism* would frequently pop up in the form of internet graphic design or an advertising billboard. What Wang Guangyi initiated and popularized is indeed a distinct and capacious visual pattern and code.

As an artist with considerable popular appeal and tremendous market success, Wang Guangyi enjoys much critical acclaim as well, especially after a November 2002 retrospective exhibition. The retrospective was held at the government-funded He Xiangning Art Museum in Shenzhen and amounted to an official recognition of Wang, along with Zhang Xiaogang (1958–) and Fang Lijun (1963–), as a pioneer who, working outside the established system of support for artists, has made a deep impact on contemporary Chinese art and visual culture. Titled *Image Is Power*, the exhibition was presented as part of a research project on the history of contemporary art. It signaled a forceful assertion of contemporary art, up until then largely regarded as independent or even dissident, as well as a

new critical discourse, in the increasingly diversified field of cultural production. It was also clear that the curators sought to appreciate these prominent artists in the context of contemporary Chinese art and cultural history. Images created by Wang Guangyi, Zhang Xiaogang, and Fang Lijun are particularly powerful because, in the words of the curators, their highly sensitive, original artwork "has infused contemporary Chinese art with a steady tension between reality and idealism." What the three featured artists have in common, furthermore, is "the provocative means and historicist approach that they employ in their reflections on the profound changes in our lives and experiences."[5]

Wang Guangyi continues to be provocative, as he keeps a keen eye on the changing cultural landscape and responds to it by turning to look ever more deeply into historical experiences, both personal and global. He is also known for his bold and intriguing, if sometimes enigmatic, remarks at interviews and not infrequently does he find himself caught up in debates and controversies.

In 2008, art critic Huang Zhuan, who was a co-curator of the earlier *Image Is Power* exhibition, organized a comprehensive retrospective devoted entirely to Wang Guangyi. A close observer of Wang's work, Huang Zhuan intended to examine through the new exhibition Wang Guangyi's "visual politics" and to uncover a different artist than the mythologized "father of Chinese Political Pop." He evidently wished to counter a simplistic reading of Wang Guangyi, either as a belated Andy Warhol, or as provocateur for a given cause.[6] To resist a facile endorsement or rejection of Wang's work based on a narrow view of what constitutes politicality, the art critic called for a firm grasp of the internal logic as well as conceptual operations underlying the artist's creativity. It is clearly a sensible and productive approach. Yet in portraying the artist as a masterful strategist who, with no specific position or commitment of his own, takes pleasure in triggering new visual sensations at opportune moments, Huang runs the risk of neutralizing Wang Guangyi's politics altogether.

For instance, insightful as his study is of a commercialized Wang Guangyi, Huang Zhuan may have difficulty in accounting for the continuing relevance of a pivotal notion such as "socialist visual experience" to Wang's work. With this notion, which he began elaborating around 2000, the artist claimed not only a historical memory and artistic resource, but also a cultural identity. It is a theoretical concept that compels him to regard the present historically and to position himself in a critical relationship with other visual practices and regimes. As we will discuss in this chapter, through the concept of a "socialist visual experience," Wang Guangyi voices a pluralistic understanding of history and eventually arrives at a critique of the institution of contemporary art. The concept, in other words, helps us recognize successive stages in the artist's development.

BEGINNINGS

More directly than any of his contemporaries, Wang Guangyi has since 2000 expressed a desire to reexamine the "socialist visual experience." He has also stated repeatedly that his goal is to revive, or to return to, a "socialist spirit." It is tempting to regard Wang's claims as a gimmick or idiosyncrasy, as some commentators have readily done, just as it is hard for many others to believe that a market-savvy and best-selling artist of *Great Criticism* fame should be at all interested in a disavowed mode of cultural production that was organized around a systemic rejection of market mechanism and the exchange value of art. Wang himself is acutely aware of the seemingly disingenuous contradictions between his professional success and his beliefs. In a 2008 interview he lamented that regardless of what he had to say nowadays, most people would probably think of only one term: show off! He could even hear their unspoken retort: "With all the money under your belt, what business do you have talking about what you are talking about?"[7] Wang's frustration was profound. He accused a mercantile society of treating works of art as nothing but objects for possession, and vowed to make society appreciate the true value of art through his work.

Yet the "socialist turn" in Wang Guangyi was far from an abrupt departure or fiction. The fact is that a critical moment in his evolution as a contemporary artist was pivoted on the discovery of visual materials from the socialist era. This rich resource has ever since the late 1980s served as a key element in Wang's artistic vision and conceptual explorations. We should therefore view his call to revisit the socialist visual experience at the turn of the new century as acknowledgment of a latent but enduring search. As we will also see, "socialist visual experience" was the artist's thoughtful response to a rapidly changing world as well.

We may locate the moment when Wang Guangyi discovered the critical potential of visual materials from the socialist era in a work that he made in 1988. On a 22 cm × 21 cm black-and-white photograph of Chairman Mao waving to Red Guards from the rostrum in Tiananmen Square during the Cultural Revolution, Wang drew six thick horizontal lines over five equally steady parallel vertical lines with a marker and called it *Waving Mao Zedong: Black Grid*. Not unlike graffiti, the neat grid of dark lines converted the photograph from a magazine into a ready-made. As art historian Lü Peng comments, the artist accomplished, in a Duchampesque manner, a calculated remaking of a once sacred printed image and effectively, in fact playfully, altered our relationship to it (Figure 4.2).[8]

In the few years leading up to this moment, Wang Guangyi had dedicated himself to creating a number of series called *Post-Classical*, *Red Rationality*, and *Black Rationality* respectively. In those succeeding experiments, he would subject iconic images in Western art history, such as the

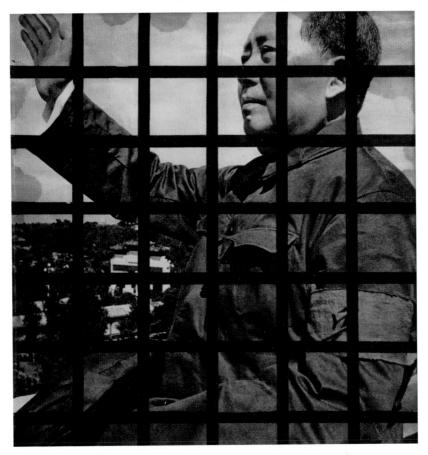

4.2 Wang Guangyi, *Waving Mao Zedong: Black Grid*, 1988, mixed media.

pietà, the *Mona Lisa*, and *The Death of Marat*, to a stoic and systematic revision and recodification. One source of inspiration for this analytical approach was E. H. J. Gombrich's theory of inherited "schemata" in perception and their revisions by succeeding artists in the course of art history. Gombrich's work on art and illusion was introduced to Chinese art circles in the mid 1980s, and the thirty-year-old Wang Guangyi quickly absorbed the gist of his theory justifying continual revisions. "It is Gombrich who has given me notions about schema/culture revisions as well as continuity," he remarked in 1987.[9] Another source of exciting new ideas for Wang and his generation was their exposure to American Pop artists such as Andy Warhol, Robert Rauschenberg, and Jasper Johns. The November 1985 Rauschenberg exhibition in Beijing, funded by the American artist himself, was an exhilarating eye-opener to many and sparked widespread interest. After seeing the show twice at the China Art Gallery,

Yu Feng (1916–2007), an esteemed seventy-year-old woman artist and art critic, fell in love with the American "daredevil" and admired his ingenuity for "making the ordinary extraordinary."[10]

Waving Mao Zedong: Black Grid continued the rigorous and impassive analytical approach that Wang Guangyi employed in his *Red* and *Black Rationality* series, but it signaled a new departure. With this seemingly accidental but inspired work, the artist brought himself much closer to the spirit of Pop Art and experienced the thrill of making the contemporary world an object of his artistic revision. He began to look away from the hallowed but remote European masterpieces, and directed his gaze at his own lived visual environment. Soon enough, the conceptual implications of *Waving Mao Zedong: Black Grid* were played out on a large scale in *Mao Zedong – Red Grid No. 1*, a triptych in oil that won Wang unprecedented attention in the landmark and eventful exhibition *China/Avant-Garde*, which took place at the China Art Gallery in February 1989. The emotionless grid is still there and is evenly spread over the standard portrait of Mao, one of the most recognizable visual icons of the twentieth century (Figure 4.3).

According to Wang Guangyi, the grid was but a reference to a widely used device for properly transferring the portrait of Mao to a supersize canvas for public display during the Cultural Revolution years. By foregrounding a device that is meant to remain invisible, he brought to the fore the pictorial nature of a powerful political icon and compelled us to view the image differently and as assembled fragments. Both the image and its construction are presented as a deliberate process, and our viewing habit and assumptions are put to test. In an interview some twenty years later, Wang Guangyi would reject the suggestion that the grid is either American or specifically Mondrian-like, and he insisted that his action "was a gesture of deep respect toward Chairman Mao, meant to make him human."[11]

Indeed, Wang Guangyi would look back and consider the "Mao under the grid" series (altogether five oil paintings) that he finished in 1988 a major turning point in his career. In a 2004 interview with Li Xianting, the charismatic art critic instrumental in promoting Political Pop and contemporary art in general, Wang recalled his excitement at coming up with the idea of applying his analytical method to the image of Mao. The reason that he stopped reassembling Western classics and turned his grid to Mao was because he had been "unconsciously looking for something related to my own life." Critics may have had complex things to say about his *Post-Classical* imagery, but the artist never felt truly excited. Through *Mao Zedong – Red Grid No. 1*, however, Wang gained a new confidence as well as a new understanding: "One reason for the existence of contemporary art is that it must be related to your life experience." He reached a meaningful maturity, he later believed, when he brought Mao Zedong onto his canvas, because it made him better see what to do next. Portraits of Mao had been an intimate part of his upbringing, and they also pointed

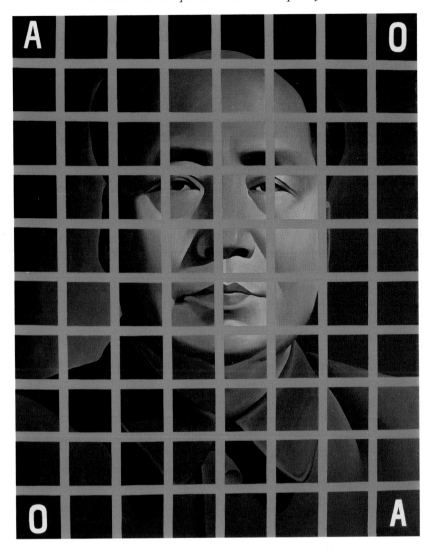

4.3 Wang Guangyi, *Mao Zedong – Red Grid No. 1*, 1988, oil on canvas.

to a potent and far-reaching visual order and mode of image-making. "Had I not made the 'Mao under the grid' series, I could not have gone very far with my art," reflected Wang in 2004.[12] What this early series ignited is an enduring interest in revisiting and reimagining the socialist visual culture produced in twentieth-century China.

By 1990, Wang Guangyi was already publicly announcing a reorientation in his art. With sweeping generalizations that were part of the earnest style of intellectual discourse in the 1980s, he sought to give contemporary art a distinctive identity and mission. Contemporary art differs from classical art on the one hand and from modern art on the other, he asserted, because a

contemporary artist no longer subscribes to either the classical myth of "depiction" or the modern myth of "creation." Instead, a contemporary artist regards existing visual images and cultural artifacts with a dispassionate, analytical eye and studies such materials as in an academic discipline. Wang conceded that such a rational approach to "cultural remnants" could be a demanding affair, which explains why even a prominent contemporary artist such as Joseph Beuys would occasionally retreat to the realm of mythologies. Yet without dispensing with ontological myths about art, which Wang attributed to "humanistic passions," one would not be able to acquire a "language that experiments with logic." Nor could one hope "to enter into a problem-solving relationship with art." Wang then declared his calling as a contemporary artist was to "provide a logical solution to mythological problems."[13]

The language of this seminal 1990 essay by Wang Guangyi is occasionally opaque, even impenetrable, but his embrace of contemporary art is loud and clear. For him, contemporary art is to be driven primarily by conceptual innovations, by methodical analyses and revisions of prevalent artistic conventions. It demands a mode of abstract thinking that enables a discerning but also disciplined view, which in turn transforms an artist's relationship to "cultural artifacts from the past." It is this perceptual realignment that opens up an opportunity for the artist to assert his presence, and to make his art speak to his contemporary world.[14] "Contemporary" therefore designates more than a temporal awareness; it prescribes a present intervention that reorders existing forms and hierarchies. The compelling force behind contemporary art, Wang observed in conclusion, is the cultural condition in which an artist finds himself. An artist may not be able to solve any problems, but he ought to raise questions by means of his art and charge his work with critical intelligence.

In the same essay Wang Guangyi also introduced several of his recent works as evidence of his commitment to the concept of contemporary art. One of them was the *Great Criticism* series, which he began creating in 1990.

DOUBLE VISION

His distaste for myth-making in art notwithstanding, the moment that brought forth Wang Guangyi's *Great Criticism: Coca-Cola* is often mythologized in various accounts that he himself has proffered over time. One story has it that the artist was inspired when, working in his studio one day, he caught sight of a pack of cigarettes lying on top of an old political poster.[15] Wang would also recall drinking from a can of Coke as the epiphanic moment.[16] Regardless of its genesis, the series of medium-sized oil paintings collectively called *Great Criticism* quickly attracted attention when it appeared in 1990, because the images were both familiar to Chinese viewers and yet entirely unexpected. By 1992, these works would

already be hailed as "Political Pop" par excellence, and Wang Guangyi anointed as father of Pop Art with Chinese characteristics once and for all.

The initial exposition on *Great Criticism* that Wang Guangyi provided in his 1990 essay would serve as a basic interpretive framework for many commentators over the next few years. In this series of works, Wang explained, "I combine images of workers, peasants, and soldiers from the 'Cultural Revolution' with those imported commercial graphics that have filtered into the everyday life of the public today. Cultural elements from two different time periods therein cancel out each other's essential content in a relationship of irony and deconstruction, and an absurd but total emptiness emerges."[17] Variations on this reading would follow, and most commentators would note the effect of irony and a comical mismatch. Art critic Li Xianting, for instance, agreed that by willfully directing Cultural Revolution-style mass criticism against Western commercial culture, Wang achieves "a humorous and absurd effect that yet carries with it an implied cultural criticism."[18]

A more developed reading came from art critic and historian Lü Peng when he sought to explain why *Great Criticism* was both unsettling and amusing to a Chinese viewer. Well acquainted with Wang Guangyi's work and interests, Lü Peng sees the series as an exemplary case in which the artist acted on Gombrich's theory and elevated revisions of visual schemata to the level of cultural critique. At the heart of the composition, he observes, is a striking monochromatic "historical visual schema" – a familiar image that triggers involuntary and painful memories of a recent past. Yet working with the rhetoric of Pop Art, the artist nonchalantly replaces the objects of deadly mass criticism, which used to be either political enemies or symbols of traditional culture, with familiar commercial logos. A viewer, therefore, is first disoriented and then startled when he or she realizes the targets of denunciation are signs and logos ubiquitous in contemporary everyday life, and that "mass criticism" of the past turns into a "great criticism" of the present. It is as if criticism conducted in a bygone era were extended and deferred to the present moment. At the same time, the once richly symbolic figures in *Great Criticism* appear helplessly ridiculous, as they are cut off from their historical context. And the ideas they embody also appear hopelessly outlandish. Through an operation akin to what Jacques Derrida names "*différance*," Lü Peng claims, Wang Guangyi gains a "genuine critical dimension," a dimension not seen in American Pop artists such as Warhol, Lichtenstein, or Rosenquist.[19]

Insightful and endorsing as his reading may be, Lü Peng nonetheless does not fully explain where the critical dimension of Wang Guangyi's work resides or comes from. He asserts that *Great Criticism* confronts current political issues, but he does not address the question of which political issues or what the artist's politics may be. In addition, there is an evident unease with the striking monochromatic image at the center of Wang's canvas. The formulaic rendition of workers, peasants, and soldiers

(the socialist trinity) is in the critic's eye a past instrument of political oppression, a symbol of proletarian dictatorship. And the contemporary viewer is expediently presumed to be a victim in the previous political culture, an object of mass criticism rather than an active agent or subject. What startles this hypothetical viewer/victim in Lü Peng's reading is first of all the spectral return of a nightmare, which the critic refers to as "an unbearable history." But there is another shock in store, as the viewer realizes his contemporary surrogates in this nightmarish vision are nothing but Western commercial logos. Maybe this is why the viewer/victim in Lü Peng's account desperately needs to find the spectral figures ridiculous and laughable. He cannot bear to see himself ridiculed or struggled against once again.

At the heart of Lü Peng's critical insights lies a blindness attributable to a reactive and consensual negation of the Cultural Revolution, a negation mandated by a disavowal of the complexity and aspirations of the recent past. It is a blind spot that lets the art critic see only reduced aspects of images retrieved from the Mao era, and keeps him from fully grasping what constitutes Wang Guangyi's cultural critique.

An even more one-dimensional reading of *Great Criticism* may be found in the accusation that "most Political Pop artists are ambivalent about the Cultural Revolution and Mao's ideology." By "ambivalence," Gao Minglu, another influential art critic and historian active since the 1980s, meant a lack of resolute rejection of, or even an inexcusable flirtation with, the terrifying Mao era. Those Political Pop artists, he complained, "glorify the persuasive power and unique aesthetic of Mao's propagandist art," and Wang Guangyi's placing of propagandist art next to consumer mass culture epitomizes the "double kitsch" that is Political Pop. Writing in 1998, Gao Minglu was critical of a strategy that marketed Political Pop as an independent avant-garde in order to cater to an international art community still clinging to a Cold War geopolitical imagination. His point was that Political Pop and Cynical Realism, the other best-selling brand of Chinese art in the early 1990s, were neither independent nor avant-garde, but an odious "combination of ideological and commercial practices." In portraying Wang Guangyi and other Political Pop artists as money-grabbing "career artists" in cahoots not only with the current regime but also with Maoist legacies, however, Gao Minglu seemed to be urging the international art community to renew its Cold War anti-communist vigilance and commitment.[20] And his dismissal of *Great Criticism* as "a kitsch advertisement of an advertisement" hardly addresses the complex reactions that Lü Peng began to describe.[21]

The label of "double kitsch" coined by Gao Minglu was utilized by another critic in a discussion of various avant-garde positions in Chinese contemporary art. Norman Bryson saw in *Great Criticism* a pessimism that is exceptional. "The aspirations active in the social field on each side of the

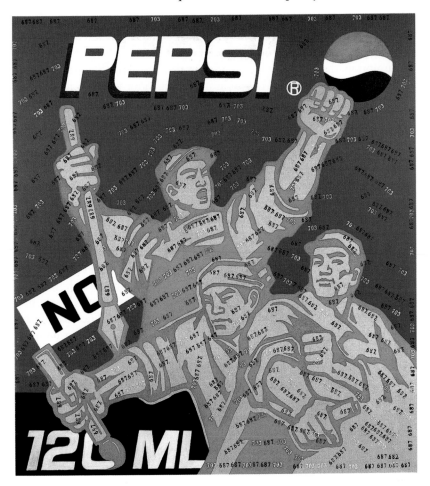

4.4 Wang Guangyi, *Great Criticism: Pepsi*, 1998, oil on canvas.

dual system (modified socialism, modified capitalism) are mocked and negated by reducing both to a level of kitsch design: each system is treated as a set of debased signifiers and formulae, as though both systems were already essentially dead."[22] This observation may remind us of Wang Guangyi's own remark about "an absurd but total emptiness" with regard to *Great Criticism*. Yet what Wang juxtaposes on his canvas are not two contemporaneous, or equally dead, sign systems. Rather, he retrieves a vanished image and pits it against a contemporary state of affairs that is self-evident and writ large (Figure 4.4).

The non-synchronicity of the two visual systems that Wang Guangyi brings together on a flat surface is of critical importance. The two systems may share the same background of loud primary colors, but the present moment belongs to Western brand names, and the Chinese political

subjects are an afterimage of a once strident but now muted era. Those pervasive commercial logos are at once abstract and concrete, distant and yet tangible, and they form a contemporary hieroglyphics of desire and consumption that claims to be a universal language. By contrast, those afterimages of the socialist trinity are formulaic and faded, but they still possess sharp and robust lines and movements, and they exude a purposeful, if now apparently misplaced and spectral, self-confidence.

The compositional device of *Great Criticism* is juxtaposition, which foregrounds the distance between two contrastive systems by holding them in intimate proximity. It is a device that effectively reveals a structural incompleteness, because only fragments, instead of totalities, of different systems can be presented in juxtaposition. This is how the most powerful and emblematic symbol of a given system, be it socialist or capitalist, becomes exposed as but a sign of a limited and parochial vision or reach. This is also why Wang Guangyi believes his work establishes a relationship of irony and deconstruction, which in turn allows the truth claims of two disparate time periods to cancel each other out. When we see both belief systems as inherently incomplete, as Wang observes perceptively, we find ourselves looking over an "absurd and total emptiness." The absurdity is complete because there is no positive term or value for us to embrace wholeheartedly, and because our desire to identify with or hold onto either of the two debunked systems is itself shown to be absurd.

This is evidently the effect that many critics, including the artist himself, appreciate and associate with deconstruction and a Derridean *différance*. Li Xianting, for instance, sees in "the seemingly arbitrary combination" a "humorous and absurd effect" mixed with a biting satire. Yet while juxtaposition serves as an expedient deconstructive device, the real conceptual breakthrough occurs at the moment when the artist decides what to juxtapose or simply what to see. It is a breakthrough informed by Wang Guangyi's commitment to methodically examining "cultural artifacts from the past," and to finding a "language that experiments with logic" through his art. In the visual materials of an era that was universally believed to be bankrupt and passé, he found a new resource, a way of seeing beyond the current visual regime. His innovation consisted, therefore, in bringing the remnants of a past imagination back into our view and inserting them as a stubborn, unresolved remainder in the contemporary system of meaning or visual order.

The *Great Criticism* series therefore introduces a new way of seeing, through which we are enabled to see not only incongruous signs and fragments, but also different historical formations and subjectivities. Amid the rising consumerist landscape, Wang Guangyi reactivates the spectral afterimage of a socialist past and splits our vision. Refracted through his canvas, the desiring gaze that we direct at a consumer product such as a can of Coca-Cola or a Nikon camera becomes distracted and perverted by a

peripheral object. Our gaze is led through a distant scene that is at once outlandish and familiar, at once inexplicable and vaguely exciting. No longer in full possession of our gaze, we begin to see ourselves mirrored in the afterimage, or rather see ourselves misrecognized, and as we moment-arily lose our concentration, the commodity in front of us also loses its allure and promissory power. At this point, we may seek relief in laughing out aloud or in bemoaning a general absurdity, but the fact is that our gaze has been rendered asunder and made incoherent.

The cultural critique of *Great Criticism*, therefore, stems not from a past critical gesture being transposed onto the present, but rather from a fragmentation of the current visual order. Wang Guangyi's work at this stage concerns not so much different political visions, as it does the politics of vision. Or, as Jacques Rancière would say, it enables a redistribution of the sensible, a practice that we will discuss more below.

SOCIALIST VISUALITY

In March 1991, soon after the *Great Criticism* series began appearing, the *Beijing Youth Daily* devoted a special section to "the Wang Guangyi phenomenon". Presenting the artist as a leading figure as well as a "com-plex entity filled with contradictions," editors of the special section called attention to Wang Guangyi's statement that society always selects its artists for either success or failure. They were happy to take Wang's latest work as a sign that contemporary art was becoming more accessible, since *Great Criticism* seemed to exemplify the idea of art "from the masses and to the masses." In his interview with the newspaper, Wang remarked: "As far as contemporary art is concerned, it ought to be, it seems to me, a reorganiza-tion of shared public experiences. It affects everyone, is a large-scale 'game,' and compels the public to participate in it."[23]

Wang's statement on the public nature of contemporary art underlines the exciting possibilities that came with his new self-positioning with regard to the object of his art. He put much emphasis on a shared public visual environment or culture, and suggested that the artist's task was to enable the public to relate to it anew and differently. Given the context of his recent work, it was clear that he believed the Cultural Revolution had generated a public, shared visual experience. Yet in the interview he chose not to dwell on this important source of his latest work, lest his treatment of visual materials from the Cultural Revolution should pose a troublesome question to the current mainstream consensus, which was eager to dismiss the decade of 1966–76 as an unprecedented and unmitigated catastrophe willfully inflicted on Chinese society and culture by Mao himself.

On this occasion Wang's decision was to let the images speak for themselves. For a viewer with either experience or knowledge of modern

Chinese visual culture will recognize that those resurrected images of workers, peasants, and soldiers engaged in "great criticism" bespeak a socialist mass culture, specifically a strident visual culture produced and broadly disseminated through much of the Cultural Revolution. It was a resolutely public and vociferous visual culture, sustained by artistic practices that had no comparable precedents in scope or scale. A distinct visual grammar and vocabulary emerged from the Cultural Revolution, as did radical understandings of art and innovative methods of making art. Mobilized as a vital instrument in a grassroots revolt against the old world and existing structures of power, art was itself subjected to far-reaching critiques and reclaimed as a necessary part of the collective effort to implement a socialist transformation in the visual sphere and experience.

The most concentrated and most radical expression of this desire to create a revolutionary visual culture was the Red Guard art movement that reached its explosive peak in 1967, hardly a year into the violent *Sturm und Drang* of the Cultural Revolution. The onset of the Great Proletarian Cultural Revolution is usually dated to May 1966, when the Central Committee of the ruling Communist Party issued a circular to the party and the entire nation. The document exposed deep ideological divisions within the leadership, and called on party members and general citizens faithful to Mao Zedong's program of a cultural revolution to rise up and seize power from the reactionary capitalist authorities now dominating various cultural institutions, such as education, academia, the press, literature, and the arts.[24] Within weeks, posters aggressively denouncing school administrators for political insidiousness appeared on a university campus in Beijing. When Mao hailed them as "the first Marxist-Leninist big-character posters in the nation" a few weeks later, the fury of a youthful revolt was fully unleashed.

Many complex factors, from political infighting to geopolitical pressures, from philosophical disagreements to demographic shifts, led Mao to launch a grassroots revolution against the social order and cultural establishment of the very New China that he had envisioned, brought forth, and presided over. It was far from a whimsical or deranged decision. On the contrary, a true revolutionary, Mao had long believed in a constant revolution in culture and consciousness as a necessary antidote to the Soviet-style ossification of the spirit of socialism in the form of bureaucratic institutions and compartmentalization. Through a cultural revolution, he sought to address, as the historian Arif Dirlik put it succinctly, "a basic problem of socialism in power: that socialist societies are as vulnerable as any other to producing structures of power that attenuate the revolutionary vision of freedom and equality."[25]

Sensing that few in the leadership were as committed to fighting revisionist inertia and deviation, Mao placed his hope on idealistic youth to revitalize the revolution independently of the system. Red Guards,

consisting of members of the generation born after the Communist victory in 1949, thereby emerged in the summer of 1966 as the "earnest vanguard of the Cultural Revolution." They were college and high school students, who organized themselves in a paramilitary fashion, and who viewed it as their grand historic mission to defend Chairman Mao and eradicate his enemy, which consisted of both the current power structure and traditional values and practices. Their youthful faith was expressed in a popular battle cry: "Revolution is not a crime; to rebel is justified." Ardent in their desire to reclaim the revolutionary heritage, millions of Red Guards took pride in methodically plunging first Beijing, then the entire country, into a "Red Terror," resorting with pious passion to the theatrics of violence that the young Mao Zedong had eloquently endorsed with regard to the peasant movement in Hunan in the late 1920s.[26]

Integral to the passionate anti-establishment revolt of the Red Guard movement was a futuristic imagination that had bestirred different generations across the continents. The destruction of museums, libraries, and everything else redolent of *passatismo* that an ebullient F. T. Marinetti urged in his "Futurist Manifesto" in 1909, for instance, turned into an anti-traditional ritual, many varieties of which the Red Guards performed repeatedly and on a staggering scale. Unaware of such spiritual connections, the young Chinese revolutionaries took to heart the Futurist slogan "Except in struggle, there is no more beauty!" At the same time, Mayakovsky's Constructivist vision of city streets turning into brushes and public squares spreading out as palettes for artists engaged in building a new socialist life in Russia of the 1920s was taken as an inspiring blueprint for action. For a group of Red Guards from the Beijing Aeronautics Institute, an intense project over summer 1966 was to paint or spray every wall, gate, store front, and other public surface in the country so that a "red ocean" would arise and inundate the world as we knew it. The campaign of painting China red was short-lived, but it loudly proclaimed the symbolic value of the primary color in a revolutionary visuality. Ever since the late 1910s, Futurist poetics of modernity had held a lasting fascination to Chinese poets and artists, but for the Red Guard generation, life in the present was nothing but the future in the making. This future-present life was to be lived creatively as a work of art, just as art must become a vital part of a fulfilling life (Figure 4.5).

The Red Guard art movement not only conducted extensive experiments with new modes of making art, but also succeeded in producing a distinct visuality. By pushing to their logical extreme the fundamental tenets of a socialist visual culture, participants in the movement redefined art as well as the role of an artist and committed themselves to creating a far more comprehensive visual environment than mere fine art objects. They vowed to bring art back to life and rejected the notion of artistic autonomy as what had turned art into a superfluous and mystifying decoration. To return it to life meant to overcome the privileged

4.5 Red Guard artists at work, 1967, photograph.

institution of art and to make art a meaningful and accessible experience to the people. In the process, the artist was also to be transformed and become an art worker whose task, analogous to that of an industrial or agricultural worker, was to contribute to the new socialist imagination.[27]

On these core issues, the Red Guard art movement shared similar aspirations that have driven various avant-garde movements in other parts of the world, especially in early twentieth-century Europe. Some art historians have proposed describing and understanding it as a "red modernism,"[28] but it certainly was far from the variety of high modernist revolution in the realm of fine art celebrated by a Clement Greenberg. Others, especially some artists, prefer to see the Red Guard art movement, or Cultural Revolution art in general, as inseparable from, even foreshadowing, contemporary art. Xu Bing (1955–), a leading conceptual artist, for instance, found it impossible to deny the legacy of Cultural Revolution art. While in New York, he was asked how, as an artist trained in a conservative country such as China, he would end up making conceptually challenging art. Xu Bing explained that his artistic sensibility had everything to do with his experience during the Mao era. "I know that

my creative work reflects the genes of an artist with a socialist back-
ground," he wrote in 2008. "That is something which cannot be concealed
and will always reveal itself in the end."[29] On another occasion, Zheng
Shengtian (1938–), who participated in the Cultural Revolution as a young
artist and had his share of hardship and suffering, refused to disavow his
youthful passion and experience. He felt puzzled when an American
artist expressed sadness over what reportedly happened. "I appreciated
his sympathy," Zheng Shengtian wrote when reviewing his own career as
an artist. "But I think the efforts of members of my generation have not
been in vain. Many of us sought to create a new art for a new world,
as artists in other countries and other times had tried to do. Their
importance to the Chinese visual culture of the twentieth century cannot
be denied and their influence can still be seen in contemporary Chinese art
today."[30]

From the outset of the Cultural Revolution, its nature as a grassroots
protest movement was expressed in a blasting visual environment consist-
ing of aggressive posters, demeaning caricatures, and an uncompromisingly
bombastic graphics and language.[31] In 1967, Red Guard groups and
factions in fine arts academies published scores of journals and pamphlets,
through which they conducted "great criticism" of the existing institution
of art and issued their fiery manifestos, visual as well as textual. In June of
that year, *Fine Arts Storm*, a journal published by a Red Guard coalition at
the Central Academy of Fine Arts, proclaimed that the goal of the current
movement was to "Seize power! Seize power!! Seize power!!!" "We will
make the sky over the art field glowing with Mao Zedong thought, and the
ground underneath a warm and nurturing territory for workers, peasants,
and soldiers."[32]

Red Guard art groups from art academies also organized massive and
innovative art exhibitions in 1967, often in association with rebel groups
from other work units, even from the army. The series of large-scale art
shows in Beijing culminated in a spectacular national exhibition entitled
Long Live the Triumph of Chairman Mao's Revolutionary Line. It opened on
the National Day of October 1 and displayed over 1,600 objects ranging
from ink-and-brush paintings to oil paintings, woodcuts, posters, and clay
sculptures. Participating artists came from all over the country, and a large
number of them were amateurs from all walks of life. After its run at the
China Art Gallery, exhibition teams took some of the works and slides to
remote rural areas in order to extend their impact far and wide. In
November, *The People's Daily*, the party organ still firmly controlled by
Mao and his fellow radicals, endorsed the exhibition and identified its
three laudable features: the event was revolutionary in its theme, combat-
ive in its effect, and mass-based in its production. "The art exhibition
constituted a popularization as well as elevation of revolutionary artistic
practices among the vast masses of workers, peasants, and soldiers."[33]

While the most iconic work of art from the Cultural Revolution era was probably the oil painting *Chairman Mao Goes to Anyuan*,[34] the art form most favored by the Red Guard art movement was the black-and-white woodcut. The cultural as well as the political symbolism that the woodcut acquired in the twentieth century, in particular its position as a public, expedient, anti-elitist, and socially committed visual art, made it a logical choice through which to express the ethos of a grassroots revolution. Red Guard artists drew inspiration from the classics of modern Chinese woodcuts, some of which were directly influenced by German Expressionist works, and developed an energetic, assertive, and versatile graphic language. They also incorporated elements from satirical cartoons as well as folk art such as paper cutouts. Yet given their impatience for action in a rapidly unfolding revolution, young artists were seldom willing to spend the time working on wood blocks and then manually printing images. Instead, they would use a brush or marker to approximate the visual effect of a woodcut for mass-production. In the process, a highly recognizable visual style and idiom specific to the Cultural Revolution was developed and codified (Figure 4.6).

As the Cultural Revolution moved on, Red Guard art would gradually phase out as the Red Guard movement itself was fractured and eventually suppressed. By the early 1970s, an "art by workers, peasants, and soldiers," or amateur art created with the assistance of professionally trained artists, would be promoted as the new socialist art. A prominent example of such new art was the brilliantly colored peasant painting from Huxian county in

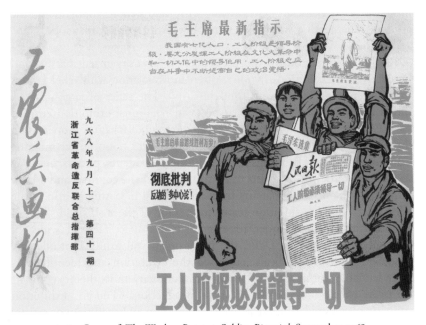

4.6 Cover of *The Worker–Peasant–Soldier Pictorial*, September 1968.

Shaanxi province.[35] Nonetheless, the visual idiom of the woodcut would still have a broad appeal and find itself translated or adapted in other media, such as oil painting, ink-brush painting, and advocacy posters.

One of the most common visual statements popularized by the Red Guard art movement in the late 1960s was that of a worker, peasant, and soldier as resolute cultural revolutionaries. The critical agents could change into Red Guards in paramilitary uniform and other groups as well. The visual impact of the image stemmed as much from the socialist subjects depicted in stark black outline, as if printed from a key wood block, against a background of vibrant red, as it did from a striking transformation of earlier renditions of the same subjects in the socialist age before the Cultural Revolution. No longer optimistic socialist constructors, they now appeared much more militant and more resolute, as they focused their denunciatory force on a given enemy, which could range from American imperialism to Soviet revisionism to capitalist values and practices. They were, in other words, already a modification of a prevalent visual paradigm. When they reappeared in Wang Guangyi's oil painting of the 1990s, they would undergo yet another change, or what the artist would call, following Gombrich, a revision of schemata (Figure 4.7).[36]

That Wang Guangyi would resurrect widely circulated but ephemeral and disposable print-based images on an oil canvas is therefore fraught with art-historical significance and self-consciousness. By amplifying those print images without leaving any gestural traces suggestive of an individual presence, he gave them an afterlife as contemporary Pop Art. He blew them up in a streamlined form for a more intense visual impact. Also, by juxtaposing them with globally recognizable commercial logos, Wang Guangyi accorded the images created by anonymous Red Guard artists an unexpected status. They are brought back as a competing, if also equally significant, universal visual language.

PLURAL HISTORIES

Apart from art-historical references, *Great Criticism* had momentous conceptual consequences as well. Through a fractured double vision, it affirmed the inevitability of dissensus, which Jacques Rancière at one point simply defines as the "manifestation of a gap in the sensible itself."[37] As a critical intervention, Wang Guangyi would come to identify and embrace a "socialist visual experience" in an effort to puncture the current visual order. He would become ever more invested in what had become a disavowed way of making art. This disavowal had taken place in the early 1980s when a reform consensus was reached in Chinese society after the Communist Party unequivocally denounced the Cultural Revolution as a grave error committed by Mao, who had died in 1976.

In a substantive interview with curator and art critic Charles Merewether in 2002, Wang Guangyi placed his creation of the *Great*

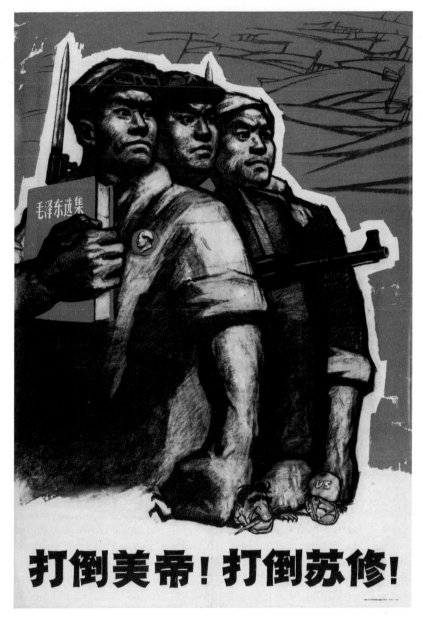

4.7 *Down with American Imperialism! Down with Soviet Revisionism!*,
February 1969, poster.

Criticism series in the context of profound changes in Chinese politics, culture, and economy that had occurred by the early 1990s. He clarified that when he proposed an analytical approach to art in the late 1980s, he was arguing against a tendency for an artist to be self-absorbed in

metaphysical reveries. He wanted to search for a way to reestablish the connection between art and social experiences. "In my view," Wang stated, "the real issue exposed in *Great Criticism* is the conflict between Western culture and socialist ideology. The meaning of this conflict may be better grasped through a study of different cultures than simply as an art problem."[38] This view on his most famous work has a different tenor from the artist's own initial exposition in 1990. He had suggested that by placing two cultural systems "in a relationship of irony and deconstruction," he was able to reveal or comment on "an absurd but total emptiness." By 2002, Wang Guangyi would underline the conflict that *Great Criticism* visualizes. Furthermore, he would argue that it was not a face-off to be dissolved through irony or sarcasm into nothingness, but an enduring conflict with global ramifications.

In the same interview with Merewether, Wang observed that it was in the 1990s that he came to see his double role: as both an artist and a social critic. "As an artist, I also exist as a critic of society." Yet he was clear about what kind of social criticism he was committed to. In response to the interviewer's follow-up question on the artist's relationship to history, Wang replied: "I don't think one's role should be simply that of a critic in this regard. To me at least, the most important task is to excavate, from a contemporary perspective, possible meanings of past history." From the perspective of a contemporary artist, he went on to elaborate, the Cultural Revolution was a meaningful event, because "it provided a visual modality developed from the socialist experience of a given period of time." This "visual modality" was a complex one; it remained relevant because it was based on a systematic perception of the world and exerted a lasting impact. His recent work, Wang remarked, was an effort to recapture this complex visuality and to "remind the audience of the likelihood that a way of seeing and thinking may be forgotten or disappearing."[39]

Excavating the socialist visual experience therefore became a concerted project for Wang Guangyi around the turn of the new century. He continued his *Great Criticism* series and expanded its scope to include ever more brand names and institutions. The piece *Great Criticism – WTO* from 2001 was a timely response to the arrival of a new stage of globalization with China's accession to the World Trade Organization (Figure 4.8). Yet in a series of installation or sculptural pieces, he sought to exert a greater impact, as he acknowledged in the Merewether interview. More than ever, he was interested in presenting a historical view of the contemporary, post-Cold War world. In a 2001 installation work entitled *Elementary Education*, and first exhibited in Hamburg, Wang extended the method of juxtaposition to include a miscellany of objects. He collected Chinese anti-war posters and graphics on safety measures in case of nuclear bombing, all of which were published in 1967–8 at the height of the Cultural Revolution, and put them in picture frames next to a

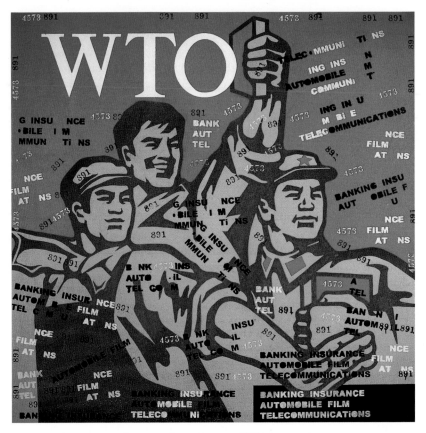

4.8 Wang Guangyi, *Great Criticism: WTO*, 2001, oil on canvas.

construction scaffold, spades, and boots for military personnel. (The spades provided by his German host were a welcome addition.) He wanted to recreate a work site where "everything is just about to begin." What would happen next was left to the viewers' imagination, but Wang was clear that his intention was to "show the education that our generation received and how, in the wake of the Cold War, we may continue to look at the current configuration of the world."⁴⁰ Retrieved through this installation work is indeed a way of seeing that cannot be simply reduced to Cold War geopolitics or expunged as ideological indoctrination.

This desire to foreground the specific educational and cultural legacy defining a contemporary Chinese outlook underlay a set of seventy-two sculptural pieces that Wang Guangyi made between 2001 and 2002. The set is collectively called *Materialists*, as the philosophical opposite to *idealists*, rather than in the sense of individuals obsessed with material possessions. Wang regarded the concept of "a materialist" (more accurately

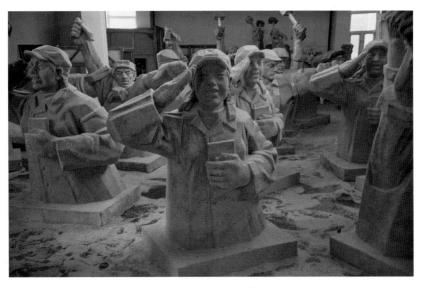

4.9 Wang Guangyi, *Materialists*, 2001–2, glass-fiber reinforced plastic and millet.

"a historical materialist," in contradistinction to an idealist) as particularly significant in the Chinese context because it has a revolutionary connotation and points to "an oppositional power of critique" against myopic thinking and self-deception. He also observed that even though the sculptural figures may have the gestures or facial features of the characters from his *Great Criticism* series, they form a simpler and purer presence, because they are no longer caught in a confrontation with their opposites. They now stand on their own. "I want to restore a socialist spirit … Without placing them in a dichotomous relationship, I want these sculptures to reveal in and of themselves all the possible purity as well as complexity of the socialist visual experience."[41] On another occasion, he stated, "I want to reconstruct the power and meaning of visual components drawn from the experience of socialism" (Figure 4.9).[42]

Making seventy-two fiberglass statues in honor of idealized and nameless socialist heroes was a monumental statement. It asserts in visual terms Wang Guangyi's considered choice when faced with the conflict that *Great Criticism* spells out. After exposing the tension between two disparate systems and cultural choices, as it were, the artist now invites us to identify with the "great critics," assume their position, adopt their vision, and direct a critical gaze at the world around us. He no longer needs to include a reference to a "dichotomous relationship" because his artwork itself now stands in opposition to a prevailing order and seemingly entrenched reality. Instead of splitting our vision, as he does through *Great Criticism*, he now urges us to look closely and focus on recognizing a vanished history

and subjectivity against the clamorous surroundings of triumphant consumerism and market economy.

In this sculptural work, the socialist subjects, some of them Red Guards, are restored as robust three-dimensional, larger-than-life monuments. They retain their self-confident gestures and exude a youthful optimism and defiance. They seem exaggerated in their expressions, and they are silent. A socialist spirit, according to Wang Guangyi, is observable in their torsos, gestures, expressions, and the millet glued all over them. The fine, bright yellow grains of millet that cover the fiberglass sculptures are an important element because, as Wang told Merewether, "millet is full of revolutionary significance in China." As a staple food that sustained the Communist-led Eighth Route Army during the War of Resistance against Japan in the 1930s, millet is a legendary object in the lore of the Chinese revolution. To understand its meaning, Wang remarked, one has to study Chinese culture, just as one needs to delve into European culture in order to understand the significance and the Europeanness of the coarse felt that Joseph Beuys repeatedly used in his work.[43]

Equally monumental as the group of sculptures from 2001–2 are two series of oil paintings that Wang Guangyi finished in 2003. The fifteen paintings under the general title *Forever Shining* present a striking visual counterpart to *Great Criticism* in that the new work evokes a film negative that reverses black and white and reduces colors unnaturally. All are images based on familiar socialist posters, some of them having already appeared in *Great Criticism*. By bringing to our view their negatives, Wang Guangyi inserts a photographic dimension and possibility. They suggest not only an indexical relation to a photographed moment or experience, but also the possibility of generating many fresh positive prints for our present (Figure 4.10).

As if to help us see a brilliant image from the negative, Wang Guangyi also created a mini series titled *Faces of Belief*. The five works in this series present the most archetypal and fantastic images retrieved from the socialist past. Three of these could be viewed as a triptych that reenvisions the revolutionary trinity of the socialist imagination. Here the digits that once intrigued viewers of *Great Criticism* return, but even they seem to constitute orderly sequences. These inspired and inspiring faces are further enlarged in *The Face of Belief A* and *B*, where the graphic property of a woodcut is also demonstrated as indispensable for a socialist iconography. A radiating positivity without ambivalence, as well as the sheer size of these canvases, bespeaks the longing for a longing that opened up a visionary world and left behind a distinct way of seeing and being seen (Figure 4.11).

It should be abundantly clear by now that what Wang Guangyi vows to retrieve from "the socialist visual experience" is more a cultural identity and a historical legacy than a political ideology or doctrine. "The visual components drawn from the experience of socialism," an idiosyncratic phrase that the artist would also use to describe the object of his

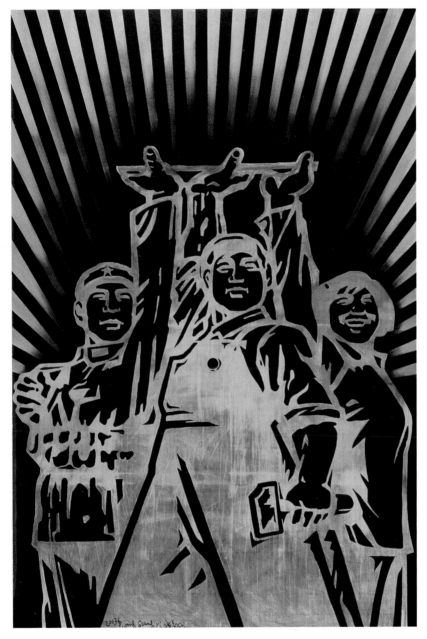

4.10 Wang Guangyi, *Forever Shining No. 3*, 2003, oil on canvas

investigation, put emphasis on concrete practices and experiences of socialism in China rather than on abstractions. For the same reason, he has been very careful to distinguish the complex meanings of the Cultural Revolution, insisting that it had a very different impact on politics than on

4.11 Wang Guangyi, *The Face of Belief B*, 2002, oil on canvas.

art. He also believed that the socialist visual experience is an inescapable cultural tradition for Chinese contemporary artists. "Before we judge its merits, we need to acknowledge it as a fact of our life. It shapes our perception, and determines the difference between our approach to depicting an object and anyone else's."[44] In actively claiming rather than disavowing or regretting this "fact of life," Wang Guangyi puts himself at odds with the contemporary mainstream negation of the Cultural Revolution and thereby establishes a critical distance from many strands within the field of contemporary art.

As art historian Wang Mingxian has observed, Wang Guangyi is the most prominent contemporary artist who has consistently turned to visual images from the Cultural Revolution as sources for his artwork. With his theorization of a socialist visual experience around the turn of the new century, Wang Guangyi has broadened his scope and become ever more confident of his role as a cultural critic who refuses to accept the contemporary world as it is. On several related levels, we see how this refusal leads to

a productive insistence on *history as meaningful difference*. In terms of visual strategies, he shifts his attention from a deconstructive "double vision" to an excavating project that aims at "reconstructing a way of seeing." Monumentality is his preferred style and method by which to challenge the current visual regime and to force a conceptual breakthrough. (An installation work he finished in 2001 is called *Monument to the Worker*.) Such a break-through reintroduces a past vision or what Wang calls "the socialist spirit," which, once it has broken into our view, haunts us like a specter and demands that we review and recount our relationship to the present.

Yet this critical review, which may express itself as a critique of con-sumer society, also reveals that there are contests over the present on another, more global level. This is where a divergence between different historical narratives and different cultural identities becomes observable. This is why, in *Materialists*, Wang Guangyi goes beyond the period of the Cultural Revolution and covers his sculptures with millet. When he asserts that one cannot understand the significance of millet in his work until one delves into Chinese culture, Wang explicitly turns revolutionary history into a source of cultural identity, and expands Chinese culture, in turn, beyond its usual association, especially for Western observers, with a remote and tranquil aesthetic tradition.

Only with the backing of this expanded cultural identity does Wang Guangyi feel confident enough to engage in a "cultural contest" with the hegemonic power of Euro-America.[45] It is a hegemonic power not only in having shaped the contemporary art discourse and market, but also for its capacity to reshape historical memories and narratives in its own image and interest. Wang foresees a protracted cultural contest because he remains skeptical of the triumphalist narratives that, in order to celebrate the outcome of the Cold War and the alleged "end of history," systematically reduce and rewrite twentieth-century world history. He, for one, believes the socialist history in China has left behind an enormous shadow. Regardless of its effect, "this shadow will have a long-lasting impact on China as well as on the world ... When you face it, you will feel its pressure," asserted Wang in 2004 (Figure 4.12).[46]

CODA: GLOBAL RESONANCES

Wang Guangyi remains the most prominent contemporary artist to have embraced the "socialist visual experience" and persisted in exploring its relevance. His efforts at reactivating a socialist way of seeing are provoca-tive and often cause bewilderment and unease because he refuses to let the socialist subjects disappear when socialism is often taken to mean hardly anything more than either a failed experiment or a misleading pretense. He brings those once widely disseminated images back in altered, monumental forms, and insists that we recognize them as our

4.12 Wang Guangyi, *Great Criticism: Art Nation*, 2005, oil on canvas.

contemporaries, as embodying passionate human lives that still demand to be seen and heard. By inserting these disquieting forms into our field of vision, he hopes to make us see in a new light the way we see the world and ourselves.

For Wang Guangyi, socialist visuality is the powerful expression of a revolutionary culture that is based on the fundamentally political practice of differentiation and confrontation. This revolutionary culture is a complex living legacy not only because it has left an indelible mark on the identity of his generation of Chinese, but also because it was an inextricable product of the Cold War, which, in his view, continues to shape the geopolitics of the world today. A series of large-scale installation projects that Wang undertook in 2007–8 is directly called *Cold War Aesthetics*. Using a wide range of objects and resources (old public posters, fiberglass sculptures, cement blocks, and video display) at different exhibition venues, he created scenes of Chinese citizens and militia preparing for nuclear, chemical, and biochemical attacks that were presumed to be an imminent danger in the mid-twentieth century. "My art is about searching for an opposition," the artist stated in an interview about the installations. "This is where the charm of the world lies, in this oppositional beauty, in the existence of opposites."[47] By restaging tensions that he regards as both historical and unresolved, Wang voices his skepticism of celebrations of

globalization and insists on seeing the world as uneven, unequal, and haunted by past memories and promises. For him, dated political expressions turn into cultural legacies that in turn allow him to raise unsettling questions about the new world order, on both global and local levels.

Yet, as a major contemporary artist who openly declared his desire to "restore a socialist spirit" in his art, Wang Guangyi bears hardly any resemblance to artists working in the socialist era. On the contrary, he is a superstar in the bustling field of contemporary art, known for his acquired and expensive taste for a good cigar. An oil painting by him may carry a price tag of hundreds of thousands, if not millions, of dollars and is internationally sought after, collected, and forecast to continue rising in value. In his splendid success in the marketplace, we see a vivid illustration of the ascendancy of the contemporary art system and the simultaneous withdrawal of the socialist production system formally established in the early 1950s. We cannot lose sight of this side of the picture when we look at and examine Wang Guangyi's work. A double vision on our part is in order.

Wang Guangyi himself is no less aware of the price of his success. Shortly before *Great Criticism* began to be marketed and sold briskly as Political Pop in the international art market, he had advocated earnestly the need to establish an art market in China, arguing that art and money would bring both good things and contentment.[48] Now, with a domestic art market functioning no differently than a stock market and fully globalized as an investment option, the success of the current art system appears to be nothing but a pyrrhic victory. "Our entire society is in the business of humiliating art," he complained bitterly in a 2008 interview, and he vowed to "restore the dignity of art and the artist" through his work.[49] The dignity that he wished to restore is not some sort of distinction or prestige on the part of the artist. On the contrary, it is respect for the artist as a committed cultural critic, and for works of art as purposeful interventions in the social and spiritual life of the nation. As such, art should not be reduced to a commodity or an invidious possession. In deploring contemporary society's loss of respect for art, Wang not only turned against the manipulative art market, but also expressed his desire for an organic public art resonant with collective passions. Obviously related to his earlier program of restoring a socialist spirit, the new restorative project will have to start with a critique of the institution of art, in whose establishment Wang has played an instrumental role, and of which he has been a notable beneficiary (Figure 4.13).

And he knows that he is not powerful enough to alter the "powerful reality" that is the current art market. Nonetheless, starting with the *Cold War Aesthetics* installations, Wang Guangyi has articulated a new strategy regarding his work. His goal in this expansive project was to "make it not look like art," and to present the finished work as a textbook, rather than an art exhibition. He has come to have little regard for "artsy art," because "such art is too easily aestheticized, too easily monetized." For this reason,

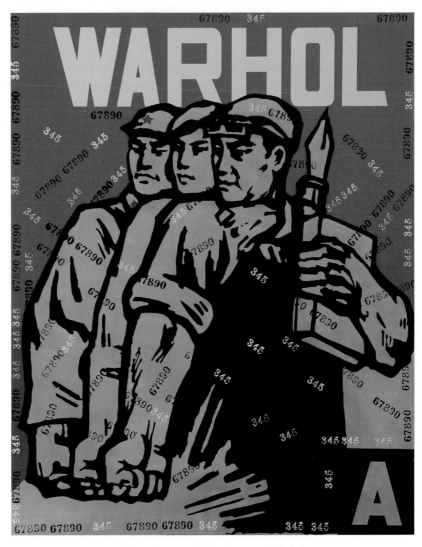

4.13 Wang Guangyi, *Great Criticism: Warhol*, 2005,
oil on canvas.

he thinks his *Cold War Aesthetics* is better and more provocative than the *Great Criticism* series, because the latter still falls into the conventional category of collectable art objects.[50] What he seeks to bring about now is anti-art, or historical experience and imagination that cannot and should not be contained within the current system of art.

"I do not want art to be some rarified sphere," Wang Guangyi stated in a 2008 interview, and he went on to underscore the popular as well as public origins of his own work. It was "the power of the people," he claimed, that had enabled him to complete the *Great Criticism* series because the familiar

images of workers, peasants, and soldiers had come from non-professional artists and they reflect the political imaginings of the ordinary people. "I try my hardest to use the people's hands to express my ideas; that is my ideal."[51] In the artist's new emphasis on the public nature of his art, we may hear a distant echo of the aspirations that once animated the Red Guard art movement half a century ago. It is also an emphasis with far-reaching global resonances as we continue to confront, in various locations and with different legacies, questions about art and its relationship to our contemporary life, collective as well as imaginary. More specifically, as we will see in Chapter 6, Wang Guangyi echoes a deep anxiety among some other contemporary artists who continue to work with an artistic medium closely associated with the socialist visual culture.

NOTES

1 Wang Guangyi, "Guanyu 'Qingli renwen reqing'" (On "Sorting out Human-istic Passions"), first published in *Jiangsu huakan* (*Jiangsu Art Magazine*), no. 10 (1990). An English translation of the text is available in *Wang Guangyi: Works and Thoughts 1985-2012*, edited by Demetrio Paparoni (Milan: Skira, 2013), 317–18. Beautifully illustrated, this volume is an excellent resource, as it contains the artist's entire oeuvre, critical assessments, and key documents in translation.

2 See Linda Sandler and Katya Kazakina, "Collector Farber Makes 63 Times Cost on Chinese Art," October 13, 2007: www.bloomberg.com/apps/news.

3 Quoted in Karen Smith, *Nine Lives: The Birth of Avant-Garde Art in New China* (Zurich: Scalo Verlag, 2006).

4 See Li Xianting, "Jiedu Wang Guangyi de sange jiaodu" (Three Approaches to Interpreting Wang Guangyi), in *Wang Guangyi* (Hong Kong: Timezone 8 Ltd., 2002), 60.

5 Huang Zhuan and Pi Li, "*Tuxiang jiushi liliang*" (*Image Is Power*), collected in He Xiangning Art Musuem, ed., *Muji tuxiang de liliang: He Xiangning meishuguan zai 2002 nian* (*Witnessing the Power of Images: The He Xiangning Art Museum in 2002*) (Nanning: Guangxi shifan daxue, 2003), 205.

6 See Huang Zhuan, "Introduction" to Huang Zhuan, Fang Lihua, and Wang Junyi, eds., *Shijue zhengzhi xue: ling yige Wang Guangyi* (*Visual Politics: Another Wang Guangyi*) (Guangzhou: Lingnan meishu, 2008), 13–28. Regarding Wang Guangyi as "the most challenging contemporary artist in China," Huang Zhuan asserts that at every turn in recent art history, the artist has come through with unexpected and stimulating questions. According to Huang Zhuan, through constant interrogation, Wang has formulated a unique visual politics, in which historical and political resources are mobilized to enable a visual strategy and discursive intervention, rather than resorted to as an expression of political beliefs or agenda. An English translation of Huang's essay is available in Paparoni, *Wang Guangyi*, 343–55.

7 "Wang Guangyi: wo meiyou chuangzao guo renhe dongxi" (Wang Guangyi: I Have Not Created Anything by Myself), interview with Yang Ruichun and Wu Yao, *Nanfang zhoumo* (*Southern Weekly*), November 5, 2008.

8 See Lü Peng, "Tushi xiuzheng yu wenhua pipan" (Schemata Revisions and Cultural Critique), in Yan Shanchun and Lü Peng, eds., *Dangdai yishu chaoliu zhong de Wang Guangyi* (Wang Guangyi in the Currents of Contemporary Art) (Chengdu: Sichuan meishu, 1992); excerpted in Huang *et al.*, *Visual Politics*, 32.

9 See "Xinchao meishujia (er) Wang Guangyi" (New Wave Artists [2]: Wang Guangyi), *Zhongguo meishubao* (*Fine Arts in China*), no. 39 (September 28, 1987), 1. This issue of *Fine Arts in China* introduces Wang Guangyi as a cutting-edge artist on its first page.

10 See Yu Feng, "Wo kan 'wantong' zuopin" (My View of the "Daredevil's" Work), *Zhongguo meishubao*, no. 22 (December 21, 1985), 1. This issue of *Fine Arts in China* devoted most of its four pages to discussions of Rauschenberg's art and Pop Art in general. One contributor applauded the Rauschenberg show as a refreshing "big joke" for the all-too-serious Chinese audience.

11 Jérôme Sans, "Wang Guangyi: A Pop Agitprop Aesthetic," in *China Talks: Interviews with 32 Contemporary Artists by Jérôme Sans* (Beijing: Timezone 8, 2009), 99.

12 "Li Xianting yu Wang Guangyi fangtan lu" (Li Xianting Interviewing Wang Guangyi), conducted in January 2004, collected in Huang *et al.*, *Visual Politics*, 78–94. The quote here comes from p. 84.

13 See Wang Guangyi, "On 'Sorting out Humanistic Passions,'" in Paparoni, *Wang Guangyi*, 317–18, translation modified.

14 In a letter to a friend in 1988, Wang Guangyi made the following statement: "The existence of all cultural schemata does not mean absolute authority. We may regard them with a critical eye and then subject them to revisions. It is such acts of revision that prove the value of my existence." See Wang Guangyi, "Dui san'ge wenti de huida" (My Answer to Three Questions), *Meishu* (*Fine Arts*), no. 3 (1988), 57.

15 See Chang Tsong-zung, "A Politics of Engagement and Ideology of Strife," in Susan Acret, ed., *Wang Guangyi: The Legacy of Heroism* (Hong Kong: Hanart T. Z. Gallery, 2004), 7–8.

16 See Huang Liaoyuan, "Shehui zhuyi de shijue jingyan" (The Socialist Visual Experience), *Huasheng shidian* (*Huasheng Viewpoint*), no. 11 (2002), 79–80.

17 See Wang Guangyi, "On 'Sorting out Humanistic Passions'," in Paparoni, *Wang Guangyi*, 318.

18 Li Xianting, "Major Trends in the Development of Contemporary Chinese Art," in *China's New Art, Post-1989* (Hong Kong: Hanart T. Z. Gallery, 1993), xxi. Wang Guangyi is the first artist to be introduced in the section on Political Pop, and the textual panel in the catalogue offers a fuller description of his *Great Criticism* series: "In these works, the artist applies a deconstructionist approach to a clear language of symbols . . . This seemingly arbitrary combination of political and commercial symbols creates a humorous and absurd effect that carries with it a biting satire of both the ideology of the Mao era and the blind craze for Western consumer products prevalent in China today, coupled with a frank delight in the silly glamour of Cultural Revolution and pop marketing images" (3).

19 See Lü Peng, "Schemata Revisions and Cultural Critique," 32.

20 Gao Minglu, "Toward a Transnational Modernity: An Overview of Inside Out: New Chinese Art," in Gao Minglu, ed., *Inside Out: New Chinese Art* (Berkeley: University of California Press, 1998), 29–30.

21 Gao Minglu, "From Elite to Small Man: The Many Faces of a Transitional Avant-Garde in Mainland China," in *Inside Out*, 153. Here Gao offers a closer reading of *Great Criticism*: "The paintings are meant to show that though the two systems (political and commercial) are not united, the principal goal of each is to convince the population of the authenticity and singularity of its products ... Wang Guangyi's painting became a kitsch advertisement of an advertisement, and he himself became a producer of commodities instead of a preacher" (152–3).

22 Norman Bryson, "The Post Ideological Avant-Garde," in Gao Minglu, *Inside Out*, 52–3.

23 See "Zouxiang zhenshi de shenghuo" (Toward a True Life), *Beijing qingnian bao* (*Beijing Youth Daily*), March 22, 1991, 6.

24 Known as the May 16 Circular, the document, adopted by the Central Committee of the Chinese Communist Party under Mao's leadership in 1966, was not published in the *People's Daily* until May 16, 1967, by which time the Cultural Revolution had entered its most violent stage. The principal arguments and decisions contained in the circular were made public on June 1, 1966, in a *People's Daily* editorial, "Sweep Away All Monsters and Enemies," which is widely regarded as the open call for the Cultural Revolution across the nation. The text of the May 16 Circular can be accessed at www.baike.baidu.com/view/136043.htm.

25 Arif Dirlik, "Socialism without Revolution: The Case of Contemporary China," *Pacific Affairs*, vol. 54, no. 4 (1981–2), 632–61, included in Dirlik, "Back to the Future: Contemporary China in the Perspective of its Past, circa 1980," in Ban Wang and Jie Lu, eds., *China and New Left Visions: Political and Cultural Interventions* (Lanham, MD: Lexington Books, 2012), 3–42. The quote here is from p. 5.

26 See Andrews, *Painters and Politics in the People's Republic of China, 1949–1979*, 314–42, for a useful account of the Red Guard movement and Red Guard art in Beijing.

27 In his classical study, Peter Bürger argues that the central imperative of the avant-garde movements in early twentieth-century Europe was to deinstitutionalize artistic autonomy and return art to the praxis of life. See Bürger, *Theory of the Avant-Garde*, trans. Michael Shaw (Minneapolis: University of Minnesota Press, 1984).

28 See Wang Mingxian, "The Red Guards' Fine Arts Campaign," in Melissa Chiu and Zheng Shengtian, eds., *Art and China's Revolution* (New York: Asia Society in association with Yale University Press, 2008), 187–98. For a much more detailed and extended version of the essay in Chinese, see Wang Mingxian, "Hongweibing meishu yundong ji dui dangdai yishu de yingxiang" (The Red Guard Art Movement and its Impact on Contemporary Art), *Yishu tansuo* (*Art Exploration: Journal of Guangxi Arts College*), vol. 19, no. 2 (2005), 32–40.

29 See Xu Bing, "Yumei zuowei yizhong yangliao," collected in An Su, ed., *Xu Bing Prints* (Beijing: Wenhua yishu, 2010), 206–18. An English translation of the article by Jesse Robert Coffino and Vivian Xu appears in the volume under the title "Ignorance as a Kind of Nourishment," 220–37. Quotes from p. 237.

30 Zheng Shengtian, "Art and Revolution: Looking Back at Thirty Years of History," in Melissa Chiu and Zheng Shengtian, *Art and China's Revolution*, 39.

31 See Richard King and Jan Walls, "Introduction: Vibrant Images of a Turbu-lent Decade," in Richard King, ed., with Ralph Croizier, Shengtian Zheng, and Scott Watson, *Art in Turmoil: The Chinese Cultural Revolution, 1966–1976* (Vancouver: University of British Columbia Press, 2010), 3–24, for a succinct narrative of art and art-making during the Cultural Revolution.

32 Quoted in Wang Mingxian, "The Red Guard Art Movement and its Impact on Contemporary Art," 37.

33 Quoted in Wang Mingxian and Yan Shanchun, *Xin Zhongguo meishu tushi 1966–1976 (An Illustrated Art History of New China, 1966–1976)* (Beijing: Zhongguo qingnian, 2000), 13.

34 For an introduction to this painting and an interview with its creator, see Melissa Chiu and Zheng Shengtian, *Art and China's Revolution*, 119–32.

35 For a recent account of Huxian peasant painting and its contemporary development, see Ralph Croizier, "Hu Xian Peasant Painting: From Revolu-tionary Icon to Market Commodity," in King, *Art in Turmoil*, 136–63.

36 An excellent resource for the study of visual culture in contemporary China is the website Chineseposters.net supported by the International Institute of Social History in Amsterdam.

37 Jacques Rancière, "Ten Theses on Politics," in his *Dissensus: On Politics and Aesthetics*, ed. and trans. Steven Corcoran (New York: Continuum, 2010), 39.

38 Charles Merewether, "An Interview with Wang Guangyi on the Socialist Visual Experience," in *Wang Guangyi* (Hong Kong: Timezone 8 Ltd., 2002), 28. Both the English and Chinese versions of the interview are included in this volume (26–35, 50–7), with the English translation provided by Robert Bernell, but there are some discrepancies between them. I have opted to translate Wang Guangyi's comments from the Chinese version. The English text is included in Paparoni, *Wang Guangyi*, 319–25.

39 Merewether, "An Interview with Wang Guangyi," 29–33.

40 Merewether, "An Interview with Wang Guangyi," 31. For photos of this installation work, see Paparoni, *Wang Guangyi*, 206–9.

41 Merewether, "An Interview with Wang Guangyi," 35.

42 See "Chongxin jiedu: Zhongguo shiyan yishu shinian" (Rereading: Ten Years of Experimental Art in China), *Beijing Youth Daily*, November 28, 2002.

43 Merewether, "An Interview with Wang Guangyi," 35. For a useful reading of Wang Guanyi's millet-covered sculptures, see Shu Kewen, "Wang Guangyi de xiaomi weiwu zhuyi" (The Millet Materialism of Wang Guangyi), collected in Huang *et al.*, *Visual Politics*, 286–88.

44 See Huang Liaoyuan, "The Socialist Visual Experience."

45 See "Li Xianting Interviewing Wang Guangyi," 94.

46 See "Li Xianting Interviewing Wang Guangyi," 94.

47 "Faxian 'Lengzhan' zhi mei" (Discovering the Beauty of "the Cold War"), *Guangzhou ribao (Guangzhou Daily)*, December 29, 2007.

48 See Wang Guangyi, "Yishy yu jinqian" (Art and Money), *Yishu yu shichang (Art and the Market)*, no. 1 (Changsha: Hunan meishu, 1991), 3–4.

49 See "Wang Guangyi: I Have Not Created Anything by Myself."

50 See Wang Guangyi's interview with Jérôme Sans, in *China Talks*, 103. For an introduction (by Sara Boggio) to this installation work and photographs, see Paparoni, *Wang Guangyi*, 262–77.

51 Sans, *China Talks*, 100–1.

How (not) to watch a
Chinese blockbuster

Not until the turn of the new century, when commercial and entertainment cinema had regained steady ascendancy and popularity in China, was watching a film from the People's Republic ever expected to be an entertaining or lighthearted matter, especially for viewers in the West. Grave historical events and complex political subtexts embedded in Chinese films would invariably turn the viewing into a sobering, if not also sobbing, affair. From cinematic epics such as *Farewell My Concubine* (dir. Chen Kaige, 1993) and *To Live* (dir. Zhang Yimou, 1994), we learn that we should not expect a happy ending or an individual hero's defiant triumph in contemporary Chinese narrative cinema. We should also have a box of Kleenex handy and be prepared to sink ever lower in our despair at the senselessness of human action. If these admittedly superficial features may suggest that we are looking at an un- or even anti-Hollywood cinema, the fact that most of the Chinese films released in the West since the 1980s were relegated to brief runs at art-house theaters, often after winning a prestigious prize or two at international film festivals, lends further support to such an observation. Even more Chinese titles would be available only as DVD for distribution in a niche market that proffers foreign films as authentic ethnic food for thought.

There are certainly rewards for our fortitude in this viewing endeavor. We gain an opportunity to affirm to ourselves a cosmopolitan commitment to appreciating different cultural traditions and sensibilities. Since a large number of the films were reportedly forbidden in China or independently made, whatever these labels may mean, watching them outside China becomes no less than fulfilling a moral obligation to render our support for those deprived of their artistic freedom. This uplifting sense of solidarity in turn compels us to accept such films as presenting a true and realistic, because unofficial, insight into China. We are happy to suspend our disbelief and, as Rey Chow observes in discussing cinema and visibility, happily proceed to invest "artificial images with an anthropomorphic realism," equating "such images with the lives and histories of 'real' cultural groups."[1]

One consequence of attributing representational authenticity to foreign cinema is the wide use of Chinese films in the American college classroom as visual aids for lessons on recent Chinese history and politics. To students of Chinese culture, early films by Fifth Generation directors are assigned as particularly fruitful material, as this body of work is clearly driven by a concerted effort at national allegory and distinct visual expression. As a result, class after class of American college students have viewed Chinese films as course assignments, learning about China and receiving a sentimental education of sorts in the process. In the meantime, a new academic field had emerged in American research universities by the mid 1990s, subjecting Chinese films to an array of historical as well as theoretical analyses but mostly within the confines of area studies.[2] It

has largely become, as Daniel Vukovich puts it in a critical study, un-problematized Sinology on the screen.[3]

Yet these cerebral rewards for watching Chinese films appeal to the educated elite much more than to the general moviegoer. (A more positive spin is that Chinese films in recent years "have made it necessary, once again, for Western intellectuals to come to terms with aspects of what in so many ways still remains an exotic culture."[4]) Broadly defined Chinese-language films, spearheaded by the phenomenally successful *Crouching Tiger, Hidden Dragon* (dir. Ang Lee, 2000), may have become "even more popular in the American market than those from any of the European countries," but, as Stanley Rosen has shown through charts and numbers, a series of formidable structural obstacles will persist in keeping Chinese films from ever being competitive against the flexible and global-ized Hollywood juggernaut. One particular challenge that is not going away any time soon is certain stereotypical expectations of an Asian film playing abroad.[5] (This explains why Chinese-language films with the most box office success in the US since 1980 have all been martial arts films.[6]) For instance, Zhang Yimou's early international renown as a Fifth Gener-ation filmmaker is owed to his satisfying such expectations, in the words of the *New York Times* film critic A. O. Scott, with "visually glorious tales of historical turmoil and forbidden love like *Raise the Red Lantern* and *Ju Dou*."[7]

Indeed, the group of Chinese filmmakers commonly known as the Fifth Generation that began its professional career in the mid 1980s was instru-mental in shaping Western perceptions of what a new Chinese cinema ought to be like in the wake of the Cultural Revolution.[8] It was, as we may recall, widely cheered as constituting the Chinese New Wave at the time. As direct participants in the heady intellectual movements in 1980s China, the grand pursuit of which was cultural root-seeking and reflection, Fifth Generation filmmakers took their art seriously and regarded cinematic visualization as ultimately motivated by cultural critique. They were much more passionate about presenting a profound artistic statement or inter-vention than making popular or entertaining movies. They took it upon themselves to search for a cinematic vision in sharp contrast to current conventions. The classic example of Fifth Generation filmmaking from this period is *Yellow Earth* (1984), a pensive and ponderous examination of the meaning of the Communist revolution in rural China. A film that demands patient viewing and more patient decoding, it continues to excite academic interest and remains the unavoidable paradigm-setting moment in any account of contemporary Chinese cinema.

Yellow Earth, along with other Fifth Generation films that followed, ushered in a new way of visualizing China that would enjoy tremendous staying power, especially among Western viewers, who find the rural landscape, ethnographic details, archaic traditions, and historical upheavals

refreshingly projected on screen at once remote and real, appalling and yet attractive. As "visually glorious tales," these films befit a long enduring Euro-American view of first dynastic and alien, and then chaotic and still alien, China. Not surprisingly, some critics, in China as well as abroad, disparaged films such as *Ju Dou* (1990) and *Raise the Red Lantern* (1991), both directed by Zhang Yimou, for engaging in blatant "self-Orientalization" to cater to a Western demand for exotica. And apologists for Zhang, assuming the position of cosmopolitan commentators, would argue that his films are metaphoric vehicles for poignant commentary on contemporary events, even courageous political dissidence.

These conflicting views of early Zhang Yimou point to the awkward position a film may occupy as it travels across different cultures and contexts, but in the case of Fifth Generation films, their complex operation of cultural critique was steadily reduced in the Western context through a *dissidence hypothesis*, which presupposes any expression of criticism voiced in China to amount to an act of political dissidence subversive, and therefore intolerable, to the repressive regime. Duplicating the logic of political paranoia, it is a hypothesis that determines the relevance and value of a Chinese cultural product solely from a political calculation, in a manner not unlike the crude reductionism widely practiced during the Cultural Revolution.

As recently as 2004, when the heartwarming mainstream film *Postmen in the Mountains* (dir. Huo Jianqi, 1999) opened in New York, a local reviewer, "who actually found the film 'endearing' and 'likable,' also noted in the same sentence that 'its benign surface may cover some subtle propaganda on behalf of China's centralized government.'"[9] A deep-seated suspicion simply would not allow the reviewer to enjoy a moving human drama from China. As if to counteract what this reviewer's political instinct had detected as a "poisonous weed" (a label that Chinese Red Guard critics in the 1960s would routinely pin on what they viewed as politically incorrect works of art), a film festival that soon followed granted its feature film award to *Stolen Life* (dir. Li Shaohong, 2005), thereby providing the opportunity for a reassuringly familiar dispatch in *The New York Times*: "Banned Chinese Film Takes Top TriBeCa Prize," although no commercial distributor was foolhardy enough to pick up the dark made-for-TV drama about deception and betrayal in marriage.[10] (*Stolen Life* was subsequently broadcast in Shanghai in June 2005, and its director, widely recognized as an outstanding female member of the male-dominated Fifth Generation, remains an active filmmaker and producer in China. Her 2010 adaptation of the classical novel *Dream of the Red Chamber* into a fifty-episode television series received mixed reviews.)

The dissidence hypothesis may be observed in Western mainstream interest in contemporary Chinese cultural products (from films to novels to artwork), and it seemed to gain validation in the early 1990s when the

triumphant West at the end of the Cold War was all but ready to dismiss China as a political dinosaur. Yet the either/or logic of this hypothesis could hardly account for the complexity of Fifth Generation filmmakers, let alone the dynamics of contemporary Chinese politics and culture. As the West continued to deplore a China stuck, as Bill Clinton memorably put it in 1997, on the wrong side of history, that country was in fact undergoing the kind of rapid and condensed economic and cultural transformations that no Western societies have experienced in recent memory. Contemporary America in comparison was much more conservative and settled in its own way of life. Amidst the maelstrom of historic changes in contemporary China, the Fifth Generation filmmakers repositioned themselves while a more diverse Sixth Generation of filmmakers surfaced and, for a duly brief period, regarded itself as independent, even underground.

With the dissidence hypothesis continuing to shape Western perceptions of contemporary China, a different conflict came to a head in 1999, when Zhang Yimou withdrew his films *Not One Less* and *The Road Home* from the Cannes Film Festival in protest at what he believed to be willful political appropriation of his new work. In an open letter to the festival directors, he wrote: "What I cannot accept is that the West has for a long time politicized Chinese films. If they are not anti-government, they are just considered propaganda. I hope this bias can be slowly changed."[11]

By then, Chinese cinema was far more robust and diversified than it was in the 1980s. In addition to mainstream cinema, which continued to update the institutional as well as the conceptual legacy of New China cinema, one could also clearly see different operations being set up for commercial cinema, art-house films, and independent filmmaking. The system as a whole had ingeniously adopted some of the Hollywood approaches to production, distribution, and marketing.[12] One particularly noteworthy genre that emerged in the late 1990s was the New Year film, initially inspired by Jackie Chan's international blockbuster *Rumble in the Bronx* (dir. Stanley Tong, 1995) and gradually developed by the filmmaker Feng Xiaogang for the domestic market.[13] Released around the lunar New Year holiday season, New Year films were tremendously successful in creating a commercial cinema and, according to Ying Zhu, gave rise to the idea of a "Chinese blockbuster."[14]

The arrival of Chinese blockbusters, however, has also underscored the fact that, with few exceptions (most prominently the martial arts epic *Hero* [dir. Zhang Yimou, 2002]), there is hardly any correspondence between Chinese films screened and popular in China and Chinese films screened and embraced in the West. This may be due to different cultural habits and expectations. American viewers, for instance, had no interest in Feng Xiaogang's *Big Shot's Funeral* (2001), an enormously popular film in China

with a notable international cast. The film offers, remarked one American commentator, "a vastly different view of Chinese society than most Western moviegoers are used to seeing,"[15] their taste having been shaped by art-house films about rural China that, as we discuss in Chapter 3, were the favorites of international film festivals in the 1990s. In the view of *Variety* film critic Derek Elley, the dismal failure of Feng Xiaogang's 2001 film in the American market indicates a "complete lack of marketing templates for mainstream China-set comedies."[16]

What is also missing, in addition to marketing templates, is a viewing position that does not rely on the dissidence hypothesis to make sense of Chinese movies, a position that recognizes the evolving tradition of mainstream and commercial cinemas in China and their relevance. Without establishing such a viewing position, we cannot meaningfully explain the necessity of national cinema beyond serving as an ethnic supplement to Hollywood. Nor can we comprehend the notion or phenomenon of a Chinese blockbuster without instinctively dismissing it as either government propaganda or mindless entertainment. The making of a Chinese blockbuster, just like the production of mainstream and popular culture in China, is a far more complex process than allowed for in such facile dismissals, and there is every indication that, as the Chinese economy continues to grow, ever more creative energy will go into developing a competitive cinema as well as a globally significant Chinese-language film and television industry.

While it is unlikely that American moviegoers will flock to see Chinese films in the foreseeable future, an expanded view of Chinese cinema is much needed so that we may see whatever is made available in an American theater or classroom *in dialogical relation to* Chinese film genres and subject matter that are not shown or marketed. It should be a view that refuses to see Chinese films shown in America as isolated glimpses of truth or ethnographic records. For students of contemporary Chinese culture more specifically, a blockbuster from China may present a challenging object of study because it calls for critical rethinking on several levels and brings together academic and public discourses.

The notion of a Chinese blockbuster brings back a stark choice that Yingjin Zhang, a prolific and knowledgeable scholar in Chinese film studies, urged fellow researchers to make at the turn of the new century: We either "follow the Orientalist trend and perpetuate a myth that reduces China to rural China, to barren landscape, to exotic rituals, to male impotence or castration, to repressed female sexuality – in short, to all that falls under 'primitive passions;' or demystify Western fantasies . . . and redirect attention to other aspects of Chinese cinema."[17] The choice is actually harder to make than it may first appear, because to demystify those fantasies and extend our vision, we will need to rethink many viewing habits and assumptions of our own.

On October 1, 2009, a brief news story about China appeared on Worldfocus.org, a website supported by American Public Television that seeks "to localize international events for an American audience – making foreign news less foreign."[18] The news story is a personal one, told by Hsin-Yin Lee, an international news editor at a Chinese newspaper in Beijing, about her handwringing over what appeared to be an impossible choice: should she and her friends go to see *Final Destination 4*, a Hollywood horror thriller, or *The Founding of a Republic*, a Chinese blockbuster released on the eve of the sixtieth anniversary of the People's Republic (Figure 5.1)?

Torn between what she viewed as "Hollywood sensation and Beijing propaganda," Lee consulted a few reviews and learned that the Chinese film is "magnificent" on several accounts. The film showcases some 170 stars, including Hollywood heavies such as Jackie Chan, Jet Li, and Zhang Ziyi, many of whom made cameo appearances for free. Production of the two-hour epic film cost less than $5 million and took only 120 days, with the cast traveling to ninety settings across China and eight directors, including Chen Kaige, Feng Xiaogang, and Peter Chan from Hong Kong, working on various scenes. Lee observed a palpable patriotic passion stirred by the film, citing a blogger who proudly asked: "Do you think Hollywood could get so many superstars for . . . *Independence Day*?" She also noticed a controversy among Chinese netizens about the fact that many of the stars have acquired foreign citizenship.

As a Taiwanese, however, Hsin-Yin Lee could not bring herself to feel comfortable about a film that, all that magnificent star power notwithstanding, to her understanding, "commemorates the 60th anniversary of China's Communist Revolution." She would rather think that *Final Destination 4* might be more "substantial" for the buck. By the time she published her story on Worldfocus, Lee and her friends were still agonizing over which movie to watch.[19]

Brief as it is, this report echoes the deep unease and mistrust that is shared by many an English-language news story or blog about the film that was setting box office records in China in 2009. Two weeks prior to its release, the Associated Press had already, in its usual imperiously disembodied voice, branded *The Founding* a "propaganda blockbuster" masterminded by "China's staid cultural commissars." The AP judgment was swiftly followed by lesser news outlets, such as Cinemaspy.com, where a story entitled "Chinese Stars to Appear in Propaganda" describes the upcoming film as indicating "a tactical shift for China's ruling party with regards to getting its message out."[20] Headlines like this in turn would readily stir up trigger-happy Cold Warriors patrolling the blogosphere. One blogger, without ever seeing the film, felt betrayed, and bitterly denounced Jackie Chan and Jet Li for committing a grand "Hollywood

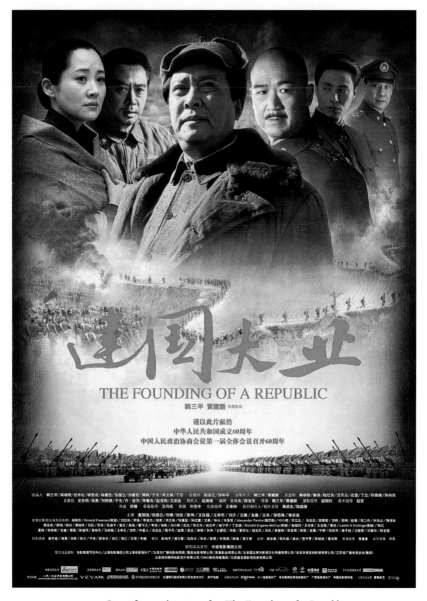

5.1 One of several posters for *The Founding of a Republic*

hypocrisy" by collaborating in the whitewashing of "the brutal history of the People's Republic of China."[21]

The twin epithets of "propaganda" and "state-funded" were so prevalent in the initial English-language reports that even before it opened in China the film had been turned into nothing less than an odious affair internationally. (A blogger, originally from Kansas City but now living an

exciting life in the "Heart of Beijing," noted that "Predictably, Western media have been quick to label *The Founding of a Republic* 'propaganda.'"[22]) By classifying it as state-funded propaganda, these reports effectively condemn the film as misleading and manipulative. The label evokes a sinister specter against which Western liberal democracies have long defined themselves, namely, the individual being brainwashed by Big Brother and reduced to an automaton. (Think of *The Manchurian Candidate*.) Eventually the not so subtle strategy of containment plays out in the seemingly factual Wikipedia entry on the film, which begins by characterizing it as a "Chinese historical film commissioned by China's film regulator and made by the state-owned China Film Group."

Just like the R rating dutifully meted out by the Motion Picture Association of America for the public good, the label "Propaganda" affixed by the Associated Press serves as a protective warning to the potential viewer: this film contains moving but false material and your loyalty and integrity will be tested. Propaganda, in this case, is shorthand for either an outright falsehood that will nonetheless seduce or confuse you, or some hidden truth that is too painful to confront. Either way, our desire to name and dismiss propaganda reveals a deep-seated fear for our susceptibility to its effect. This unease about seeing oneself challenged, about coming face to face with radical otherness in disguise is what made Miss Lee, our Taiwanese editor working in Beijing, agonize over choosing between "Hollywood sensation and Beijing propaganda." She would rather believe a supernatural horror flick to be more "substantial," because she knows that, as entertainment, *Final Destination 4* will be less demanding, more vacuous, and therefore more reassuring to her sense of self.

Coincidentally, P for Propaganda, a rating often generously dished out in Western media coverage when it comes to state-funded Chinese films or publications, is a warning exclusively about ideologically objectionable content and substance, rather than against provocative filmmaking or depraved sensibility. (For the same reason, Michael Moore's recent films have also been denounced as propaganda.) *The Founding*, for instance, merits a P rating because it is presumed to give a different version of history from the one audiences in America (or Taiwan, for that matter) have accepted or assumed. Moreover, it must be a version endorsing the Chinese party-state since the government reportedly bankrolled it. In carefully pointing out every time whether a Chinese film is state-funded or independent, news stories or film reviews seek to put us in the right viewing position before the event, lest we lose sight of the clear and present indoctrination that comes with state funding or sponsorship.

This well-nigh instinctual suspicion of state agency has always been a cornerstone of liberalist ideology, but it has hardened into a triumphalist article of faith in the post-Cold War era, a period that asserted itself in 1989 with the celebration of "the universalization of Western liberal democracy as the final

form of human government" (Fukuyama). To this liberalist vision of a post-ideological human history, anything with government backing is an abomination and ought to be dismantled: from state-owned industry, to state-run medical care, to state-sponsored filmmaking or cultural programming. The greatest abomination to the vaunted universalization of Western liberal democracy, of course, has been China. Governed by the Communist Party, China not only did not collapse in 1989 amidst widespread protests and in accordance with liberal democratic expectations, but has emerged in recent years as a formidable economic powerhouse. Indeed, an odd mixture of disbelief and distaste is the unmistakable undertone of English-language reports, from the AP to the BBC, on the "propaganda blockbuster" commemorating the sixtieth anniversary of the founding of the PRC.

WHAT TO WATCH?

The report on *The Founding* by Clifford Coonan for the London-based *Independent* is no exception. After seeing a sneak preview in early September, 2009, Coonan offered some detailed information on this "stirring propaganda epic," suggesting that it is "up alongside Sergei Eisenstein's *Battleship Potemkin*, Leni Riefenstahl's *Triumph of the Will* or Roland Emmerich's *Independence Day*." He also surmised from the preview that the filmmaker was successful in delivering the punch, because the audience "cheered loudly and chuckled when their favorite actors or pop stars appeared on screen." And by his count there are close to 200 such stars in the 140-minute movie. His overall skepticism aside, Coonan made the following observation: "Anyone visiting China, who wonders why the face of founding father, Chairman Mao Zedong, is still on all the banknotes after the disasters of the Great Leap Forward in the 1950s and the vicious excesses of the Cultural Revolution (1966–76), need only watch this movie."[23]

It is not entirely clear whether Coonan was warning those visiting China against this "stirring propaganda epic" or was actually making a recommendation. If his point was that *The Founding* visualizes a different understanding of recent Chinese history than the one most likely held by foreign visitors, he was certainly right. Yet the film is about neither the Great Leap Forward nor the Cultural Revolution. Rather it focuses on the four-year civil war between the Nationalists and the Communists that began soon after World War II and ended with the Communist victory in 1949. The main plot line is about the Communist effort, after a peace treaty with the Nationalists failed, to win the war and at the same time to convene the first Chinese People's Political Consultative Conference that would serve as the initial legislative body in the creation of a new national government. Devoting as much time to Mao as it does to his arch-rival, the Nationalist leader Generalissimo Chiang Kai-shek, and portraying both with sympathy and respect, the film unfolds a vast scroll populated with

5.2 Historic footage, incorporated in the film, of Mao at Tiananmen, October 1, 1949.

many historical personalities and takes the viewer to numerous locations as far away as Moscow and Washington DC. In the end, historic footage of the grand ceremony in Tiananmen Square on October 1, 1949, during which Mao Zedong declared the establishment of the People's Republic and announced to the world that "the Chinese people have stood up," is adroitly integrated, and swirling images of ecstatic crowds and a rousing sound track steadily pushes the film to its emotional climax (Figure 5.2).

To suggest, therefore, as Coonan did, that watching the film will help put in perspective the disastrous events that happened *after* the time period covered in the film is an astute observation. It is a gentle reminder that the history of the PRC is more momentous than those cataclysms that many prefer to remember it by. It also acknowledges the importance of a mythology of beginnings in shaping national identity and psyche.

Here we see a telling divergence between Coonan's inclination to see *The Founding* as a biopic of Mao and the film's much broader scope. The last frame of the film, for instance, is a close-up of the new Chinese national flag, whose design we now understand better, as debates over it among delegates of the Chinese People's Political Consultative Conference (CPPCC) are dramatized in the film. As the camera pulls us closer to the flag, the screen gradually changes from documentary-style sepia footage to brilliant color and the fluttering flag turns flaming red against a blue sky. This transition encapsulates the transformation of the flag from a specific historical object to a living symbol in the contemporary world. The concluding scene is picture perfect, because the flag is presented at once as a visual icon and as an abstract concept, and the film serves as a narrative explaining its creation and symbolic meanings. In other words, the final image of the flag constitutes an emphatic thesis statement: the film is about the birth of a new national government and identity rather than about the political or military victory of one party over another.

The raising of the flag at the end of the film has the effect of at once performing a ritual and witnessing the ritual performance. It thereby changes the position of the film viewer, who at this instance may realize that he or she is no longer a spectator but is being called upon to affirm his or her national allegiance and to participate in the epic patriotic drama. As a key device for interpellating modern subjectivity, the Chinese flag functions no differently than any other national flags raised during various wars, at sport events, or in cinematic representations, in that nationalism remains the most visceral and most entrenched ideology of belonging in our uneven and differentiated world. The American flag that appears on the top of Iwo Jima at the very last moment of *Flags of Our Fathers* (2006), for instance, is no less affirmative and prepossessing as a symbol of national identity, in spite of the fact that the Clint Eastwood film tells an unsettling story of war heroes betrayed by peace in postwar America.

Yet *The Founding* did not become a box office sensation simply because of the patriotic pride it inspired, even though it did cash in on the celebratory mood on the sixtieth anniversary of the PRC. The film was explicitly produced as a grand "offering" to commemorate the historic moment, much in the same way a lunar New Year film is specifically conceived, produced, and marketed for the festive holiday season. Star power is a key element in the success of films designed to entertain and appeal broadly on such occasions, and *The Founding* evidently had more than its fair share. A great draw for many viewers is to see with amusement their favorite stars play unexpected parts, or to find familiar historical figures appear in a new light. The pleasure of watching a performance where make-believe requires audience participation is hard to resist. The film, as one Chinese commentator observed, creates a virtual public square where the stars invite the audience to join in a carnivalesque celebration and to partake of a visual extravaganza.[24] Another reviewer saw the film as replicating, on a much larger scale of course, the popular musical video *Beijing Welcomes You* put out by many star singers ahead of the 2008 Summer Olympics.[25]

Indeed, as Huang Jianxin, one of the two lead directors, described it, shooting the film over three months in early 2009 was largely a process of coordinating the various schedules of all the participating stars. It was an unconventional production process, since the stars were the main attraction of the film. Huang also revealed that he had pushed for inviting even more stars after he joined the team, because from his experience of collaborating with Hollywood and dealing with the "mainstream cinema market" he knows what star power means for a film.[26]

With star power as its selling point, the focal interest of *The Founding* shifts from a unified and unilinear narrative to multiple plot lines propelled by a series of evocative scenes and memorable characters, crosscut and juxtaposed to suggest uneven, non-synchronic but related and sequential

happenings. By doing so, it presents a marked departure from the genre of epic historical films that has been the cornerstone of mainstream cinema in China, in particular a collection of films that had already treated comparable topics, most notable among them being *The Birth of New China* (dir. Li Qiankuan, Xiao Guiyun, 1989) and *National Anthem* (dir. Wu Ziniu, 1999), both of which were made to commemorate earlier anniversaries of the formation of the PRC. The 2009 film, by comparison, is much slicker, faster paced, visually more stimulating, and closer to entertainment cinema by design and in effect. It no longer takes as its main objective to explain through a seamless narrative, but rather seeks to turn past political history into a contemporary cinematic sensation that appeals to the moviegoer not merely as a political subject. The goal is to produce a film with lasting human interest.

As co-director Han Sanping put it, in trying to bring life to historical personalities, he and his team wished to weave a "brilliant string of pearls of history from those rich and dramatic lives that touched each other." He intended this precious "pearl necklace" as an elegant present to celebrate the birthday of the PRC.[27] Indeed, much in the same way as the star-studded CCTV Spring Festival Evening Gala program, which has become an integral part of the lunar New Year festivities in China since the early 1980s, the feature film shines and entertains through cameo appearances and skits, instead of striving for a grand narration of complex and impersonal historical events.[28] "The pic is a cameo-spotter's paradise," quipped the *Variety* film critic Derek Elley in his appreciative review of "a cannily assembled, smoothly made chunk of political filmmaking."[29]

What results, as one analyst puts it, is a series of scenes and vignettes stitched together to constitute a historical epic.[30] It is an epic with a mobile and porous narrative structure, allowing for many anecdotal possibilities and imaginative retakes, from which the viewer derives the gratification of being able to witness or enter into imagined historical scenes in unexpected ways. One of the most salient examples of such refreshingly intimate revisions is the sensitive portrayal of Chiang Kai-shek by Zhang Guoli, an award-winning and versatile film and television actor as well as a producer with a stake in the film's financing. In sharp contrast to the depiction of Chiang as a ruthless and foul-mouthed military strongman in previous films, Zhang brings out a calculating and perceptive political leader unable to reverse his defeat or the course of history. Chiang also appears as a trusting and revered father to his son Chiang Ching-kuo, and is thereby decisively humanized by his embodying a cardinal relationship in the Chinese moral code. At one critical turning point, we even enter his vision and aerially survey a vast battlefield with him from a military aircraft. As the elegiac orchestral music continues, we see from a reverse shot a forlorn Chiang Kai-shek staring vacantly into the camera, but he is no longer tossed up and down by a bumpy ride in the air. Instead, we realize, in the following point-of-view shot, that he is being driven to

the presidential palace in Nanjing, and in fuzzy dream-like imagery the glorious moment of him assuming the presidency a few months earlier shimmers in front of his (and our) unfocused, or perhaps teary, eyes (Figure 5.3).

5.3 Viewers are invited to sympathize with Chiang Kai-shek and feel his loss.

5.3 *(cont.)*

A similarly emotionally charged and imaginative moment is reserved for Mao as well. Following the peaceful liberation of Beiping (soon to be renamed Beijing) and with a national victory in sight, Mao and other Communist leaders conduct a grand review of their triumphant troops at a military airport outside the city. (This fluidly filmed episode includes the use of a hand-held camera to suggest the experience of an excited eyewitness and participant. It was guest-directed by Chen Kaige, whose experience in making *The Big Parade* some twenty years previously came in handy on this occasion.) As a veteran Red Army soldier fights back emotions to finish reporting to Chairman Mao, the motorcade, with Mao standing on the flagship Jeep, begins to roll. The camera first presents a shot of the parade from Mao's perspective; it then cuts to a close-up of Mao giving his salute. As we observe Mao surveying his troops, color gradually fades from the screen and we are shown what Mao must be seeing or recalling at this moment: Mao trudging through snow with Red Army soldiers during the Long March, soldiers celebrating, Mao riding a horse in a recent retreat, and Mao basking in joy at the news of a great victory (Figure 5.4).

Some of the flashbacks in this sequence are in sepia, and some of the scenes come from earlier moments in the film, now presented as historical footage and memory. They do not form a comprehensive gallery of highlights from Mao's political career, but imply an intriguing relationship to history, since the scenes are presented not from Mao's point of view, but rather as how a visual rendition of history, or a historical eye, would see them, with Mao as the central agent. In other words, from the commanding view of the present, Mao sees himself as an agent in a historic light and part of an epic narrative. When color returns to the screen, we are again looking at Mao looking at scenes both near and far, and we see a tear slowing coming down his face. The close-up invites us to imagine Mao's

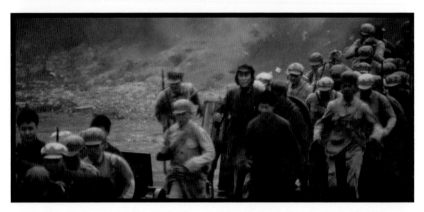

5.4 Mao reviews troops and history.

emotions at that moment and to share his point of view, which, as we have seen, coincides with ours.

Such scenes are often further enriched by the persona that an actor has established on or even off screen. For instance, Zhang Guoli, who plays

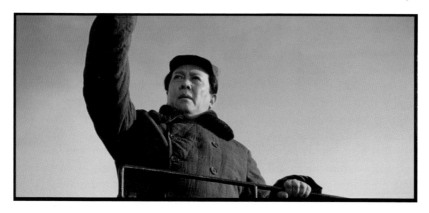

5.4 (*cont.*)

Chiang Kai-shek, became a household name for his role as reigning Qing emperors in successive and enormously popular television series in the 1990s. Equally well known as a versatile actor, Tang Guoqiang started playing Mao in film and on TV in the mid 1990s. The footage showing a younger Mao during the Long March in *The Founding* in fact came from Tang's earlier film. At the same time, Tang Guoqiang has in recent years appeared on Chinese television as a spokesperson for probiotic products, capitalizing to no small extent on his renown as the best Mao impersonator on screen.

The involvement of numerous stars with different professional profiles and market appeals, together with the determination to generate visual excitement, allowed the filmmakers to incorporate a great variety of film genres and styles, from war, gangster and espionage movies, to political drama and documentary, in the making and assembling of serial episodes. Even the slick editing style of MTV and TV commercials is readily adopted, as it helps enliven scenes of speeches and meetings. The scene of the poet Wen Yiduo giving a passionate public speech in protest against the policies of the Nationalist government, for instance, contains eighteen sequencing shots over seventy-two seconds, with each shot lasting an average of four short seconds. The electrifying effect of a keynote speech delivered by Mao at the opening of the CPPCC, too, is conveyed through twenty rapidly crosscutting shots over 100 seconds.[31]

All of this, however, does not mean that *The Founding* is a collage of fragments with no coherence to it. On the contrary, the film strikes a careful balance between its overall narrative structure and the overwhelming star power at its disposal, between its underlying dramatic conflicts and the various self-sufficient scenes and engaging styles. For co-director Huang Jianxin, trimming the film from an initial cut of 190 minutes to the current 135 minutes was a process of assiduously clarifying what the

film was about. It was a painful process too, as he had to leave out many excellent performances by accomplished actors and actresses, but he was fully aware that the ultimate criterion was the integrity of the dramatic action of the film.[32]

The conflict that provides an organizing frame for the entire film is the rivalry between Mao Zedong and Chiang Kai-shek, each representing a political force and each surrounded by colorful supporting characters. The contrast between these two opposing sides is sharply illustrated through a consistent color scheme, with the Communists often illuminated in earthy and warm natural light, and the Nationalists associated with a cold and wet built environment (Figures 5.5 and 5.6). Color schemes and tones serve as an unmistakable visual cue and device to endow the drama with thematic coherence, but in highlighting the contrast between the rural and the urban, the organic and the constructed, they also comment on the divergent backgrounds and power bases that in the end shape the respective destinies of the Communists and the Nationalists.

5.5 Mao with his comrades.

5.6 Chiang Kai-shek and his son Chiang Ching-kuo.

An even more comprehensive commentary that gives the film its emo-
tional unity is the rich and resonant musical score, which accompanies
four-fifths of the 135-minute film and forms a magnificent symphony with
multiple movements. While helping to underscore transitions from scene
to scene, the score also elevates the viewer to the position of a sympathetic
but impartial witness to history.[33]

For the composer Shu Nan, whose music offered consolation to the
shocked nation in the wake of the devastating 2008 earthquakes, compos-
ing for *The Founding* was an opportunity to contemplate with compassion
and understanding the nation's not so distant experience of civil war,
rather than to harp on the confrontation between the victorious and the
vanquished, or good and evil.[34] By utilizing predominantly Western
orchestral instruments instead of native options, he also casts the events
unfolding on the screen as part of a modern condition with global
resonances rather than as a local curiosity. The sobering prelude, flowing
slowly and pensively from stringed instruments as the film opens, strikes a
reflective keynote, which is then reinforced by a chorus of male and female
vocals, as if in collective lament over the oncoming conflicts. During the
film, the motif associated with Chiang Kai-shek is as elegiac as it is tender,
heightened by a demonstrative violin. A more symphonic and yet subdued
variation of the same haunting theme brings a dream quality to a sequence
in which Mao and his comrades celebrate their decisive win on the
battlefield. As the gentle humming of a deep male voice drifts over,
bringing with it the halting notes of a wistful guitar, we see two young
girls look intently through a window, as if wondering what all this may
mean for their future. Following their innocent gaze, we see Mao leaning
against the wall and smiling broadly with his eyes closed, obviously elated
by joyful visions. The pensive humming continues and renders inaudible,
while also providing an emotional unity to, the boisterous next scene, in
which Mao and the two girls join many soldiers and civilians in a jubilant
dance (Figure 5.7).

(The deeply compassionate commentary in the form of music in this
film may remind us of its symphonic counterpart in the American film
Gettysburg [dir. Ronald Maxwell, 1993], in which generals of the Confeder-
ate army are portrayed as noble but ill-fated heroes. A significant difference
between *The Founding* and the American film is that the latter was made
130 years after the historical event, whereas the Chinese film is about a civil
war that was raging some 60 years ago and is technically still ongoing, in
part, coincidentally, thanks to American involvement, a situation that may
further remind us of the British backing of the Confederacy in the
American Civil War.)

At the end of the film, as the new national flag is raised, *Hymn to the Red
Flag*, an orchestral piece regularly performed on National Day and other
ceremonial occasions since its premiere in 1965, is liberally quoted and

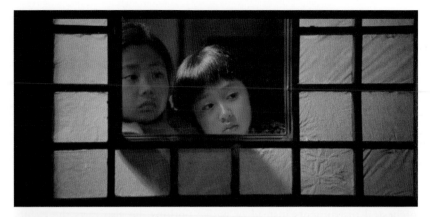

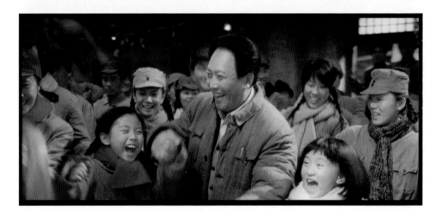

5.7 Alternating views of a historic turning point.

integrated into the grand finale.[35] The hymn was originally composed to commemorate the historic first PRC flag raised in Tiananmen Square on October 1, 1949, and it belonged to a concerted effort in the high socialist era to develop symphonic music with distinct Chinese elements. Its

5.8 Wen Yiduo, the poet.

quotation in *The Founding* pays tribute to a living musical culture and to this popular "red classic" in particular. The quotation also accords it a new imaginary moment of origin.

There are similar instances of quoting iconic images from modern visual sources as well. One example is the portrayal of Wen Yiduo in a close-up as he is about to face assassination by Nationalist agents in a dark alley. The close-up directly refers to probably the best-known photograph of the poet, which has been recreated in many artistic forms, including a striking black-and-white woodcut from 1947 (Figures 5.8 and 5.9). Much later in the film, the scene of PLA soldiers taking down the Nationalist flag over the presidential palace in Nanjing directly evokes an oil painting that Chen Yifei and Wei Jingshan finished in 1977 about the same historic moment (Figures 5.10 and 5.11).

Another example is the crane shot of Mao and Zhou Enlai standing on a boulder and surveying the mountainous landscape as Communist soldiers march in a valley below. The shot offers a cinematic update on Shi Lu's canonical reformed ink-and-brush painting *Fighting in Northern Shaanxi* (1959), in which Mao is depicted standing on top of a rocky mountain looking over an ocean of barren and undulating loess. The film version is more modest and closer to the human scale, and the implied perspective is not as airborne as in the romantic painting, but the rising motion introduced by the camera evokes the same all-encompassing vision and confidence conveyed by the original artwork, which owes a great deal to the Chinese tradition of depicting majestic landscape.[36] Indeed, the depiction of Mao in the film, much like Steven Spielberg's *Lincoln* (2012), activates the many iconic portraits and photographs that constitute our visual memory and imagination about a historical figure.

Evidently the making of a blockbuster in *The Founding* drew on many resources, the most significant among them being the talent pool that

5.9 Xia Ziyi, *Portrait of Wen Yiduo*, 1947, woodcut print.

reflected the depth as well as reach of the growing entertainment-oriented cultural industry. The gala-style presentation of popular stars made the film a unique phenomenon and was a key factor in its box office appeal. Star power in this case did not result in a large production budget (reportedly about $8 million – a sum, a commentator said, a Hollywood director would not even bother getting out of bed for), or necessitate

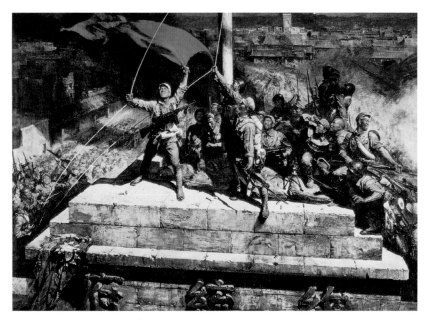

5.10 Chen Yifei and Wei Jingshan, *Taking the Presidential Palace*, 1977,
oil on canvas.

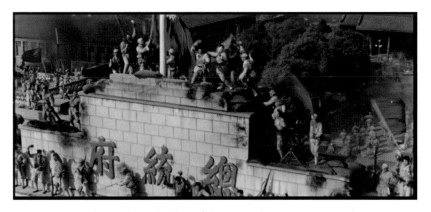

5.11 The Presidential Palace of the Nationalist government is taken.

the extensive use of special effects, two ingredients that are considered indispensable in the formula for any successful Hollywood blockbuster. Nonetheless, the very fetishization of star power is an entrenched Hollywood practice and value, and director Huang Jianxin was explicit about learning from this model. Even the musical component of the film, in particular its instrumentation and complementary relationship to the action on screen, according to the director of music, "is of the Hollywood style entirely."[37]

Creatively adopting the Hollywood studio system and its marketing strategies has been crucial to the rise of commercial cinema in contemporary China, and in *The Founding* commercial cinema and more public-minded, message-oriented filmmaking came together and produced a successful example of mainstream cinema. Or, as one observer saw it, the film is a "landmark achievement in making political film entertaining," and indicates the arrival of a "new central theme cinema."[38]

A useful concept that has gained currency among Chinese commentators since the turn of the twenty-first century is "new mainstream cinema," which describes films that convey a positive social message but are produced and marketed like commercial cinema.[39] New mainstream cinema signals a creative packaging of "central theme cinema," a concept first put forward by administrators in the late 1980s, when it became obvious that the traditional state-sponsored film industry had to undergo reform and become competitive in a diversifying film market, and that a cinema devoted to promoting mainstream ideology should be cultivated and promoted with systematic government support. The initial conception of "central theme cinema" had its institutional origin in the socialist cultural production of an earlier era, but it also anticipated the need for an affirmative and unifying cultural sphere in an age of profound social transformations. The target audience of this cinema, therefore, was always assumed to be the national public in a domestic film market. Yet critics and audiences alike often have little patience with films clearly earmarked as presenting an officially endorsed theme, which may be either contemporary heroics or revolutionary history, because such films tend to be didactic and officious. In new mainstream cinema, market success becomes a main consideration and entertainment value is grasped as a key element.[40] "A central theme film that no one wants to see is pointless, no matter how good you say it may be," remarked Huang Jianxin with regard to *The Founding*. "Since it is culture, it is meaningful only when it communicates," and he believed the mechanism for effective mass communication in this case was the market.[41]

New mainstream cinema is inevitable in contemporary China, not only due to the development of commercial cinema, but also because of the steady integration of the Chinese economy and daily life into the global system. It is yet another indicator of the steady transition to a post-revolutionary society in China, where the production of social consensus and cultural identity is no longer carried out through political agitation or mass mobilization. All the borrowing of Hollywood strategies and even systems notwithstanding, the irreducible core of this new mainstream cinema is to articulate a Chinese subjectivity and structure of feeling, even though it is a core that is negotiated and constructed in every filmic iteration. This is the legitimating function of mainstream cinema in any living society. On this account, we may indeed compare *The Founding*, as Coonan suggested in his report, to *Independence*

Day (timed for release on July 3, 1996!). The differences between these two films are of course numerous, but nowhere is their contrast better illustrated than when and how the two different national flags are introduced. Whereas the Chinese flag, as we have seen, is raised at the very end of *The Founding* to salute the creation of a new government and the renewal of an ancient people, the static American flag on the moon is shown threatened by an encroaching dark shadow at the beginning of *Independence Day*, a cinematic spectacle eulogizing Pax Americana. Here lies the telling contrast between a national imaginary and a fantasy of the world as an empire under American tutelage and protection.

WHICH CONTEXT?

Amid the rather extensive Western media coverage of *The Founding*, first as odious and extravagant propaganda, then as an intriguing, because unexpected, blockbuster, hardly any mention is made of the systematic evolution of mainstream cinema in contemporary China. This admittedly may be a topic of greater interest to academic researchers than to the general moviegoer. Yet within the American academic field of Chinese film studies, when it comes to the contemporary period, research interests tend to gravitate toward auteurs, art-house films, independent and underground filmmaking, or expressions of identity politics as framed by academic discourse in the West. There are certainly noteworthy studies that examine the history of Chinese cinema and its political and cultural significance, and some researchers have begun to pay more attention to the changing Chinese film industry, but overall, we see a remarkable continuity in what journalistic reports and scholarly analyses choose to focus on with regard to contemporary Chinese cinema. And, not surprisingly, the interest is frequently not in what is popular or mainstream in China. In this respect, academic scholarship has largely given up maintaining a productive, even critical, tension with Western media by challenging its assumptions or by offering an alternative view.

For news agencies and cultural institutions in America, a basic position for viewing Chinese films or other cultural products has long been framed, as I suggest above, by the dissidence hypothesis. It is a viewing position that renders ready support to whatever is marginalized or forbidden in China, but regards anything that appears to be mainstream or publicly promoted there with deep suspicion. The reasoning behind this entrenched position is not all that complicated or subtle. It is part of the geopolitical legacy of the Cold War era, during which time the demonization of Red China as enemy and threat readily drew on and added to a long tradition of regarding the Chinese as a racial other, and of dismissing the Chinese political order, whatever form it may take, as peculiar and ill-founded. With regard to contemporary China, there continues to be far more tacit mutual

reinforcement between American mainstream media and the political estab-lishment than the partisan tension and contention that is all too evident over domestic issues and debates. Both the left and the right on the American political spectrum seem to have a common cause in finding China odious and objectionable, and the impressions of China one gathers from American mainstream media are invariably those of a paranoiac and illegitimate police state, a scheming government good at predatory currency manipulation, a crisis-laden society both tightly controlled and really uncon-trollable, or a fast-growing military brazen enough to challenge American power and its allies. As a liberal democracy, America avowedly endorses difference as a positive value as far as domestic politics is concerned, but in international relations, it regards differences, in particular different political systems, with great alarm and readily pursues strategic containment and global hegemony. There is hardly any interest in, or even claim to, building a world system based on values and principles of democracy in international relations, instead of the values and ways of life of the rich and the mighty. It is realpolitik sanctioned as liberal democracy that sustains the dissidence hypothesis and continues to justify a reductive view of Chinese cultural expressions.

An egregious example of such reductive viewing may be found in *Time* magazine's report on *The Founding*. "The slickly produced (though ponderously paced) state-backed film," we are told, is more than "routine propaganda." After certifying the film as state-funded propaganda, the reviewer feels reassured to proceed and decode it for encouraging subver-sive messages. But there is a twist: "What's striking is how the film exposes – intentionally, we would assume – some of the thinking of the Chinese leadership today." And the reviewer has ample justification for treating the film as a source of material intelligence: "Political rulers everywhere rewrite and use history for their ends. But as China looms ever larger in the global consciousness, anything we can glean about its leadership is especially valuable."[42] Diligent gleaning then leads the reviewer to conclude that the film fulfills many political needs, but in suggesting that Beijing is both the sender and recipient of conflicting messages, he seems hopelessly confused about who is sending which message to whom and for what purpose. He may have identified some of the symbolism and political considerations that went into the making of the film, but he has no clue as to why *The Founding* should have been a popular success. Pieces of intelligence extracted reveal more of the review-er's own preoccupations and geopolitical unconscious ("It's today's CCP that made the new new China – modern, strong, feared.") than the cultural and emotional resonances of the object of his analysis.

A less troublesome and more expedient form of reducing culture to politics is to focus on dissident expressions as if they constituted the entire and absolute truth. This is a familiar approach and we see it at work in a

New York Times report on "Indie Filmmakers: China's New Guerrillas," published on September 25, 2009, perhaps intended as the venerable news organization's own greeting of sorts on the sixtieth anniversary of the PRC, or at least as a cool counterbalance to lesser news outlets' frenzy over the current Chinese blockbuster.

The combative *New York Times* report begins with Zhao Dayong, an independent filmmaker, whose documentary *Ghost Town* was the sole Chinese entry at the New York Film Festival that had just opened. What makes Zhao Dayong's documentary particularly noteworthy, explains the reporter, is that "his project was apparently illegal" in China.[43] Documenting life in a remote rural village in southwest China over a period of six years became an illegal project because the filmmaker brushed aside government regulations and shunned the official review process. As a result, there was no permit to release or distribute the final work, and only a few thousand viewers, in the filmmaker's own estimation, ever saw his film in China.

Challenging the established system may be the nature or trademark of independent filmmaking anywhere, but the *New York Times* reporter is quick to paint the issue here as a struggle between artistic freedom and government censorship. "The Chinese government has decreed that all films must be approved by government censors before being distributed and screened, including in overseas film festivals." The reporter is more than ready to sympathize with the filmmaker for his defiance against the government, even though the reporter is also aware that "China's nascent yet highly dynamic crop of independent filmmakers . . . pursue their art in apparent violation of the law." Yet a few more paragraphs into the news story, we are told that "there are now at least four major independent film festivals around the country [i.e. China] and at least two theaters, both small, dedicated to showing Chinese independent films."

What the *New York Times* reporter did not bother to mention is that *Ghost Town* was publicly screened at the Yunnan Multicultural Visual Festival (Yunfest) in Kunming in August 2008.[44] (Or could it be that the filmmaker divulged only selective information for a more coherent self-image?) Moreover, Sinoreel.com, a popular film website based in Guangzhou, had recommended *Ghost Town* in February 2008 and had, in 2007, reported that Zhao Dayong won a jury prize at the Fourth Chinese Documentary Exchange Week with his first work *Street Life*. *The New York Times* obviously had no interest in such inconvenient and compromising details, because it apparently saw the devil in the larger picture. Nor did it feel compelled to find out how, when the government is supposed to censor everything, there could be four specialized festivals for independent films in China. It was beyond the reporter's interest and imagination to ask how *Ghost Town* would be received if it were publicly released in theaters or broadcast on television, or who its anticipated or targeted audience might

be. ("The most accomplished filmmakers have found their largest audiences overseas," we are told, "especially at international film festivals.")

A pat answer to such questions came from Richard Peña, program director for the Film Society of Lincoln Center, which produces the New York Film Festival. "There's been an extraordinary explosion of young filmmakers – quite a few of them are quite talented – who are dedicated to record and tell the real story of what's going on in China," Mr. Peña is quoted in the story. "That story is really more fascinating than the story that the regime wanted to be told." Once again, subscription to the dissidence hypothesis compelled this international film festival organizer to believe that the real story about China is to be found in presumably unsanctioned underground documentaries. Their story must be real because their "ground-level views" exude an "unvarnished authenticity" not seen in "mainstream, government-sanctioned films." It is a more interesting story to Mr. Peña because his interest is in seeing his preconceptions of China confirmed rather than challenged. Yet if we replace the term "government-sanctioned" with "commercial" in the description here, we see that organizers like Richard Peña are absorbed in the familiar structural and genre-specific tension between a low-budget indie or documentary and a Hollywood production. How would an independent film set itself apart otherwise?

The fact is that independent filmmaking is a robust artistic practice and a thriving cottage industry in contemporary China. It is also, as Abé Mark Nornes remarked in observing the Chinese independent documentary scene first-hand, a movement with a "rambunctious anything-goes attitude."[45] The movement attracts many talented young artists who seem bent on repeating the enviable success that some contemporary visual artists, such as Wang Guangyi, achieved in the 1990s. In March 2009, Shelly Kraicer, a programmer for the Vancouver International Film Festival and expert on Chinese cinema, expressed his excitement about the young indie filmmakers: "There's much important, risky, creative work going on in Chinese cinema. However, that work is concentrated in the margins, way outside the system, in independent, low budget DV documentaries, shorts, and features that China's younger filmmakers are fervently at work on."[46]

A few weeks after the *New York Times* story about indie filmmakers being China's new guerrillas, Shelly Kraicer expressed concern about the Chinese "indie conventions" already becoming formulaic. He begins by describing a recurring dream that he had in China while watching self-declared independent films that were presented to him. "The daydream, or perhaps it's a fantasy, is this. There exists, down some dusty grey *hutong* alleyway of Beijing, a Chinese Indie Director's Discount Emporium. You want to make a film? Step right in and assemble your movie at bargain prices." This vivid, if absurd, dream goes on, and Kraicer knows that it tells more about international film programmers like himself than

the aspiring filmmakers. With programmers hunting for such "East Asian art film attributes" that are offered at wholesale prices at the imaginary *hutong* indie shop, Kraicer asks, "Who can blame a young director from China, who, with little or no chance of gaining any return on his or her investment within his own country, tries to design a film to suit those foreigners who pay the bills, fund post production, and just might offer an overseas distribution deal?" He goes on to caution that "it's too easy to choose more of what you already know, and it's too easy to train audiences (I should say, to educate audiences) to expect a certain kind of film experience from a certain brand of national cinema."[47]

It may be easy to train audiences to expect certain aesthetic attributes as characteristic of Chinese cinema, but it is much harder, and yet more important, to help Western viewers to develop *a mental bifocal*, a way of seeing Chinese documentaries *in dialogical relation to* other visual and cinematic images that form the context or environment of those documentaries to begin with. In theory this should not be a difficult task or skill to master, since our daily life is saturated with abundant visual materials that we continually encounter, process, sort out, make sense of, absorb, and file away accordingly. The flow of information and images on the evening news channel, for instance, requires that we constantly shift our mental focus from story to story, segment to segment. But when we encounter a documentary or even a feature film from a different society and culture, by virtue of being removed from its contextualizing image flow, it can appear so much more arresting, intense, and therefore real, as Richard Peña has found out to his great satisfaction and relief.

From his astute on-site observations of the independent documentary scene in Beijing and Kunming in 2009, Abé Mark Nornes admired the energetic and resourceful filmmakers for having made visible "a China one will not find on television, and that is precisely the point." "Using a fairly unprocessed version of direct cinema," according to him, "they address the spectrum of life the government usually stakes off as taboo: prostitution, bureaucratic corruption, rural protests against land expropriation, the impoverished elderly and mentally handicapped, a compromised education system, religious fervor, homosexuality, and just sexuality period." "Needless to say," Nornes continued, "this does not square with one's image of China's image culture. However, these kinds of transformation in style and subject matter should come as no surprise to those familiar with the history of documentary."[48] Nornes's comments remind us that documentary should first of all be viewed as a film genre, and that American viewers, furthermore, are hardly in danger of ever seeing much of Chinese television or understanding what "China's image culture" is all about.

In other words, Chinese independent documentaries form an "image culture" of their own, contributing to what has been called an "alternative archive" of visuals and memories.[49] This contending image counterculture

speaks the lingua franca of direct cinema and tells personal stories that in fact fit much better a familiar frame for viewing China from outside, a frame that rests on two assessments informed by the classical liberal belief in the opposition between state and society. One may be called the (lack of) civil society assessment, which regards Chinese society as little more than the Chinese Communist Party. The other centers on (the lack of) legitimacy, asserting that the Chinese government has little political legitimacy and relies on ever escalating nationalism and economic growth as compensation for its ironfisted authoritarian rule. These twin assessments have spawned ongoing predictions or wishes for "the coming collapse of China" and are constantly reproduced in the popular image of contemporary China as a headless economic juggernaut. They also fuel a constant search for any and all signs of unrest and discontent, for the purpose of convincing us that the underground and the suppressed tell us about the real China, and that a film like *The Founding* is both slick state-funded propaganda and revealing intelligence.

A well-adjusted bifocal vision should let us see how these ideological assessments may easily pervert one's view of a country as complex as China. For this flexible vision will remind us that Chinese society is greater and more complicated than what those documentaries expose and archive, and that the image counterculture generated by a rambunctious movement (or the "new guerrillas") will not thrive or even exist without a robust and evolving mainstream image culture. (As Lü Xinyu, a scholar whose work has been instrumental in defining the New Documentary Movement in China, demonstrates in a detailed account, independent documentaries emerged through many "links and connections with documentaries made inside the state-owned television system."[50]) Such bifocal vision will allow us to recognize the structural interdependence as well as dynamic interaction between the mainstream and the marginal, between the systemic and the sensational, the constituent and the provocative, the publicly expressed and the politically sensitive. When we see all these dialogical relations, we should realize those tensions and oppositions exist in China just as they do in America or any other living societies.

CODA: A GRAND EXPERIMENT

Having seen that it is securely placed in the category of state-funded propaganda and that there are no marketing templates for it, we should hardly expect *The Founding* to be embraced in America, not to mention that the dissidence hypothesis continues to shape expectations of films and stories from China, and "the China threat" is perceived to grow ever more imminent and to migrate from the economic to the cultural domain, most recently in the guise of the sage Confucius. ("Pic isn't likely to get Western distribution anytime soon," so concluded Derek Elley of *Variety*.)

There are more specific reasons for American moviegoers showing no interest whatsoever in such a film. To begin with, the intended or ideal audience of this film is not an international one, but the Chinese public gearing up for a very special celebration. It was a gala show in a gigantic, multi-segmented party of the nation. Even though it comes with highly readable English subtitles, the film would make little sense to an audience not already familiar with the historical references and personalities. It would turn into a dull and confusing history lesson. The bottom line is that this Chinese blockbuster does not target a global audience. Moreover, the entertainment value of *The Founding* as a "lavish star-spotting game" would be entirely lost on someone not knowing or interested in the stars. With over 170 stars on its roster, the film presents the closest thing to a literacy test in contemporary mass culture. (This was indeed how Elaine Chow, an American living in Shanghai, felt about the film when it opened there: "guess we've got to review our Chinese actor/actress trivia!"[51])

(In November 2011, over two years after the film's initial release, David Bandurski, a Hong Kong-based producer of Chinese independent films, informed readers of *The New York Times* that media outlets in Hong Kong and Taiwan had reported "with unmistakable schadenfreude that an October 17 showing at Lincoln Center of the 2009 Chinese propaganda epic *The Founding of a Republic* had drawn not a single filmgoer."[52] The screening was part of a series featuring "popular cinema from China." Bandurski himself is much more taken with the "real creativity" of independent filmmakers such as Zhao Dayong. Quick to see through China's clumsy efforts at gaining soft power, he seems blissfully blind to the question of who gets to define such power and benefits from its exercise in today's world.)

The truth is that even Han Sanping, co-director of *The Founding*, did not expect the film to be the record-breaking blockbuster that it turned out to be. At the film's release in September 2009, he said his goal was a box office return of RMB 100 million, only to see it reach RMB 406 million a few weeks later. As CEO of the China Film Group Corporation, Han Sanping directly controls the largest film studio and its subsidiaries in the country and is known as the top tycoon in the business. Described by the *Southern Weekend* as someone who harbors a deep "Mao era complex," by which is meant as much an emotional attachment to a past political culture as a readiness to acknowledge the relevance of the Mao era to the present, he nevertheless is very clear about the commodity nature of a film and vows to learn from Hollywood in order to keep the Chinese film market from being overwhelmed and colonized. To Han Sanping, there was never any question that a central objective is to compete with Hollywood. He saw the making of *The Founding* as both a necessity and an experiment, believing that it could become a model for future productions.

Indeed, the film was a bold experiment in its conception as well as its execution. It experimented with and succeeded in making historical events

and characters accessible as well as entertaining, and in translating politics and political processes into memorable cinematic spectacles. It also experimented with organizing a narrative film to accommodate an unprecedented number of stars, and with coordinating as many as five directors' contributions and assembling them into a coherent piece. The result was a complex full-length feature film produced at extraordinary speed, an event that mirrors what has been known, for good or ill, as "the China speed" in economic development and transformation. (This pursuit of speed does not always mean perfection or patience with details. In the scene of storage houses in Shanghai being sealed off by anti-corruption police, for one fleeting moment the shadow of a moving camera is clearly visible.) In short, the making of *The Founding* should be regarded as part of an ongoing experiment that is the creation of contemporary Chinese culture.

It so happened that on the eve of the October 1 National Day, 2009, when *The Founding of a Republic* was showing in many packed movie theaters in Beijing, Orville Schell, a veteran China expert, took a stroll through Tiananmen Square and found himself contemplating a paradox or perhaps even a Hegelian ruse of history. Not so long ago, Schell recalled, an "end-of-history" euphoria emboldened "many latter-day American political missionaries to proselytize for democracy as well as capitalism – to urge China's leaders to abandon state controls not only over their economy, but over their political system as well." Yet in 2009, in Schell's view, "China is veritably humming with energy, money, plans, leadership, and forward motion, while the West seems paralyzed." Mindful of the deepening economic crisis stemming from Wall Street, Schell had nothing but disdain for those "market fundamentalists," but he was not quite ready to denounce those political evangelists as democracy fundamentalists yet. "It is intellectually and politically unsettling," he wrote, "to realize that, if the West cannot quickly straighten out its systems of government, only politically un-reformed states like China will be able to make the decisions that a nation needs to survive in today's high-speed, high-tech, increasingly globalized world."[53]

Schell is not alone in finding the reality of contemporary China – or shall we say "the China experiment"? – unsettling. At about the same time, writing to reflect on the long and difficult transition in post-Communist Eastern Europe, Slavoj Žižek understands why China has posed such a challenge to ideologues: "capitalism has always seemed inextricably linked to democracy, and faced with the explosion of capitalism in the People's Republic, many analysts still assume that political democracy will inevitably assert itself." Žižek goes on to ask, "But what if this strain of authoritarian capitalism proves itself to be more efficient, more profitable, than our liberal capitalism? What if democracy is no longer the necessary and natural accompaniment of economic development, but its impediment?"[54]

These are not easy questions because to answer them, even hypothetically, we will have to rethink a host of assumptions, beliefs, and historical

lessons. We may need to think outside the box and regard our contemporary world as having raised other, more challenging questions. A good case in point, I believe, is *The Founding of a Republic*, which as an experimental cultural event and cinematic spectacle demands a new viewing position from us while we try to understand how a changing China may change the world as we know it.

NOTES

1 Rey Chow, *Sentimental Fabulations, Contemporary Chinese Films: Attachment in the Age of Global Visibility* (New York: Columbia University Press, 2007), 12.
2 See Yingjin Zhang, "The Rise of Chinese Film Studies in the West."
3 See Daniel F. Vukovich, "Screening Sinology: On the Western Study of Chinese Film," in his *China and Orientalism*, 100–25.
4 Rey Chow, *Sentimental Fabulations, Contemporary Chinese Films*, 14.
5 Stanley Rosen, "Chinese Cinema's International Market," in Ying Zhu and Stanley Rosen, eds., *Art, Politics, and Commerce in Chinese Cinema* (Hong Kong University Press, 2010), 42.
6 See Rosen, "Chinese Cinema's International Market," 47, Table 2.4.
7 A. O. Scott, "Fanciful Flights," *The New York Times*, December 3, 2004, B21, quoted in Rosen, "Chinese Cinema's International Market," 52.
8 For a comprehensive study of the Fifth Generation in English, see Paul Clark, *Reinventing China: A Generation and its Films* (Hong Kong: The Chinese University Press, 2005).
9 Rosen, "Chinese Cinema's International Market," 53. For the review, see Dave Kehr, "*Postmen in the Mountains*," *The New York Times*, October 22, 2004, B12.
10 *The New York Times*, May 2, 2005, B2. Rosen noted the contrast between Dave Kehr's review of *Postmen in the Mountains* and the TriBeCa prize for *Stolen Life*. See his "Chinese Cinema's International Market," 53.
11 Quoted in Rosen, "Chinese Cinema's International Market," 54.
12 For a systematic account, see Ying Zhu, *Chinese Cinema During the Era of Reform: The Ingenuity of the System* (Westport, CT: Praeger, 2003).
13 For a discussion of this topic, see Rui Zhang, *The Cinema of Feng Xiaogang: Commercialization and Censorship in Chinese Cinema after 1989* (Hong Kong University Press, 2008), esp. Chapter 4, "New Year Film and Chinese Cinema at the End of the 1990s," 63–102.
14 See Ying Zhu, "New Year Film as Chinese Blockbuster: Feng Xiaogang's Contemporary Urban Comedy to Zhang Yimou's Period Drama," in Zhu and Rosen, *Art, Politics, and Commerce in Chinese Cinema*, 195–207.
15 Wendy Kan, "Comedy Hit Banks on Crossover," *Variety*, March 25–31, 2002, 26, quoted in Rosen, "Chinese Cinema's International Market," 53.
16 Derek Elley, "*Big Shot's Funeral*," *Variety*, March 25–31, 2002, 41, quoted in Rosen, "Chinese Cinema's International Market," 53. By the end of its one-week run in two select theaters, *Big Shot's Funeral* reportedly had a box office gross of $820.
17 Yingjin Zhang, "The Rise of Chinese Film Studies in the West," 112. Zhang here argues that the exhibitionism of Zhang Yimou's earlier films "is very much a product of Orientalist surveillance exercised by the international film festivals in the West."

18 See worldfocus.org/blog/2008/09/09/about-worldfocus/373/.

19 See worldfocus.org/blog/2009/10/01/patriotic-chinese-film-stirs-passions-on-nations-anniversary/7555/.

20 See www.cinemaspy.com/article.php?id=3129.

21 See paxalles.blogs.com/paxalles/2009/10/hollywood-hypocrisy-the-founding-of-a-republic-honoring-chinas-60th-stars-celebrities.html.

22 See heartofbeijing.blogspot.com/2009/09/irony-in-founding-of-republic.html

23 See www.independent.co.uk/news/world/asia/the-thoughts-of-chairman-mao-starring-jackie-chan-and-jet-li-1783408.html.

24 Qi Liyan, "Zhuxuanlü dianying de kuanghuan hua xushi" (Carnivalesque Narratives in Central Theme Cinema), *Dianying wenxue (Film Literature)*, no. 4 (2012), 89–90.

25 See Wang Guoping, "*Jianguo daye*: mingxing zhishi yige 'dian'" (*The Founding of a Republic*: The Stars Are But One "Aspect"), *Dazhong dianying (Popular Cinema)*, no. 20 (2009), n.p.

26 See an interview with Huang Jianxin by Ma Asan, "Huang Jianxin: *Jianguo daye* yanyuan shi zhongxin" (Huang Jianxin: Actors Are the Center of *The Founding of a Republic*), *Dazhong dianying*, no. 19 (2009), 22–3.

27 Duanmu Chenyang, "*Jianguo daye* qunxing canlan" (*The Founding of a Republic* is Illuminated with Stars), *Dazhong dianying*, no. 19 (2009), 15.

28 Li Liangjia suggests that *The Founding* is modeled on the CCTV Spring Festival Evening Gala that began in 1983 and has become an entrenched tradition. As a result, the scenes in the film resemble the skits by comedians that are the most popular components of the TV gala. See Li Liangjia, "Cong minsu kan xianlipian" (Present-Offering Films from an Ethnographical Perspective), *Journal of Central South University (Social Science)*, vol. 19, no. 1 (2012), 178–81.

29 See www.variety.com/review/VE1117941365.html.

30 Li Qi, "*Jianguo daye*: yi changmian zhuiliancheng de lishi shishi (*The Founding of a Republic*: A Historical Epic Formed from Scenes Stitched Together), *Dianying wenxue*, no. 9 (2010), 48–9.

31 For a close technical analysis of the film, see Liu Yongning and Yu Zhongmin, "*Jianguo daye*: mingxing qiguan yu shiting zashua de shengyan" (*The Founding of a Republic*: A Feast of Star Gazing and Audio-Visual Acrobatics), *Dianying wenxue*, no. 13 (2010), 58–61. On pp. 60–1, the authors discuss the dynamic MTV-style editing employed in this and other scenes.

32 See "Huang Jianxin: Actors Are the Center of *The Founding of a Republic*," 23.

33 For a relevant analysis, see Yang Haijun, "Xi *Jianguo daye* de dianying yinyue" (An Analysis of the Music Score to *The Founding of a Republic*), *Dianying wenxue*, no. 10 (2010), 124–5.

34 For a detailed discussion of the film's musical score, see the composer Shu Nan's interview with Miao He, "Huidao renxing guanhuai de qidian" (Returning to the Starting Point of Human Concerns), *Dianying yishu (Film Art)*, no. 6 (2009), 57–61.

35 For a technical analysis of the quotation of *Hymn to the Red Flag* in the film, see Liu Jingqiu, "Guanxianyue *Renmin wansui* he *Hongqi song* zai zhuxuanlü dianying zhong de yunyong" (The Use of Orchestral Music *Long Live the People* and *Hymn to the Red Flag* in Central Theme Cinema), *Dianying wenxue*, no. 16 (2010), 129–30.

36 For a systematic study of the artist's work, see Juliane Noth, *Landschaft und Revolution: die Malerei von Shi Lu* (Berlin: Dietrich Reimer Verlag, 2009).

37 See Li Menghua, "*Jianguo daye* yinyue zhong de renxingmei" (The Beauty of Humanity in the Music of *The Founding of a Republic*), *Dianying wenxue*, no. 2 (2011), 127–8.

38 See Wang Lei, "*Jianguo daye*: xin zhuxuanlü yingpian de jueqi" (*The Founding of a Republic*: The Rise of New Central Theme Cinema), *Dianying wenxue*, no. 9 (2010), 50–1.

39 See Zhang Lingyun, "Leixinghua: zai zhengzhi he shangye zhijian" (The Turn to Genre Films: Between Politics and Commerce), *Dangdai dianying* (*Contemporary Cinema*), no. 3 (2005), 83–7.

40 For a recent study of "central theme cinema" and its historical function, see Hongmei Yu, "Visual Spectacular, Revolutionary Epic, and Personal Voice: The Narration of History in Chinese Main Melody Films," *Modern Chinese Literature and Culture*, vol. 25, no. 2 (2013), 166–218.

41 Quoted in Li Ying, "Xin shiqi zhuxuanlü dianying de tuwei" (Breakthroughs in the Central Theme Cinema of the New Period), *Dianying wenxue*, no. 9 (2010), 52–3.

42 See www.time.com/time/world/article/0,8599,1928956,00.html.

43 See www.nytimes.com/2009/09/27/movies/27semp.

44 See blog.tianya.cn/blogger/post_show.asp?BlogID=1794641&PostID=14859790.

45 See Abé Mark Nornes, "Bulldozers, Bibles, and Very Sharp Knives: The Chinese Independent Documentary Scene," *Film Quarterly*, vol. 63, no. 1 (2009), 50–5.

46 See dgeneratefilms.com/critical-essays/an-independent-film-scene-thriving-miles-from-main-street/. Kraicer made the observations here after attending the Third Annual Beijing Independent Film Festival (BIFF) in November 2008. The BIFF is supported in part through the Film Fund of Li Xianting, the art critic known as the godfather of contemporary art in China, and a locally owned art center in Songzhuang, which is itself an artists' colony east of downtown Beijing.

47 See dgeneratefilms.com/category/shelly-kraicer-on-chinese-film/.

48 Nornes, "Bulldozers, Bibles, and Very Sharp Knives," 50.

49 See Chris Berry and Lisa Rofel, "Alternative Archive: China's Independent Documentary Culture," in Chris Berry, Lu Xinyu, and Lisa Rofel, eds., *The New Chinese Documentary Film Movement: For the Public Record* (Hong Kong University Press, 2010), 135–54.

50 Lu Xinyu, "Rethinking China's New Documentary Movement: Engagement with the Social," in Berry *et al.*, *The New Chinese Documentary Film Movement*, 22.

51 See shanghaiist.com/2009/09/17/the_founding_of_a_republic_opened.

52 See latitude.blogs.nytimes.com/2011/11/07/chinas-third-affliction/.

53 See www.asiasociety.org/policy-politics/international-relations/us-asia/china%E2%80%99s-short-march.

54 See www.nytimes.com/2009/11/09/opinion/09zizek.html.

*Where to look for art in
contemporary China*

In March 2012, the European Fine Art Foundation (TEFAF), an organization based in the Netherlands that claims to host the world's leading art fair annually in the city of Maastricht, reported that China had overtaken the United States in the previous year as the world's largest market for art and antiques. The report surveyed the global art trade over the past twenty-five years and observed that, after surpassing the United Kingdom in 2010, in 2011 China had a 30 percent share of the world art market and edged out the United States by one percentage point. Dr. Clare McAndrew, a cultural economist and author of the commissioned report, described the development as "perhaps one of the most fundamental and important changes in the last 50 years," providing yet another indicator of the "seismic shifts in the wider global economy."[1]

According to the TEFAF report, the global art market continued to recover from the recent economic crisis, with the total volume of transactions reaching $60.84 billion in 2011. The driving forces behind the recovery were the strong performance of the Chinese auction market and the rise of sales in fine art. The fine art market in China, in turn, was dominated by the sectors of modern and contemporary art, which accounted for nearly 70 percent of all sales. The explosive development of the Chinese art market, explained McAndrew, "has been driven by expanding wealth, strong domestic supply and the investive drive of Chinese art buyers." More specifically, "growing domestic difficulties in Chinese property and stock markets and the lack of other alternatives appear to have led to a significant amount of substitution into art as an investment by Chinese consumers."

There is no question that art has become a big business and investment option in China. As the *Wall Street Journal* Market Watch reported in June 2011, the value of China's art market, which includes mainland China, Hong Kong, Macau, and Taiwan, more than doubled between 2009 and 2011. (Coincidentally, in 2010, China became the second-largest economy in the world, trailing only behind the United States.) It was evident that the world art market was drifting east, a development that the Market Watch report portrayed as posing a threat to Europe's traditional preeminence in the art trade. The same report also quoted McAndrew, who believed that Chinese art buyers "have embraced the money-making potential of art more quickly than other societies."[2]

Shadowing this business news story about China's art market boom and its global implications is another, much more familiar story. It is the story of political repression and censorship that we keep getting from mainstream Western media as background information on contemporary Chinese art; it is a persistent narrative that had its beginnings in the Enlightenment critique of oriental despotism and was reinforced by the ideological divide of the Cold War in more recent times. The thesis of this familiar narrative is that art, as a creative expression of freedom and

individuality, is fundamentally incompatible with an authoritarian system, in which true artwork, as opposed to government propaganda, is necessarily a form of political dissidence, if not outright protest. It is a thesis predicated on the classical liberal conception of society as resistance against state, of personal liberty in opposition to tyrannical power. The basic plot that ensues therefore invariably revolves around an individual artist, who is censored or, even better, persecuted by the state, but who for that very reason deserves to be revered as the speaker of truth. The appeal of such a narrative is that it clarifies matters by rendering them black-and-white, identifies a larger-than-life hero as the object of our moral support, and thereby makes art from a different culture and society intelligible in terms of our own political concerns and interests. Once a society is characterized as repressive or authoritarian, its art may quickly fall into place because we now have a standard with which to judge it and position ourselves.

The latest version of this gratifying narrative finds its hero in Ai Weiwei, billed by *The New York Times* as "one of China's most prominent and provocative artists" as well as "one of the most outspoken critics of the Chinese Communist Party."[3] These two superlative titles bestowed on the artist explain why Ai Weiwei has become the darling of Western mainstream media and art establishments in recent years, after enduring many years of relative obscurity when he lived in New York until the mid 1990s. For instance, at the 2012 Sundance Film Festival, *Ai Weiwei: Never Sorry*, a documentary that filmmaker Alison Klayman spent two years in making while intimately observing the artist's daily life in China, was awarded a Special Jury Prize for Spirit of Defiance.

In February 2012, a solo exhibition of photographic and video art by Ai Weiwei opened at the prestigious Jeu de Paume in Paris. As a review in the online *Bonjour Paris* made clear, "the Chinese artist is hot property at the moment, with *Art Review* positioning him at the top of its 'Power 100' ranking last year." The exhibition *Interlace* consists of two sections and, lest we miss the point, *Bonjour Paris* was rather didactic about the design: "The first room lets the viewer appreciate him as a political activist while the second shows Ai as an artist."[4] Within days, as if determined not to be outdone in the transatlantic (or NATO) chorus adulating a new star, Tate Modern in London announced that it had purchased an installation work that Ai Weiwei exhibited at the museum in late 2010. However, for whatever reason, the Tate acquired only a small piece of the work – 8 million out of 100 million porcelain sunflower seeds, which, while on display, were found to be toxic.[5]

It is no secret that the celebrity status accorded to Ai Weiwei outside China is the chief dividend of his role as a dissident artist in China. He is cheered first of all as an activist and political dissident against a repressive regime, while his art, to his supporters, becomes hardly more than an

accidental means or pretext. The fact that he lived in New York for over a decade, speaks competent English, and is media-savvy does not hurt either. Ai's flamboyantly provocative art, such as the series in which he photographed presumably himself sticking a middle finger up at symbolic structures such as Tiananmen, the Eiffel Tower, and the White House, is carefully filtered to preserve his image as a defiant artist against Chinese repression. For *The New Republic*'s veteran art critic Jed Perl, who has the audacity to suggest the artwork in question is rather "terrible," Ai remains nonetheless a "wonderful dissident."[6]

In turning Ai Weiwei into a contemporary cause célèbre, Western mainstream media and arts establishments follow a well-scripted narrative and readily vent their distaste for what they view as an alien, opaque, and tyrannical system. Fueling their moral outrage may well be a vicarious thrill derived from urging from afar others to intervene in life elsewhere. Not interested in comprehending politics in China as anything more complex than defying an overbearing, if altogether illegitimate, government, Ai Weiwei enthusiasts see nothing but enviably pertinent political art at work in his case, its political correctness far less troublesome than art on controversial issues, from gay marriage and illegal immigration to racial tensions, may prove to be in the West. Because they do not regard Chinese politics as embedded local contestations, these international supporters can grant themselves the satisfaction of passionately defending freedom of expression without having to consider either the responsibility or concrete consequences of such freedom in context. Some of them would go so far as to contend that Ai Weiwei's unconditional freedom completely outweighs any relevance or value of Chinese civilization, as was evidenced in a widely circulated petition to boycott the summer 2011 exhibition of treasures from the Forbidden City at the Milwaukee Art Museum. Among the few dissenting voices against such shortsighted agitation was that of Julia Taylor, a civic leader in the greater Milwaukee area. "One of the problems is that Americans tend to want to impose their own values," she commented. "Chinese culture has been around for over 5,000 years, so I think we have to be somewhat cautious in dictating the approach that this older culture should take."[7]

Curiously enough, these two stories about art in contemporary China (art as big business and art as political dissidence) seldom intersect, as if they belonged to two parallel but insular universes. We would not have an inkling of Ai Weiwei's commercial success and vast wealth, for instance, from the international uproar over his detention, until we learned that he was ordered to pay $2.4 million in back taxes and penalties by the authorities in Beijing, which was of course promptly denounced by the artist and his backers as sheer political persecution. (The *New York Times* report seemed to suggest that $770,000 in unpaid taxes would be more acceptable.[8])

Disconnected as they may appear, both narratives follow a similar reductionist logic, one reducing art to commodity, the other to political stance; both result in an evaluative statement as well, with one assessing the size of the art market, the other the degree of political freedom or repression. Drastically different pictures may emerge from these two plot lines, but neither brings us any closer to contemporary Chinese art. A report on the art market may reveal trends observable at auction houses and art fairs, but it sheds little light on the not so subtle manipulations and constraints exercised by the market logic on artistic creations. Nor would it care to explain that there has always been a cottage industry specializing in making politically sensitive art for gullible foreign consumers.

More skewed and less useful is the political narrative, which postulates that the most significant and commendable art from China ought to express dissidence and activism. Such an approach can neither make sense of the robust art market there, nor account for the many roles that art and artists play in a complex and fast-changing society. In short, the prejudicial agenda of the political narrative will keep us from gaining a comprehensive view of contemporary Chinese art that, as part of a dynamic cultural production, gains increasingly noticeable global relevance. To achieve that full view, we will need to shift our perspective, just as in the case of making sense of a Chinese blockbuster such as *The Founding of a Republic.*

What follows is first of all the story of how one group of artists contributes to the making of contemporary Chinese art. This is not a group identified by a common credo or artistic style. Rather it consists of a large number of printmakers from across several generations who have in recent years witnessed their art form continually being marginalized in the new art scene, after decades of being at the center of a socialist visual order. This is a story about their anxieties, desires, and self-reinventions in an age when art is steadily privatized and the politics of art is much more complex than public protests. From their reflections, we will have an opportunity to consider the meaning of public art, the reach of the art market, and a critique of contemporary art. What emerges, I hope, is a revealing case study of the condition of making art in contemporary China.

TWO PERSISTENT ANXIETIES

In May 2011, less than a year before the release of the TEFAF report that declared China to be the largest art market in the world, a forum on the changing contexts of contemporary printmaking took place at the Guanlan printmaking village, shorthand for the Guanlan Original Printmaking Base, just west of the young metropolitan city of Shenzhen in southern China. The printmaking village, so named because it is located in a well-preserved traditional Hakka village, was formed in 2008 under the aegis of

the local district government, the Shenzhen municipal branch of the Chinese Federation of Literary and Artistic Circles, and the Printmaking Art Commission of the Chinese Artists Association.

An enterprise with government as well as institutional support, the printmaking village took as its mandate the development of a high-profile, world-class center for promoting prints as both a distinct fine art and a marketable cultural product. For this purpose, the resourceful enterprise acquired state-of-the-art equipment; instituted residence programs for notable domestic as well as foreign printmakers; set up galleries specializing in prints; pursued systematic market development; and began organizing a series of juried exhibitions. A bold experiment in streamlining art production through market mechanism and government sponsorship, the Guanlan printmaking village demonstrated tremendous energy and gained steadily growing international visibility. The third Guanlan International Print Biennial in 2011, for instance, received almost 3,700 submissions by 1,991 artists from eighty-one countries and eventually selected 248 works for exhibition.[9]

Sponsored by several institutions, the May 2011 forum coincided with the third Guanlan Biennial and was attended by leading printmakers, art critics, educators, and scholars. Participants in three panels discussed various issues in the field of printmaking, and the panel generating the most interest was the one that considered the history of printmaking and contemporary challenges and opportunities for this art form. Questions addressed at this panel ranged from how to define a print and understand its serial reproducibility, to the relationship between printmaking and conceptual innovations. The question of a print's unique aesthetic properties also came up. In his remarks, printmaker Ying Tianqi (1949–) distinguished "printmaking" from "print art" and insisted that the latter is an original form of art. He urged fellow artists to uphold the meaning and value of "original print art," keeping it from being commandeered by either popular or market demands. He also argued for a legitimate place for creative prints in contemporary art.

At the close of the forum, an art historian summarized the discussions and observed two pressures confronting the field of printmaking: the art market on the one side, and contemporary art on the other. These, he remarked, cause two main anxieties in the field. One is the anxiety over whether to regard a print as original or reproducible, and therefore lesser, art; the other is over how to stake a claim for printmaking in contemporary art.[10]

Ever since the mid 1980s, Chinese printmakers have faced with unease the twin challenges posed by a rising art market and a vibrant contemporary art scene. The consensus among many is that printmaking, largely untouched by the sweeping New Wave art movements of 1985 that brought forth new artistic conceptions and practices, drifted on along its

own path and went into decline. By the early 1990s, printmakers in general saw their work not only lose social and cultural relevance, but also gain very little market recognition or share. A large number of them began to leave the field altogether in search of more lucrative opportunities. More disheartening to some was the fact that exciting and trend-setting works in contemporary art seldom come from artists trained as printmakers, the sole notable exception probably being Xu Bing and his unique *Book from the Sky* of 1988. Critics and commentators often described the field of printmaking since the mid 1980s as at a nadir, marginalized, or constricted by its own inertia, and passionate calls for breaking out of the confining marginality were continually made, their reverberations clearly still audible at the Shenzhen forum in May 2011. Two prevailing themes of these repeated calls have taken the form of twin imperatives to contemporary printmakers: march toward the market, and move beyond printmaking.

Yet the underlying story is far more complex than is suggested by such slogans. The two departures – commercialization and conceptual updating – remain vague and are often not proposed in tandem, not to mention each has encountered its due share of skepticism. They are in fact different responses to a systematic decentering of printmaking in contemporary art, a process that since the 1980s has gradually removed this particular art form from the central position it once occupied in socialist visual culture. (We observed this erstwhile centrality in Chapter 1 of this study.) In trying to adapt to a new cultural economy, contemporary printmakers are compelled to reposition themselves and consider their art in a fresh light, often in competition with other art forms and practices. This repositioning has led to fruitful reflections and debates that are not confined to the fate of printmaking alone, but often present historical insights into the dynamics as well as the limitations of contemporary artistic production, a condition increasingly defined by and centered on the art market.

WAS IT A DECLINE OR A WITHDRAWAL?

One of the most comprehensive analyses of the difficult transition was published in 1990 by the veteran printmaker Li Yitai (1944–), even though complaints about a lack of direction for printmakers had been openly registered as early as 1982.[11] A historic turning point, according to Li, occurred in the mid 1980s when the general program of reform and opening-up ushered in new techniques, styles, ideas, subject matter, and talents to the field of printmaking. He regarded the transition as anticipating a third stage in the development of modern Chinese prints, preceded first by a revolutionary stage from the 1930s to the 1950s, and then more recently by a realist stage from 1950 to the beginning of the 1980s.

Upbeat as he tried to sound about the dawning new stage, Li Yitai found the field failing to deliver and faced with a severe challenge on

several grounds. The situation was distressing because, first of all, print-making was no longer taken seriously, and other forms of visual arts, such as ink-and-brush painting, oil painting, and sculpture, proved to be much more popular in a society eager to bid farewell to revolutionary agitation. This general neglect left printmakers without adequate institutional support or even equipment, and led many of them to stop making prints or to leave the field altogether. In particular, as a legacy of the recent socialist practice of promoting amateur art, academically trained print-makers continued to find themselves distracted by various demands and unable to create excellent works with concentrated energy and attention. Without professional printmakers playing a leading role, Li worried, no world-class achievements would be possible.[12]

A far more serious threat to the future of the art of printmaking, in Li Yitai's view, was the rising art market. "With the development of a market economy, people's value systems are being shaken at their foundation," he observed grimly. As journals specializing in publishing prints went out of business due to poor sales, printmakers had no choice but to rely on the art market. While he understood why commercial art was gaining popularity, Li believed that, if let loose, the market would undermine many basic principles. Already, the influence of commercial art had led to a shift away from the time-honored black-and-white woodcuts and had brought forth fashionable styles as formulaic as they were preten-tious. More critically, Li Yitai warned, an unbridled art market would undo the revolutionary tradition of the modern print movement as well as the central tenets of socialist culture; it would prevent thoughtful and sophisticated masterpieces from emerging, and in the process upend the prospect of a glorious new stage in printmaking.

Sobering as his final message may have sounded, in 1990 Li Yitai was far from advocating a fundamentalist resistance to an encroaching art market. On the contrary, the veteran printmaker embraced a competitive approach and argued for an ideal situation where innovative and diverse stylistic pursuits would be encouraged. He urged, for instance, an expansion of printmaking beyond established woodcuts to include etching, lithography, and silkscreen. For him, the two pressing questions of the moment were how to help printmaking maintain its relevance in a changing cultural economy on the one hand, and how to win global prominence for new Chinese prints on the other. And a sweeping market did not seem to him either the only or the final answer.

In hindsight, Li Yitai's concerns about the current obstacles resonated with the worries that many had expressed in the early 1950s, when the national victory of the Communist-led revolution necessitated a concep-tual as well as an institutional reconfiguration of printmaking, which had served primarily as a committed and combative revolutionary art in the preceding decades. But in 1990, Li had no interest in returning

printmaking to an explicitly political role or a narrow social function; rather, he was proposing concrete ways to help transform a once socially significant art into a competitive cosmopolitan art. Addressing almost every issue that was to confront the field in the years to come, he helped highlight two crucial developments underlying the field of art in contemporary China.

The first development was the steady withdrawal of art from public life in the wake of the Cultural Revolution. It was a withdrawal justified by the assertion that art ought to be a distinct aesthetic and academic institution, instead of an expedient political instrument. This assertion has gained broad support among artists since the late 1970s because it came as a corrective to the radical policies of the Cultural Revolution, when art was reduced to direct political functionality and the institution of art was systematically dismantled and reorganized to promote social participation. When Li Qun, who since the 1930s had dedicated himself to the modern print movement and whom we met in Chapter 1, publicly reasoned in 1980 that the twin slogans of "art follows politics" and "art serves politics" were flawed and misleading, he was speaking not only for those who suffered political persecution during the Cultural Revolution, but also for the younger generation that aspired to greater artistic freedom. Instead of being subjected to politics, art should serve the people and socialism, Li Qun argued. Since people have different tastes and expectations, there is bound to be a plethora of ideas, interests, and artistic styles for printmakers to explore.[13] What Li Qun did not consider was that the proliferation of ideas and styles would depend on a diversified public as well as articulable individual experiences and identities. Nor did he explain by what means art could reach and serve the people when no political discourse or mechanism was in place to engineer and promote communal access and participation.

The withdrawal of printmaking from public life that began in the early 1980s was therefore part of the artistic and cultural realignment mandated by a robust reform consensus in the post-revolutionary era. This withdrawal was not accomplished overnight, but rather unfolded unevenly on different levels for an extended period of time. First there was a widespread sense of freedom when artists did not feel compelled to engage overtly political themes and sentiments. The critical attention and acclaim accorded to Zheng Shuang's (1935–) still life print *Hydrangea* (1981) is a good case in point (Figure 6.1). Many printmakers in the first half of the 1980s, as art critic Shang Hui observes, turned to pleasing and distinctive regional scenery to express a reawakened aesthetic sensibility.[14]

Next, the value of individuality and self-expression took hold and asserted itself as part of the general discourse on art. By 1990, for instance, a noted printmaker would define "artistic diversity," an objective long endorsed by mainstream discourse but now embraced as a meaningful

6.1 Zheng Shuang, *Hydrangea*, 1981, multiblock woodcut print.

antidote to social demands on art, as embodied in "the subjectivity and independent spiritual pursuit of each and every artist."[15] Art for a collective social cause would appear to be as unpalatable as the idea of a collective art movement.

In conjunction with this turn away from committed art was a growing emphasis on technical sophistication and professional training, which expressed itself as a widespread effort to "purify the language of printmaking." It was an effort, especially among young printmakers, to foreground the formal properties of a print, such as textural variations and unique traces and features of the printing process, in contradistinction to other media. As the art of printmaking grew more and more technically complex and demanding, systematic academic training, asserted another prominent printmaker, turned into a prerequisite.[16] Compulsory credentialization, indeed, has served a critical function in the overall restructuring of Chinese society in the reform era. It has helped ensure the transition to a post-revolutionary mentality by restoring respect for expertise and institutional hierarchy, by compartmentalizing social as well as intellectual

life, and by making politics a local and routinized practice. It constitutes part of what the influential intellectual historian and critic Wang Hui has described as a systematic "depoliticization of politics" on a global scale in the 1990s.[17]

Finally, as professional standards became de rigueur, amateur printmaking groups based on industrial centers or rural communities, the promotion of which had been a commitment of the printmaking community since the 1950s, lost their appeal and by the 1990s enjoyed little support or recognition.[18] Academic circles and interests began playing a dominant role in shaping the content as well as the look of print exhibitions on various levels across the country.

In short, by the time Li Yitai discussed the severe challenges to the field in 1990, printmaking had largely shed its profile as a publicly oriented and politically expedient art form and was repositioning itself as a fine art. This reorientation of the field was achieved through an *affirmation of taste* in aesthetics and an *academic turn* in institutional grounding. As the noted scholar Qi Fengge observes in his overview of the history of Chinese printmaking in the twentieth century, its course after the mid 1980s was driven by the twin pursuits of a fresh visual language and an "ontological rebuilding." Technical perfection became a defining goal for many printmakers, a development that Qi Fengge approves as a necessary modernization of the art.[19] Yet, while artistic styles and creativity flourished in the wake of a withdrawal from an overreaching public life or political commitment, no satisfactory mechanism appeared to be in place to help printmakers reach beyond their own circles. Hence Li Yitai's question in 1990 – "How can the value of their hard work be appreciated?" – was a practical one, and through it he grudgingly acknowledged the advent of the art market.

THE MARKET AND ITS DEMANDS

The other and more complex development that Li Yitai addressed in his consideration of the field of printmaking in 1990 was the art market, which poses a different kind of fundamental question to printmakers and has forced some to rethink the disavowed public commitment of their art. It also leads others to reconsider the relationship between printmaking and contemporary art. As might be expected, initial responses to the art market or commercialization took two opposite directions. One was represented in Li Yitai's deep concern over the contaminating effect of commercial art. The other was an optimistic assessment of the market as a neutral and effective means for bringing art to the public. In the environment of a "far-reaching economic revolution" that had brought forth a "commodity society," wrote printmakers Li Zhongxiang (1940–) and Hao Ping (1952–) in 1989, it was imperative for prints to reach ordinary households and enter

social circulation as commodities. They predicted that as public living standards rose, people would decorate their homes with original artwork, instead of hanging up photographs or other forms of mass-produced art. This change in consumer behavior would provide an excellent opportunity for printmakers, since each of the serial prints they make is an original work, but carries a far friendlier price tag than an oil or ink-and-brush painting.[20]

This rosy picture of millions of middle-class households adorned with original prints would remain attractive to many a printmaker in subsequent years. A decade later, for instance, the idea of a natural match between a middle-class living room and properly framed prints was still alive and well.[21] In 2003, as president of the Yunnan Artist Association, Hao Ping revisited his earlier call for a "commercial mechanism" and insisted prints would best serve the middle-class clientele. In order to give the public an incentive to collect and value prints, printmakers should try to meet its aesthetic expectations, and "provide it with the most accessible and popular 'products'." He hastened to add that this was not an endorsement of kitsch, but an efficient way of making artwork accessible to the market.[22]

However, neither the market nor the new middle class, when they did come into being, seemed to have much interest in prints. Compared to the robust business involving oil and ink-and-brush painting throughout the 1990s, the market share of prints remained negligible. In 2000 the printmaker Zhong Changqing (1949–) offered a clear-eyed analysis of this situation. First, he debunked the notion of a middle class, asserting that the current economic development was such that original artwork still had a long way to go before it entered ordinary households, especially when the significant gap in living standards between city and countryside was taken into account. He also acknowledged that the public's cultural sophistication – its aesthetic habits and capacity for artistic appreciation – determines that a print will not be a first choice as interior decoration. Most likely people will go for a traditional ink-and-brush painting or an oil painting for their respective cultural associations.

Secondly, Zhong pointed out that the art market then was largely propped up by offshore art galleries and big corporations. Only a very small number of artists had benefited from this niche market. Furthermore, even those works embraced by the market needed careful packaging and intense promotion. As most art critics were far more passionate about "avant-garde works with cultural significance" than about traditional art, he noted, no wonder many printmakers should wish to switch to contemporary art so as not to be ignored altogether.[23]

Searching for an "outlet" for their work was a topic of considerable urgency to many printmakers around the turn of the new century. Unlike those earnestly discussing how to turn prints into a hot commodity, in his

2000 article Zhong Changqing took a critical view of the art market and zoomed in on several core issues. He saw the market as a system that cared far more about profit than art, a complex globally coordinated operation that promoted its own interests and preferences. He also refused to idealize the public, which for him designated not so much a political entity or agency as a cultural condition, a situation that would not change overnight but would improve only incrementally and with dedicated efforts to shape and cultivate it. He did not counsel outright capitulation either. On the contrary, he argued that market success was not always a true measure of great art and that, in fact, the current situation of printmaking was a normal one, if one looked beyond non-essential factors such as the market. On this last point, Zhong Changqing was not alone. Several respected figures in the field had agreed that compared to the hustle and bustle that overwhelmed artists working with other media, in particular oils, the relative quiet and insulation from market forces meant a more peaceful working environment for printmakers.[24]

One issue touched upon in Zhong's essay was to gain particular salience as worries over the market's indifference to the art of printmaking continued to mount. This is the issue of prints being viewed as multiple, and often presumably identical, impressions rather than singular, therefore more valuable, works of art. Zhong attributed to cultural habits and a lack of information the evident reluctance among the public to regard prints as collectables, but he also pointed out that the current art market catered almost exclusively to wealthy patrons and speculators. This tendency would continue and in fact intensify in the following decade, as the art market underwent remarkable expansion, and phenomenal auction results convinced collectors that the art trade was a good business. For those auction house regulars, a print had little investment value simply because it could not claim to be a unique piece.

As an analyst pointed out in 2006, two qualities – mediatedness and multiplicity – make the print an awkward commodity in the art market because it presents a challenge to the prevailing system of value appraisal and appreciation. The analyst blamed a poorly regulated market along with profit-seeking investors for the fact that prints failed to receive market attention, but she seemed ready to concede that prints with multiple (or randomly numbered) editions are indeed a liability.[25]

There is more than a little irony here, for in the 1930s, when modern printmaking was introduced, practitioners and supporters of the woodcut argued that the possibility of generating multiple impressions from one woodblock made it a democratic and revolutionary art form. They embraced printmaking as a new public art that was predicated on rejecting a fetishistic possession of art objects. As late as 1987, Xu Bing, a conceptual artist trained as a printmaker, would defend "multiplicity" and "mediatedness" as the defining feature and essence of printmaking.[26] Yet in an age when the art market functions as a specialty stock market, investors

overlook printmaking because a printed image cannot be possessed exclusively. As we have seen, anxiety over the allegedly less than desirable status of printmaking as an art form was still palpable at the Shenzhen forum in May 2011.

On how to cope with what was clearly an intractable situation, Zhong Changqing issued an unambiguous warning. It would be a mistake to attempt various self-negating modifications just for the sake of making printmaking more marketable. This strategy was short-sighted, he warned, because the fundamental way for any art form to win recognition was to insist on and play up its distinctive properties. Zhong pointedly rejected a proposition that was gaining momentum at the time. The proposition was that, in order to participate in contemporary art and lift their art out of the rut it was in, printmakers should shift their focus from working on the block or plate to the production of images by means of a variety of printing technologies. Once the emphasis was put on the generation of images rather than on the purity of media, printmakers would be able to create more meaningful connections with contemporary culture and reality, which in turn would lead them to experience greater creative impulse as well.[27] The best way to overcome its marginal position in contemporary art, from this perspective, was to rethink altogether what constituted printmaking.

At the turn of the new century, therefore, Zhong Changqing observed a forceful convergence that was to shape the field of printmaking. While the marketplace seemed to reinforce the idea that prints are an odd and lesser commodity because they could not be marketed as unique works of art, art critics and analysts also began making increasingly strident calls for printmakers to update their art and overcome its marginality. Such calls were invariably based on the observation that printmaking had failed to claim a significant presence in contemporary art. Yet the main driving force of the art market in China, ever since its beginnings in the late 1980s, has been a specific form of contemporary art. What does this convergence between the art market and discourse on contemporary art mean? What do we learn about the art market and contemporary art from the pressure exerted by these two institutions on the art of printmaking? Or, more specifically, why is contemporary printmaking not regarded as contemporary art by some critics?

CONTEMPORARY ART AND ITS LIMITATIONS

The crescendo of calls for printmakers to embrace contemporary art reached a peak in 2001, when the art theorist Gao Tianmin argued passionately that it was time to "move beyond printmaking." Further elaborating on the thesis that printmaking had to update its medium in order to become contemporary, Gao constructed a highly condensed narrative on the necessity of expanding our conception of what a print

is. The "ontological return" to printmaking that began in the mid 1980s, according to this narrative, has enabled a specific form of artistic expression but also caused a side effect when printmakers prioritized technical perfection and formal purities over conceptual innovations. He called the side effect a "hypotrophy of the self," since insistence on formal distinctions of the art form had paradoxically resulted in a rigid defense against explorations and experiments, which in turn had reduced the reach and impact of printmaking as an expressive art form.

This hypotrophy phase, which Gao Tianmin also described as a period where form trumped content, was in his view a reaction to the preceding stages in the development of modern printmaking from the 1930s through the mid 1980s, the historical ethos of which was content dominating form, or politics and society overpowering art. Here Gao narrated the development of the art field since the late 1970s as primarily a process of extracting art from politics, or what has often been celebrated as "returning art to itself." This "rebuilding of autonomy" was the precondition for the rise of experimental art or the avant-garde since the mid 1980s. Yet in 2001 Gao would argue it was time for a dialectical synthesis that would lead to a "conceptual expansion." Specifically, as the concept of a print was extended to comprehend all and any imprints generated by various means and on various materials, the unease over multiple copies would become irrelevant, and printmaking would achieve much broader applicability. Printmaking would thereby claim, he asserted, its legitimacy as contemporary art instead of merely as an "art form" in a technical sense.[28]

In more metaphoric language, the award-winning printmaker Chen Qi (1963–) followed up and made a similar call for action in 2002. That printmaking was insignificant in contemporary art as it was ignored by the public, Chen Qi wrote, was an indisputable fact and the printmakers themselves were to blame. Collectively obsessed with technicality and turning a blind eye to new artistic trends, since the 1990s they had behaved no differently than escapees amusing themselves on a desert island. They had also made printmaking an obscure art impenetrable to other artists. The greatest challenge for them was therefore not a question of techniques, but "their impoverished ideas and lack of engagement with contemporary culture." "Before we are printmakers," Chen Qi averred, "we ought to be artists interested in developing concepts."[29]

Both the artist and the theorist stressed the importance of printmakers participating in contemporary culture and of printmaking integrating itself into the context of contemporary art. They predicated the future of the art of printmaking on its practitioners' willingness to break with a formalist isolation. Yet neither was suggesting a return to an earlier practice of direct political and social engagement, which they acknowledged as prehistory to the current condition. Instead, they urged a new departure, through which printmaking would enter contemporary art as a capacious and innovative

form. Cultural production rather than political activism became their stated objective.

Furthermore, for both polemicists, contemporary art had a definite and specific meaning. It did not simply refer to art from the contemporary period, but rather designated artistic practices that challenged existing conventions, foregrounded conceptual breakthroughs, and constantly explored new media and new frontiers. A more appropriate appellation for it might be "experimental art" or an institutionalized or institutionally necessitated "avant-garde art." It is no surprise, therefore, that Gao Tianmin should end his essay with an emphasis on the pivotal role of the academy in making printmaking more experimental, and in sustaining contemporary art in general.

With regard to the art market, the idea of "moving beyond printmaking" so as to participate in contemporary art has specific implications. The destination of this proposed move is not the public but a particular art market or establishment. The kind of contemporary print that Chen Qi and others envisioned is a different cultural product than those that Hao Ping, for instance, urged printmakers to create in order to satisfy the needs of the populace in the late 1980s. Printmaking as experimental art is a far cry from prints as accessible fine art. It aspires to be a form of elite and cutting-edge research that finds more favorable acceptance and greater prestige in museums and with connoisseurs than in ordinary households. As such, it appeals to the current art market, not so much because the market always promotes risk-taking, as because printmaking thereby may tap into institutional resources, art criticism and discourse among them, that will help make prints marketable in the existing system of high art. Once presented as experimental art, as Gao Tianmin promised, multiple copies of a printed image should no longer be a concern. Conceptual adventurism rather than political activism was now proposed as a solution to the decline of a once highly vibrant and visible artistic tradition.

It would of course be naive to imagine that contemporary experimental art is all that the art market cares about, but there is little dispute that such art follows the market logic closely in its ever accelerating introduction of new styles and shock effects. It is also evident that ever since its inception, contemporary art in the narrow sense has been promoted as the Chinese avant-garde by the international art establishment and has been associated with a specific understanding of politics. The international attention given to the contemporary avant-garde in China still follows the dissidence hypothesis that we discuss in Chapter 5, which regards experimental art as invariably a form of political and cultural resistance or dissidence in a repressive authoritarian regime.[30] This was the geopolitical unconscious of many celebrations of the Chinese avant-garde through much of the 1990s outside China, and the same considerations continue to sustain the widespread support of Ai Weiwei as a heroic dissident artist.

For a scholar of modern Chinese printmaking, the history of the art form provides a critical framework that exposes the limitations of a narrowly conceived contemporary art. In an essay published in 2007, Zhang Xinying probed the contemporary relevance of the realist tradition that once defined modern Chinese printmaking. The New Wave art movements of the mid 1980s, in her opinion, displaced a "cultural belief" that had been developing for over half a century and had given rise to creative artwork, specifically prints, conveying a strong sense of cultural identity. But the various movements in the mid 1980s ushered in an inchoate age of contemporary art without a discernible mainstream value, belief, or order. Viewed against a tradition in which prints as public art were widely disseminated and socially engaged, contemporary art appears unapologetically elitist and insular from public interests or attention. "This is an age in which we must rebuild our belief," Zhang Xinying wrote. "No matter how developed our society becomes, we need to answer clearly what is the point of art, what is its purpose, meaning, and value."[31] Yet, she was keenly aware of the clout of the art market and the demands of a consumer culture. In an earlier article, she observed that because printmaking does not produce sensational works as avant-garde art, it can hardly attract consumer attention in the market.[32]

Based on her historical knowledge, nonetheless, Zhang Xinying believed that the greatest challenge to contemporary printmaking was how to balance elite art and public art, academic art driven by research and innovation and public art aimed at popularization and education. "This is also the common question faced by the entire art field," she concluded.[33] Her observations remind us that the art market cannot possibly fulfill all the functions that art is expected to serve in a complex society, just as the market cannot be the solution to every need in human life. They also remind us that art in the contemporary era is a much broader concept than contemporary experimental art, as we will see in the diverse interests of three contemporary printmakers presented below.

Indeed, neither the art market nor the narrow conception of contemporary art is capable of addressing or satisfying the historical aspirations of an art form that was instrumental in the creation of a socialist visual culture. On the contrary, the systematic difficulties that confront the art of printmaking in the contemporary period enable us to see, as if in a rear-view mirror, salient features of the socialist approach to art making. In striving to contribute to a new public visual culture, socialist art in China sought to go beyond the academy and against the prerogatives of specialists or connoisseurs. Instead of signifying a hierarchy of taste or cultural differentiation, art was charged with the promotion of social agendas and action. The continuing emphasis on amateur participation, and on artist engagement with social life therefore bespoke an anti-elitist, populist vision, according to which art was to remain an organic and communal experience in defiance of division of labor and various systems of privilege.

Harsh measures for implementing this deeply romantic vision, as well as its radical consequences, however, eventually led to its disavowal, and the reform program, in the aftermath of the Cultural Revolution, methodically went about reaffirming the authority of expertise, artistic autonomy, and academic institutions in order to safeguard art as well as society from being either subsumed or consumed by political agitation. The reform era also entailed a gradual fragmentation of the presumed uniform socialist public, recognizing in its place different talents, professions, interests, and even classes. It was at this juncture that a young generation of printmakers valorized artistic diversity and vowed to accentuate the aesthetic properties of their artistic medium. But the desire to reach an audience larger than one's own circle persists, and the once vibrant vision of a participatory and socially resonant art can hardly be contained entirely through strategies of depoliticization, professionalization, or commercialization.

The anxieties over the fate of printmaking that we witness here, therefore, amount to a critique of the failing of the current system of art as much as they acknowledge the relevance of a past tradition. Prints created in the mid-twentieth century appear refreshingly unaffected and genuine to Zhang Xinying because, in her view, they stand in sharp contrast to our current visions and preoccupations. Productive expressions of similar anxieties often begin with a reclamation of the legacy of socialist visual experience and may turn it, as we have seen in the work of Wang Guangyi and Xu Bing, into a critical resource for creating genre-busting, boundary-crossing artwork for the contemporary world. Such productive rediscoveries we may also observe in the works of some of the best printmakers in China today, as we regard them as an integral part of contemporary Chinese art, rather than through the restrictive lens of a codified contemporary art.

THREE PRINTMAKERS AND THEIR CHOICES

All the challenges facing the art of printmaking in China in recent years may lead us to wonder whether anyone would still be motivated to make prints at all. The sense of urgency that we get from the various writings and opinions about the current situation makes it hard not to view printmaking as all but an impossible and endangered art form. Yet a more complex and energetic picture emerges as we take a closer look, especially when we consider the different roles that printmakers may choose to play in multiple and overlapping spaces.

The most vital institutional space for contemporary printmaking is no doubt the academy. Practically all active printmakers in China today have received formal academic training, and most of them teach in fine arts academies or art schools. In 2007, Qi Fengge, a leading scholar in the field, observed that academic printmakers as a group have become the predominant force, overtaking amateur groups on the one hand and professionals

associated with non-teaching art centers on the other.[34] As a core academic unit, prints departments remain central in fine arts higher education, the basic pedagogical approach of which was laid out in the 1950s with explicit recognition of the heritage and importance of printmaking. Since the 1980s, various prints departments, just like the art academies and schools to which they belong, have undergone considerable expansion and restructuring, incorporating in the process new media and methods into their curricula. With the steady growth of higher education as an industry in recent years, ever more students arrive each year to pursue training in printmaking.

The institutional prominence of printmaking within the academy bespeaks the legacy of the socialist era and its cultural commitment, even though prints no longer enjoy the same cultural and symbolic status in contemporary society as they did. Far from unique to the field of printmaking, this tension between institutional legacy and rapid contemporary development may cause some, purists in particular, to feel either anxious or confused about the current situation, but it may also generate productive controversies and possibilities. The notion of "academic printmaking," for instance, has brought forth both cheering and serious hand-wringing. While Qi Fengge defends printmaking in the academy as indispensable for cutting-edge innovations in both techniques and conceptions, others, such as the printmaker Li Shuqin (1942–), caution that "academic printmaking" must not mean an elitist insulation from social life and public concerns.[35] At issue is whether "academic printmaking" describes a condition for making art or prescribes an aesthetic orientation.

Many have pointed out that the academy as a haven has provided printmakers with a stable, if also stimulating, environment and has at the same time shielded them from the din of the marketplace. Indeed, much of the most innovative and exciting work in contemporary printmaking is created by artists based in academia, as may be observed in the roster of participants in three successive exhibitions in Shenzhen that featured "academic printmaking" between 2006 and 2010.[36] Yet few printmakers feel satisfied with their work being labeled as "academic." They may operate in and benefit from the academic system, but neither the academy nor the artists themselves are content to set the institution as the limit to the appeal of their work. In fact, the academy serves as much more than a shelter or confinement; by systematically accelerating the cycle of innovation, it makes it possible for printmakers to break new ground and experiment with new ways of reaching beyond academic circles. One printmaker who pursues this possibility seriously and is passionate about integrating his art into social life as well as public space is Liu Qingyuan.

Born in 1972, Liu Qingyuan graduated from the Prints Department of the Guangzhou Academy of Fine Arts at the age of twenty-four and, after a

6.2 Liu Qingyuan, *Urban Youth No. 2*, 1998, woodblock print.

stint at another art school, returned to his alma mater as professor of graphic design in 2010. In 1999, Liu's first solo exhibition, consisting entirely of black-and-white woodcuts, opened at a small independent bookstore called Borges in a neighborhood in Guangzhou. The location as well as the content of that art event signaled the artist's passions in the years to come. He works almost exclusively with oil-based black-and-white woodblock prints and self-consciously evokes the visual idiom of German Expressionism and modern Chinese woodcuts from the 1930s. In several series we also see a direct homage paid to the Belgian master printmaker and graphic storyteller Franz Masereel (Figure 6.2). Like Masereel,

Liu Qingyuan's favorite subject matter is life in the city. As he puts it, "besides serving the purpose of life itself, art more readily serves the purpose of observing life . . . My art is never just a method, but more like an amusing and informal experiment, in which tradition finds its parodies in contemporary life."[37]

In a series entitled *One Kind of Reality* (1999–2004), which features street scenes and urban vignettes, Liu brings to our view stark images of lonely and rebellious youths, disoriented individuals, forlorn lovers, rowdy crowds and noisy rock concerts (Figure 6.3). One critic marvels at the melancholy lyrical poetry embodied in Liu's images; another observes that, through his raw and evocative woodcuts, Liu gives new life to a once politically potent artistic medium and makes us realize how ornate and pleasing much of contemporary printmaking tends to be.[38]

If one way to appreciate Liu Qingyuan's work is to see it as the bold reincarnation of an avant-garde aesthetic of the early twentieth century, his efforts to complicate the public visual domain resonate even more profoundly with the historical avant-garde's desire to reconnect art and social life. Over the past decade, Liu has exhibited his woodcuts in an array of venues: museums, galleries, bookstores, civic and performance centers, even a subway station (Figure 6.4). He has also made posters, signs, stamps, and t-shirts from his woodcuts, and has periodically created illustrations for newspapers and magazines. Making woodcut prints, he once stated, keeps him in sync with our post-revolutionary age, and his job is to "reawaken our desire to claim a public vision."[39] In 2011, he designed the logo for a newly opened independent bookstore in Shenzhen and displayed his works among the bookshelves there. More recently, the artist took part in an NGO project to help rebuild a rural community in the province of Anhui. For this event, he created a calendar for 2012 and switched to a festive red for the key color, but the pensive and determined young man who reappears throughout the months is an unmistakable hero in the artist's imaginative world (Figure 6.5).

Hardly any other printmakers have been as assertive as Liu Qingyuan about the continuum between his art and everyday experience. Making woodcuts, as one art critic puts it, is like breathing for Liu. "Cutting a woodblock is to him a daily exercise of life; his standard for gauging everyday reality is a black-and-white print."[40] The artist also sees endless topics and issues to explore through his art, because in his eyes "China is in the midst of nothing but an age of woodcuts."[41] Yet this does not mean that Liu Qingyuan is ready to reduce his art to direct social statements or give up seeking new ways of seeing. On the contrary, he continues to experiment in order to extend the visual possibilities of the woodcut. The brightly illuminated and colorful images that he constructed from his woodcuts and displayed at the 2010 Shanghai Biennale are a good case in point (Figure 6.6).

6.3 Liu Qingyuan, *Evening Cruise on the Pearl River*, 2002, woodblock print.

No contemporary printmaker, in terms of artistic style and self-positioning, may be any more distinct from Liu Qingyuan than He Kun (1962–), an artist based in the town of Simao (recently renamed Puer), Yunnan, and ten years his senior. A quick glance at their respective prints

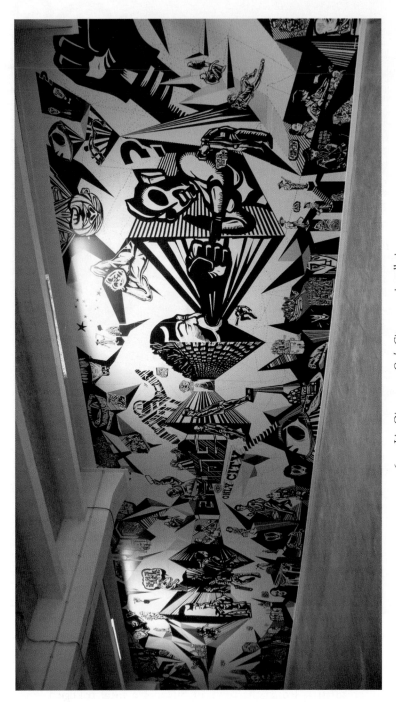

6.4 Liu Qingyuan, *Only City*, 2009, installation.

6.5 Liu Qingyuan, *Life Makes City Better!*, 2010, poster.

will tell us that they speak in very different visual languages, in spite of the fact that they both work with woodblocks. Their differences are systematic and, for our purposes, highly informative as well.

After graduating from the art department of a local college in 1980, He Kun became a leading figure in a small group of young printmakers

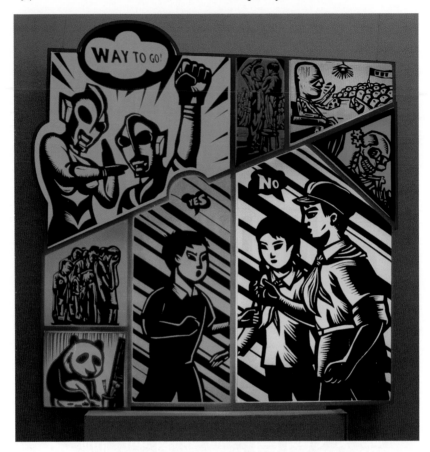

6.6 Liu Qingyuan, *Crossbreeding 1*, 2010, mixed media.

from the same area, who in the 1980s developed an unconventional way of making reduction woodblock prints and gained national prominence. In 1989, his print *Autumn Song: The Blanched Land* won a national award and brought further recognition to what was now known as the Yunnan School of printmaking (Figure 6.7). One central feature of the Yunnan School is the particular reduction printing method, in which the artist usually begins with a dark background and superimposes layers of lighter color as the block is continually cut and reduced after each impression. It is a process that allows a great degree of spontaneity and produces a print with deeply saturated and intense colors. (It feels like, as He Kun once described it, painting with a block.) Dancing shapes of color, fluid lines, rich details, and an expressive texture are all part of the visual properties that come with a print made this way (Figure 6.8).

Another defining feature of the Yunnan School is its singular subject matter. Distinctive landscapes of southwest China and its local customs, in

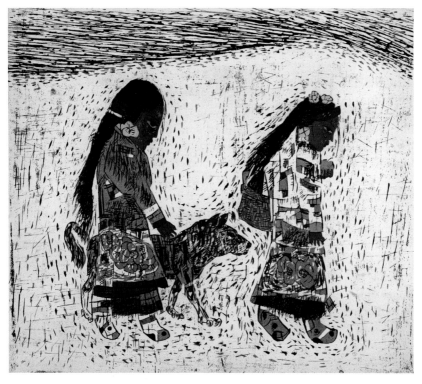

6.7　He Kun, *Autumn Song: The Blanched Land*, 1989, reduction woodcut print.

6.8　He Kun, *Open Country*, 2002, reduction woodcut print.

particular the many ethnic minorities in the region, are themes continually explored by this group of artists. Like several other notable regional printmaking groups in recent history, the success of the Yunnan School lies in developing a unique visual idiom to highlight and express a regional sensibility. Yet differently from those other regional schools that began emerging in the early 1960s, since the 1990s members of the Yunnan School have consciously sought to create a brand name that would contribute to the local economy and cultural prominence. Two products that the city of Puer is best known for, claimed He Kun in 2008, are its namesake tea and reduction woodblock prints, both of which the municipal government spares no effort in promoting.[42]

The fact is that He Kun and his fellow printmakers have enjoyed support from various local government offices from an early stage in their career. The first public display of his artwork was in a modest group exhibition held at the Simao Palace of Mass Arts in May 1983. In early 1984, at a workshop organized by the Yunnan Provincial Department of Culture and offices in charge of fine arts and public culture, He Kun and some thirty aspiring young artists had an opportunity to hone their printmaking skills and learn about the reduction printing method. Following the workshop, young printmakers from Yunnan began attracting attention by winning national prizes. Their achievements would be proudly embraced by interested local and provincial government offices, which would organize reviews and assessments to help young artists win even greater recognition.[43] (After his national award in 1989, for instance, He Kun received for the same work the Yunnan Province Special Prize for Achievements in Fine Arts.)

Printmaking in this case was far more than an academic affair, and had much to do with a coordinated effort to cultivate a distinct cultural product with national visibility. It was part of a public culture development program that was itself an institutional legacy of the socialist period. In other words, we may regard the emergence of the Yunnan School by the early 1990s as one of the last successes of the socialist mode of cultural production (Figure 6.9). This may explain why the dominant color tone of prints by the Yunnan School is usually bright and celebratory, and the sentiments expressed therein are often uplifting and communal. Such an affirmative aesthetic in celebration of a public life and vision is consistently exemplified in He Kun's work, including the magnificent print that he made on the sixtieth anniversary of the People's Republic (Figure 6.10).

Yet there is also a restless energy pulsating in the best of He Kun's work. This energy, which charges his prints with bursting colors and swirling cuts and dashes, also expresses itself through an intrepid entrepreneurialism. In 1994, He Kun formed a company in the city of Zhuhai to market Yunnan-style reduction woodblock prints. After the unsuccessful venture

6.9 He Kun, *Village in Summer*, 2008, reduction woodcut print.

folded less than two years later, he turned his attention abroad and established a presence in Europe, in particular the UK, in the following years. The most rewarding projects for the enterprising artist were those that he developed in alliance with the local government in Puer in the new century. By then the local government was functioning more like a corporation than a political unit, and the market economy had legitimated a business approach to maximizing cultural resources. In the government's blueprint for building a "green, ecological, and cultural" Puer, the tea

6.10 He Kun, *Joys of Spring*, 2009, reduction woodcut print.

industry, tourism, and printmaking were identified as the three pillars of the local economy. In 2007, with full government backing, He Kun created an artists' village on the outskirts of Puer and its first group of visitors came from the UK. In November of the same year, an exhibition that combined Yunnan-style woodblock prints with "ethnographical tourism photography" was opened at the Shanghai Museum of Art as part of a week-long, government-sponsored program to promote the city of Puer and its attractions. Since then, He Kun's ambition has been to turn his artists' village into a vacation complex that will include a five-star hotel, a golf course, a lake circled with bike paths, and a world-class printmaking studio.

Between Liu Qingyuan and He Kun, we witness the contemporary adaptations of different moments and aesthetics from the earlier stages of modern printmaking. While Liu is much closer in spirit to the avant-garde movement in urban centers of the 1930s, He Kun retains as well as appropriates the socialist vision of a fulfilling rural life. For both artists, the "public" continues to function as a pertinent concept, although on different grounds. There is a critical edge to Liu Qingyuan's woodcuts insofar as he seeks to enable us to have an alternative, indeed intensified, view of reality and our relationship to it. By contrast, He Kun aims at stimulating, rather than challenging, the imagination and expectation of a mainstream viewing public through an affirmative aesthetic of rich and fantastic colors.

The social interests and strategies of engagement pursued by these two artists appear even more striking when we consider the case of another award-winning printmaker and his approach to art. Chen Qi, whose call for printmaking to update itself as contemporary art we have already come across above, teaches at the Central Academy of Fine Arts in Beijing and is best known as a master of the water-printing method. As a young art student in the 1980s, Chen Qi tried various media and styles, including oil painting and Expressionist-style woodcuts, but eventually he found his true passion in the traditional method of making woodblock prints with water-based Chinese ink, a technique first systematically revived in the late 1950s. Over the past quarter-century, he has perfected the complex techniques involved in water printing, revolutionized the process by introducing computer technology, and created some of the most memorable images in contemporary art. The most monumental work to date is titled *1963*, an 11 ft × 25.5 ft monochromatic print that took him over two months to make in 2009 and which belongs to the *Water* series that he had started six years before. The nine shades of water-based black ink that he separated and printed with ninety-six plywoord panels on specially ordered paper constitute a majestic surface of rippling water that is as mesmerizingly realistic as it is beautifully abstract (Figure 6.11).

6.11 Chen Qi, *1963*, 2009, multiblock woodcut printed with water-based ink.

On the occasion of *1963* being exhibited in an art gallery in Beijing, Chen Qi offered the following reflections:

I hope in my work one can obtain a view of an invisible secondary nature by means of the visible primary nature. When it ceases to function as a visual record, or superficially to represent situations in life, or to serve utilitarian purposes, art will have access to the greatest space of freedom and a much broader horizon of cultural significance.

He also believes that in our time, when painting is no longer called upon to be a record of either life or history, "what an artist needs to possess is a capacity for observation and insight, as well as an ultimate concern for humanity."[44]

A philosophical interest in contemplating human existence and the infinite runs deep in Chen Qi's work. He loves to regard an object, be it a gorgeous unfurled lotus flower (Figure 6.12), an antique musical instrument, or even a crystal ashtray-turned-fishbowl, with absolute concentration and to reveal in it an entire universe of tender light and caressing

6.12 Chen Qi, *Dancing Lotus*, 1999, multiblock woodcut printed with
water-based ink.

shadows. With the exception of a very few prints from the early 1990s that
are dotted with one or two solitary receding figures, Chen Qi does not
bring human beings, modern or ancient, into his work. Some critics sense
a coldness in this absence, but others recognize a refined literati sensibility
of the past expressed in contemporary form. "His work conveys a mysteri-
ous tranquility, quietly reverberating across a vast space," observes curator
Tony Chang.[45] In 2001, Chen Qi started a series called *Butterfly – The
Other Shore*, in which a Buddha's gesturing hand or *mudrā*, a fluttering
butterfly, and a serene landscape are gathered together as homage to the
three main Eastern philosophical traditions (Figure 6.13). But it was upon
undertaking the *Water* series in 2003 that he felt an even more expansive
realm had opened up. He felt his need for spiritual expression was met by
technical preparations, and water printing as a medium was perfect for
depicting water. "If my earlier work expresses a 'limited self' and still relies
on cultural symbols, *Water* allows me to break free of such constraints and
enter a realm of freedom."[46] In front of a sublime image of water that he

6.13 Chen Qi, *Butterfly – The Other Shore No. 2*, 2002, multiblock woodcut printed
with water-based ink.

created, he found himself as well as his notion of art both transformed
(Figure 6.14).

In series after extraordinary series of works since the 1990s, Chen Qi has
profoundly transformed the vocabulary as well as the concept of a multi-
block woodcut printed with water-based ink. "His precise delineation of
fine lines over empty space, his ability to define the grey areas between
black and white, as well as his delicate control over moisture in paper are
simply incomparable, not to mention the seemingly effortless capturing of
an ineffable rhythm, of the wood grain and texture on paper."[47] He takes
extraordinary care to achieve technical perfection, but he is never absorbed
in it. On the contrary, as one art critic remarked appreciatively, in front of
Chen Qi's exquisite prints, we experience the power of a simple and
dedicated search for "the true way" of the universe. "Chen Qi's art is
richly imbued with the spirit of Chinese philosophy, but at the same time
its modality is entirely contemporary."[48]

6.14　Chen Qi, *Water No. 7*, 2010, multiblock woodcut printed with water-based ink.

This celebrated "contemporary modality" means more than a determined search for a fresh and distinctive form in the present. It entails a resolute departure from other artistic styles and practices of the modern era, leaving them behind as historically embedded and limited, and also conceptually parochial. To conceive and create contemporary art for Chen Qi is tantamount to fashioning a transcendent cosmopolitan imaginary with the many resources, from cultural to philosophical, that the artist has at his disposal. The contemporaneity of such a cosmopolitan, in fact cosmic, imaginary lies in the implicit belief that local and immediate concerns or strivings are intrinsically historical, whereas universal visions and values will always be the final and absolute horizon. In this sense Chen Qi speaks of an "ultimate concern for humanity" with regard to his art. Also in this sense we may regard Chen Qi's project as one of creating a globally resonant art for our contemporary world.

By comparison, both Liu Qingyuan and He Kun are contemporary artists who, in their respective ways, "express their views out of concern for events in contemporary society," as He Kun put it in describing his understanding of contemporary art.[49] The latest example of global art from Chen Qi is his *Notations of Time* series (2010–), inspired by moth-eaten antique books as well as the notion of the "wormhole" in theories of general relativity about spacetime. The series grew from prints to installation pieces to eventually an open-air structure that captures passing daylight as undulating shapes and traces (Figure 6.15).

This increasingly expansive cosmic vision has helped Chen Qi's work garner ever greater critical acclaim and general appeal. Recipient of numerous national prizes, Chen Qi sees his prints eagerly sought after by international art museums as well as private collectors. (Incidentally, both Chen Qi and He Kun were award winners in the Seventh National Fine Arts Exhibition of 1989. Each won a gold medal in a national prints exhibition after that, and both have received the Lu Xun Printmaking Award, the highest honor for a contemporary Chinese printmaker.) Unlike the kind of organic public art that Liu Qingyuan is committed to making, Chen Qi's prints belong to the category of fine art. They are displayed in museums and galleries but do not circulate in streets or as disposable print material. Also, Chen Qi is primarily represented by a commercial gallery based in the well-established 798 Art District in Beijing, an arrangement that neither Liu Qingyuan nor He Kun has yet fully embraced. In 2009 and 2010, the Amelie Art Gallery mounted two exhibitions solely to promote Chen Qi's latest work. In 2013, Chen Qi held a solo exhibition at the National Museum of China, a distinction not yet shared by either Liu Qingyuan or He Kun.

The more rewarding question to ask at this juncture, I would suggest, is not which of the three artists introduced here is more significant or valuable, but rather what their divergent pursuits tell us about the state of contemporary printmaking. To privilege one over the others will

6.15 Chen Qi, *Notations of Time – A Place without a Trace*, 2010, installation.

inevitably be an evaluative assessment that reveals more about our own preferences and wishes than anything else. In looking at the three print-makers together and recognizing their respective positions and aspirations, we are better positioned to appreciate the different legacies that continue to shape contemporary printmaking. We also gain a better view of the multiple players and components that constitute the dynamic field of contemporary Chinese art, a field far richer and deeper than can be reduced to either profit margin or political posturing in the name of art.

NOTES

1 See "China Overtakes the US to Become the World's Largest Art and Auctions Market," March 17, 2012: www.tefaf.com.

2 See "China's Art Market Boom Threatens Europe," *Wall Street Journal Market Watch*, June 15, 2011: www.marketwatch.com.

3 See "Ai Weiwei" under "Times Topics," *The New York Times*, updated November 15, 2011, topics.nytimes.com/top/reference/timestopics/people/a/ai_weiwei.

4 Lindsey Marsh, "Ai Weiwei, Entrelacs (Interlace) at the Jeu de Paume until April 29th," *Bonjour Paris*: www.bonjourparis.com/story/ai-weiwei-entrelacs-interlace-jeu-de-paume.

5 See Carol Vogel, "Tate Modern Buys 8 Million Works by Ai Weiwei," in "Arts Beat," *The New York Times*, March 5, 2012: artsbeat.blogs.nytimes.com/2012/03/05/tate-modern-buys-8-million-works-by-ai-weiwei/. Vogel also reports that in 2011 Sotheby's in London sold a mini-version of the *Sunflower* series that was composed of 100,000 seeds at about $5.60 a seed, for a total of $559,394.

6 See Jed Perl, "Noble and Ignoble: Ai Weiwei: Wonderful Dissident, Terrible Artist," *New Republic*, February 2013: www.newrepublic.com/article/112218/.

7 See Mary Louise Schumacher, "Should the Milwaukee Art Museum Protest Ai Weiwei's Detention?," JSOnline.com, May 20, 2011: www.jsonline.com/blogs/entertainment/.

8 See Andrew Jacobs, "China Seeks $2.4 Million from Dissident," *The New York Times*, November 1, 2011: www.nytimes.com/2011/11/02/world/asia/.

9 See Zhou Aimin, "Hewei banhua? Banhua hewei?" (What Are Prints? What Are Prints For?), *Meishu* (*Fine Arts*), no. 9 (2011), 94–8. Information on the Guanlan International Prints Biennial in 2007, 2009, and 2011 is also available on the printmaking village's official website: www.guanlanprints.com.

10 See Zhou Aimin, "What Are Prints? What Are Prints For?," 98.

11 See Ma Ke, "Banhua santi" (Three Theses on Printmaking), originally published in *Wenyi yanjiu* (*Research in Literature and Arts*), no. 4 (1982), reprinted in Qi Fengge, ed., *Ershi shiji Zhongguo banhua wenxian* (*Documents on Twentieth-Century Chinese Prints*) (Beijing: Renmin meishu, 2002), 89–92.

12 Li Yitai, "Yanjun de shike" (A Serious Moment), originally published in *Meishu*, no. 7 (1990), reprinted in Qi Fengge, *Documents on Twentieth-Century Chinese Prints*, 139–42.

13 Li Qun, "Tan banhua yu zhengzhi" (On Printmaking and Politics), originally published in *Banhua* (*Prints*), no. 1 (1980), reprinted in Qi Fengge, *Documents on Twentieth-Century Chinese Prints*, 85–8.

14 Zou Yuejin and Shang Hui, "Chunhua qiushi" (Spring Flowers and Autumn Fruit), in *Chunhua qiushi: 1949–2009 xin Zhongguo banhua ji* (*Spring Flowers and Autumn Fruit: Prints of New China 1949–2009*) (Changsha: Hunan meishu, 2009), 4–5.

15 See Li Zhongxiang, "Dui banhua chuangzuo xianzhuang de sikao" (Thoughts on the Current State of Printmaking), originally published in *Banhua yishu* (*Print Art*), no. 31 (1990), reprinted in Qi Fengge, *Documents on Twentieth-Century Chinese Prints*, 143–5. He goes on to state the following: "'Self-expression' and 'subjectivity' are not a negation of objective reality or of the importance of life; rather they reveal a self-will confidently making judgments and choices, and a self that is continually enriched and strengthened as it intervenes in society" (144).

16 See Song Yuanwen, "Banhua xuyao zengqiang zhuanye suzhi" (Printmaking Needs Better Professional Preparations), originally published in *Banhua yishu*, no. 33 (1990), reprinted in Qi Fengge, *Documents on Twentieth-Century Chinese Prints*, 97–9.

17 See Wang Hui, "Qu zhengzhihua de zhengzhi, baquan de duochong goucheng yu 60 niandai de xiaoshi" (The Politics of Depoliticization, Multiple Construction of Hegemony and the Passing of the 1960s), in his *Qu zhengzhihua de zhengzhi: duan 20 shiji de zhongjie yu 90 niandai* (*The Politics of Depoliticization: The End of the Short Twentieth Century and the 1990s*) (Beijing: Sanlian shudian, 2008), 1–57.

18 The last public endorsement of amateur regional printmaking groups was probably made by Ma Ke in his "Lun banhua qunti de jueqi" (On the Rise of Printmaking Groups), *Meishu*, no. 7 (1987), 11–13.

19 Qi Fengge, "Ershi shiji Zhongguo banhua de yujing zhuanhuan" (The Changing Contexts of Chinese Printmaking in the Twentieth Century), originally published in *Wenyi yanjiu* (*Research in Literature and Arts*), no. 6 (1997), reprinted in Qi Fengge, *Documents on Twentieth-Century Chinese Prints*, 176–85.

20 Li Zhongxiang and Hao Ping, "Banhua fazhan de shangye jizhi" (The Commercial Mechanism for the Development of Printmaking), *Meishu*, no. 3 (1989), 15.

21 For instance, printmaker Dai Daquan wrote, "At a time when Chinese ink-and-brush painting is so overdeveloped as to be hawked on the sidewalk, and when oil painting still refuses to rid itself of an aristocratic mindset, prints are provided with an open market space in reaching the middle-class." See his "Banhua de shichang" (The Market for Prints), *Meiyuan* (*Garden of Beauty*), no. 1 (1999), 63–4.

22 Hao Ping, "Banhua shichang suixiang" (Random Thoughts on the Print Market), *Zhongguo banhua* (*Chinese Prints*), no. 22 (2003), 7. Around the same time, Zheng Shuang also stated that prints intended for people's living rooms should be aesthetically pleasing and elevating. They should not appear as weapons, or "daggers and spears," as was expected during the revolution. See Zheng Shuang, "Qiantan Zhongguo banhua de xianzhuang yu chulu" (Preliminary Remarks on the Current Situation of Chinese Prints and their Future), *Wenyi yanjiu*, no. 1 (2003), 87–8.

23 Zhong Changqing, "You banhua 'kunjing' suo xiangdao de" (Thoughts on the "Difficult Situation" of Prints and More), *Yishu tansuo* (*Explorations in Art*), no. 2 (2000), 94–5.

24 In Zheng Shuang's 2003 essay, referred to above, she concurs with a series of prominent artists from different generations (Jin Shangyi, Song Yuanwen, Guang Jun, and Su Xinping) who share the opinion that, left alone by the market, printmakers have gained an advantage over other fields of art.

25 See Zhang Xinying, "Rongyao yu kunhuo tongzai de dangdai Zhongguo banhua" (Glories and Confusions of Contemporary Chinese Printmaking), *Zhongguo meishuguan* (*China National Gallery*), no. 12 (2006), 53–7, esp. 56.

26 See Xu Bing, "Dui fushu xing huihua de xin tansuo yu zai renshi" (New Explorations and Reconsiderations of Plural Painting), originally published in *Meishu*, no. 3 (1987), reprinted in Qi Fengge, *Documents on Twentieth-Century Chinese Prints*, 103–4.

27 Wang Lin, "Chongchu banhua chuangzuo de kunjing" (Break Out of the Difficult Situation in Printmaking), originally published in *Zhongguo banhua*, no. 5 (1994), reprinted in Qi Fengge, *Documents on Twentieth-Century Chinese Prints*, 137–8.

28 See Gao Tianmin, "Zouchu 'banhua'" (Move out of "Printmaking"), *Meishu guancha (Fine Art Observations)*, no. 8 (2001), 6–7.

29 Chen Qi, "Zouchu bianyuan" (Move out of Marginality), *Yishu jie (Art Circles)*, no. 3 (2002), 71–3.

30 For a more extended discussion of this topic, see my essay "On the Concept of the Avant-Garde in Chinese Art," *Journal of Korean Modern and Contemporary Art History*, 20 (2010), 202–14.

31 Zhang Xinying, "'Xianshi zhuyi' de dangxia yiyi zhuiwen" (Inquiries into the Contemporary Meaning of "Realism"), *Huakan (Journal of Art)*, no. 3 (2007), 58–61.

32 See Zhang Xinying, "Glories and Confusions of Contemporary Chinese Printmaking."

33 Zhang Xinying, "Inquiries into the Contemporary Meaning of 'Realism'," 61.

34 See Qi Fengge, "Xueyuan banhua de dangxia yujing" (The Current Context of Academic Printmaking), *Meishu daguan (Art Panorama)*, no. 6 (2007), 4–5.

35 See Li Shuqin, "Ruhe qu zhuanqian: Yeshuo banhua de 'dangdai zhuangtai'" (How to Make Money: My Thoughts on the "Current Condition" of Printmaking), *Zhongguo meishuguan* no. 12 (2006), 45–6.

36 Qi Fengge, who first put forward the notion of "academic printmaking" in 2001, was instrumental in organizing the three exhibitions on "contemporary Chinese academic printmaking," each presenting some thirty mature and yet innovative printmakers from across the country. The second event took place at the Guanlan Printmaking Village, and the third exhibition included artists from Taiwan, Hong Kong, and Macau.

37 Artist statement in *Multiple Impressions: Contemporary Chinese Woodblock Prints*, exhibition catalogue, ed. Xiaobing Tang, University of Michigan Museum of Art, July 16 – October 23, 2011, 69.

38 See Huang Canran, "Liu Qingyuan muke de shuqingxing" (The Lyrical Quality of Liu Qingyuan's Woodcuts), and Yang Xiaoyan, "Muke shi huxi: Liu Qingyuan de heibai muke yu richang shijian" (Making Woodcuts Is Breathing: Liu Qingyuan's Black-and-White Woodcuts and Daily Practice), both in Liu Qingyuan, *Suipian: Liu Qingyuan muke zuopin, 1998–2006 (Fragments: Woodcut Prints by Liu Qingyuan, 1998–2006)* (Guangzhou: Zuojia, 2006), 1–5, 18–21.

39 See Liu Qingyuan's interview, in *Yishu shijie (Art World)*, no. 257 (2011), 21–2.

40 Yang Xiaoyan, "Making Woodcuts Is Breathing," 18.

41 Email communication with the author, January 4, 2012.

42 See He Kun, interview with the journal *Xin shijue (New Visuality)*, no. 7 (2008), republished in *He Kun juebanhua (Reduction Prints by He Kun)*, exhibition catalogue (Hangzhou: Panorama Gallery, 2009), 120.

43 For informative accounts of the history of the Yunnan School of printmaking, see Guo Xiaochuan, "Lun Puer jueban muke" (On Reduction Woodblock Printmaking in Puer), and Qi Peng, "Puer jueban muke fazhanshi yanjiu" (Study of the Development History of Reduction Woodblock Printmaking in Puer), both in *Reduction Prints by He Kun*, 126–9, 130–8.

44 Chen Qi, "Shengming de qinggong" (Pure Offerings of Life), in *Chen Qi 1963: The Making of Water*, bilingual exhibition catalogue (Beijing: Amelie Art Gallery, 2009), n.p. Translation modified.

45 Comment by Tony Chang, in *Chen Qi 1963*, n.p. Translation modified.

46 Comment by Chen Qi, in *Artist Chen Qi: Notations of Time*, bilingual exhibition catalogue (Beijing: Amelie Art Gallery, 2010), n.p. Translation modified.

47 Comment by Qi Fengge, quoted in *Chen Qi 1963*, n.p. Translation modified.

48 Comment by Guo Xiaochuan, quoted in *Chen Qi 1963*, n.p. Translation modified.

49 He Kun, interview with *New Visuality*, 121.

Seeing China from afar

There is all the difference in the world between thinking about China as exotic – an old way of annexing China to the domain of western consciousness – and thinking about exoticism in China, which is a universal subject.

<div align="right">Joseph Levenson (1969)</div>

On July 16, 2011, the exhibition *Multiple Impressions: Contemporary Chinese Woodblock Prints* opened at the University of Michigan Museum of Art (UMMA) in Ann Arbor. The exhibition brought together 114 woodblock prints made by forty-one Chinese printmakers between 2000 and 2010, creating the first large-scale display of such works in the United States. It was made possible with support from many institutions, among them the Andrew W. Mellon Foundation, the Henry Luce Foundation, the China Academy of Art in Hangzhou, and several offices within the University of Michigan. As the curator of the exhibition, and after having worked on the complex project for over three years, I was elated to see the exhibition expertly and splendidly presented in two galleries at UMMA. Appreciating in the museum setting all the prints, almost every one of which I had examined and admired in different parts of China – from Puer in the southwest to Daqing in the northeast – I felt I was welcoming a group of dear friends arriving from afar for a joyous gathering. It had been a novel but most rewarding experience to curate the exhibition, in part because the process gave me an opportunity to reach beyond the academic circle and to present my research to the American public in such a direct and accessible way. The experience also prompted reflections that subsequently went into the writing of the present volume. As a way of bringing my current work on Chinese visual culture to a conclusion, I will consider briefly a number of issues that rose in connection with the exhibition.

In the brief text panel that greeted viewers and introduced them to the art show, I made the following explanation:

The title *Multiple Impressions* refers first to the process of repeatedly inking and printing a block to make copies – the essence of printmaking; it also points to the array of styles, techniques, and innovations transforming the art of printmaking in China today. The diverse works are presented here in dialogue with one another,

so that we may appreciate them with an ear for intersecting conversations and an eye for resonances and divergent visions.

Conceptually the works were grouped into three sections: Landscapes Old and New, Fellow Beings, and Layered Abstractions. Yet the configuration of the two adjacent galleries did not impose a linear structure, and visitors could freely move through and across the exhibition space, enjoying the prints in no particular order and developing a narrative or viewing process of their own. The same introductory panel also contains a thesis statement:

The proliferation of styles and spirit of exploration in contemporary Chinese printmaking testify both to the maturity of the art form and to the cultural conditions that make them possible. In a 2009 interview, Xu Bing, perhaps the best-known artist in the exhibition for Western viewers, likened Chinese society today to a gigantic laboratory highly conducive to artistic innovation. Indeed, pragmatic experimentalism has been the guiding principle of the reform era, which over the last three decades has brought forth profound changes in Chinese politics, culture, social life, the economy, landscape, and, of course, art. The prints collected in *Multiple Impressions* are part of this grand, ongoing, and multi-dimensional experiment. It is my hope that they will help us gain a closer view of a changing and complex society.

The idea of organizing such an exhibition came to me in the spring of 2008, when I studied for two months the art of making a woodblock print at the China Academy of Art in Hangzhou. My trip was made possible by a generous New Directions fellowship from the Mellon Foundation, which enabled me to pursue training in a new field beyond literary studies. During those memorable eight weeks, I spent most of my time in the printmaking studio along with a group of young and talented art students, most of them understandably puzzled by my presence and evident amateurism. I also made friends with many faculty members in the prints department and had extensive conversations with some of them while viewing their work. I was greatly excited and intrigued by what I saw. I had most recently worked on a scholarly monograph tracing the development of the black-and-white woodcuts in the 1930s, but the large and colorful woodblock prints that I saw in 2008 struck me as both familiar and yet refreshingly contemporary, not unlike the Chinese language, which has changed and expanded to such an astonishing extent in recent years that I find myself constantly learning about the meaning and usage of new words and expressions, even though it is my mother tongue and I recognize its deep grammatical structure.

From my printmaker friends I also learned their concerns and strivings, gaining an intimate knowledge of the contemporary condition of an art form that always speaks to me with a particular force. It was then that I felt the urge to bring an exhibition of contemporary Chinese prints to America. I felt compelled because I realized such a project would be an excellent way for me to make sense of an exuberant field and also to convey

my excitement about it. I realized that we in the United States had not kept up with this extraordinary development, with our prevalent view of what defines and drives contemporary art from China determined by what we wish to see and or what we think we should see.

A key element in my decision to undertake a curatorial project, therefore, was my realization that the art exhibition would need to present a full and complex picture of China today. In my initial letter of invitation to the many printmakers, I made it clear that I saw the exhibition as a cross-cultural event that was about more than art objects.

Its implicit interlocutors will be the history of modern and contemporary printmaking in China, as well as a certain perception, based primarily on oil painting, of Chinese contemporary art (or more precisely a contemporary art catered to the overseas market). I hope the exhibition will not only illustrate the rich developments in themes and techniques that we see in contemporary woodblock prints, but also reflect the vitality, diversity, and tension in contemporary Chinese culture and society.

I was aware that when displayed in a different cultural environment, artworks would inevitably acquire an allegorical dimension, and that, furthermore, contemporary Chinese art exhibited in America has often been subjected to what I have come to describe as a "dissidence hypothesis" upheld by public opinion, an interpretive apparatus that, as I explain in the course of this book, is unsatisfactory because it is reductive and ultimately betrays a condescending embrace of exotica. It was my task as curator, therefore, to enable the viewer to see in the exhibition more than is expected, and to help him or her become curious about, and patient with, ongoing conversations in another place and another language. It would be impossible to suspend or do without allegorical readings altogether. In fact my own presentation of the works in *Multiple Impressions* is itself an instance of allegorization. But there are allegories on different scales and for different purposes, and my hope was that the exhibition would allow American viewers to appreciate a vast living tradition and, with that appreciation, to recognize the parochial nature of the dissidence hypothesis. The point was not to disavow allegorical narratives, but rather to explain the limitations of certain allegorical thinking that happily takes itself to be both natural and universal.

As I began considering hundreds of images and different possibilities, I knew that the ideal checklist for the exhibition should acknowledge the many styles, schools, practices, and generations that constitute the contemporary field of printmaking. It should also make evident why it is more productive and rewarding to recognize such constitutive diversity than to identify or endorse one particular vision or style. I decided to focus entirely on woodblock prints because, for one thing, it would be an exceedingly complex undertaking to include other media, such as silkscreen and

lithography. Besides, with the long native tradition of making woodblock prints, as well as its modern indebtedness to European influence, it is an artistic medium with rich cultural resonances. I saw to it that all known technical variations, from water printing to reduction prints to wood engraving, as well as major regional schools, such as the exuberant Yunnan landscape prints and the Daqing tradition of exploring the imagination excited by industrialization, were represented in the exhibition. I also purposely selected works that would invite comparative viewing in terms of style or subject matter. For instance, the section on "Fellow Beings" includes several prints that depict different families (urban, rural, extended, nuclear, symbolic, and ethnic minority) in markedly different styles, ranging from realistic to humorous to grotesque.

Furthermore, I found it important that differently positioned groups of printmakers were represented. As I further explained in an introductory essay to the exhibition catalogue,

most of the participating artists teach at art academies, but some are professional artists outside the academy and still others hold positions at various cultural organizations. Many are prominent and critically acclaimed, winners of national and international prizes; some are commercially more successful than others; others are young and new to the field. Some regularly participate in art shows at museums large and small, at home and abroad; some have contracts with galleries and display their works there periodically; some promote and sell their works online. A few do all of the above.[1]

The process of constructing the checklist was long and arduous, involving continual reflections on my own position and extended journeys across China to meet artists and see their work. As the list grew increasingly concrete, I became ever more confident as well. I understood that I was not duplicating the scale or structure of the established national print exhibition that takes place in China every three years. Rather I was organizing an exhibition for a specific audience, for whom China remains a culturally distant and politically alien country, even though economically it may appear too close for comfort. I began to see more clearly my position as that of a sympathetic observer – sympathetic because I recognized the complex sources and motivations underlying the artistic expressions, and because I saw the need to resist the temptation to reduce or disregard that embedded and defining complexity. And from this position, seeing China as a living culture rather than as a political monolith is far more revealing and consequential. I was reminded of Joseph Levenson and found particularly relevant one of his statements, especially if we take the liberty of updating it for our contemporary world: "There is all the difference in the world, between thinking about China as political – an old way of annexing China to the domain of western consciousness – and thinking about politics in China, which is a universal subject."[2]

After it finally opened in July 2011, *Multiple Impressions* was well received and a wide spectrum of viewers, from members of the public to university faculty, expressed to me their appreciation and amazement. The museum staff received highly positive feedback too. One of the most perceptive observations came from Judy Burns, a docent at UMMA, who marveled at the show and remarked that "everyone coming to see it will find something special to relate to and think about." To me this is the best endorsement of my effort. It encapsulates what a successful large-scale public art event should ultimately be about. Several local media outlets, paper as well as digital, published reviews and recommended the show to their respective readers. The review appearing in the *Ann Arbor Observer* stands out in my mind because of what it revealed about the reviewer's approach. I found it a fascinating text to read and ponder over.

"If you took 'Chinese' out of the subtitle of the current exhibit at UMMA, you might not recognize the exhibit as such," so begins the brief review.[3] The "only unifying theme" that the reviewer could see is that all the participating artists are from China. She does not address what "Chinese woodblock prints" ought to look like or whether she would have mistaken the show for one of American art, if she had not been told otherwise. Instead she senses a new recognition is in order: "That's not to say it's unorganized, just that the perspectives represented are nearly as diverse and broad as China itself." She then goes on to describe a sense of being overwhelmed by the "striking and beautiful" prints that display "a dizzying array of styles and subjects – from pure abstraction to photorealism."

Perhaps unwittingly, the reviewer puts her finger on the growing tension between a narrow and ossified American notion of China and the rich and dynamic reality in that once remote country. From a modest collection of images by some forty artists, she intuitively realizes that the "diverse and broad" cultural landscape in China exceeds her familiar conceptual framework, and that she might be prompted to reconsider what her expectation of "Chinese art" or "Chineseness" entails. Yet that seems to be a discomforting, in fact vertiginous, task. Feeling dizzy in front of the "striking and beautiful" prints, our reviewer seeks reassurance and turns her attention to the several prints that depict peasant life, which she finds most relatable and intriguing. "Despite using a diverse mix of styles and showing everything from field hands to shepherds, the artists almost always portray only one person in a vast landscape." This is a perceptive observation, and it is arrived at when she singles out a theme or genre as an entry point, forgoing the more strenuous effort to grasp the multifaceted relationship between this chosen theme or genre and other topics and variations also present in her view.

If images of peasant life in China lead our reviewer to muse about a lonely and hard existence, her seeking out of works with "a political

7.1 Li Chuankang, *A Family of Four*, 2004, reduction woodcut print.

leaning" is a more subjective, and unfortunately clumsier, endeavor. One of the two prints where she identifies a political undertone is Li Chuankang's *A Family of Four* (Figure 7.1). It is a striking image made by means of reduction printmaking, through which the artist wishes to present, in his own words, an ordinary Tibetan family "realistically and at a sympathetic eye level." As if posing for a photograph, a husband and wife with their child stand in front of us and all three squint somewhat uneasily under the bright Tibetan sun. We are aware that the husband, who is a soldier of the People's Liberation Army (PLA) on a family visit, is looking directly at us, but his wife and child, neither of them smiling and

with her ethnicity clearly marked by her attire, are looking at someone else, possibly a photographer or a tourist, whose presence is suggested by a partial shadow on the foreground. The moment captured is that of distraction, before a pose is all set up and a formal portrait is composed. It is an accessible and yet complex moment fraught with humane observations and many possible readings.

Yet, in the eye of our reviewer, the image shows "a brave Chinese artist who turns a sympathetic eye toward Tibet," confirming her own geopolitical imagination that pits China against Tibet in a simplistic relationship of antagonism. She might have been bitterly disappointed to learn that Li Chuankang is a highly acclaimed artist in the PLA, who is stationed in Yunnan and whose understanding of life in Tibet has nothing in common with her fancy, and that *A Family of Four* has won major national prizes in China since its appearance in 2004. In telling "the story of an ordinary Tibetan family in our times" through vivid detail, the artist invites us to imagine the daily and intimate life of this family (who is its fourth member?). There is little pretense or histrionics, since on display are not exotica but rather a tangible lived moment of multiple trajectories and possible narratives. We find it impossible not to return the warm and confident look directed at us from the relaxed, smiling husband; we see the mother and her child look askance at someone or something outside the frame, their searching, even incredulous, expression making us wonder what they are looking at, or what they think of what they can see and how they are seen. We look at the mother and her child, and we are aware of being looked at from the side too. In this triangulated visual field, facile explanations or identifications are possible only when one painstakingly overlooks the fact that one's own viewing position is also called into question and subject to examination. Our reviewer's eagerness to reduce *A Family of Four* to geopolitical terms that make sense to her therefore reveals more of her skewed view and fantasy than an understanding of the complex picture she is looking at.

Finally, as if not satisfied that Li's print is not as explicit as it should be, the reviewer spells out her own anxiety in concluding her piece: "The exhibit could be better only if it said more about the artists' experience of censorship in China." She is anxious to hear about censorship in China because that would be a familiar and proper topic. Not that she cares so much about artistic creativity or diversity there, since she already feels overwhelmed by such a small sampling of a specific art form from one short decade. Rather she desperately needs to claim a moral high ground from where she can order things to her liking and create an object in her own image. In short, she is not so much interested in what China is or is becoming, as she is obsessed with what China is not. Only when she is reassured that China is different will she feel confident to speak, although when she does speak, she will insist that the Chinese should be just like us.

The vicarious yearning for political action and drama over there (it does not need to be China) is but the age-old quest for exotica updated for the postcolonial era. And the habit of seeing nothing but politics in anything Chinese repeats the practice of racial stereotyping, the logic of which is to substitute a part for the whole and to posit otherness as at once intrinsic and inexplicable.

The complaint that an exhibition of art from contemporary China somehow is less useful to American viewers when it does not foreground the issue of censorship helps me see even more clearly that *Multiple Impressions* was a timely event. It was timely because the artwork in the show revealed the inadequacy of certain viewing habits. "If there is a point to this exhibition as a cross-cultural event," as I expressed my hope in the catalogue, "it is to help us appreciate the complex and experimental cultural conditions that make possible the rich and distinct prints on display."[4]

This appreciation will need to begin by recognizing the historic legitimacy as well as the complex ecology of contemporary Chinese society, culture, and politics, which means moving beyond seeing Chinese art and culture in terms of political dissidence or politics as we project it from afar. In short, a shift in our viewing of China is in order and in fact long overdue. We need to shift from seeing China, consciously or unconsciously, as exotic, opaque, irrational, and therefore threatening, to recognizing it as a living society that continues to respond creatively to many of the same issues faced by other societies, and which, furthermore, has the same fundamental aspirations that are embraced in other parts of the world. We need to shift away from reducing China to a monolithic state, and Chinese society to a political alien.

Only with such a paradigm shift can we proceed to appreciate, "realistically and at a sympathetic eye level," the great variety of resources that artists in China today self-consciously draw on in their efforts to create new artistic forms and cultural identities. We will then be better prepared to grasp the global resonances of such creations and free ourselves from parochial expectations of what Chinese art ought to be like or about. Such are my hopes occasioned by the experience of curating *Multiple Impressions*. And they help me think through some of the issues and concepts that I have further explored in this volume with regard to a range of topics. My ultimate argument is that, by understanding the aspirations and transformations that define the historical specificity as much as global relevance of contemporary Chinese visual culture, we will have a more meaningful view of a society that plays an increasingly visible role in shaping the world we live in.

NOTES

1 Xiaobing Tang, "Introduction: Continual Experimentation in Modern Chinese Printmaking," *Multiple Impressions: Contemporary Chinese Woodblock Prints*, 14.

2 Levenson's original statement, quoted as an epigraph at the beginning of this conclusion, is in his *Revolution and Cosmopolitanism*, 2.

3 Katie Whitney, "Multiple Impressions: Contemporary Chinese Woodblock Prints," *Ann Arbor Observer*, October 2011, 61. Following quotations from the review are all from the same page.

4 Tang, "Introduction: Continual Experimentation in Modern Chinese Print-making," 16–17.

Glossary

Ai Weiwei	艾未未	Li Qun	力群
biaoxian	表现	Li Shuqin	李树勤
Cao Yong	曹勇	Li Xianting	栗宪庭
Chen Kaige	陈凯歌	Li Yitai	李以泰
Chen Sihe	陈思和	Li Zhongxiang	李忠翔
Chen Qi	陈琦	Li Zhun	李准
Cheng Conglin	程丛林	Liang Qichao	梁启超
Chiang Ching-kuo	蒋经国	Liang Yongtai	梁永泰
Chiang Kai-shek	蒋介石	Liu Qingyuan	刘庆元
Ding Ling	丁玲	Lü Peng	吕澎
Dong Xiwen	董希文	Lü Xinyu	吕新雨
Fang Lijun	方力钧	Luo Gongliu	罗工柳
fanshen	翻身	Ma Ke	马克
fanxin	翻心	Mao Zedong	毛泽东
Feng Xiaogang	冯小刚	*nianhua*	年画
Gao Minglu	高名潞	*nei*	内
Gao Tianmin	高天民	*nongcun pian*	农村片
gaibian	改编	Pan Gongkai	潘公凯
gaikuo	概括	Qi Fengge	齐凤阁
gaizao	改造	Shang Hui	尚辉
Gu Yuan	古元	Shu Nan	舒楠
Han Sanping	韩三平	*suku*	诉苦
Hao Ping	郝平	Sun Yat-sen	孙逸仙/孙中山
He Kun	贺昆	Tang Guoqiang	唐国强
Huang Jianxin	黄建新	*wai*	外
Huang Zhuan	黄专	Wang Guangyi	王广义
kuzhu	苦主	Wang Hui	汪晖
Li Chuankang	李传康	Wang Meng	王蒙
Li Hua	李桦	Wang Mingxian	王明贤
Li Jiefei	李洁非	Wang Qi	王琦
Li Keran	李可染	Wang Shikuo	王式廓

Wen Yiduo	闻一多	Zhang Xiaogang	张晓刚
Xie Fei	谢飞	Zhang Xinying	张新英
Xinchao	新潮	Zhang Yimou	张艺谋
Xu Beihong	徐悲鸿	Zhao Dayong	赵大勇
Xu Bing	徐冰	Zheng Shengtian	郑胜天
Yang Jie	杨劼	Zheng Shuang	郑爽
Ying Tianqi	应天齐	Zhong Changqing	钟长清
Yu Feng	郁风	Zhou Libo	周立波
Zhang Guoli	张国立	Zhou Xiaowen	周晓文
Zhang Huaijiang	张怀江	Zhou Yang	周扬
Zhang Ruifang	张瑞芳	Zhu Naizheng	朱乃正

Illustrations

261

Filmography

Ai Weiwei: Never Sorry. Alison Klayman. Expressions United Media, MUSE Film and Television, and Never Sorry, 2012.

Battleship Potemkin. Sergei M. Eisenstein. Goskino, 1925.

The Big Parade (大阅兵). Chen Kaige 陈凯歌. Guangxi Film Studio, 1986.

Big Shot's Funeral (大腕). Feng Xiaogang 冯小刚. China Film Group, Columbia Pictures, and Columbia Pictures Film Production Asia, 2001.

The Birth of New China (开国大典). Li Qiankuan 李前宽and Xiao Guiyun 肖桂云. Changchun Film Studio, 1989.

Crouching Tiger, Hidden Dragon (卧虎藏龙). Ang Lee 李安. Asia Film Union and Entertainment, China Film Co-Production Corporation, and Columbia Pictures, 2000.

Ermo (二嫫). Zhou Xiaowen 周晓文. Shanghai Film Studio and Ocean Film, 1994.

Farewell My Concubine (霸王别姬). Chen Kaige 陈凯歌. Tomson (HK) Films Co. Ltd. and Beijing Film Studio, 1993.

Final Destination 4 (死神来了4). David R. Ellis. New Line Cinema, Practical Pictures, and Parallel Zide, 2009.

Flags of Our Fathers. Clint Eastwood. DreamWorks SKG, Warner Bros., and Amblin Entertainment, 2006

The Founding of a Republic (建国大业). Han Sanping 韩三平and Huang Jianxin 黄建新. China Film Group, CCTV Movie Channel, Shanghai Film Studio, Media Asia Group (HK), Emperor Motion Pictures Ltd. (HK) *et al.*, 2009.

Gettysburg. Ronald F. Maxwell. TriStar Television, Esparza/Katz Productions, and Turner Pictures, 1993.

Ghost Town (废城). Zhao Dayong 赵大勇. Lantern Films, 2008.

Hero (英雄). Zhang Yimou 张艺谋. Beijing New Pictures Film Company, China Film Co-Production Corporation, and Elite Group Enterprises (HK), 2002.

The Hurricane (暴风骤雨). Xie Tieli 谢铁骊. Beijing Film Studio, 1961.

The Hurricane (暴风骤雨, also translated as *The Storm*). Duan Jinchuan 段锦川 and Jiang Yue 蒋樾. Documentary. 2005.

In the Wild Mountains (野山). Yan Xueshu 颜学恕. Xi'an Film Studio, 1985.

Independence Day. Roland Emmerich. Twentieth Century Fox Film Corporation and Centropolis Entertainment, 1996.

Ju Dou (菊豆). Zhang Yimou 张艺谋. China Film Co-Production Corporation, Cineplex Odeon Films (Canada), Tokuma Shoten (Japan), and Xi'an Film Studio, 1990.

King of the Children (孩子王). Chen Kaige 陈凯歌. Xi'an Film Studio, 1987.

Li Shuangshuang (李双双). Lu Ren 鲁韧. Shanghai Film Studio, 1962.

Life (人生). Wu Tianming 吴天明. Two Parts. Xi'an Film Studio, 1984.

Lincoln. Steven Spielberg. DreamWorks SKG, Twentieth Century Fox Film Corporation, and Reliance Entertainment, 2012.

The Manchurian Candidate. John Frankenheimer. M. C. Productions, 1962.

National Anthem (国歌). Wu Ziniu 吴子牛. Xiaoxiang Film Studio, 1999.

Not One Less (一个都不能少). Zhang Yimou 张艺谋. Beijing New Pictures Film Company, Columbia Pictures, and Film Productions Asia, 1999.

Our Leader Niu Baisui (咱们的牛百岁). Zhao Huanzhang 赵焕章. Shanghai Film Studio, 1983.

Postmen in the Mountains (那山那人那狗). Huo Jianqi 霍建起. Xiaoxiang Film Studio, 1999.

Raise the Red Lantern (大红灯笼高高挂). Zhang Yimou 张艺谋. ERA International (Taiwan), China Film Co-Production Corporation, and Century Communications, 1991.

The Road Home (我的父亲母亲). Zhang Yimou 张艺谋. Beijing New Pictures Film Company, 1999.

Rumble in the Bronx (红番区). Stanley Tong 唐季礼. Golden Harvest Company (HK) and Maple Ridge Films (Canada), 1995.

Stolen Life (生死劫). Li Shaohong 李少红. Rosat Film Production and China Television Media Co. Ltd., 2005

The Story of Qiu Ju (秋菊打官司). Zhang Yimou 张艺谋. Sil-Metropole Organization (HK) and Youth Film Studio of Beijing Film Academy, 1992.

Street Life (南京路). Zhao Dayong 赵大勇. Documentary. 2006.

To Live (活着). Zhang Yimou 张艺谋. ERA International (Taiwan) and Shanghai Film Studio, 1994.

Triumph of the Will. Leni Riefenstahl. Leni Riefenstahl-Produktion and Reichspropagandaleitung der NSDAP, 1935.

Women from the Lake of Scented Souls (香魂女). Xie Fei 谢飞. Tianjin Film Studio and Changchun Film Studio, 1992.

Yellow Earth (黄土地). Chen Kaige 陈凯歌. Guangxi Film Studio, 1984.

Young People in Our Village (我们村里的年轻人). Su Li 苏里. Changchun Film Studio, 1959.

Xilian (喜莲). Sun Sha 孙沙. Changchun Film Studio, 1995.

Select bibliography

Acret, Susan, ed. 2004. *Wang Guangyi: The Legacy of Heroism*. Hong Kong: Hanart T. Z. Gallery.

Adorno, Theodor *et al.* 1980. *Aesthetics and Politics*, with afterword by Fredric Jameson, trans. Ronald Taylor. London: Verso.

An Su 安夙, ed. 2010. *Xu Bing Prints* 徐冰版画, bilingual edition. Beijing: Wenhua yishu chubanshe.

Anderson, Marston. 1990. *The Limits of Realism: Chinese Fiction in the Revolutionary Period*. Berkeley: University of California Press.

Andrews, Julia F. 1994. *Painters and Politics in the People's Republic of China, 1949–1979*. Berkeley: University of California Press.

Andrews, Julia F. and Kuiyi Shen, eds. 1998. *A Century in Crisis: Modernity and Tradition in the Art of Twentieth-Century China*. New York: Guggenheim Museum.

Artist Chen Qi: Notations of Time. 陈琦时间简谱. 2010. Bilingual exhibition catalogue. Beijing: Amelie Art Gallery.

Berry, Chris, ed. 1991. *Perspectives on Chinese Cinema*. London: BFI Publications.

Berry, Chris, Lu Xinyu, and Lisa Rofel, eds. 2010. *The New Chinese Documentary Film Movement: For the Public Record*. Hong Kong University Press, 2010.

Bürger, Peter. 1984. *Theory of the Avant-Garde*, trans. Michael Shaw. Minneapolis: University of Minnesota Press.

Chen Lüsheng 陈履生, ed. 2000. *Xin Zhongguo meishu tushi 1949–1966* 新中国美术图史 1949–1966 (*An Illustrated Art History of New China, 1949–1966*). Beijing: Zhongguo qingnian chubanshe

Chen Qi 1963: The Making of Water 陈琦 1963. 2009. Bilingual exhibition catalogue. Beijing: Amelie Art Gallery.

Chen Xiangbo 陈湘波, and Xu Ping 许平, eds. 2012. *Ershi shiji Zhongguo pingmian sheji wenxian ji* 二十世纪中国平面设计文献集 (*Documents on Twentieth-Century Chinese Graphic Design*). Nanning: Guangxi meishu chubanshe.

China Contemporary: Architecture, Art, Visual Culture. 2006. Exhibition catalogue. Rotterdam: NAi Publishers.

China's New Art, Post-1989. 1993. Exhibition catalogue. Hong Kong: Hanart T. Z. Gallery.

Chiu, Melissa, and Zheng Shengtian, eds. 2008. *Art and China's Revolution*. New York: Asia Society in association with Yale University Press.

Chow, Rey. 2007. *Sentimental Fabulations, Contemporary Chinese Films: Attachment in the Age of Global Visibility*. New York: Columbia University Press.

Clark, Paul. 1987. *Chinese Cinema: Culture and Politics since 1949*. Cambridge University Press.

2005. *Reinventing China: A Generation and its Films*. Hong Kong: Chinese University Press.

2008. *The Chinese Cultural Revolution: A History*. Cambridge University Press.

Clark, Timothy *et al.* 1994. *The Revolution of Modern Art and the Art of Modern Revolution*. First published 1967. Norfolk, UK: Chronos Publications.

Croizier, Ralph. 1988. *Art and Revolution in Modern China: The Lingnan (Cantonese) School of Painting, 1906–1951*. Berkeley: University of California Press.

Dikovitskaya, Margaret. 2006. *The Study of the Visual After the Cultural Turn*. Cambridge, MA: MIT Press.

Dissanayake, Wimal. 1993. *Melodrama and Asian Cinema*. Cambridge University Press.

Dobrenko, Evgeny. 2007. *Political Economy of Socialist Realism*, trans. Jesse M. Savage. New Haven, CT: Yale University Press.

Fitzgerald, John. 1996. *Awakening China: Politics, Culture, and Class in the Nationalist Revolution*. Stanford University Press.

Gao Minglu 高名潞, ed. 1998. *Inside Out: New Chinese Art*. Berkeley: University of California Press.

Guo Moruo. 1963. *Moruo wenji* 沫若文集 (*Collected Writings of Guo Moruo*). Beijing: Renmin wenxue chubanshe.

He Kun juebanhua 贺昆绝版画 (*Reduction Prints by He Kun*). 2009. Exhibition catalogue. Hangzhou: Panorama Gallery.

He Xiangning Art Musuem 何香凝美术馆. 2003. *Muji tuxiang de liliang: He Xiangning meishuguan zai 2002 nian* 目击图像的力量：何香凝美术馆在 2002年 (*Witnessing the Power of Images: The He Xiangning Art Museum in 2002*). Nanning: Guangxi shifan daxue chubanshe.

Hinton, William. 1997. *Fanshen: A Documentary of Revolution in a Chinese Village*, paperback edn. First published 1966. Berkeley: University of California Press.

Holloway, David, and John Beck, eds. 2005. *American Visual Cultures*. London: Continuum.

Hu Feng 胡风. 1999. *Hu Feng quanji* 胡风全集 (*The Complete Works of Hu Feng*). Wuhan: Hubei renmin chubanshe.

Huang Zhuan 黄专, Fang Lihua 方立华, and Wang Junyi 王俊艺, eds. 2008. *Shijue zhengzhi xue: ling yige Wang Guangyi* 视觉政治学：另一个王广义 (*Visual Politics: Another Wang Guangyi*). Guangzhou: Lingnan meishu chubanshe.

Hung, Chang-tai. 2011. *Mao's New World: Political Culture in the Early People's Republic*. Ithaca, NY: Cornell University Press.

Jameson, Fredric. 1971. *Marxism and Form: Twentieth-Century Dialectical Theories of Literature*. Princeton University Press.

1981. *The Political Unconscious: Narrative as a Socially Symbolic Art*. Ithaca, NY: Cornell University Press.

Jenks, Chris, ed. 1995. *Visual Culture*. London: Routledge.

Jiang Feng 江丰. 1983. *Jiang Feng meishu lun ji* 江丰美术论集 (*The Collected Essays on Fine Arts by Jiang Feng*), ed. Hong Bo 洪波 *et al*. Beijing: Renmin meishu chubanshe.

Jiang, Jiehong, ed. 2007. *Burden or Legacy: From the Chinese Cultural Revolution to Contemporary Art*. Hong Kong University Press.

Ke Ling 柯灵. 1979. *Dianying wenxue congtan* 电影文学丛谈 (*Miscellaneous Essays on Cinematic Literature*). Beijing: Zhongguo dianying chubanshe.

King, Richard, ed. 2010. *Art in Turmoil: The Chinese Cultural Revolution, 1966–1976*. Vancouver: University of British Columbia Press.

 2010. *Heroes of China's Great Leap Forward: Two Stories*. Honolulu: University of Hawaii Press.

Levenson, Joseph. 1971. *Revolution and Cosmopolitanism: The Western Stage and the Chinese Stages*, with a foreword by Frederick E. Wakeman, Jr. Berkeley: University of California Press.

Li Hua 李桦 and Li Qun 力群, eds. 1959. *Shinian lai banhua xuanji* 十年来版画选集 (*Selected Prints from the Past Decade*). Shanghai renmin meishu chubanshe.

Li Jiefei 李洁非 and Yang Jie 杨劼. 2010. *Jiedu Yan'an: wenxue, zhishifenzi he wenhua* 解读延安：文学，知识分子和文化 (*Reading Yan'an: Literature, Intellectuals, and Culture*). Beijing: Dangdai Zhongguo chubanshe.

Li Shuangshuang, cong xiaoshuo dao dianying 李双双，从小说到电影 (*Li Shuangshuang, from Short Story to Film*). 1963. Beijing: Zhongguo dianying chubanshe.

Lin Chun. 2005. *The Transformation of Chinese Socialism*. Durham, NC: Duke University Press.

Liu Qingyuan 刘庆元. 2006. *Suipian: Liu Qingyuan muke zuopin, 1998–2006* 碎片：刘庆元木刻作品，1998–2006 (*Fragments: Woodcut Prints by Liu Qingyuan, 1998–2006*). Guangzhou: Zuojia chubanshe.

Lü Peng. 2010. *A History of Art in Twentieth-Century China*, trans. Bruce Gordon Doar. Milan: Charta.

Mao Tse-tung. 1961–77. *The Selected Works of Mao Tse-tung*. 5 vols., 1st edn. Peking: Foreign Languages Press.

Mittler, Barbara. 2012. *A Continuous Revolution: Making Sense of Cultural Revolution*. Cambridge, MA: Harvard University Asia Center and Harvard University Press.

Mirzoeff, Nicholas. 1999. *An Introduction to Visual Culture*. New York: Routledge.

Paparoni, Demetrio, ed. 2013. *Wang Guangyi: Works and Thoughts 1985–2012*. Milan: Skira.

Qi Fengge 齐凤阁, ed. 2002. *Ershi shiji Zhongguo banhua wenxian* 二十世纪中国版画文献 (*Documents on Twentieth-Century Chinese Printmaking*). Beijing: Renmin meishu chubanshe.

Rancière, Jacques. 2009. *Dissensus: On Politics and Aesthetics*, ed. and trans. Steven Corcoran. New York: Continuum.

Rawlinson, Mark. 2009. *American Visual Culture*. Oxford: Berg.

Robin, Regine. 1992. *Socialist Realism: An Impossible Aesthetic*, trans. Catherine Porter. Stanford University Press.

Sans, Jérôme. 2009. *China Talks: Interviews with 32 Contemporary Artists by Jérôme Sans*. Beijing: Timezone 8.

Shui Zhongtian 水中天. 2001. *Lishi, yishu yu ren* 历史，艺术与人 (*History, Art, and Human Beings*). Nanning: Guangxi meishu chubanshe.

Silbergeld, Jerome. 1999. *China into Film: Frames of Reference in Contemporary Chinese Cinema*. London: Reaktion Books.

Smith, Karen. 2006. *Nine Lives: The Birth of Avant-Garde Art in New China*. Zurich: Scalo Verlag.

Tang, Xiaobing 唐小兵. 1996. *Global Space and the Nationalist Discourse of Modernity: The Historical Thinking of Liang Qichao*. Stanford University Press.

 2000. *Chinese Modern: The Heroic and the Quotidian*. Durham, NC: Duke University Press.

 ed. 2007. *Zai jiedu: dazhong wenyi yu yishi xingtai* 再解读：大众文艺与意识形态 (*Re-reading: Literature and Art for the Masses and Ideology*). First published Oxford University Press, Hong Kong, 1993. Expanded edn Peking University Press.

 2008. *Origins of the Chinese Avant-Garde: The Modern Woodcut Movement*. Berkeley: University of California Press.

 2011. *Multiple Impressions: Contemporary Chinese Woodblock Prints*, exhibition catalogue, University of Michigan Museum of Art, Ann Arbor, July 16 – October 23, 2011, distributed by the University of Washington Press.

Van Fleit Hang, Krista. 2013. *Literature the People Love: Reading Chinese Texts from the Early Maoist Period (1949–1966)*. New York: Palgrave Macmillan.

Vukovich, Daniel F. 2012. *China and Orientalism: Western Knowledge Production and the P.R.C.* London: Routledge.

Wang, Ban, and Jie Lu, eds. 2012. *China and New Left Visions: Political and Cultural Interventions*. Lanham, MD: Lexington Books.

Wang Guangyi 王广义. 2002. Hong Kong: Timezone 8 Ltd.

Wang Huangsheng 王璜生, ed. 2007. *Liang Yongtai: chungui er huashi* 梁永泰：春归而华实 (*Liang Yongtai: Achievements in Youth*). Hong Kong: Gongyuan chuban youxian gongsi.

Wang Hui 汪晖. 2008. *Qu zhengzhihua de zhengzhi: duan 20 shiji de zhongjie yu 90 niandai* 去政治化的政治：短二十世纪的终结与90年代 (*The Politics of Depoliticization: The End of the Short 20th Century and the 1990s*). Beijing: Sanlian shudian.

Wang Mingxian 王明贤, and Yan Shanchun 严善錞. 2000. *Xin Zhongguo meishu tushi 1966–1976* 新中国美术图史 1966–1976 (*An Illustrated Art History of New China, 1966–1976*). Beijing: Zhongguo qingnian chubanshe.

Wang Shikuo yishu yanjiu 王式廓艺术研究 (*Studies of Wang Shikuo's Art*). 1990. Beijing: Renmin meishu chubanshe.

Xu Bing 徐冰, Wang Huangsheng 王璜生, and Yin Shuangxi 殷双喜, eds. 2011. *Cong Yan'an dao Beijing: ershi shiji Zhongguo meishu jujiang Wang Shikuo* 从延安到北京：二十世纪中国美术巨匠王式廓 (*From Yan'an to Beijing: The Great Artist in Twentieth-Century Chinese Art, Wang Shikuo*). Beijing: Wenhua yishu chubanshe.

Yan Shanchun 严善錞, and Lü Peng 吕澎, eds. 1992. *Dangdai yishu chaoliu zhong de Wang Guangyi* 当代艺术潮流中的王广义 (*Wang Guangyi in the Currents of Contemporary Art*). Chengdu: Sichuan meishu chubanshe.

Zhang, Rui. 2008. *The Cinema of Feng Xiaogang: Commercialization and Censorship in Chinese Cinema after 1989*. Hong Kong University Press.

Zhang, Yingjin. 2002. *Screening China: Interventions, Cinematic Reconfigurations, and the Transnational Imaginary in Contemporary Chinese Cinema*. Ann Arbor: University of Michigan Press.

Zhou Yang 周扬. 1985. *Zhou Yang wenji* 周扬文集 (*Collected Writings of Zhou Yang*), ed. Luo Junce 罗君策. Beijing: Renmin wenxue chubanshe.

Zhu, Ying. 2003. *Chinese Cinema During the Era of Reform: The Ingenuity of the System*. Westport, CT: Praeger.

Zhu, Ying, and Stanley Rosen, eds. 2010. *Art, Politics, and Commerce in Chinese Cinema*. Hong Kong University Press.

Index

273